# 'RACE IS EVERYTHING'

# 'Race Is Everything'
# Art and Human Difference

David Bindman

Foreword by Henry Louis Gates Jr

REAKTION BOOKS

*In memory of my dear friend Louis Edward Wilson,*
*Professor of History at Smith College (1939–2022)*

*Published by*
Reaktion Books Ltd
Unit 32, Waterside
44–48 Wharf Road
London N1 7UX, UK
www.reaktionbooks.co.uk

First published 2023
Copyright © David Bindman 2023

Printed and bound in Great Britain by TJ Books Ltd, Padstow, Cornwall

A catalogue record for this book is available from the British Library

ISBN 978 1 78914 696 7

# CONTENTS

# Foreword

HENRY LOUIS GATES JR

How were human beings representationally turned into animals? How were African people rhetorically turned into apes? Going back to at least the seventeenth century, writers, scholars and scientists attempted to link Black people sexually and genetically with apes – a disturbing badge of inferiority. As Wulf D. Hund and Charles W. Mills have noted, Jean Bodin claimed that humans had sex with animals in sub-Saharan Africa, and from these unions monsters were created. In 1570, Antonio de Torquemada wrote of a woman from Portugal having an African ape's children. In 1689, John Locke wrote that 'women have conceived by drills [mandrills or baboons]' in Guinea.[1] Thomas Jefferson wrote in 1785 of 'the preference of the Oran-utan [orangutan] for the black women over those of his own species'. And in 1799, Charles White wrote that Africans were 'nearer to the brute creation than any other of the human species', and that they belonged to 'another race of mankind besides that descended from Adam'.

Immanuel Kant took the ideas of race and racial inferiority further, adding a scientific cast to these decidedly unscientific ideas. In 1775 he declared the existence of four permanent races, each with its own characteristics. Nina Jablonski explains the result in *Living Color: The Biological and Social Meaning of Skin Color* (2012):

> Kant had scant personal knowledge of human diversity but opined freely about the tastes and finer feelings of groups about which he knew nothing. For Kant and his many followers, the rank-ordering of races by skin color and character created a self-evident order of nature that implied that light-colored races were superior and destined to be served by the innately inferior, darker-colored ones . . . a

fixed natural hierarchy of human races, graded in value from light to dark, gained tremendous support because they reinforced popular misconceptions about dark skin being more than a physical trait. The preference for light over dark – strictly speaking, white over black – was derived [in part] from pre-medieval associations of white with purity and virtue and of black with impurity and evil.[2]

Kant was not an outlier. The eighteenth and nineteenth centuries saw dubious claims of racism justified by various interpretations of science. In this fascinating book, David Bindman argues that racial scientists went beyond Kant's emphasis on skin colour. After all, they reasoned, there were too many skin-colour variations within any one ethnic or racial group – too many shades to measure 'objectively'. Thus, we see the beginnings of skull measurements: the dreadful idea, which was to become prevalent, that the size of a person's skull represented not only that person's race – and the supposed defects that went along with it – but that person's social class, economic class or even propensity towards criminality.

The names of these 'scientists' have become familiar. Georges Cuvier (1769–1832) and Johann Caspar Lavater (1741–1801) connected a person's appearance with their racial and character traits. And as Pieter Camper (1722–1789) and others tried to argue, whatever traits applied to one member of a race applied to *all* members of a race. As Bindman writes, they sought an 'incontrovertible connection between the form of the head and the mind contained within it, so that the intelligence and the moral character not only of an individual, but the whole race from which she or he came throughout the ages, could be read from a face.'

The context here is critical: during the 1790s, this pivotal decade for the association of the shape of the skull with racial characteristics, 1,671,944 Africans were shipped across the Atlantic, and 1,491,171 arrived in the New World. More than 86,000 enslaved Africans arrived in the United States.[3] But what changed in the nineteenth century? This shift is Bindman's focus. 'In the eighteenth century,' Bindman writes, 'aesthetics and racial theory were generally confined to the work of philosophers and natural scientists, while in the nineteenth century aesthetic and racial ideas became part of the conversation of the educated classes and of course the subject-matter of artists themselves, eventually having implications at the popular level.' The nineteenth century thus saw the connections between race and art solidify for an even greater audience. Has there ever been a more effective or diabolical way to argue for fundamental

differences between people than showing an image that focuses the viewer's eye on apparent distinctions, extrapolated – and stretched beyond exaggeration – over time?

The racial scientists of the nineteenth century endorsed the idea that race was permanent, biological and unaffected by cultural or environmental factors. Widespread belief in racial permanence led to what Bindman calls a 'representational fallacy' in art; that is, that 'a drawing, painting, print or sculpture of a human being from the ancient past can be seen as an exact representation of that person, unmediated by the artist or the period in which it was made.'

We can see the danger here. If white artists believed that the marble majesty of the *Apollo Belvedere* represented the ideal of artistic beauty, then they could portray its opposite – people with dark skin – as objectionable, ugly, criminal, inferior. But what about the dark-skinned peoples of ancient Egypt, another source of inspiration for artists and scholars? To nineteenth-century racial scientists such as Josiah Nott and George Gliddon, Egyptians were white (a supposition that led to Frederick Douglass's famous retort: 'Egypt is in Africa. Pity that it had not been in Europe, or in Asia, or, better still, in America!'). We might call Nott, Gliddon, Louis Agassiz and Samuel Morton the unholy quartet – the rogues gallery of racial scientists.

The nineteenth century saw the relative democratization of the creation and dissemination of visual culture. Lithography, machine printing and other technological changes made it much less expensive to spread racial imagery, which was so often based on racial caricature. Advertisements, postcards, games and other forms of publishing and entertainment used racist images of non-white people to such a prolific degree that they became embedded deeply in popular culture worldwide.

Photography was of the utmost importance – both to racists and to the people who fought them. On the one hand, consider the eugenicist Francis Galton, who, Bindman writes, created 'Composite Portraits' that saw him 'photograph series of physiognomies according to types of race, criminality, disease and ancient rulers on coins consecutively onto the same photographic plate, underexposing each one so that the common features emerged more distinctly than the individual in the final print.' Taking the 'scientific' aspect further, Galton hoped that the different profiles could be measured according to facial types and stored in a sort of database of numerical descriptions of race that could be shared easily, even by telegram.

On the other hand, the democratization of photography opened the door for people of colour to fight back. Bindman foregrounds two men who have inspired me throughout my career: Frederick Douglass and W.E.B. Du Bois. Douglass was the most photographed American of the nineteenth century, and he viewed himself as the representative coloured man in the United States. He took the responsibility seriously because, as he wrote in 1849, 'Negroes can never have impartial portraits, at the hands of white artists. It seems to us next to impossible for white men to take likenesses of black men, without most grossly exaggerating their distinctive features. And the reason is obvious. Artists, like all other white persons, have adopted a theory respecting the distinctive features of negro physionomy [sic]'.[4]

By 'fashioning and refashioning' himself, Douglass seized upon imagery as a tool for the redemption of his race. Du Bois also embraced this idea, as shown in his 'American Negro' exhibit at the 1900 World's Fair. The men and women depicted in the 363 black-and-white photographs were dignified and refined; they were exemplars of Victorian values, not the caricatures of Black people found in books like Charles Carroll's *The Negro a Beast*, published that same year, or the racist 'Darktown' cartoons published by Currier and Ives in the United States during the dark years that followed Reconstruction.

Few scholars have done more than David Bindman to untangle the complex, interconnected histories of art and race. Fewer still have attempted to do so across such a dramatic sweep of time and space. Throughout this important study, he deftly shows how the visual culture of the nineteenth century both depended on and promoted racial ideologies, which were so often based in contemporary conceptions of science. Indeed, Bindman writes, 'the science on which such racial hierarchies were based was essentially visual.' Without visual representation, racial science would have struggled to survive. But with visual representation, it was, by the end of the century, more prolific and inescapable than ever, being broadcast in advertisements and other images that became a central part of the way people lived and learned. Bindman brilliantly explains the historical antecedents of this process, as well as its disastrous results.

# Preface

Art historians, like most historians or critics, in the past tended to either ignore questions of race, or dismiss racial remarks made by artists, writers or critics by claiming they were typical of their time, and moving on quickly to more congenial topics. This book belongs with a number of recent publications that have sought to look at ideas of race head on, analysing the way such ideas impacted the art of the past, and how the art of the past impacted ideas of race. I have concentrated here on the nineteenth century, when racial consciousness was at its height and least challenged. It goes without saying that racial attitudes even then were varied, complex and often self-contradictory; they bordered on or are often discussed as if they were synonymous with nationality, ethnicity and/or culture. Sometimes discussions of race are not about race at all; equally they can be essentially about race without mentioning the word. In other words race in the nineteenth century, or indeed at any other time, is rarely reducible to simple binaries. I do not propose to offer a definition of race, but suffice to say it always contains one or more of the following: appeal to a common ancestry, the inheritance of 'blood', a certain biological permanence, and an imagined community based on one or more of the former.

This volume is made up of a series of studies in broadly chronological order that look at the interface between ideas of race from the viewpoint of those who wrote about it, and visual culture in Europe and North America in the nineteenth century; it ends by looking back from some twentieth-century episodes that reveal continuities and breaks from the previous century. Its main, though far from exclusive, focus is on 'racial science', a pairing of words that might seem to be an oxymoron in an age when we tend to see racial attitudes as inherently irrational. But in the nineteenth century race was universally accepted as a respectable subject for academic

study in European and American universities, and the word was used in educated circles without inhibition. Vast amounts of research were devoted to its elucidation and measurement of real human bodies, and many great reputations were earned in its pursuit. This is not to say that the status or contours of each race were universally agreed, or even that there was ever general agreement on the number of races in the world; in fact the very uncertainties around race made it an attractive field of study for ambitious researchers, who could live in the hope of finally sorting it out.

What follows is not principally about the depiction of race, nor of its horrific effects on those victimized in its name. It is about the way nineteenth-century ideas of race interacted with art, visual culture and aesthetics. It attempts to look at race from the outside, taking where possible a dispassionate view of beliefs that are to me and my academic colleagues profoundly alien and abhorrent, but were in the nineteenth century common assumptions. No field of study was immune to the dominance of racial or even racist ideas in the nineteenth century, including the history of art. As Éric Michaud has rightly said: '[the history of art] was neither more nor less racist than the other social sciences, and all of them were oriented by racial thinking to classify and create hierarchies of people according to certain somatic and psychological traits.'[1]

Having said that I am acutely aware that racial attitudes have not magically disappeared from either sphere, though they are rarely expressed as blatantly as they were. I am also painfully aware that language itself makes it almost impossible to write historically about the subject without using words that inadvertently perpetuate racially charged attitudes. How, for instance, can one talk about racial mixture, in itself a doubtful concept, without using words like 'mulatto', or 'mixed blood' (*sang-mêlé*)?

The history of European art we have inherited from its late nineteenth-century pioneers rests to a degree on a racially inflected division between Latin, Mediterranean or Southern style, and the Germanic or Northern style, each divided into separate national 'schools'. This division still affects the layout of museum and art gallery exhibits, though there has been an increasing pushback against it in recent years.[2] As a discipline rooted in the nineteenth century, art history has a long tradition of racialized discourse, but race and its artistic manifestations as a subject of study in itself has over the last hundred years been largely absent. I am glad to say that this is no longer the case; there are many art historians who have brought it to the fore, and new generations are actively working on it as an unavoidable feature of earlier societies.[3]

This book generally uses racial ideas of the time as a starting point, rather than looking outwards from a consideration of works of art themselves, except in the case of Chapter Four, which makes a case for artists as having contributed to the creation of new inflections on ideas of race. Though the book ranges across the countries of Europe and North America, it does not deal comparatively with every country, nor does it look at race outside those regions, or consider non-European forms of racial theory, though that would be a fascinating series of tasks for scholars with the right expertise. This book has as one of its aims to show that the painful issues around race and its histories can – indeed must – be confronted if we are to come to terms even in a small way with what is still one of the most urgent problems confronting the world in the twenty-first century.

Race as a biological and cultural classification grew in strength through the nineteenth and twentieth centuries in Western countries, but was ostensibly discredited by its inescapable consequences in the Holocaust. Unfortunately, it is evident that the ideas of race developed in the nineteenth century have been given a new life on the Internet, and continue to affect, not always unconsciously, contemporary politics. To give examples, a group of Republican members of the U.S. Congress have talked recently of 'uniquely Anglo-Saxon political traditions', a claim that the *Washington Post* has equated with nineteenth-century calls for White supremacy.[4] Former President Trump responded to criticism from African Americans by suggesting they were of 'low IQ',[5] invoking the absurd claim, going back at least to Georges Cuvier at the beginning of the nineteenth century and backed by dubious statistics until the end of the century and beyond, that there is a correlation between the shape of the African skull and a low level of intelligence. In Britain it is expressed in the government-supported campaign against 'woke', and its attempts to suppress the discussion of Britain's long and central involvement in the slave trade.[6]

This book is divided into six main sections, each of which discusses clusters of ideas that involve both visual imagery or aesthetics and race. The first section is about the visual aspects of racial comparison, based mainly on the measurement of the skull as a scientific method of distinguishing and comparing the abilities of each race. The second looks at the myth of the Saxons and its role in the development of what became known as the white race. It also looks at the contentious relationship between nationalism, religion and race, and the role played in joining them together by artists in Germany and England. It is followed by a third section on the importance of antiquity and especially ancient Egypt in the formation

of nineteenth-century racial ideas, particularly the construction of 'the Jewish race'. It also considers the vital role played by perceptions of ancient Egyptian art, particularly in the mid-century writings of the American ethnologists Samuel Morton, Josiah Nott and George Gliddon.

The fourth section is about aesthetics and race, arguing that aesthetic judgements played a fundamental part in theories of racial difference, especially in Charles Darwin's theory of sexual selection in the process of evolution, which he saw as both a complement to and distinct from natural selection. The fifth section is about France and the racial implications that came largely from the French defeat in the Franco-Prussian war for such artists as Puvis de Chavannes, Degas and Cézanne. It is followed by a discussion of the artistic consequences of eugenics.

The sixth and final section considers the transmission of ideas associated with racial science into objects that were part of daily life through new methods of reproducing images in large numbers that were easily visible to the general population. It is followed by three episodes from the twentieth century: the fightback against racial science by Franz Boas and W.E.B. Du Bois; the display of *The Races of Mankind* in the Field Museum in Chicago, and finally a consideration of the complex and controversial part played by race in the art of the German Expressionist painter Emil Nolde.

My academic career has been a highly privileged one, largely based at the University of London in Britain and also in the United States, where I have taught and held research fellowships. My interest in the subject of race dates back to the early 1990s when I was invited to produce the 'Eighteenth Century' volume of the venerable series *The Image of the Black in Western Art*, founded by Dominique and Jean de Menil and published by Harvard University Press, the first volumes of which appeared in the 1970s and '80s. This followed naturally from my interest in caricature and ideas of art as representation of national attributes, deriving from a 1989 exhibition I curated on British attitudes to the French Revolution, which contained many caricatures based on stereotypes of the French.[7] My work on *The Image of the Black* volume led after many vicissitudes to an editorial role, along with Henry Louis Gates Jr, in bringing the whole series to completion, with the addition of two volumes on the twentieth and twenty-first centuries, finally achieved in 2014. I am currently working on the second of two companion volumes, on *The Image of the Black in Latin American and Caribbean Art*, and, with Suzanne Blier, on *The Image of the European in African Art*.

In the years from 1998 onwards, when *The Image of the Black* volumes were in abeyance, before it was taken over in 2005 by what was then the

Du Bois Institute for African and African American Research (now the Hutchins Center) at Harvard University, I embarked on a book that looks widely at the whole question of race and its relationship to aesthetics, published as *Ape to Apollo: Aesthetics and the Idea of Race, 1700–1800* (2002).[8] The present book follows on from it, but looks more fully at art as well as aesthetics. This reflects the fact that in the eighteenth century, aesthetics and racial theory were generally confined to the work of philosophers and natural scientists, while in the nineteenth century aesthetic and racial ideas became part of the conversation of the educated classes and of course the subject-matter of artists themselves, eventually having implications at the popular level. We can begin to see something becoming commonplace that was rare in the eighteenth century: the incorporation of racial science into the language of works of art and popular imagery. Artists themselves as well as their public had, from the 1780s and '90s, easy access to discussions of the relationship between skull shape and racial origin.

This book owes much to the work I have done with my co-editor Henry Louis Gates Jr, and also with Suzanne Blier and Alejandro de la Fuente on individual volumes of *The Image of the Black in Western Art*. It also follows on, with some theoretical differences, from Victor Stoichita's outstanding book *Darker Shades: The Racial Other in Early Modern Art* (2014; translated into English and published by Reaktion, 2019), which deals with earlier centuries. Stoichita's book deals principally with the concept of 'the Other', which means that it focuses on the representation of racial others in paintings and sculptures by Western artists, and not on racial theories. In the nineteenth century, however, there is a large theoretical literature of a kind that barely existed in previous centuries, which looked on race as a positive and even progressive force that affected every aspect of society, believing that it could change the world for the better – though, as we well know, it had catastrophic consequences for those outside what Darwin called the 'favoured' races.

Among the works that have influenced the present study is one that does not focus directly on art and race but has much of interest to say about it: Mary Cowling's *The Artist as Anthropologist* (1989). Its focus is more on class, but she reveals its close connections with race in the Victorian period in England. Something similar can be said about Anthea Callen's *The Spectacular Body: Science, Method and Meaning in the Work of Degas* (1995), which, despite the seeming limitation of the subtitle, contains a wide-ranging account of the racial and artistic implications of scientific physiognomy.

This book has also been influenced by the interest in recent years in 'whiteness' of skin and its implications, initiated in Britain by Richard Dyer's book *White* (1997), by writings by and conversations with the late art historian and my former student Angela Rosenthal, and the writings of Nell Painter.[9] Though whiteness tends to be seen as an unmarked category and 'invisible' in contemporary discourse, it was extremely visible in the nineteenth century through ideas of 'Aryan' or 'Anglo-Saxon' races, or the 'White Man's burden', which were public ways of constructing 'superior' as opposed to 'inferior' races.

I should also add a debt to Eric Michaud's *The Barbarian Invasions: A Genealogy of the History of Art* (2019), which is very much about race and art in the nineteenth century. He is centrally concerned with the role of racial theory in the historiography of the history of art rather than the relationship between race and art. Even so we are often concerned with some of the same issues and people, and I have learned much from his book.

Finally, there is the question of what topics are not dealt with in what is a relatively short and admittedly Eurocentric book on a very large subject. I have concentrated on attitudes towards race by and about Europeans, and European attitudes mainly though not exclusively towards those of African and Jewish heritage, that is to say 'the two principal forms of racism to emerge in Europe: antisemitism and prejudice against people of colour'.[10] But there are studies to be written on attitudes towards Middle Eastern, 'Oriental' and Turkish peoples, and of course racial attitudes directed by non-Europeans towards Europeans themselves. There is also the fascinating Victorian episode of the application of cranial theory in satirical representations of Irish Fenians, which make them more simian in physiology than the most demeaning caricatures of Africans. I have almost nothing to add to the remarkable book that came out on the subject as early as 1971 by L. Perry Curtis Jr, *Apes and Angels: The Irishman in Victorian Caricature*.

Readers might find that there is less on photography than is justified by its importance to racial science. I have discussed photography in relation to Frederick Douglass and eugenics principally, but I am aware that there is a whole story which deserves telling from its very invention to its adoption by nineteenth- and twentieth-century anthropologists. However, the subject has been excellently covered by Elizabeth Edwards, Deborah Willis and others;[11] for me to go over it again would, in my view, be redundant. For other omissions, of which I admit there are many, I can only hope that this book will stimulate others to work on them.

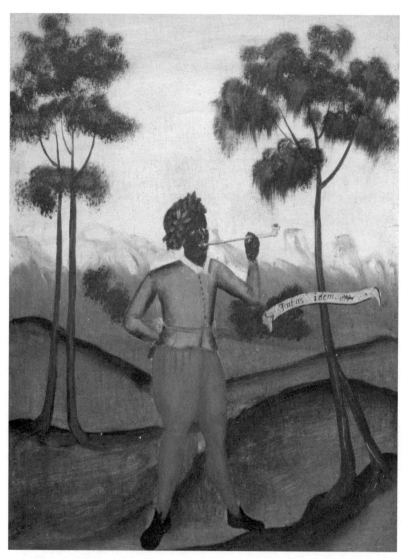

1  *Intus idem*, emblem of a Black man smoking a pipe, *c.* 1610, oil painted panel from Lady Drury's Closet (the Hawstead Panels).

# Introduction:
# Racial Science and Visual Culture

Negroes can never have impartial portraits, at the hands of white artists.
It seems to us next to impossible for white men to take likenesses of black men,
without most grossly exaggerating their distinctive features. And the reason
is obvious. *Artists, like all other white persons, have adopted a theory
respecting the distinctive features of negro physionomy* [*sic*].[1]

FREDERICK DOUGLASS, *North Star* (1849)

Not only have they [the ancient Greeks] had the glory of giving the world
such admirable types as a Venus, an Apollo, a Farnese Hercules; but also there
is a visible hierarchy of beauty established from ancient times even among
themselves, and in this natural aristocracy the Europeans are the most eminent,
by their grace of outline and strength of muscular development.

ARTHUR DE GOBINEAU, *The Inequality of Human Races* (1854)

The remark above by the African American activist and former slave
Frederick Douglass (1817–1895) gets to the heart of this book, because
he makes the connection between European stereotypes of people of dif-
ferent races and 'a theory', by which he means what he called 'ethnology',
but has been generally known as 'racial science',[2] the nineteenth-century
European and American scientific attempts to deduce and if possible to
measure moral and intellectual character from outward appearance, based
on the kind of assumptions made above by Gobineau.

Racial science has a complex history. It derives most immediately from
the eighteenth-century Enlightenment, but it also draws upon earlier ideas
like the Great Chain of Being, which goes back ultimately to Aristotle, pro-
posing a hierarchy from the lowest organisms to the highest, human beings

– or for Christians, angels. But racial science is essentially a late eighteenth- and nineteenth-century construction in its use of classification and exact comparative measurement.

Racial science and racial prejudice in general rested on a traditional, even proverbial idea that the inner person or 'the soul' is defined by outward appearance, but there was an equally strong traditional belief that appearances could be deceptive. This dichotomy can be seen in two panels from a painted closet, made for or possibly painted by Lady Drury (the sister of the amateur painter Nathaniel Bacon) probably at the beginning of the seventeenth century. It is now in a public museum, Christchurch Mansion, in Ipswich.[3] The imagery derives from contemporary emblem books, and each panel consists of a Latin epigram on a scroll and a painting illustrating it. A painting of a Black man smoking a pipe (illus. 1) has the epigram 'Intus idem', 'the same inside', which suggests that outer appearance reflects the internal character of a person, thus a man of black skin is seen as necessarily black in character. This of course also references the Christian tradition of associating whiteness with cleanliness and moral purity, and blackness with evil and the Devil. In opposition to this idea, another painted panel of a white man of gentlemanly appearance is seen measuring his own forehead with a pair of compasses, accompanied by the epigram 'Fronti nulla Fides', or 'No faith or trust in the forehead or face'. This suggests the opposite to the previous panel, implying that outer appearance is *not* a trustworthy way of revealing character. In the nineteenth century this perception was generally overshadowed by the former as racial science dominated intellectual life in Western countries.

Douglass identifies one of four deep-rooted premises – we might even call some of them fallacies, some of which are age-old while others are completely new – that relate ideas of race to the visual world in the nineteenth century. They were taken for granted by scientific authorities, and by most people living in Europe and the Americas, especially those with a scientific education. According to the racial science developed in the early nineteenth century by Georges Cuvier (1769–1832) and others, an educated white person would generically have a larger skull, the visible shape of which is conditioned by the brain, which acts like a kind of muscle that expands to fill and extend the space, and thus enables the exercise of intellect and imagination. If, on the other hand, a person has black or brown skin it was believed with equal conviction, and confirmed to the satisfaction of the enquirer by experiment, that they had a skull that is smaller with a lower forehead, a sign of a constricted brain within that cannot expand freely, thus limiting the person's intellectual capacity.

It was further proposed by Johann Caspar Lavater (1741–1801) that the aesthetic appearance of a person was connected to their level of virtue or vice; a beautiful face implies a beautiful soul and an ugly one a tendency to wickedness. This was an idea inherited from antiquity but challenged in the late eighteenth century by the German writer Georg Christoph Lichtenberg, who pointed out that the great Greek philosopher Socrates was proverbial for both his beautiful mind and his physical ugliness.[4]

The second premise comes out of the first one, that the judgement of a person's character from her or his appearance applies to *all* that share the same skin colour or head shape, and can be supported by exact measurement of the skull, first proposed by the Dutchman Pieter Camper (1722–1789).[5] These attributes apply not only to individuals or small groups but to all people who are deemed to constitute a racial group. It therefore denies the inevitable differences that there are between people – and indeed skull types – in any community.

The third premise is that each race can be placed on a scale based on appearance and culture, from the superior race, always assumed to be represented by an educated white European, sometimes by the ideal ancient Greek head of the *Apollo Belvedere*, to the 'inferior' races, defined by darker skin colour or smaller skull capacity. This physical scale was virtually synonymous with a cultural scale from the civilized to the savage, or from the human to the animal. The European is always assumed to be the most developed, while Africans or Fuegians, or other people deemed inferior, are deemed to be closer to the animal kingdom.

THE FOURTH PREMISE, that we might call the representational fallacy, is that if a person's race is a permanent attribute going back to the earliest recorded history of humanity, which was often assumed to be ancient Egypt, a drawing, painting, print or sculpture of a human being from the ancient past can be seen as an exact representation of that person, unmediated by the artist or the period in which it was made. This means that in the nineteenth and early twentieth centuries racial scientists were able to use images from ancient art, usually Egyptian or Greek, to identify prototypes of peoples thousands of years later, thus giving present-day races a seemingly incontestable history.

These premises rested on a firm belief in scientific objectivity but also on a particular construction of history, which was largely derived from the study of ancient works of art, whether from ancient Greece or from Egypt,

whose monuments and images of people were in the process of discovery throughout the nineteenth and twentieth centuries. Ideas of relative beauty, so important for the classification of races, co-existed with a belief in the superiority of ancient Greece, while ancient Egypt offered a vast archive of images of different races from the beginning of recorded time.

Any one of the beliefs discussed above, if openly promoted today, would be enough to have its protagonist dismissed as belonging to the extreme political fringe. But it is important to reiterate that all of these beliefs were in varying degrees the bases of professional practice by some of the most revered scientists of the nineteenth century in Europe and the Americas, and were only systematically challenged in the twentieth century. To give an example of their authority, at the back of the Royal Academy in London's Piccadilly there is an ornate Victorian building now incorporated into the building. It was originally the administrative centre of the University of London, built in the 1860s to create a unified university out of the previously separate University College and King's College. On the lower level of the facade around the portico is a series of imposing full-size statues in niches of great men of learning of the modern era, including Francis Bacon and Isaac Newton. As part of a group of 'illustrious foreigners', including Leibnitz and Linnaeus, there stands Georges Cuvier, a French natural scientist revered throughout Europe and especially in Britain (illus. 2).

Cuvier is now best known for being the first person to identify and reconstruct the skeletons of extinct creatures from fossils. But in his day he was probably most famous for his work on brain structure and intelligence, which he applied to a racial hierarchy from 'the Negro' to 'the European', that 'proved' that the shape of the former's skull constricted his intelligence, while the latter's allowed it to expand, and thus be capable of greater imagination and thought, comparing the brain of the former explicitly with that of the ape. Thus, what is now the most offensive of all racial tropes, the supposed closeness of the African to our common simian ancestors, was given the authority of science by one of the most respected intellectuals of his day in nineteenth-century Europe. In reporting on the dissection of the body of Sarah Baartman, known as 'the Hottentot Venus', Cuvier remarked that there proved 'no exception to this cruel law which seems to have condemned to eternal inferiority the races with cramped and compressed skulls'.[6]

These assumptions that brought measurement to bear on skull variations express the basic premises of racial science and the enormous and almost totally malign consequences that followed from it. In the first place it gave scientific authority to the idea that each 'race' was solid enough

2 Statue by Patrick MacDowell of Georges Cuvier on the facade of the former University of London building, now the Royal Academy.

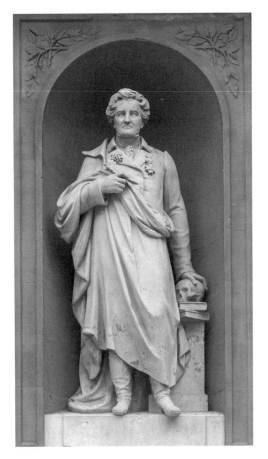

conceptually to have an essential form, an idea that went back at least to an ancient Greek treatise once attributed to Aristotle.[7] First, it meant that it could be assumed that there was such a thing, for example, as an essentially African head, or in more sophisticated studies one that defined a nation or ethnic group, which had permanent and identifiable differences from the heads of other races or groups. Second, it made a direct and seemingly incontrovertible connection between the form of the head and the mind contained within it, so that the intelligence and the moral character not only of an individual, but the whole race from which she or he came throughout the ages, could be read from a face. It meant that if you believed – against all evidence – that, for instance, Africans were congenitally lazy, it could be assumed to be hard-wired into their very being, over millennia and across the generations.

In nineteenth-century Europe and the Americas such assumptions were not only part of scientific discourse but constituted the common sense

of most educated people, even if they were not central to their concerns. It was taken as axiomatic in England and America that a male person (females were often deemed to share physical and mental characteristics with 'inferior' races) who appeared by skin colour or skull shape, or by shared 'blood', to belong to the 'Anglo-Saxon race', had access to moral principles, whether they exercised them or not; tended to be highly literate; were capable of exercising leadership; and possessed light skin and fair hair. The lower classes, by contrast, had none of those qualities or characteristics, and might have been of a different race or descent altogether. A member of the 'African race', it was believed by the majority of educated white people in the nineteenth century, was by nature capable of being tamed and enslaved; at the mercy of his physical instincts, she or he was likely to act without moral restraint.

The idea of race as a biological division of humanity goes back essentially to the great Swedish botanist and zoologist Carl Linnaeus (1707–1778), writing between the 1730s and 1750s, while 'aesthetics' was first defined in 1751 by Alexander Gottlieb Baumgarten as 'the science of sensual understanding',[8] and given its more modern meaning as being about the idea and judgement of beauty by K. P. Moritz and Immanuel Kant later in the century.[9] But the idea that non-Europeans were not only morally inferior but usually less beautiful than Europeans, or even downright monstrous, goes back at least to the Greek historian Herodotus in the fifth century BC. The Roman Pliny's claim that parts beyond the known world like India and Africa were inhabited by bizarre humanoid monsters, like Cynocephali or Dog-Heads and Sciapodae whose single enormous foot could act as a sunshade for itself, remained current throughout the Middle Ages and even appeared as one of the conflicting discourses in Christopher Columbus's journal of his 1492 expedition.[10]

The kind of aesthetic judgement relevant to eighteenth-century racial ideas was applied to the human body and physiognomy, and then generalized to apply to a group, ethnicity, nation or race. This could be a traveller's or scholar's blanket judgement, for instance, that the women of the Caucasus were beautiful and those of Lapland ugly.[11] 'Philosophical' observers, like the natural scientist Johann Reinhold Forster, would make comparative judgements, claiming that the inhabitants of one South Sea island were more or less beautiful than others, and would use these judgements as an index of their level of civilization.[12]

The idea that someone's character could be read from their face or, to a lesser extent, from their body thus goes back to classical antiquity

and had some currency in the sixteenth century, but its modern iteration began with the Swiss preacher Johann Kaspar Lavater, writing in the last decades of the eighteenth century, who proclaimed in massive and beautifully illustrated volumes,[13] from the evidence of portraits of people past and present, that not only was a person's moral character stamped irrevocably on their face, but a beautiful face signified a beautiful soul and an ugly face a sinful one, as in the case of Judas (illus. 3), because the repeated expression of particular emotions eventually altered the shape of the skull in discernible ways.

3 'Judas after Holbein', from Johann Caspar Lavater, *Physiognomische Fragmente, zur Beförderung der Menschenkenntniß und Menschenliebe* (Essays on Physiognomy, for the Promotion of the Knowledge and the Love of Mankind), vol. 1 (1775).

Race came into conjunction with such an idea because at about the same time the Dutch doctor and artist Pieter Camper had lined up in a chart what he believed to be representative skulls of different races and measured their facial angles comparatively, from the ideal head of the *Apollo Belvedere*, to the European, the Calmuck, the Negro and finally the ape (illus. 4, 5).[14] This chart gave the possibility of making exact comparative measurements of racial difference. It was thus not a big step to attribute a moral judgement of

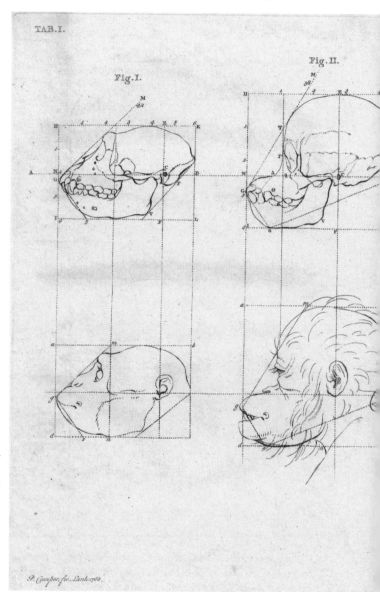

4 Illustrations from Pieter Camper, *Verhandeling . . . over het natuurlijk verschil der wezenstrekken in menschen van onderscheiden landaart en ouderdom* (A Treatise on the Natural Difference of Features in Persons of Different Countries and Periods of Life, 1791).

an individual's physiognomy to a skull that was claimed to represent a whole race, a move that was first made not by Camper but by Georges Cuvier and Charles White at the very end of the eighteenth century.

This development was obviously of interest to artists. Camper's book on comparative racial skulls, as is proclaimed in the title of his collected works, was itself designed for their use. The most highly regarded of these at the time, the 'history painters', who essentially followed the elevated art

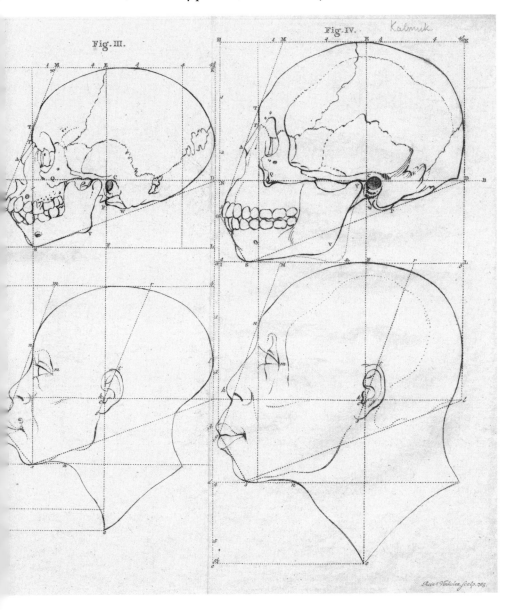

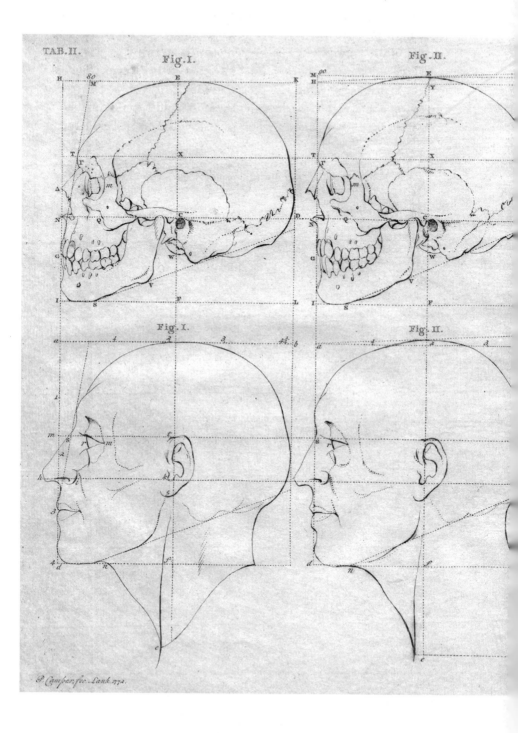

TAB. II.

Fig. I.

Fig. II.

Fig. I.

Fig. II.

P. Camper fec. Lank. 1772.

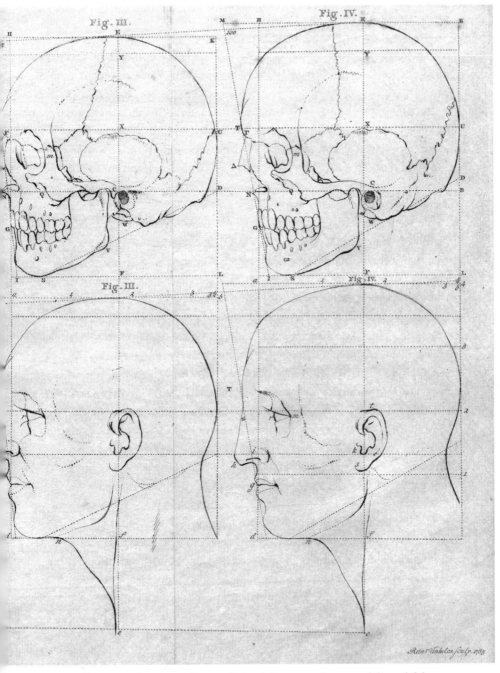

5  Illustrations from Pieter Camper, *Verhandeling . . . over het natuurlijk verschil der wezenstrekken in menschen van onderscheiden landaart en ouderdom* (1791).

of the Italian Renaissance painter Raphael and his fresco paintings in the Vatican, and whose works were enshrined in academic art teaching in all European countries from the seventeenth century onwards, depicted moral subjects derived from the Bible or the classics. They had an interest in portraying figures as racially accurate as possible, especially the Jews of the Old Testament, as did portrait painters when they added a Black attendant as a foil to the sitter.

But history painting was only one of those genres that made up the world of physical images in the nineteenth century, all of which intersected with ideas of race in different ways. There was landscape and portrait painting, which could on occasion represent racial types or themes; and the whole realm of documentary imagery, the main function of which was to record natural phenomena, human-made objects and works of art, and technical drawings and prints, like the diagrammatic illustrations to Camper's works. In addition, there was a long tradition in Europe of visual satire that was either political or about universal human folly, but was always responsive to public discussion of race or slavery, and dealt naturally in racial stereotypes.

At the furthest end from history painting, and particularly important for the widespread distribution of ideas of race in the nineteenth century, was popular everyday imagery, mainly advertisements. Such works were enabled by the enormous technological advances in reproductive media like lithography and machine printing, which resulted, through mass-produced images and 'humorous' coloured prints, in the creation of vast numbers of demeaning stereotypes mainly of those of African descent in Europe and the Americas (a few of which, like marketing for Aunt Jemima pancakes, Uncle Ben's rice and Land O'Lakes butter, lingered on well into the present century).[15] As Frederick Douglass put it 'yet for nothing is this age more remarkable than for the multitude, variety, perfection, and cheapness of its pictures'.[16]

Finally there was photography, which increased dramatically in popularity from the 1840s onwards and was frequently used to document racial, criminal and medical typologies, not only in Europe and America but in the colonies of India and Africa, among others. As Douglass put it, with some hyperbole: 'Daguerre [the putative inventor of photography], by the simple but all-abounding sunlight, has converted the planet into a picture gallery.'[17] These different genres were not necessarily separate from or antithetical to each other, but formed a kind of continuum, from paintings and sculpture mainly available only to the wealthy to public advertisements in cheap publications, which could be seen by anyone. As Douglass also

remarked, again with some exaggeration, 'What was once the special and inclusive luxury of the rich and great is now the privilege of all. The humblest servant girl may now possess a picture of herself such as the wealth of kings could not purchase fifty years ago ... As knowledge has left the cloister, pouring itself through the iron gates of the printing press, so art has left the studio for new instruments of expression and multiplication.'[18]

Art – or perhaps it is more accurate in the present context to say visual culture – thus covers a multitude of different practices, many of which changed in various ways through the nineteenth century. What is the difference between art and visual culture? The latter may be said to encompass the former, but art is usually distinguished by an implicit concern with the aesthetic as some kind of value in itself. There are no hard and fast boundaries between the two, however; there are genres such as caricature that are hard to classify as one or the other, and of course in the present age many artists have sought to incorporate commercial imagery into their work. But in the nineteenth century art was firmly associated with museums and often explicitly opposed to commerce, despite being traded extensively in the marketplace.

Attitudes towards race also varied according to time, place and circumstances, general and personal, and were always full of contradictions. This was especially true of the period in question, between 1800 and 1900, and the half century beyond. There was never general agreement as to whether the concept of race should be applied to the people of a particular continent, country or region, or to religious or ethnic groups such as Jews and the Romani people ('Gypsies') who lived in more than one country. The difference between races was generally expressed through biology, that is to say through ancestry, skin colour, skull shape or 'blood', or, alternatively, through cultural difference or custom that could be ranked on a continuum from animality and 'savagery' to 'civilization'; or it could be a mixture of some or all of those. Some late eighteenth-century authors divided the world into 'light' and 'dark' races – or, like the Göttingen academic Christoph Meiners, into the 'beautiful' and 'ugly' races[19] – others into the four, or subsequently five, races that corresponded to the known continents. But in the nineteenth century ever smaller subdivisions or 'sub-races' were conceived, sometimes within the frame of a 'greater' race; Robert Knox described the national and regional wars in Europe in the middle of the century entirely in terms of the racially defined countries and regions that they were fought upon.[20] As late as the 1940s even some followers of Franz Boas (1858–1942), who were firmly opposed to racial hierarchies, agreed

that there were three 'Great Races': the 'Caucasian', the 'Mongoloid' and the 'Negroid'.[21]

For a race to have an identity of any kind it had to be assumed that its present members were directly descended from, and shared blood and physical and psychological characteristics with, those in the far-distant past, though these might be concealed, lost or altered and in need of reclaiming or reviving. A distinction could be made between those of 'pure' race and those of mixed ancestry. If the Germanic tribes who had defeated the Romans were pure and incorruptible so should their present-day descendants be to exhibit their true selves, though obviously the ancient Germanic tribes were, in reality, varied in their customs and ways of life. If Africans were deemed to belong to a single race (an absurdity given the variety of the peoples of Africa) living in a savage state, then that state was by definition unchanging. The idea of race derived its strength from the widespread belief that it was an essential and defining attribute of the human condition.

How can race be distinguished from nationalism or ethnicity? The answer has to be: with difficulty, if at all. This is especially the case with the Romantic German and English artists discussed in Chapter Four, who rarely, if ever, used the word 'race'. The four painters who are discussed in detail – Philipp Otto Runge, Caspar David Friedrich, William Blake and Samuel Palmer – were all fervent nationalists and devout Protestants concerned with the fate of their imagined nations of Germany and England, but they also looked at their nations in a religious light, merging national and spiritual redemption. This created a sense of community, what Herder called a *Volksgeist*, as potentially exclusive and as indivisible as those based unequivocally on physical inheritance, though Herder rejected race as a category.[22] But in the nineteenth century the word 'race' was also claimed in application to a single nation, like the Anglo-Saxon race, or could encompass several peoples, like the Aryan, Caucasian and Nordic races, which could collectively be taken to be synonymous with the white race or races.[23] The concepts of race, nationality and ethnicity (which may itself be subsumed in race) are all ways of perceiving the world and one's place, or the place of others, in it.[24]

Also closely associated with ideas of race, though not necessarily synonymous with it, is what the historian Peter Mandler has called the 'civilisational perspective'.[25] This was shared by social thinkers, certainly in Britain, France and other European countries. It was particularly predominant in Britain in the first two-thirds of the nineteenth century, and reflected an ironclad

belief in the intellectual and social superiority of the British-educated classes, but could also encompass a universalist belief that other, lesser nations could be brought up to the same standards; even recalcitrant 'savages' could move up the ladder of civility by firm rule and education.

There is a further overlap that came to the fore in the nineteenth century, between race and social class. Much of the drive behind the creation of eugenics in the 1880s came from a fear, mainly in England and the United States, of the uncontrolled breeding of the lower classes that might threaten to 'swamp' the settled educated classes. This, particularly in immigrant societies such as the United States, shaded into questions of race and racial mixing, as African, Chinese, Irish and Italian populations formed communities that were confined mainly to menial or forced labour. But in Victorian England it was often claimed that social classes were as varied as the races of the world. Henry Mayhew, the author of *London Labour and the London Poor* (1851), asked rhetorically 'Is not the "pet parson" of some West End Puseyite chapel as ethically and physically different from the London prize-fighter, and he again from the City Alderman, as is the Mongol from the Negro, or the Negro from the Red Indian[?]'[26] There was also a tendency in Victorian England to identify each social class with a particular race: the aristocracy was seen generally as being of Norman descent, the middle class as inheriting the stolidity of their Saxon forebears and the working class as Celtic throwbacks to a more primitive age.

There was also an overlap with gender. Arguments used to define characteristics associated with race and social class could also be used to claim that women were intellectually deficient.[27] The idea that there was a correlation between skull shape and intelligence and moral probity was on occasion applied to female physiognomy to claim that they could not compete intellectually and morally with their male superiors, though this was fiercely denied by John Stuart Mill in *The Subjection of Women*, published in 1869. As Charles Darwin put it bluntly, in direct contradiction of Mill, in *The Descent of Man* (1871): 'It is generally admitted that with women the powers of intuition, of rapid perception, and perhaps of imitation, are more strongly marked than in man; but some, at least, of these faculties are characteristic of the lower races, and therefore of a past and lower state of civilization.'[28]

The nineteenth century saw increased efforts by European powers and the United States to colonize Africa and other parts of the world, largely to exploit mineral resources and to enter into markets for commodities. The idea that the colonized countries were inhabited by people of different races – heathens in states of arrested development or endemic savagery – made it

easier for Europeans and North Americans to claim that exploitation and displacement were essentially driven by enlightened motives, and were even selfless. They brought the gifts of orderly government, Christian truth and, paradoxically, freedom to those previously deprived of them. Through this lens colonization could be seen not as a process of cold-hearted material gain, but as a noble and thankless sacrifice for the benefit of those governed. This sentiment was expressed in Rudyard Kipling's idea of the 'White Man's burden', as shown in his poem of 1899 of the same name:

Take up the White Man's burden –
Send forth the best ye breed –
Go bind your sons to exile
To serve your captives' need;
To wait in heavy harness
On fluttered folk and wild –
Your new-caught, sullen peoples,
Half devil and half child.[29]

The artistic expression of colonial ideology can be seen at its most vivid in the sculptural decorations to the Belgian Royal Museum for Central Africa in Tervuren, outside Brussels, built to showcase King Leopold II's Congo Free State for the International Exposition of 1897.[30] In the magnificent central hall, which has survived the recent 'decolonialization' of the museum, there is a series of full-size gilded sculptures, each showing an allegorical female figure of Belgium, accompanied by small-scale 'natives' seeking enlightenment or protection, as if from a parent. They are by Arsène Matton (1873–1953) and were erected in the 1920s. The titles of three of them are extremely telling: *Belgium Brings Civilization to Congo*, *Belgium Brings Security to Congo* and *Belgium Brings Well-Being to the Congo*.[31]

This book does not tell a linear story of progress in which racism is gradually banished by the light of truth. It is a fact insufficiently realized that a belief in the idea of race was more central to intellectual life in Europe and the Americas in the century and a half from 1800 to the mid-twentieth century than it had been either before or since. Scientists and writers at that time did not see any problem in proclaiming their own race; famous authors such as Thomas Carlyle and Ralph Waldo Emerson – even though the latter was strongly opposed to slavery – openly proclaimed their own racial identification in the titles and content of their books.[32] In the late nineteenth and early twentieth centuries dozens of books and articles were

produced contemplating the origins, present state and future of 'the Anglo-Saxon race', while dignitaries speaking at school and college ceremonies exhorted children and young people to promote the ideals of their race.

We tend to assume in the twenty-first century that the natural home of believers in biological racism is where it lives overwhelmingly today, among the politically far-right and the naturally conservative. The Catholic monarchist aristocrat Arthur de Gobineau (1816–1882) certainly fulfils that expectation. His book *An Essay on the Inequality of the Human Races* (1849) claimed that aristocrats were entitled to rule because they possessed more 'Aryan' genetic traits and were less interbred than 'inferior' races, but that they were in acute danger of degeneration through mixture with the latter.[33] However, Gobineau's belief in the biological foundations of race was shared with, among many other intellectuals, his contemporary Paul Broca (1824–1880), one of the founders of modern anthropology. Broca was a passionate believer in the power and probity of exact science, which he applied to the comparative measurement of human skulls. Unlike Gobineau, he was socially progressive and anti-monarchist; his work was anathema to the former, but it was also treated with political suspicion by the conservative regime of Napoleon III.[34] Broca was by any standard a real, even a great, scientist, but we need to be aware that the parameters of science are not constant throughout the ages. We may challenge the premises of some of his work and the work of others on the subject, as did a number of German scholars and Cuba's José Martí in 1892, who, as he sought to build a multiracial coalition against the Spanish colonialist occupiers of his country, mocked the 'bookshelf races' produced by 'theorists and feeble thinkers' around the globe.[35] It was also challenged by Frederick Douglass, other African American authors and by the Haitian Anténor Firmin (see Chapter Eight).

Ideas of race in the nineteenth century were not only about judging different peoples as superior or inferior, but also about reinforcing what people might have in common. Behind the denigration of other races was the idea that the 'white race' represented an unchallengeable norm against which others fell short. It was usually self-defined as people of northern European descent, but it could include people from Southern and Eastern Europe. Late nineteenth-century ideas of the 'Anglo-Saxon race' or 'Celtic fringe' created a mythical unity of peoples who might live on different sides of the Atlantic. The names applied to Africans, like 'Negro' or the 'African race', implicitly denied the variety of different peoples and cultures on the continent of Africa. Above all, in the eighteenth and nineteenth

centuries there was a deep suspicion of racial mixture – though it was an undeniable feature of slave-owning societies, as everyone knew, because of the widespread sexual exploitation of Black women, whether free or enslaved, by white plantation owners and settlers. Racial mixture might involve the intermingling, physically or culturally, of two or three 'races', which it was widely believed, without any foundation, led to 'degeneration' and caused the eventual dissolution of societies, though a few racially conscious people, like the archaeologist Flinders Petrie, argued that racial mixture could have a regenerative effect on some nations.[36]

Race, then, can define a people as occupying the heights of civilization, or as destined by nature to be 'barbaric' or 'savage', to be ruled over or enslaved by others. 'The Anglo-Saxon race', however, was as much about nation as it was about physical difference, for it was seen by English and American thinkers as a way of asserting superiority over rival nations, like the French, the Spanish and the Germans, though attitudes to the last were complicated by the belief that the Anglo-Saxons were, by definition, of Germanic origin. There were also outliers such as Jews, who were particularly troubling, because many of them lacked any obvious physiognomic or intellectual differences from other members of the population, and Romani, who both became defined as racial groups in the nineteenth century and were often subsumed within larger racial configurations, like the 'darker races'.

Art and visual culture hover around all of these categories, reinforcing and giving form to racial difference but also occasionally, as in a small number of paintings by Dürer, Rembrandt, Rubens, Velázquez and others, revealing or emphasizing the common humanity of different peoples. The principal visual method of identifying race was through stereotyping, which might define a common appearance for all people of African descent. Like the words 'negro' or 'black', the stereotype rested on the assumption that millions of Africans, and the African diaspora, were broadly the same in skin colour and physiognomy, and perhaps in psychological makeup. They were assumed to have frizzy hair, snub noses and large lips (a stereotype that goes back long before the eighteenth century), just as the present-day descendants of ancient German tribes were assumed to have blonde hair and blue eyes. Racial stereotypes could incorporate the ideals of ancient Greek sculpture into their portrayal of the 'European' or Teutonic races, or they could suggest the ape-like in African and Irish physiognomies. There is, of course, a difference between works of art that belong in museums and grand private collections, and readily available popular imagery in the forms

of caricatures and cheap advertising, but their racial assumptions have had – disconcertingly – much in common.

The *Oxford English Dictionary* defines racism as 'Prejudice, discrimination, or antagonism directed against someone of a different race based on the belief that one's own race is superior'. I would suggest that in evaluating visual representations it can be based on three things: generalization, essentialism and a maligning, demeaning or patronizing effect that may or may not be intended. The first involves attributing particular characteristics of an individual to a whole race; the second, maintaining that such characteristics are essential to the character and behaviour of a race; and the third is exhibiting hatred, fear, contempt and condescension in varying degrees towards those who are perceived to be different. Was it, or is it, racist to argue that different races were biologically different and had different shaped skulls? Such an observation would certainly conform to the first and second criteria, though not necessarily the third, unless the shape of the skull is seen as defining intelligence or moral character – or the lack thereof – conclusions that followed quickly on from the first comparative skull measurements. Camper and Blumenbach, both pioneering promoters of scientific skull comparison, did *not* rank people according to the intelligence or moral capacity of those to whom the skulls belonged, though their arguments were clearly structurally linked to racism, and their followers were less inhibited in creating racial hierarchies.

Was it possible for an artist to be racist and yet for her or his art not be racist? The *locus classicus* of such a question would surely be the career of the great French painter Edgar Degas, discussed later in this book, who became a fierce antisemite around the time of the Dreyfus affair, when Jewish influence was blamed by many influential polemicists as the principal cause of France's current degeneration. There is no easy answer to this, but it is worth bearing in mind that people are and were invariably inconsistent, at different ages and times, and between their private and public life. Degas, for instance, had close Jewish friends but excoriated 'the Jew' as a threat to French society. Such attitudes, as Linda Nochlin has advised us, 'are not total, rational systems of behaviour but rather fluctuating and fissured responses, changing over time, deeply rooted in class and family positions but never identical with them.'[37]

Peter Fryer and Tzvetan Todorov both make a distinction in effect between 'high' and 'low' racism. In Fryer's case he contrasts what he calls racial prejudice, which is simply the unthinking dislike of other peoples and is 'relatively scrappy and self-contradictory', with racism proper, which is

based on a knowledge of racial theories.[38] Todorov contrasts 'racism', which is a matter of behaviour and based on hatred of difference, with 'racialism', which is a matter of ideology and has a literature of its own, again, as with Fryer, beginning in the eighteenth century.[39] Though I see the force of these distinctions, it seems to me to oversimplify the relations between the two, which became particularly fraught in the nineteenth century with the vast increase in popular racial imagery. I would argue that what we see in such imagery is not so much the spontaneous eruption of racial ideas in popular consciousness, but the adaptation and vulgarization of racial science, which itself owes much to popular belief. The emphasis on an animal-like physiognomy in the representation of those of African descent may have earlier origins, but for many people in the nineteenth century it went back no further than the writings of Cuvier and others, and the illustrations to their works. Whenever a racist football fan throws a banana on the pitch and makes monkey noises at the sight of a Black player on the field, he is unconsciously referring back to nineteenth-century theories of Cuvier and others that claim that Africans are closer to the animal kingdom than to Europeans. But then, despite Cuvier's huge claims for his own scientific prowess, he himself must have absorbed such a claim from the common culture of which he was also part.

The word 'racism' was unknown to the nineteenth century; its first recorded use was in 1902,[40] and it only became common to claim that someone might be 'racist' in the 1930s. But prejudice against others of a different skin colour, religion or customary behaviour, disdaining them as barbarians, was universal in the ancient world and in medieval and early modern times, though arguably it was possible for a barbarian to 'become' Greek or Roman if he adhered to the right values;[41] there were, for example, Egyptian pharaohs from Nubia and Roman emperors of Black African descent. The idea of dividing the whole of humanity into races only became fully established in the eighteenth century through the writings of Linnaeus, when they were seen originally as coterminous with the Four Continents, as 'the Great Races' of Europe, Africa, Asia and America, their identities formed by the climate and topography of the places they inhabited.[42]

It was virtually impossible for any nineteenth-century European, especially in the slave-owning nations like Britain, Denmark, France, Holland, Portugal and Spain, to be totally unaffected by an unconscious belief in European cultural superiority, even if some argued that non-Europeans were inferior not by *nature*, but by *culture*. Racial attitudes, which may or may not be defined as racist, have always been made up of clusters of

opinions, often self-contradictory, from Edward Long, the apologist for eighteenth-century plantation slavery and nineteenth-century plantation owners in the southern United States, who claimed that Africans were destined by God and biology to be slaves,[43] to the majority of abolitionists who believed Africans needed 'rescuing' not only from the horrors of forced servitude but from their pagan condition, and their supposed mental limitations, meaning that they could never hope to rise above being servants to white people.

The assumption of a racial hierarchy from the 'civilized' to the 'savage races' spanned the main fault line in the religious and intellectual life of nineteenth-century Europe and the Americas, between the belief that the world was created purposefully by a benign and all-powerful god, or – an idea that began to emerge in the later eighteenth century – that the world and mankind evolved over millions of years, without the close involvement of a directing deity. It could also span the divide between monogenists, usually Christians, who thought all races shared a common humanity and were ultimately descended from a single pair of original parents, Adam and Eve, or at least from a single source, and polygenists who believed that the races were descended from separate creations, and therefore constituted separate species, a position taken up with enthusiasm particularly by supporters of the enslavement of Africans.

Was there resistance to the broad ideas of racial comparison and classification in the nineteenth century, as there had been in the eighteenth century, by such writers as Georg Christoph Lichtenberg or Georg Forster? There were of course those who campaigned tirelessly against slavery, but it did not always follow that they thought of Africans as being on an equal level of civilization. Nor did that necessarily lead them into a denunciation of the *premises* of racial discrimination. One who certainly did believe in the equality of Africans was the great campaigner for the abolition of slavery Thomas Clarkson (1760–1846), who promoted African accomplishment and welcomed the Haitian revolution, but it appears he did not take a position on race in and of itself. One of the few nineteenth-century intellectuals before the final years of the century to reject the whole principle of racial comparison, at least at one time in his life, was the great German explorer Alexander von Humboldt (1769–1859). In *Kosmos: Entwurf einer physischen Weltbeschreibung* (Cosmos: A Sketch of a Physical Description of the Universe, 1845–62), a five-volume treatise on the unity of the universe, he wrote: 'in maintaining the unity of the human race we also reject the disagreeable assumption of superior and inferior peoples. Some peoples are

more pliable and highly educated and ennobled by intellectual culture, but
there are no races which are more noble than others. All are equally entitled to freedom.'[44] It is no coincidence that when he was young Humboldt
had as a mentor the natural scientist Georg Forster, who, with his father
Johann Reinhold, had been on Cook's second expedition to the South
Seas. Georg Forster was a radical thinker who eventually became a representative of Mainz to the French Revolutionary convention, but he had
also challenged directly the rigidity of Kant's racial categories in a series of
published critiques.[45] So, in a way, Humboldt's anti-racism can be seen as
an example of the continuity of Enlightenment ideas into the nineteenth
century, and a prefiguring of those of the next century.

There seems in fact to be a continuous thread of resistance to the
premises of racial science in Germany between Forster's and Alexander
von Humboldt's liberalism and Franz Boas's early twentieth-century rejection of racial-hereditarian concepts, through such scientists as Friedrich
Tiedemann (1781–1861) and Rudolf Virchow (1821–1902), who taught
Boas, and there may well have been others. The racial theories of French and
American ethnographers of the mid-nineteenth century were challenged
by the Haitian Joseph Auguste Anténor Firmin (1850–1911), author of *De
l'égalité des races humaines* (On the Equality of Human Races, 1885), a direct
rebuttal of Gobineau's work *Essai sur l'inégalité des races humaines* (Essay
on the Inequality of Human Races) but also the most comprehensive and
unrelenting demolition of racial science in the whole nineteenth century.[46]
Apart from the scholars mentioned above, polemical resistance to racial
science in the nineteenth century came, as one might expect, mainly from
authors who belonged to peoples who were oppressed by it, like Firmin
himself and the African American Frederick Douglass.

Art's connection with race in the Western world had been expressed
in representations going back to the thirteenth century, featuring the early
Christian martyr St Maurice as an African; those from the early fifteenth
century of the Black Magus, usually Balthazar, in paintings of the *Adoration
of the Magi*; and to the mid-sixteenth century in Italy of aristocrats and
merchants accompanied by a Black page, of allegorical representations of
the continents, and of Old Testament and Oriental scenes. There can be, as
Angela Rosenthal argued, a deliberate emphasis on whiteness of skin that
bears on questions of race.[47] But there are also artistic choices made in
response to racial science and romantic ideas of race that helped to
define, promote and very occasionally challenge ideas of race, and these
are discussed in what follows.

PART I

THE RACIAL BODY

I

# Measuring Racial Difference

This width of the facial angle, measuring the degree of protrusion of the forehead, seems rightly to us to be a sign of development of intelligence since, in effect, its increase translates externally the enlargement of brain volume.

M.-M. DUVAL and A. BICAL, *L'Anatomie des Maîtres* (1890)

Despite being preceded by François Bernier in a text of 1684, if the idea of race based on biological difference had an inventor it would be the great Swedish natural scientist Carl von Linné or Linnaeus (1707–1778). He began by classifying the plant and animal kingdoms and then moved on to human beings, though he did not use the word 'race'. In the revised edition of *Systema naturae* (1758) he divided humanity into the Four Continents, defined according to skin colour, moral character and the classical four temperaments: sanguine, phlegmatic, choleric and melancholic, categories that remained in currency through most of the nineteenth century.[1] Europe was 'ingenious, white, sanguine, governed by law'; Africa 'crafty, lazy, careless, black, governed by arbitrary will of the master' and phlegmatic; America 'happy with his lot, liberty loving, tanned and irascible, governed by custom', red and choleric; and Asia 'yellow . . . governed by opinion' and melancholic.[2]

The problem for eighteenth-century natural scientists in trying to classify humanity was that skin colour and temperament were not easily quantifiable, though attempts were made in Mexico and France to provide taxonomies of colour based on the race of parents. In eighteenth-century Mexico multiple series of 'Casta' paintings were produced that showed parents of different races – European, Native American and Hispanic, and mixtures of any of these – with their children, in a hierarchical sequence,

often with outlandish names for the issues of various unions; the offspring of a marriage between a Spaniard and a *morisco* (a forced convert from Islam) was known as an *albino torna atrás* (return backwards), while that between a *No te entiendo* (I don't understand you) and a *Cambuja* (offspring of an Indian woman and African man) was a *tenete en el aire* (hold yourself in mid-air), and there were other unions with equally strange names.[3] Médéric-Louis-Elie Moreau de Saint-Méry, the principal racial theorist of the eighteenth-century French Caribbean colonies, devised a systematic taxonomy of racial mixture in 1797.[4] It was based entirely on skin colour on a continuum from white to black, always assuming white males had copulated with Black or racially mixed females, according to a scale of whiteness: *mulâtre, quarteron, métis, mamelouque, quarteronne* and finally *sang-mêlée* (mixed blood), which almost fades into whiteness. Moreau de Saint-Méry's taxonomy was a lawyer's attempt to promote orderly central government in the French colonies, in response to the growing power and restlessness, in Saint Domingue and other islands, of a large and assertive free mixed-race population within a slave-based economy. Such a situation was seen as threatening to French control; but by the time the title appeared, part of the island colony of Saint Domingue was already in the process of breaking away from France to become the independent country of Haiti under Black rule, though in the mid-nineteenth century the eastern part of the island split off to become itself Saint-Domingue, or the Dominican Republic, a division that remains today.

The idea that racial differences could be not only tabulated but quantified came to the fore at the end of the eighteenth century and, as discussed in the Introduction to this work, was focused on the shape and malleability of the skull. The measurement of skulls was validated by the claim that it was based on exact scientific observation. Such was its prestige, and its seemingly ironclad scientific credentials, that comparative skull measurement of different kinds was practised until the 1940s in virtually all the great research institutions and universities in Europe and the United States. Almost without exception they had academic teams engaged in the systematic measurement of body parts according to racial criteria, vainly seeking an authoritative consensus on the number and defining characteristics of the races that made up humanity.

The shift towards skull measurement and physiognomy rather than skin colour as indices of racial difference was initiated by Pieter Camper,[5] and was taken up in France by Georges Cuvier, who was closely connected to Camper through the latter's son Adriaan. Adriaan was responsible for

the posthumous publication in several countries from 1791 to 1796 of his father's work on the facial angle: *Treatise on the Natural Difference of Features in Persons of Different Countries and Periods of Life*, first published in English in 1794. Physiognomy as an index of character was taken up also by Lavater, who was a devout Christian and was not interested in exact measurement. The scientific study of race in the nineteenth century and beyond was effectively based on the combination of Camper's idea that the shape of the human skull could be used to create a measurable taxonomy of racial difference, Cuvier's claim that the shape of the skull affected the brain's capacity and Lavater's religious belief that the outward appearance of the face and its relative beauty, if correctly interpreted by an authority such as himself, could reveal a person's moral character, whether good or bad.

Camper's posthumous treatise, effectively the first work of physical anthropology *avant la lettre*, measured racial difference by comparing the facial angle of the skull from the forehead to the jaw, the angle of prognathism, or protrusion of the lower jaw, using representative skulls of different peoples and also apes.[6] The sequence started with the aesthetic ideal, the Grecian head of the *Apollo Belvedere* with a straight profile, descending through the increasingly sloping facial angle and receding forehead of the European, the Kalmuck and the African, to the ape (see illus. 4, 5). Camper had received some training as a painter, and specifically directed his study towards artists, who, it is claimed on the title page, would be interested in 'The Connexion between the Science of Anatomy and The Arts of Drawing, Painting, Statuary, &c, &c', and helped by his method to represent accurately different nations and types of humanity.

Camper's system of skull comparison, whatever his intentions, conformed to the long-standing belief in a visual and aesthetic hierarchy in which the gods sculpted by the great ancient Greek sculptors were enshrined as the ideal of beauty. The further one recedes from the European ideal of the *Apollo Belvedere* the closer one is to the animal, and there was also a hierarchy within simian creatures and other animals, all of which broadly corresponded to the Great Chain of Being. But Camper explicitly denied that Africans were closer to animals than Europeans, or indeed that mankind was originally white-skinned; he is at pains to keep non-Europeans fully within the frame of humanity.[7]

Lavater in his lavishly illustrated *Physiognomische Fragmente* in fact says very little about race.[8] The most notable discussion of it in his published work is a rhetorical denial that the mind of a Newton could exist in the

head of a Black (he later retracted this under the influence of abolitionist friends, by changing the example used though not the substance of the point),[9] but he does in other places make comments on images of Africans that suggest that they were closer to the animal than Europeans.[10] One particularly chilling etching in his private collection is titled by him, in handwriting, 'Animal-like Humanity' (Thierische Menschheit); it shows an African head with exaggerated lips (illus. 6).[11]

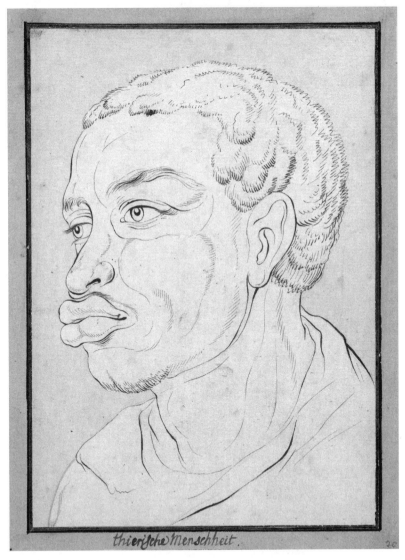

thierische Menschheit.

6  Johann Caspar Lavater, *Thierische Menschheit* (Animal-Like Humanity), 18th century, pencil, black pen and watercolour on card.

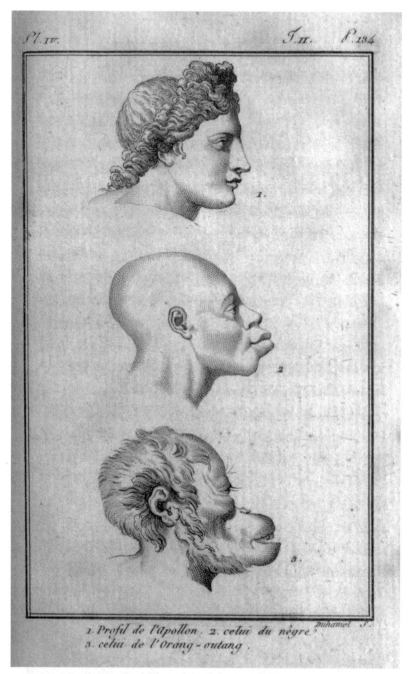

7 'Profiles of Apollo, that of a Negro and an Orangutan', from Julien-Joseph Virey, *Histoire naturelle du genre humain*, vol. II (1800).

From the start, the theories of the pioneers of racial skull comparison were given especial potency by their visual realizations. Racial difference could be taken in with a glance at a single illustration. This is particularly clear from an illustration to the early popular explanation of evolution *Histoire naturelle du genre humain* (1801) by Julien-Joseph Virey (1775–1846), in which three heads are placed in a vertical sequence of profiles with the *Apollo Belvedere* on top and a 'nègre' and an 'Orang-outang' beneath (illus. 7).[12] The same sequence is replicated in an illustration to Nott and Gliddon's notorious polygenetic *Types of Mankind* (1854), the principal scientific justification for Southern slavery (see illus. 57, 58).[13]

One of the effects of the French Enlightenment in Georges-Louis Leclerc, comte de Buffon's more gradualist view of race in his earlier universal account of mankind, *Histoire Naturelle, générale et particulière, avec la description du Cabinet du Roi* (Natural History, General and Particular, with a Description of the King's Cabinet), a work in 36 volumes written between 1749 and 1804, and in the *Encyclopédie* (1751–66), as pointed out by Anne Lafont, was to place an emphasis on the visual.[14] This is particularly clear in the work of Camper: visualization is at the heart of his conception of human difference, while at the same time the range of his study, notionally at least, encompassed the whole of humanity and to a degree the animal kingdom. Work on the skull necessitated close study of physical objects and their differences from each other, and it is in these differences that important questions about racial difference were expressed. What we now call physical anthropology could have equally well been called *visual* anthropology.

Though Camper notes that the differences between the skulls of different races were not large, the visual implications of his chart were epoch-making. Almost immediately after publication of his chart, the idea that 'the Negro' was closer to the animal was made categorical in France and England by Georges Cuvier in 1795 and by the Manchester doctor Charles White in 1799.[15] They both drew a wholly imaginary dividing line between the European and the Negro, placing the latter within the orbit of the ape rather than of humanity. White concluded that the African approached 'nearer to the brute creation than any other of the human species', and adopted a polygenist position, arguing that Africans belonged to 'another race of mankind besides that descended from Adam'.[16]

Neither Camper nor Johann Friedrich Blumenbach (1752–1840), the other pioneer of comparative skull measurement, claimed skull formation had a direct effect on intellect or moral character; the latter noted that the

'skull of the Ethiopian does not differ more from that of the European than that of the domestic sow from the osseous head of the boar'.[17] Blumenbach also collected books written by African authors to show that they were as capable of literacy as any others. Yet however benign Camper's intentions might have been, his chart of skulls ranging from the *Apollo Belvedere* to the ape became the bedrock of racial taxonomies that underpinned the racial assumptions that were to dominate European attitudes until well into the twentieth century.

In 1795 Cuvier made the decisive and highly influential step of making an explicit connection between facial angle and intelligence, arguing that the facial angle of the African was significantly closer to that of the ape and this had a direct structural effect on his mental powers.[18] This tendentious claim is based on Camper's cranial comparisons, but with one crucial difference. Camper's index of difference was based on the angle of the jaw (see illus. 2), not the forehead, so the difference did not apply directly to the brain cavity; to him the forehead was not a big point of difference between the African, the Kalmuck, the European or even the *Apollo Belvedere*.

It is worth pointing out that Cuvier was a firm opponent of ideas of the mutability of species – or *transformisme*, as it was being formulated at broadly the same time by Lamarck, his colleague and rival at the Muséum national d'histoire naturelle in Paris – though his own position on the fixity of species was not firmed up until after 1800. He was also implacably opposed to German *Naturphilosophie*, which he argued was fatally aprioristic and not based on observation or true scientific principles. Cuvier's *Leçons d'anatomie comparée* of 1800 was specifically designed to set up 'the facility of reflecting on actual facts' against *Naturphilosophie*'s 'bizarre method of philosophizing [*méthode bizarre de philosopher*]' with its a priori assumptions.[19] He had similar objections to phrenology, embodied in the work of its pioneer C. J. Gall, which he treated – despite, or perhaps because of, its huge popularity – as a pseudo-science.[20]

Cuvier claimed the facial angle of the young orangutan to be virtually the same as the Negro, while the European was 10 degrees narrower. For Cuvier such claims were based on observation, but the difference in skull shape also reinforced the European's superiority because Cuvier believed that the shape of the former's skull allowed the brain to expand, which meant, assuming that brain size corresponded to intellectual capacity, that the intellect would increase the brain's physical size through active thinking; that of the African was constricted and thereby confined to material perceptions. This was reinforced in his *Le règne animal* of 1817, where in

arguing for the three 'great races', Caucasian, Mongol and Ethiopian, he describes the last as exhibiting 'the prominent muzzle and large lips . . . [which] relate to the apes, and who have always remained barbaric'.[21]

It is still hard to grasp how such a chain of what to more recent think-ing are plainly absurd assumptions developed such authority that they were taken for granted by the most eminent scientists in Europe and America for over a century. The ostensible attraction was that they seemed to have brought scientific precision to the previously ineffable workings of the human mind, but more covertly it gave scientific justification to the assumption of European intellectual superiority. Cuvier's emphasis on *faits positifs* was a way of justifying a science of mankind based on measurable and seemingly incontrovertible physical facts. Yet it involved generations of the most highly qualified scientists of the time having to employ immense ingenuity to maintain intellectual structures that have little basis in reality, despite the close observation, accurate measurement and claims of objec-tivity they brought to the subject.[22] It hardly needs saying that Africans and other non-Europeans are *not* distinguished from Europeans by reces-sive foreheads or smaller brains (though most scientists doubt that the size of the brain has much correlation with the size of the intellect anyway), or by collectively lower intellects than Europeans.

By the early nineteenth century comparative racial theories based on skull measurement that correlated with mental capacity provided the foun-dation of a scientific orthodoxy on race in all countries of the Western world that lasted for nearly 150 years. As racial theories developed, the essential principles established by Camper, Cuvier and Lavater remained constant. The facial angle and comparative shape of the skull were defined differently by different scientists, and the identity and number of races were continu-ally debated, as was the relationship between the skull and the brain, and between skull size and weight and intellect. But the basic premise that there was a measurable connection between the skull shape of a race – however defined – or social class and their collective intellectual capacity was only rarely challenged before well into the twentieth century.

Before the end of the eighteenth century the Linnaean correlation between race and the Four Continents, enlarged by Blumenbach to five, was beginning to dissolve. In the nineteenth century it was increasingly common to talk not only of white, black, yellow and red races, but also of the 'Caucasian' or 'Aryan' race, then 'the Nordic race', 'the Anglo-Saxon race', 'the Celtic race', and later in the century 'the Semitic race' and 'the Mediterranean Race', though to eighteenth-century writers on the subject

the Nordic, Anglo-Saxon and Celtic races would probably not have been races at all. Gradually there developed an overarching hierarchy of races, like 'the Three Great Races', and what were virtually sub-races within each one, so that the Caucasian race could encompass the Nordic, Alpine and Mediterranean. Nationalism and even regionalism were defined in racial terms and could be used to mobilize populations against neighbouring countries, or even be attributed to opposite sides in a civil war.

With the uneven growth of evolutionary theory in England and France, from its beginnings in the work of Erasmus Darwin and Jean-Baptiste de Lamarck (1744–1829) at the end of the eighteenth century, ideas of race were increasingly seen in terms of the long history of humanity as well as of climate and biology. The Franks and the Gauls were taken to be racial ancestors of the modern French, the Anglo-Saxons of the modern English, the Teutons of the modern Germans and so on. The 'inferior' or 'savage' races could be seen in evolutionary terms as ancestors of the 'superior' or 'favoured' races, even if they were in the present in a state of 'arrested development'. However, according to Charles Darwin's idea of natural selection, they could also be the natural enemies of the 'favoured races', an idea enshrined in the subtitle of his fundamental work *On the Origin of Species: The Preservation of Favoured Races in the Struggle for Life* (1859). Though one might expect Darwin to see the principle of 'the survival of the fittest' as encompassing an existential struggle between and within the races, his final view in *The Descent of Man* was to take racial difference out of the province of natural selection (see Chapter Eight).

The study of racial skulls was, like evolution, deeply involved in the analysis of prehistoric and early human beings. Paul Broca, for instance, was much involved in the study of the ancient skeletal remains found in French caves, and applied similar principles of analysis to the Cro-Magnon skulls as he did to more modern ones.[23] One intention of Broca's study was to define the origins of ancient peoples in a way that would cast light on the racial history and composition of their descendants, the French people, particularly the question of the relationship between Celtic peoples and the Gauls. The connections between prehistoric and contemporary human beings were increasingly structured by the evolutionary theory of *transformisme*, developed initially in France by Lamarck at the beginning of the nineteenth century and itself transformed by Darwin in *The Origin of Species* and *The Descent of Man*.

Mathias-Marie Duval and Albert Bical's *Anatomie des maîtres* (1890), a history of anatomical drawing, demonstrates the currency of Camper's

ideas in artistic circles at least up to the last decade of the nineteenth century. Duval was a highly accomplished anatomist and anthropologist, and professor of anatomy at the École des Beaux-Arts from 1873 to 1899.[24] Through Duval's influence Camper's skull typology can be seen as late as the 1920s in the work of Galton's eugenics laboratory, and it contributed to state policy in Germany under the Third Reich. Duval and Bical represent a reversion to the stated purpose of Camper's treatise, which was to help artists to make a correct representation of the different peoples who might appear in their paintings, such as the African Magus in the subject of *The Adoration of the Magi* or Jews in paintings of Old Testament subjects. (The introduction to the 1794 edition of Camper's works records a conversation he had with Benjamin West, the president of the Royal Academy, on that very subject, as we shall see later.) Duval was also interested in the study of anthropology and was aware of the role that skull measurement played in its development, through the work of the criminologist Cesare Lombroso, Paul Broca and his follower Arthur Bordier demonstrating the ever-expanding application of skull measurement to identify not only racial types but traits of the lower and 'criminal' classes.

It is probably fair to say that of all aspects of racial science skull measurement is the most fully discredited, but it does continue to have a respectable afterlife in the study of prehistoric skulls and the identification of human beings' earliest known forebears.[25] Indeed, the story of the early evolution of humanity can only be told through the changing forms of skulls that date back millions of years. Though they are no longer discussed in racial terms, a similar process of deduction from a small number of skulls, or even fragments, is made to identify human variants such as Neanderthals in order to infer their level of civilization. Much can be learned from DNA analysis of bone fragments, but it is the skull that presents a relatable image of an early human being; it is both literally and metaphorically the face of pre-history.

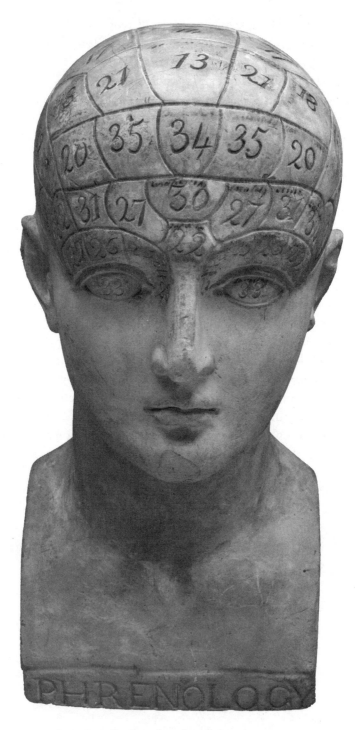

8  James De Ville, *Phrenological Head*, 1821, plaster cast.

## 2

# Bumps on the Head: From Phrenology to Physiognomy

1. The brain is the organ of the mind.
2. The mind is composed of multiple distinct, innate faculties.
3. Because they are distinct, each faculty must have a separate seat or 'organ' in the brain.
4. The size of an organ, other things being equal, is a measure of its power.
5. The shape of the brain is determined by the development of the various organs.
6. As the skull takes its shape from the brain, the surface of the skull can be read as an accurate index of psychological aptitudes and tendencies.

FRANZ JOSEPH GALL's basic principles of phrenology[1]

Phrenology, first revealed by the German neuroanatomist Franz Joseph Gall (1758–1828) in 1796, was another scientific genre that used skull shape determined by the shape of the brain as a way of penetrating the human mind. It rapidly became popular in Britain and France in the early nineteenth century, eventually spreading worldwide. Though intelligence as such was never a specific category in phrenology, the spiritual and mental attributes of 'veneration' and 'reasoning' were associated with the front of the skull or forehead, while combativeness and the more physical attributes were associated with the back of the head. This meant broadly that a prominent forehead was associated with the intellect and therefore with Europeans, while a sloping forehead and an emphatic rear of the skull were associated with the domination of the senses and violence, so were seen as attributes of 'inferior' races, but the relative prominence of the many areas could allow for a more nuanced reading of the skull.

The basic principle of phrenology, as defined by Gall, is that the brain is divided into several areas – he identified 27, but this number differed

between phrenologists – all of which are associated with a particular faculty (illus. 8). Where a person is strong in one, say that of Wonder, then that part of the brain expands to change the shape of the skull, forming a visible projection or bump. Phrenology was often called 'bumpology', and the London phrenologist James De Ville or Deville (1777–1846) was depicted in caricature as having bump-like sores all over his cranium (illus. 9).

Phrenology anticipated modern neurology in the theories of Paul Broca and his contemporaries, in dividing the brain into different areas associated with different functions. Phrenology also built on the psychological implications of Camper and Lavater, both of whose prestige remained enormous in early anthropological circles in France, though Gall argued that Camper's method was partial because it concentrated only on the facial constructions and not on the cranium and its projections.[2] Unlike skull measurement, which remained scientifically respectable until the 1940s, phrenology was rarely completely accepted as a serious science because of its lack of an experimental method. It carried with it the whiff of the fairground and seaside amusement, where it eventually ended up in the twentieth century, but, as James Poskett has noted, it

9 Henry Alken, *Calves' Heads and Brains; or, A Phrenological Lecture*, 1826, etching.

had an extraordinary reach in the nineteenth century in terms of both geography and use.[3]

Though there was an emphasis in phrenology on 'great men', a phrenologist's repertoire of skulls would usually contain African and other non-European heads. In George Combe's much reprinted *System of Phrenology* (1830), the organ of 'Conscientiousness' is found on 'the posterior and lateral parts of the coronal region of the brain, upwards from Cautiousness, and backwards from Hope'. This organ develops differently in different nations and individuals. 'The sentiment of Truth is found by English court judges to be so low in Africans, Hindoos, and in aboriginal Americans', Combe claims, 'that such individuals are not received as witnesses in the Colonial Courts.'[4] Combe also notes that 'it is a curious fact, that a defect in the organ of Conscientiousness is a reigning feature in the skulls of these nations in possession of the Phrenological Society.'[5]

Combe includes a series of accounts of non-European peoples in which their assumed characters are seen to fit with their phrenological skull types. The 'Hindoos' who are 'remarkable for want of force of character' turn out, he claims, to have skulls defective in the organs of Combativeness and Destructiveness, but large in Secretiveness, Cautiousness and Self-Esteem. The 'fierce Charibs' (survivors of pre-African peoples in the Caribbean; illus. 10), by contrast, are 'prodigiously developed' in Combativeness and Destructiveness, but very deficient in the 'reflecting organs' and in the 'organs of the moral sentiments'.[6] Among other peoples analysed similarly are New Hollanders (indigenous Australians), New Zealanders, North American Indians and Brazilian Indians.

Finally, there is a relatively sympathetic account – though still double-edged – of 'the Negro' (illus. 11), in which the moral and intellectual organs are seen as significantly larger than those of the New Hollanders.

10, 11 'Charib' and 'Negro', from George Combe, *A System of Phrenology* (1830).

'The organs of Philoprogenitiveness and Concentrativeness are largely developed', the former of which produces a love of children, and the latter a concentration of mind favourable to settled and sedentary employments; 'The organs of Veneration and Hope, also, are considerable in size.' On the other hand, there are deficiencies in 'Conscientiousness, Cautiousness, Ideality, and Reflection' that correspond to traditional stereotypes and place the Negro on a lower level than the European.[7] Combe, however, goes on to note – unusually for the time of writing – the variety of peoples *within* the African continent, differentiating between their capabilities. The one common factor he notes among Africans is superstition, reflected in the prominence on their skulls of Hope, Veneration and Wonder, counterbalanced by defective causality, which renders them prone to credulity.

The influence of phrenology on the visual arts can be seen primarily in caricature and portraiture. More than one caricaturist played variations on what became a standard joke, that those involved in phrenology developed a disconcerting resemblance to their subjects of study. In Thomas Rowlandson's caricature of Gall lecturing among his collection of skulls, many 'great men' are displayed on his shelves, while the grotesquery of his audience corresponds to the animal skulls they study so intently.[8] The subject of the lecture is clearly the evolution of the skull, for the one proffered by Gall shows the extreme facial angle of an ape, but it is also characteristic of the most prominent member of the audience, who looks at it like a long-lost brother. To Gall's right are the skulls of an alligator, perhaps the most extreme example of the facial angle, and another animal–human skull. Could the lecturer be explaining the Great Chain of Being, and the place of non-Europeans in it?

Nineteenth-century novelists were interested in phrenology as a means to delineate character, to the point that descriptions of persons were often couched in phrenological language. To take one example, Charlotte Brontë was known to have visited a phrenologist, and in her novel *Villette* (1853) Lucy, the heroine, is greeted by a servant using vulgar language, but she is not rebuked, because it is obvious to Lucy from her skull formation that this is not an exceptional occurrence but rooted in her very being: 'The terms were precisely such as Rosine – a young lady in whose skull the organs of reverence and reserve were not largely developed – was in the constant habit of using.'[9] George Eliot was also fully conversant with phrenology, but more through its interpretation by Auguste Comte, the inventor of positivism. The contrast she makes between 'egoism' and 'reverence', the former hopefully leading to the latter, is reflected in the

shape of the skull, though she was in the habit of making irreverent remarks about phrenology itself.[10]

It is unexpectedly difficult to pin down the influence of phrenology in 'high' art, though we know many artists were well aware of it. One reason is that the shape of the skull is often obscured by hair. In a response to this problem, the natural scientist Félix Voisin in 1834 chose to study the heads of prisoners in chain-gangs in Toulon because their heads were shaved and were therefore accurately measurable.[11] Also Camper's facial angle, being concerned with the front and profile of the skull, was easier to delineate than the many protrusions that would constitute a true phrenological image of a head. But the separate 'bumps' tend to be clustered around the front and rear of the head, so a prominent forehead can be read as a mark of mental power and intellect. We might then expect that people famed for their intellectual achievement would be represented with dominant foreheads.

If we look at representations of Shakespeare, the nineteenth-century epitome of intellectual prowess and an exemplum of Anglo-Saxon cultural achievement, we find that he was given a prominent forehead in seventeenth-century portraits, long before the advent of phrenology or racial science. But that forehead is the central focus of a painting by Henry Wallis of 1857, *A Sculptor's Workshop, Stratford-upon-Avon, 1617* (illus. 12), which shows a sculptor working on Shakespeare's monument in Stratford, guided by

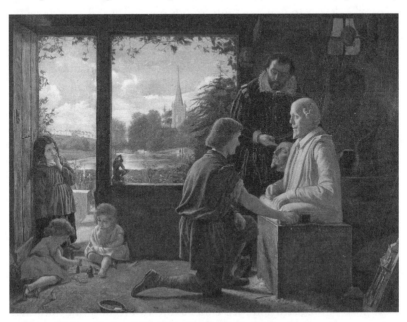

12 Henry Wallis, *A Sculptor's Workshop, Stratford-upon-Avon, 1617*, 1857, oil on canvas.

Ben Jonson, who holds the poet's death mask in his hand. The latter points to the poet's forehead, as if encouraging the sculptor to think of it as the seat of Shakespeare's creative faculty, perhaps also identifying it with veneration.

Phrenological head shapes were often referenced in racial caricature, following both the Camperian cranium and the front–back phrenological division of the head. In the first half of the nineteenth century African foreheads were often depicted as sloping backwards, but it was not always the case. Those representations of Black people that were concerned with the individual appearance of the model, like Géricault's portrait of his model Joseph (see illus. 61), reveal a prominent forehead, as does Joseph's death mask. It is also true of Cordier's representations of Africans, such as the *Vénus africaine* (illus. 13), who has a strikingly vertical forehead, though it curves back at the top towards the hairline. Cordier's treatment can be contrasted with Herbert Ward's 1902 representation of *Femme d'Afrique centrale*, where the forehead seems quite reduced in relation to the rest of the head, giving prominence to the lower part of the physiognomy, especially the lips.

A recessive forehead and facial angle in representations of Black people in the nineteenth century is not always evident, not only because of concealing hair but because of the angle of view and head coverings. There is clearly also a tendency for realist painters to choose subjects who conform to the Camperian stereotype, as being somehow more truly African than those who deviate from it. The most striking use of the facial angle, however – and one less concerned with realism – comes in an explicitly abolitionist context, in one of David d'Angers' four reliefs on the Gutenberg Monument in Strasbourg, inaugurated in 1840. The contribution of Gutenberg's invention of printing to African liberation through the abolitionists' use of a printing press is expressed in a schematic low-relief composition in which all participants but Wilberforce are shown in profile, allowing one to see clearly that the artist has observed the approved 'scientific' facial angle for the Black protagonists. This is also seen in an exaggerated, almost caricatural form in another of d'Angers' memorial reliefs, featuring the Cardinal de Cheverus, who, though French, was the first Roman Catholic bishop of Boston, Massachusetts. In the relief the Grecian profile of the future cardinal is contrasted with the extreme facial angle of the poor Black man from Boston to whom he is ministering (illus. 14).

Phrenology was, from the beginning, suspected of charlatanry; there was scepticism towards the possibility of empirical proof of the many separate areas of the brain and their connection with feelings and aptitudes. Though Broca adopted the idea of such separate areas, he was careful to

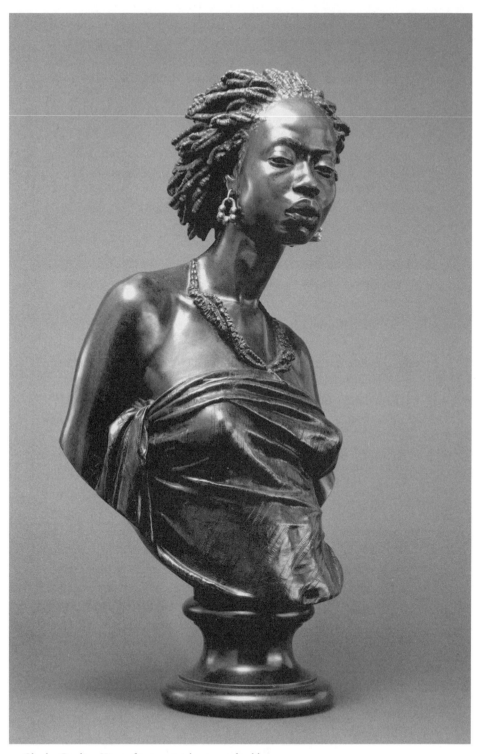

13  Charles Cordier, *Vénus africaine,* 1851, bronze and gold.

14 David d'Angers, *Soins donnés au vieil esclave noir*, 1844, preparatory plaster model, memorial relief.

dissociate himself from phrenology.[12] In the first half of the nineteenth century the emphasis of the cranial study of race was broadly on demonstrating the different physiognomies of racial types; in the second half of the century, under Broca's influence, it was more on defining that difference through numerical analysis. Broca's general position has been described by Martin Staum as 'a modified racial determinism with limited confidence in education'.[13]

Paul Broca, an open atheist, was a clinician who in 1859 founded the Société d'anthropologie in Paris, in part to counteract ideas of the ineffable nature of the theological conception of the soul, which drew towards him the implacable enmity of the Catholic Church. Quantification of cranial difference became the preoccupation of his study, and statistics formed its bedrock.[14] Phrenology nonetheless anticipated the analysis of functions of the brain by giving a physical location to its different faculties rather than perpetuating ideas based on the notion of an essence that was synonymous with the soul. Broca and his colleague Louis Pierre Gratiolet were influenced by phrenological ideas that divided the world's races into three categories: *races frontales*, white races with highly developed frontal lobes; *races parietals*, 'Mongolians' with mid-lobes prominent; and *races occipitales*, dark-skinned peoples with prominent rear skulls.[15] Given that these variations can be measured and tabulated on a grid that can also include apes, they became one of Camper's most enduring legacies. Allied to this was the idea that the sutures between skull bones and in the frontal lobes close earlier in 'inferior' races than they do in 'superior' ones. This supposedly

has the effect of restricting the growth of the brain, which in superior races can grow freely with education. It goes without saying that this has been proved to have no scientific basis.

Broca also divided the brain into two hemispheres: a left and a right side. This was a conventional view by his time; the two hemispheres were generally thought to be identical, forming 'two brains'. By the late 1860s he had come around fully to the idea that the hemispheres were asymmetrical and that the left side governed 'speech language', while the right side was subordinate and associated with emotion and instinct. A dominant left side was associated with higher levels of civilization.[16] Asymmetry was therefore a good thing, provided that the left part of the brain was the larger of the two; symmetry, conversely, was associated with negative attributes like criminality and madness. It goes without saying that the binary opposition between the left and right parts of the brain played into racial typologies, and in 1869 Broca argued that asymmetry is greater in the brains of 'whites' than in those of 'Negroes', as it was also of women and criminals.[17]

In 1875 Broca published *Instructions craniologiques et craniométriques*, for the Société d'anthropologie. It was an attempt to regularize 'nombreuses méthodes et d'innombrables procédés craniométriques [numerous methods and innumerable craniometric procedures]', on the assumption that the many people researching skulls, both ancient and modern, often used incompatible methods of measurement, given the profusion of elements in the human skull.[18] He noted there were difficulties, for instance, in knowing exactly where to place a measuring compass. Harmonizing such practices would avoid differences between authors, enabling not only exact research of individual races but a greater number of studies. It would also help researchers without large laboratories to contribute useable data. He offers much practical advice on the conservation of skulls, emphasizing the need for complete skulls and information on where they came from.

Much of *Instructions* is taken up by long descriptions of elements of the skull, and advice on measuring instruments, and it contains an exhaustive account of the facial angle, updating Camper and others. Broca also looks at ways of deriving racial information from the skulls by measuring the cephalic index.[19] The cephalic index is made up of the transversal and longitudinal diameter, but the measurement that he argues is most accurate is the nasal index, 'longeur de la region nasale' ('length of the nasal area') and 'la largeur maxima des narines' (greatest width of the nostrils), which correspond to the Three Great Races, as follows: Caucasians are (predominantly) microsemes (a skull with an orbital index below 84), Ethiopians

megasemes (having an orbital index that is relatively large), and Mongolians mesosemes (having a medium orbital index, that is, between microsemes and megasemes).[20]

BEHIND SUCH RESEARCH was a sense of a Manichaean struggle between civilization and barbarism that was being fought out between Christian traditionalists on one side, and positivists, with their veneration of scientific method and facts on the other, with Broca emphatically in the latter camp. It was perceived by both as a struggle between those who upheld the values of civilization or self-control against those supposedly in thrall to their physical instincts, the uneducated classes within each society, non-Europeans and women. If Christian traditionalists saw a conflict between righteousness and sin, biological materialists such as Broca, in common with his conservative opponents, saw society as facing an existential struggle between forces of progress and those of degeneration – a particular preoccupation in France after her humiliating defeat in the Franco-Prussian war in the early 1870s, with victory for the former by no means assured. One result was to give a renewed urgency to skull measurement and the facial angle, and for them to become, as Cesare Lombroso had argued, a way of not only classifying racial and social difference but also of predicting criminality among the lower classes. Ideas associated later in the century with eugenics, particularly in England and the United States, which divided populations into the Fit and Unfit, were already foreshadowed in France earlier in the century.[21]

# 3

# Head and Body, Skull and Skeleton

[With race] it is mainly the head which interests the artist
ROBERT KNOX, *Manual of Artistic Anatomy* (1852)

The human face ... is for us the most interesting thing in the universe ...
science has found there the origin of races, the expression of diseases and
of passions, and has there measured the energy of thought ... Without
words our face expresses ... all the multiform life which issues each instant
from the supreme organ – the brain.
PAOLO MANTEGAZZA, *Physiognomy and Expression* (1890)

Throughout the nineteenth century concern regarding the skull, and the way it was supposedly shaped by the mind and intelligence contained within it, only increased in authority. The idea that the study of skulls could enable scientifically accurate comparisons of whole peoples and races in terms of intelligence and moral capacity affected and was affected by the political and social treatment of peoples in an age of growing European imperial expansion and national rivalry. The essential basis of skull comparison, as it developed from Camper and Lavater, was that it made difference visible. It enabled ostensibly clear discrimination between different types of people, enabling comparative indices of levels of civilization, intelligence, educability and moral character. The idea of an essential skull type moved beyond race to be attached to nationality, social class, gender, criminality and even trades and occupations.

Such signs of difference, whether individual or collective, are much harder to convey in the rest of the body. One can differentiate between age, sex, relative beauty and physical strength, but there is nothing as distinctive

as facial appearance to immediately identify a person as an individual. The relative anonymity of the body was reinforced by artistic traditions of seeking the ideal going back to antiquity, either of perfect beauty or to represent a particular age or attribute. A warrior might be heavily muscled like Hercules or a slender youth like the *Apollo Belvedere*, and the body in its articulation could be the vehicle of emotion conveyed through gesture and contortion as vividly as through facial expression. There was a long tradition of painters learning the 'science' of facial expressions of emotion from Leonardo da Vinci onwards, through seventeenth- and eighteenth-century engravings after Charles Le Brun in particular; it was a standard part of academic art training embodied in textbooks.[1] Art students were exhorted to go beyond the body's exact appearance, to perceive and represent the ideal or 'the general form', as the first president of the Royal Academy Sir Joshua Reynolds called it in his *Discourses to the Royal Academy*. This required not only habitual drawing from life but the close study of earlier examples of the ideal in Greek and Roman statues and in Italian Renaissance paintings.

The leitmotif of all the late eighteenth- and early nineteenth-century campaigns to abolish slavery, *Am I Not a Man and a Brother?*, the medallion designed for Josiah Wedgwood by William Hackwood in 1787, shows a childlike figure on one knee, beseeching an unseen slaveowner to free him on the grounds of the common humanity uniting them both.[2] The physiognomy of the figure is barely indicated, but the body contrasts its own abjection and hopefulness with the implied presence of the white owner who is not represented. The supplicant is an adaptation of a stock figure in European art, deriving ultimately from putti or cherubs in Italian religious painting. The whole meaning of the figure, adapted to many uses and contexts, is entirely in the attitude of the body, from the bent knee to the supplicating gesture; its power is in the empathy it draws from the viewer.

It is not fortuitous that such an expressive body should have been so popular in England between the 1780s until at least the 1830s; those years broadly correspond to the dominance of Henry Fuseli (1741–1825), who was Professor of Painting at the Royal Academy in London from 1799 until his death. Fuseli's art was based on the idea of a malleable body that could be distorted beyond reality by the sheer force of emotion, which takes it beyond the relative staidness of the Wedgwood medallion. The muscularity of Fuseli's figures clearly derives from Michelangelo, its purpose to express terror, abjection or triumph with thrilling immediacy.

In Fuseli's only painting with a prominent Black figure in the foreground, *The Negro Revenged* (see illus. 60), a subject derived from the 1788

abolitionist poem 'The Negro's Complaint' by William Cowper, a dark-skinned figure stands with arm raised calling on the heavens to wreak vengeance and destruction on a slave ship traversing a stormy sea. The emotional power is expressed entirely in his noble, triumphant body and his gesture, but his face in *profile perdu* is barely visible, revealing no expression, so contributes nothing to the meaning of the work. 'The Negro' calling for divine vengeance is not an individual; he designates a people or even a race whose collective suffering is being represented in both poem and painting. Imagery produced in support of the abolition of slavery tended to concentrate not on physiognomy but on the whole body, which suggests more readily the common experience of humanity – a pain that can be understood by all.

We can see a similar interplay between individuality and universality in the representation of Africans in the work of Géricault and Delacroix. Géricault, who was a fervent abolitionist, made a small number of head studies of Black people, but his most famous work, *The Raft of the Medusa*, shows the common physicality of humanity, expressed in both African and European bodies as sites of common pain, suffering and redemption. In *The Raft* there are a number of Black figures. All share the abjection of their white companions, with the exception of a Black figure at the pinnacle of the group who waves a cloth to attract the attention of the rescue ship. He is seen, like the slave in Fuseli's painting, from behind, his face invisible, emphasizing his generic rather than individual presence. The abjection and pathos of the inhabitants of the raft, both Black and white, rest on their enfeebled bodies rather than their facial expressions; apart from their skin colour, they are equal in their suffering.

If the common humanity between Black and white is foregrounded in *The Raft*, in other works Géricault responds to further visual discourses. In the lithograph *Boxeurs* (1818, illus. 15), probably based on a clandestine contest he witnessed in Paris before his visit to England in 1820, the two participants are clearly distinguished from each other by skull formation; the white boxer has an almost Grecian profile that can be compared to Camper's *Apollo Belvedere* in his sequence of racial heads (see illus. 4, 5), while his Black opponent has a sloping forehead that could be derived from Virey's notorious illustrations comparing an African to an ape (see illus. 7). Though facing each other at different angles, their bodies in stance and gesture are virtually mirror images of each other, while their physiognomies are totally contrasting. In a red chalk drawing by the same artist, *La traite des nègres* (illus. 16), depicting the enslavement of Africans of both sexes,

15  Théodore Géricault, *Boxeurs*, 1818, lithograph.

there is a confrontation between the brutal captor brandishing a whip and a Black man facing him, but here the four main Black victims are picked out by physiognomies rendered in black ink, emphasizing their equality as human beings but also their individuality as Africans.

This interplay between the generalized and heroic body and individualized physiognomy can be seen in other works by Géricault, such as *Black Holding a Lance* (1820–24), in which the solid stance and enveloping drapery with the highly individualized head gives a heroic grandeur to the figure. Equally *Black on a Rearing Horse* (1820–24) is a compelling image of exotic power, expressed in the dramatic *contrapposto* of the Black horseman. By contrast, a portrait of Joseph, his Black servant (see illus. 61), is a model of sensitive regard that can be compared in its truth-effect and warmth to Velázquez's great portrait of his studio assistant Juan de Pareja in the Metropolitan Museum, New York.

Though Géricault's *Boxeurs* unmistakeably shows a knowledge and acceptance of Camper's and Cuvier's racial profiles – the white boxer being very close to 'the European' and the Black boxer to 'the Negro' – in every other respect the artist exhibits an unusual regard for the humanity of his African contemporaries. Delacroix also made a number of works

featuring Black people, but their overall emphasis is significantly different. He created several paintings of Black females in the 1820s, one of the most famous of which is the painting of the model Aspasia formerly known by the Musée Fabre in Montpellier as *Etude après une Mulâtresse* (illus. 17). The casual exposure of the breasts and the direct gaze suggest that it was intended as an erotic celebration of a 'Belle Mulâtresse', representing the proverbially beautiful, free mixed-race women of the French colonies in the Caribbean and North Africa, who beguiled planters and male settlers, and whose power and independence were a source of anxiety to colonial authorities.[3] What we see in Delacroix's painting is a version of the 'colonial gaze', one that effectively reduces the woman to her sexuality. At the same time, she can be seen to belong to an idea of the 'Orient', notionally inhabited by Arab and Moorish peoples, Jews and Black Africans, who shared a way of life thought by Europeans to be indolent, sybaritic and sensuous.

If the painting of Aspasia belongs generically with idyllic paintings set in the French colonies, another of Delacroix's Black female figures, the slave/servant in *Women of Algiers in Their Apartment* (illus. 18), refers back to a trope of earlier European art: the Black slave accompanying a grand person or persons. Normally such slaves are shown as lone accompaniments to the principal sitter. Their role is one of subordination, expressed through posture and adornment, usually a Turkish-style turban, and they often look

16 Théodore Géricault, *La traite des nègres*, c. 1800–1820, black chalk and sanguine on brown paper.

adoringly towards their master or mistress. In this case the turbaned female servant is obviously subordinate but is defined here by her active deportment, which is contrasted with the leisurely and even sybaritic attitudes of the harem-like subjects of the painting.

Though Delacroix made an implicit protest against the brutal fate and enslavement by Ottoman Turks of Greeks in his painting *The Massacre at Chios*, there is no sense from accounts of his Algerian visit in 1832, or the paintings and drawings from it, of Delacroix feeling discomfort with French imperialism. His paintings of Algerian subjects, made as part of a

17  Eugène Delacroix, *Aspasia* (formerly known as *Etude après une Mulâtresse*), *c.* 1824–6, oil on canvas.

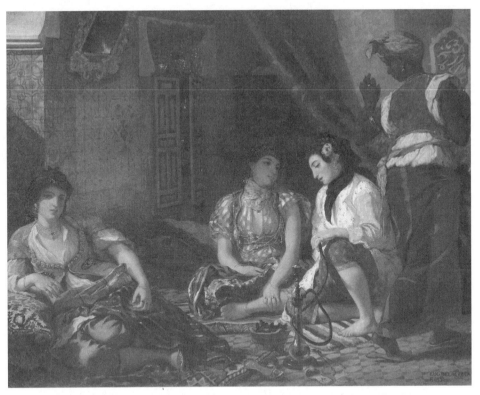

18  Eugène Delacroix, *Women of Algiers in Their Apartment*, 1834, oil on canvas.

diplomatic mission to Morocco in 1832, show him to have been fully at ease with French interventions in Africa.

It is not fortuitous that the naked Black body plays a central role in French paintings that were concerned to expose the cruelty of slavery or celebrate liberation from it. The brutality of slavery is expressed performatively in Marcel Verdier's *Le Châtiment des quatre piquets* (1843) by the public whipping of a fully outstretched naked African male, while in François-Auguste Biard's *L'Abolition de l'ésclavage dans les colonies françaises en 1848* (see illus. 64), the slaves' new freedom is signified by the central Black figure exuberantly flinging off his manacles while being embraced by his wife, as the others in the painting, both Black and white, gesture with their arms approvingly.[4]

This interplay between the head as signifying difference and the body as common humanity may be said to define the way that Black people were represented throughout the nineteenth century. It is no coincidence that Charles Cordier's busts of Africans were exhibited in the Musée d'histoire naturelle as part of an anthropological display, as well as at the Paris Salon.

In 1862 Cordier took a relatively liberal position in denying that Europe had a claim to a monopoly of beauty, arguing that 'beauty is not the province of a privileged race.' He claimed to have given to the world of art 'the idea of the universality of beauty', and remarked that 'The most beautiful Negro is not the one who looks most like us, but the one who presents the most pronounced characteristics associated with his race.'[5]

One can argue, as does Laure de Margerie, that Cordier rejected the hierarchy of race that posited the European on top, but the sculptor, not being a scientist, was understandably not always consistent in such matters. He did not always challenge ideas that assumed a measure of racial essentialism. In the Salon of 1859 he exhibited a set of three busts (now lost) of the biblical sons of Noah, Shem, Ham and Japhet (known through a surviving medal), the pre-Enlightenment creationist progenitors of the races of mankind following the Flood.[6] In a talk to the Société d'anthropologie de Paris, of which he was a member, Cordier claimed that his sculptures were based on a 'geometric procedure', not exactly the same as Camper's but ultimately derived from it, which determined the facial angle of his subjects.

*Aimez-vous les uns les autres* (Love Ourselves and Others, see illus. 63), one of his few sculptural groups rather than single figures, represents two boys in contrasting black and yellow marble.[7] The title, the intimacy of the embrace and the seeming equality of the two figures suggest that they are brothers, and that Black and white races are essentially on an equal level. But the pictorial language subtly undercuts the positive message. There is a clear contrast between the thrusting eagerness of the Black boy and the white boy's almost dignified reticence that suggests the former is taking the initiative, as if asserting equality with the latter. The Black boy recalls representations in earlier paintings of the *Adoration of the Magi* of the Black magus as a vigorous youth contrasting with the gravity of the older magi, as in Dürer's woodcut of the subject.[8] It also has something in common with William Blake's illuminated poem 'The Little Black Boy' in *Songs of Innocence*. The unequal relationship between the Black boy and the white boy is evident in the second plate, where the latter confronts Jesus directly, while the former stands back a little dejectedly, as confirmed by his words in the poem:

I'll shade him from the heat till he can bear,
To lean in joy upon out father's knee
And then I'll stand and stroke his silver hair.
And be like him and he will then love me.[9]

Cordier's busts reflect a turn towards empire, and to Africa itself, that takes the question of race beyond France and slavery. I cannot here go into the question of how far French racial ideas drove the quest for colonies or the quest for colonies drove racial ideas, but racial science undoubtedly had an important role in justifying policies towards the native inhabitants of the colonies. The French move into Africa, like all other countries' colonial incursions in the nineteenth century, was claimed to be a 'civilizing mission', though it was carried out alongside blatant economic exploitation. French government policy towards the colonies moved broadly between two general positions: assimilation or association, which could be applied to different peoples. The former position sought, in effect, to raise up certain chosen African peoples through the adoption of European values, imposing on them processes of education and Christianization, while the latter claimed that some peoples were either unassimilable or incapable of being civilized, and so should be allowed to retain their way of life. Deciding to which of the two categories individual peoples or nations belonged was a preoccupation of the geographical societies of the period, and judgements were often made using cranial comparison derived from Camper and Cuvier.[10]

From the middle of the nineteenth century onwards a number of French artists made portrait-like sculptures or paintings that accentuated the variety of and differences between Africans, often specifying the precise region in the African continent from which the models came. Cordier's transitional position in this respect is implied in the frequent changes of title he applied to his busts. *Une Négresse* of 1851 (see illus. 13) became at different times *Vénus africaine* or *Nubienne*, or *type ethiopienne*, while a male bust exhibited in the 1857 no longer has a generic title but is given a regional location as *Nègre du Soudan* (illus. 19).[11] The shift between generic and more specific regional titles is indicative of an artist of divided intellectual and professional loyalties, who exhibited as a sculptor in the Salon but also had a number of busts exhibited in the anthropology gallery of the Paris Muséum national d'histoire naturelle.

Much anthropological work was done from the mid-century onwards to distinguish and characterize different peoples and groups in ever more regions in Africa, emphasizing different ways of life according to climate and region. Cordier's art combined the appearance of scientific authenticity appropriate to an anthropology display with an exoticism and colour that made his sculpture saleable at the Salon to private collectors and public institutions. His attempt to give his sculpture an air of scientific objectivity

19  Charles Cordier, *Nègre du Soudan*, 1857, bronze.

was often taken up by other artists, but rarely with his rigour. Carolus-Duran's bust portrait of a turbaned man dated 1886 is identified not just as an African but as *Un Soudanien* (see illus. 62). Even in paintings influenced by Manet's *Olympia*, which features a nude female attended by a Black maid, the Black female figure's 'Africanness' is alluded to in her clothing, especially her head covering. This is notably the case with Frédéric Bazille's two versions, using the same model, of *Jeune femme aux pivoines* (1870, see illus. 65), both of whom have the same fetchingly elaborate striped headdress.[12]

20  Jacques-Philippe Potteau, *Mostapha Ahmed* (21 years old, Nubian), 1862, profile albumen print.

ESTNUM- 23682

21 Felix Nadar, *Maria l'Antillaise*, 1856–9, photograph.

In anthropometric photography of the 1850s and '60s, some of which is closely associated with Cordier, the sitter is often reduced to a profile and/or a full-face image for classification and comparison, configurations that go back to Camper and Lavater. It can be seen in the photographs by Jacques-Philippe Potteau exhibited in the anthropology gallery of the Muséum national d'histoire naturelle (illus. 20), alongside busts by Cordier.[13] The photographs usually diverge, however, from total emphasis on physiognomy to include identifying clothing, moving later in the century towards what Elizabeth Edwards has identified as the dominant anthropological mode of representation of the age: 'the portrait type', in

which a full-frontal three-quarter-length view of the subject is adopted as a central convention of European portraiture.[14] In Nadar's photographic portrait of a Caribbean sitter, *Maria l'Antillaise* (illus. 21), the fact that her pose – her cheek resting on her hand, resembling an Ingres portrait – is conventional only emphasizes her difference, for her breasts are exposed, denoting the open sexuality of 'inferior races'.[15] With such photographs there is no clear boundary between their roles as objects of ethnographic study and as tourist souvenirs, nor indeed is there with paintings of Black females, which invariably are directed towards the male gaze.

All but a few of the images we have considered in this chapter affirm the critical importance for nineteenth-century French art of physiognomy in the representation of individual Africans. The point in almost every case is that the internal character of the sitter can be read from their external appearance, whether it approaches towards 'savagery' or docility. It is not only their physical appearance that is represented but implicitly their inner nature, which, in all but a few cases, reads as more instinctual than reflective. Africans are rarely depicted as thoughtful or literate. On the rare occasions they are shown with a book it is either to represent them as authors, such as the eighteenth-century poet Phillis Wheatley, or in connection with attempts by missionaries to convert them to Christianity, which is one of the reasons Alexandre Dumas *père*, as an author of partially African descent, was regarded by hostile caricaturists as such a tempting anomaly.

As is so often the case, it is caricaturists who make the contrast between stereotype and individual appearance most palpable. In some caricatures of Alexandre Dumas *père et fils*, who were, as was well known at the time, of African descent through the elder's paternal grandmother, the 'Africanness' of their features is exaggerated to the point that they are totally unrecognizable.[16] The common factor in Cham's notoriously racialized caricatures of Dumas *père* is an emphasis on the smallness of his forehead in contrast with the profusion of frizzy hair that grows from it (illus. 22). By putting the mass and weight on the lower part of the physiognomy and the lips, accentuating their fleshiness, Cham sought to make the face grotesque, evoking scientific physiognomy to deny any claims that the author, or indeed any African, can have to intellectual distinction. Alexandre Dumas *père* was in eighteenth-century racial terminology probably a *quarteron*, one-fourth black, but his African ancestry was brutally emphasized by hostile critics, one of whom wrote 'Scratch the surface of M. Dumas' work and you discover the savage beneath.'[17]

Black bodies, broadly, have a less conspicuous presence in French art than Black physiognomies, but the situation is to an extent reversed in England. Though Camper and Lavater were well known in England to artists and anthropologists, there is no equivalent there to Cordier's position between art and anthropology. Furthermore, from the beginning of the nineteenth century a tradition began of using models of African descent for students to draw from at the Royal Academy. This came about through the employment from 1810 onwards of the model Wilson (first name unknown), a former sailor born in Boston.[18] Black people had been employed in grand manner portraits by the first president of the Royal Academy, Sir Joshua Reynolds, as ornamental attendants or horse grooms in imitation of Van Dyck and Titian, but the study of a Black life model by a group of students and artists was an innovation that caused a sensation at the Royal Academy.[19] The secretary to the Academy, Joseph Farington (1747–1821), a tireless diarist, records a conversation in which

[Sir Thomas] Lawrence spoke of a Black Man lately remarked in an Hospital by Carlisle [a doctor] who attended Him for some slight injury... Benjamin West and Lawrence saw Him & thought Him the finest figure He had ever seen, combining the character

22  Cham, 'Nouvelle Bouillabaisse dramatique par M. Dumas père', from *Le Charivari*, 31 March 1858.

& perfection of many of the Antique Statues. 'When his arm was suspended it appeared like that of the Antinous; when contracted for exertion it was like the Farnese Hercules.' Lawrence showed us a drawing on canvass which He had made from Him – George Dawe has studied much from Him and paid Him 2 guineas a week for standing to Him – Wm Lock had seen him and expressed equal admiration. The Man is a Sailor. He is 5 feet 11½ inches high.[20]

What they saw in him was a resemblance to the canonical figures of antiquity: a figure of ideal beauty, conforming to ancient Greek ideals, but also of great flexibility, able to emulate more than one of the Greek figures. The longest account of Wilson is to be found in the history painter Benjamin Robert Haydon's diary for 1810. Haydon had ambitions to be a history painter on a grand scale, but though he had much success, it was never enough for him to make a living, and he eventually committed suicide in 1846. Over the course of his career he made large history paintings of elevated subjects, but he also sought to define an artist's duties towards the antique and the general improvement of mankind. At this time in 1810 his head was full of the Parthenon Marbles, which had recently been brought to England and put on show in London; they had a dramatic effect on him, as they did on so many others at the time. The Marbles focused the minds of young artists like Haydon on genuine works from Greek antiquity rather than the Roman copies they had been used to, making them realize that the former was based not on generalized forms but on the closest possible study of anatomy. In essence the academic belief, enshrined in Reynolds's *Discourses*, that to achieve the grandeur of the ancients an artist had to move from the study of human anatomy and antique sculptures towards a general form, was now perceived to be simply inadequate. The Parthenon Marbles demonstrated antique grandeur, but they also proved that this grandeur was compatible with the minute and sensitive study of bodily detail and movement.

Haydon was unusual among his peers in having a strong intellectual interest in racial science, and in his early years he was involved in the 'Negro faculties debate' in a liberal weekly edited by James Henry Leigh Hunt (1784–1859), *The Examiner*. Haydon was at that point a committed polygenist and follower of Charles White in his racial determinism based on osteology.[21] He reacted angrily to an essay in the *Edinburgh Review* that he claimed condemned 'these speculationists on the inferiority of Negroes', referring to a passage that mentions 'those speculatists [*sic*] who dream

23 Benjamin Robert Haydon, *Study of a Nude Male Figure (the Black Sailor Wilson)*, 1810, black chalk on paper.

about natural and fixed incapacities of the Africans'.[22] This debate is reflected in his equivocal attitudes towards Wilson. In his autobiography Haydon describes his first meeting with him: 'About the latter end of 1810 the artists met with a black, a native of Boston, a perfect antique figure alive. On my getting sight of him, I engaged him for a month, and proceeded to draw and cast him without a moment's loss of time in all the attitudes wanted for my picture' (illus. 23). Fired by his close study of the Parthenon Marbles, which he drew from incessantly, and his study of human anatomy, Haydon describes Wilson's body minutely, his immediate concern being to use Wilson as a model for the painting of Macbeth he was working on: 'I arose this morning disgusted with my Macbeth and everything about me after contemplating that exquisite form of the black – he is a perfect model of beauty and activity – small body & large limbs, with small joints – his contour was undulating and nature suffered nothing to interrupt this beauty in any position.'[23]

Yet on reflection Haydon decides Wilson is not of *perfect* beauty, but that his beauty lies in his movements rather than static proportions. As he says, 'Every part depends on its form from its actions . . . that is the body in its motions to bend [the loins] instead of rolling on the thigh bones . . . Wilson has all the markings of the antique in these actions, but they vary as he alters his position. This was the great system of the Greeks and this is

the great system of nature.' This idea of beauty in movement is an implicit critique of the notion that ideal proportions were fixed and measurable often to be found in eighteenth-century textbooks. Haydon enlarges on this idea in relation to Wilson:

> Such was his beauty & power that whether in action or relaxation, his forms expressed either more perfectly than I ever before saw them in Nature – the moment he moved, his intentions were evident – this great principle was more strongly expressed than ever on my mind – that the form of a part depends on the action – he had that perfect suppleness that one felt but never before saw – his joints . . . in repose became . . . undulating beauties & in action vehicles of energy and refined activity . . . I was now convinced from Nature that one great cause of action & strength . . . in the antique was the parts to be moved always to be smaller and depending on the parts moving . . . [L]arge bones & small muscles are the general causes of awkwardness & deformity.[24]

Yet Haydon also retained some idea of the ideal proportions of the static body, for he measures Wilson and finds him deviating in some respects from the notional ideal, noting that his head was not of the 'correct' proportions.

For artists in the early nineteenth century the canonical male Greek statues were not at all uniform. Clear distinctions were made between representative types, broadly between the epitome of brute strength, Hercules, expressed in the *Farnese Hercules*; the divine and restrained beauty of Apollo in the *Apollo Belvedere*; and the athletic and human beauty of the *Discobolos*. Wilson's unique quality for Royal Academy artists was that he could transcend these divisions as he moved; he could act out the different modes of the antique: physical strength, God-like beauty and athletic grace. Lawrence notes that at different moments Wilson could appear to be like the Antinous or the Farnese Hercules, while Haydon describes him as 'not of the grandest Style; he is something of the Discobolos', that is to say a transcendent athlete.[25] Wilson's protean abilities recall the example of Emma Hamilton, whose various 'Attitudes' that she acted out for audiences captivated an earlier generation of artists.[26]

In the drawings now in the British Museum that Haydon made of Wilson – inscribed 'Wilson the black' – we can see references to the antique. A view from the back shows him as a stocky Herculean figure, while the two rapid sketches on the same sheet, one of him standing and the other with

his arm raised in movement, show him in all his variety. Despite Haydon's admiration for Wilson's physique, he exhibits attitudes that suggest the influence of racial science, seeing in Wilson animal characteristics uneasily compatible with the European ideal. He notes that 'The inner ankle in the Lion and all animals of that species is lower than the outer one – this seems to be an animal character, for when Monkeys & Lions stand on the hind legs like man, their feet are flat. The Black's ankle inclining that way makes the feet flatter than the European's and is a link to and characteristic of animal Nature.' Furthermore, 'The defective parts of Wilson, the black, were his Deltoid, his fore arm, his vastus internus, his claves, his ankles – and his feet – answering exactly to the defects of animals in comparison with a human form – which makes the gradation in approach. The principle is to consider all animals as inferior human beings in the gradation of creation.'[27]

Haydon drives this point home in a discussion of the intellect of human beings in relation to Wilson, for 'He that has the highest intellect is the highest being.' It follows that the body is subservient to the intellect and thus fittest to execute its will. He then goes on to argue that what distinguishes a man of the highest intellect from 'those beings who have less intellect . . . and where the form of other beings of less intellect differs, it is characteristic of a deficiency of intellect'. From this convoluted reasoning it follows that 'Blacks in their form approach that of those who are deficient in intellect – their lobes of ear small, their teeth frequent, lower jaw retreats, the scull is diminished,' and so on, reiterating that their flat feet make them shuffle rather than walk, like monkeys.[28] Even though he accepts that a high intellect may be contained within an animal form, as a painter's language is form he must express intellectual prowess in its outward human shape. In admitting that there are exceptions to the general rule he reiterates that his job as a painter is not to paint exceptions but only the ideal of its type, or the perfection of the original human being.

Haydon's response to Wilson evokes the Great Chain of Being of earlier centuries, and it also suggests a knowledge of Camper, whose racial charts had been published in England in 1794 (we know that the Royal Academy purchased a copy shortly after publication).[29] Haydon alludes to Lavater's claim that the outward form reflects the mind within, so despite his extraordinary beauty Wilson is still categorized as being on an inferior level as a human being.

The fame of Wilson nonetheless had some interesting consequences. He is clearly the object of a caricature by John Boyne entitled *A Meeting of Connoisseurs*, probably dateable to 1810–11. Here a naked Herculean Black

model is being puzzled over by a group of connoisseurs and painters who do not know what to make of such magnificent attributes – though the suggestion of homoerotic desire is obvious. George Dawe was one of the Royal Academy painters captivated by Wilson, who is shown as a figure of brute strength overcoming a buffalo in a painting exhibited in 1811. It conjures up a picture of a mythical Africa in which human beings are in constant struggle with the powerful forces of nature and have developed exceptional strength to prevail over the animal kingdom. Wilson reappears again in a different role in the Royal Academy sculptor Richard Westmacott's monument in Westminster Abbey, created 1810–23, to the great abolitionist politician Charles James Fox. Here he is a noble and muscular Black man, showing gratitude for being freed from slavery and humility towards his liberator.

Wilson's unique achievement, despite Haydon's equivocation, was to establish the potential for those of dark skin to embody classical beauty in the Greek manner. But this had to compete with the conflicting tendency to emphasize the African's otherness, his inherent savagery or racial inferiority. In George Dawe's painting he is the epitome of human strength, a Hercules, defeating a large and ferocious animal, but he is also an exotic figure, representing humanity's earliest origins in a world where he still has to fight for survival against wild animals, seeking to separate himself from the animal kingdom. In Westmacott's portrayal he is muscular and powerful, but also placid and accepting of his subordination to the deceased politician. Haydon's account, however, for all its conventional racial assumptions, is a complex portrait of a man who could transform himself in the eyes of observers from one classical archetype to another, and whose beauty was expressed not in static resemblance to a single archetype but in movement and transition.

It is interesting in retrospect to note how the protean body of 'Wilson the Royal Academy model', despite Haydon's attempts to apply scientific racial criteria to him, somehow eludes such criteria through his ability to transform himself into semblances of the white European ideal. The Black body resists the imposition of difference in everything but the superficial colour of the skin. Physiognomy was thus a much more tempting field for those interested in the perception of difference, for it could claim more plausibly, through racial science, to express the mind behind its outward appearance.

The dichotomy between head and body in images of Black people is clear in nineteenth-century France if not so much in England, where anthropological portraiture was rarely produced, though there are

Fig. 747. – FLORENCE NIGHTINGALE.      Fig. 748.—BRIDGET McBRUISER.

24 Woodcuts of Florence Nightingale and Bridget McBruiser, from Samuel R. Wells, *New Physiognomy; or, Signs of Character, as Manifested through Temperament and External Forms, and Especially in 'the Human Face Divine'* (1867).

portraits, both painted and sculpted, of notable Black people such as the military nurse Mrs Seacole. (Camper and Lavater were well known in England, but from the work of scientists like Broca and others it is clear that skull measurement had a greater impact on art in France.) Yet there was as much, if not more, information published on the topic in England, though rarely of scientific rigour.[30] Furthermore, English painting was particularly well known in France for its concern with the inner psychology of the figures depicted.

While writers on physiognomy in England in the early to mid-Victorian period tended to show more interest in class than race, the Irish were often seen as straddling the two and were typically contrasted with persons of refinement. This is expressed in a caricatural woodcut illustration of the contrasting physiognomies of the great medical reformer Florence Nightingale and the stereotypical 'Bridget McBruiser' (illus. 24). Nightingale has a high forehead and a firm, straight nose, but her Irish counterpart has a nose that combines the Snub and the Celestial types (discussed in Chapter Seven), and her thin lips reveal her teeth.[31] That the Irish, though making up a large portion of the working classes of England, were of a different race from the Anglo-Saxons was widely believed. Writers on physiognomy alert to racial science regarded them as Celts, dividing them into two kinds: the 'low Celts', who shared characteristics with lower classes everywhere, and the 'high Celts', who were more biddable to the English ascendency. In Samuel R. Wells's *New Physiognomy* (1866),

the English and the 'low Celts' are contrasted according to almost precisely the same features as Florence Nightingale and Bridget McBruiser.

This chapter has broadly looked at England and France in the first half of the nineteenth century and beyond, but the rise of imperial ambitions and the move among some natural scientists towards a greater emphasis on the measurement of racial difference brought race even more to the fore. Above all it began to inform and be informed by an increasingly fervent nationalism that affected all of the European and American powers. The following chapter looks at the beginnings of a complex relationship between nationalism and racial ideas and the rise of the Germanic races in both Germany and England, culminating in an account of a loosely connected group of English and German painters and their activities in the earlier part of the nineteenth century.

# PART II

# RACE AND NATIONALISM

25 Johann Heinrich Wilhelm Tischbein, *Hermann and Thusnelda*, 1822, oil on canvas.

# 4

# Germans, Teutons and
# the Anglo-Saxon Race

If any one insists with me that a Negro or a Tasmanian accidently born in
England becomes thereby an Englishman, I yield the point; but should he
further insist that he ... may become also a Saxon or Scandinavian, I must
contend against so ludicrous an error.

ROBERT KNOX, *Races of Men* (1850)

Where else but in the historic remains of the arts does the nationalist find
the evidence of his fixed racial character? Only the artistic monuments of
his country assure him that his ancestors were like himself and that his own
character is an unchangeable heritage rooted in his blood and native soil.

MEYER SCHAPIRO, 'Race, Nationality and Art', *Art Front*
(March 1936)

A t the heart of this chapter there is a problem of definition. How does
one distinguish 'nation' from 'race', or indeed from 'class'? Most writ-
ers in the nineteenth century, particularly in England and the Germanic
lands, were completely unselfconscious about claiming membership of any
one of the Caucasian, Aryan, Teutonic or Anglo-Saxon – or occasionally
the Celtic – races, and sometimes more than one at the same time. This did
not mean that they were necessarily committed to a belief in the centrality
of race. As discussed earlier, Peter Mandler has claimed that England, at least
in the first half of the nineteenth century, was more committed to a 'civi-
lisational perspective', in which England was defined as the most civilized
of peoples but others were potentially capable, with effort and guidance
from their superiors, of achieving something like a comparable level.[1] It
goes without saying that such a belief contains racial implications. In some

cases biological purity was insisted upon; in others a single race might have been defined as a mixture of two or more races. Protagonists of the Anglo-Saxon race might have insisted on their descent from the Germanic tribes admired by Tacitus for their refusal to mix their blood with non-Germans, or claimed that the Anglo-Saxons were themselves a product of a mixture of Angles, Saxons, Vikings, Danes or even Normans. Daniel Defoe, in his satire on *The True-Born Englishman* (1701), describes the latter as belonging to a 'Mongrel half-Bred Race'.

That still could allow the self-proclaimed Anglo-Saxon to assert membership of a 'greater' race, like the Teutonic, which would mean they could define themselves as part of a genetic group that spanned northern countries from Scandinavia to Scotland and Ireland, or even Holland, usually distinguished from the 'Mediterranean' countries of France, Italy, Greece and North Africa. At the same time this could promote larger binary divisions between 'dark races', which might include not only Africans but Jews and Gypsies, and the 'Aryan' and 'Caucasian' races, those from Europe and countries further east.

What can be confusing is that in the nineteenth century race was often mapped, however imperfectly, onto nation and stage of civilization, though Robert Knox, in the epigraph to this chapter, claims that the first is based on heredity while the second can be a matter of election. The 'Anglo-Saxon race' was usually taken to be synonymous with those of English descent, and was increasingly claimed by those of such descent who lived in the United States. The idea lives on in the derogatory acronym for the white ascendency in the United States: WASP, for White Anglo-Saxon Protestant,[2] and the early to mid-twentieth-century call for 'the Union of the English-Speaking Peoples' to include Britain and the United States, and all the 'white' Commonwealth countries. But these 'national' categories could also be part of a wider racial formation, like the 'Caucasian' and 'Aryan' races, the latter epithet deriving from the linguistic construction of the Indo-European languages.

Outside the world of racial science, nation and race became virtually synonymous. Appeals to racial pride were commonplace in all countries in the nineteenth century. Ralph Waldo Emerson, for instance, gave a lecture on 'The Genius of the Anglo-Saxon Race' in 1843, which he saw as visible in a ruddy complexion, blonde hair, blue eyes and tall stature, governed by 'an inner ferocity'. For him the Anglo-Saxons united the different nations of England and the United States, and their finest representatives, by no coincidence, lived where he did: New England.[3]

There is, however, a potential ambiguity in the words 'Anglo-Saxon'. It can mean 'English Saxons', as William Camden called them – that is to say the Saxons who came to England as opposed to those who stayed in Germany.[4] Or it can suggest a composite people made up of Saxons but also the Angles mentioned by Tacitus and Bede, who evidently came from Jutland and gave their name to England. But, of course, they were both understood to have been 'pure and unmixed' Germanic tribes. But later in nineteenth-century England there was a tendency in some quarters to identify the Anglo-Saxon race with the middle class, and as very different from their 'Norman' aristocratic compatriots. Anglo-Saxons were regarded both positively and negatively, as average, solid and rather unimaginative members of society, yet sound and dependable. This racial type was epitomized in the figures of the Frith family who feature in W. P. Frith's famous painting *The Railway Station* (1862, illus. 26). As Mary Cowling notes, Frith was the middle-class artist *par excellence*, and his boys were recognized by a critic as having 'blond, frank, and manly faces inherited from Saxon ancestors'. The Saxon type was represented ideally by John Bull, the stolid, nononsense type of Englishman, popular in caricature and quite distinct from the aristocracy, who lacked imagination and subtlety, was prone to philistinism towards the arts and preferred beer to wine.[5]

26 Detail of the foreground group in William Powell Frith, *The Railway Station*, 1862, oil on canvas.

## The Persistence of Tacitus' Picture of Germania

The idea of the Anglo-Saxon race was dependent on a particular under-standing of the ancient Germanic tribes that gave it its name. According to that understanding, which was shared by post-Reformation German authors, the Germanic lands had been inhabited in Roman times by fierce warrior tribes who looked similar to each other, lived in harmonious com-munities united by pure blood ties and defended their territories successfully against the mighty Roman Empire. This account derives entirely from a Roman text, Tacitus' *Germania*, written circa AD 98, which paints a picture of an agrarian warrior people living in forests and swamps, wholly without corruption, in contrast, so Tacitus claims, to their decadent Roman con-temporaries, to whom his text was a warning.[6] Because they had fought off all invaders and kept themselves to themselves, the Germanic tribes were unmixed with other peoples. They were therefore, according to the Loeb translation of 1914, 'a race untainted', though the word used by Tacitus in the accusative – *gentem* (nominative: *gens*) – means, strictly speaking, people rather than race:

> Personally I associate myself with the opinions of those who hold that in the peoples of Germany there has been given to the world a race untainted by intermarriage with any other race (*gentem*), a peculiar people and pure, like no one but themselves; whence it comes that their physique, in spite of their vast numbers, is identical: fierce blue eyes, red hair, tall frames, powerful only spasmodically.[7]

Tacitus' account had an enormous and long-lasting influence on both German and English self-image. After its rediscovery in the fifteenth cen-tury, Tacitus' text became part of the armoury of resistance in the Germanic lands to papal power, coming into its own at the beginning of the Protestant Reformation and helping to define a new Germany in opposition to the decadence of Catholic Rome and its religious adherents. Tacitus, in his *Annals*, also provided the Germanic lands with the name of an ancient leader, Arminius of the Cheruscan tribe, whom Tacitus described as an undefeated hero of his people, a warrior who annihilated, in the Battle of the Teutoburg Forest in Lower Saxony in AD 9, three Roman legions under Varus, effectively keeping the Romans out of the German lands beyond the Rhine: 'Arminius, without doubt Germania's liberator, who challenged the

Roman people not in its beginnings like other kings and leaders, but in the peak of its empire; in battles with changing success, undefeated in the war.'[8] After Luther's establishment of Protestantism as a German alternative to Roman Catholicism, his passionate supporter Ulrich von Hutten's Latin dialogue *Arminius* in effect converted the ancient warrior (named in the German vernacular 'Hermann' by Luther) into a national hero – an impressive feat, given that Germany was still divided into principalities at this time, and only became a nation in 1871.

But was he a *racial* hero rather than a national one? This is a question for which there is no clear answer. Tacitus' description of the Germanic tribes, their apparently deliberate separation from others, their purity of blood and physical homogeneity, and perhaps Arminius' unequivocal desire to not only defeat but annihilate his Roman enemies, has all the elements of racial discourse. Furthermore, Tacitus' *Germania* and his description of Arminius were particularly precious to the Third Reich. Hitler himself was often compared to Arminius, particularly in the region of Germany that contained the site of the ancient warrior's victory over the Romans.[9] In 1944 he brought to his office in the chancellery (Reichskanzlei) two paintings by Angelica Kauffman, a female artist whom he particularly admired,[10] originally housed in the Kunsthistorisches Museum in Vienna; these paintings are now lost, but one showed the triumphant Arminius returning to the woods where he is crowned by his devoted wife, Thusnelda, after defeating the Roman army.

Arminius, or Hermann, and Thusnelda were the subject of many literary works and operas, including one by Handel, in the seventeenth and eighteenth centuries.[11] Perhaps the most important for painters was Friedrich Gottlieb Klopstock's poem 'Hermann und Thusnelda' of 1752. The painting by Kauffman that Hitler displayed in the chancellery was commissioned in 1786 by Emperor Joseph II and is known from another version in Innsbruck (illus. 27). It was paired in Hitler's office with a painting of the death of the heroic Pallas being mourned by Aeneas, and though Tacitus described the Germans of Arminius' time as primitive beings compared to his oversophisticated fellow Romans, the Italian-trained Kauffman's painting shows them equal in refinement to their Roman contemporaries. Arminius is presented as an Apollonian hero while youths and maidens celebrate his victory decorously.

At the beginning of the nineteenth century, with the patriotic wars against the French – in which Napoleon was seen by young German nationalists as a modern-day Varus attempting to subdue the Germanic

27  Angelica Kauffman, *Thusnelda Crowning Hermann*, 1786, oil on canvas.

lands, and the French as presiding over a decadent and overstretched empire, like Tacitus' Rome – Arminius became an even more central subject for German writers and artists. In 1808 German resistance to Napoleon's invasion was invoked in Heinrich von Kleist's bloodthirsty play *Hermannschlacht*, though it was not performed until later.[12] Goethe's friend Johann Heinrich Wilhelm Tischbein painted his better-known version of *Hermann and Thusnelda* in 1822 (see illus. 25), and Karl Russ's earlier engraving *Hermann befreit Germania* (1813) refers to the victorious Battle of Leipzig, in an allegory of Arminius freeing the female figure of Germania. The most prominent commemoration of Arminius is the enormous monument by Ernst von Bandel on the presumed site of the battle against the Romans near Detmold, which features the hero on top of a circular structure wreathed with columns, conceived of in the 1830s and only completed in 1875.

In all of these cases, the visual language owes much to Italian traditions of depicting heroism. The prestige of classical sculpture and the Italian Renaissance, and their hold over art academies, meant that German artists were reluctant, in the eighteenth century at least, to leave behind the traditions in which they had been taught, though they might on occasion paint subjects from Germanic history. In the painting by Johann Heinrich Wilhelm Tischbein, costume aside, Arminius is a completely classical

figure, owing his stance to such models as Thorvaldsen's marble *Jason* of 1802,[13] while Russ's allegorical print models his heroic composition on Italian depictions of Bacchus rescuing Ariadne. The one concession in the Kauffman painting to a distinctly Germanic element – besides the forest in the background – is the figure of a heavily bearded old man, a pagan priest who raises his arms in joy at Arminius' return; he can be compared to the seated old man in the Tischbein painting.

These works, then, despite their Germanic subjects, follow conventions derived essentially from Raphael and artists of the Italian Renaissance and filtered through two centuries of artistic principles refined at academies throughout Europe, which were in turn based on Italian and French models of instruction. They tell elevated moral stories through the interaction of heroic figures and observers, but by the early nineteenth century, mainly in Germany and Britain, landscape rather than figure painting emerged as a genre for young painters who sought a new vehicle for high-minded pictorial reflection on religion, nationalism and identity.

## Romantic Nationalism in Germany and Britain: Past, Present and Future

National feeling in the years following 1806–13, the period of occupation by Napoleon of parts of Germany and the subsequent Wars of Liberation, has been the cause of much scholarly anguish. Commitment to a sacramental form of nationalism was prevalent, which some academics cast as a foreshadowing of Nazi ideas of racial supremacy; but it is more complicated than that. Though there was longing on the part of many poets and artists for the moral purity of the ancient German tribes, and ferociously hostile attitudes towards the French, many nationalist artists and writers made pleas for a more democratic and unified Germany, free from the autocratic governance of the independent princes who ruled over a fragmented country. Several of these princes had supported – or at least not offered any opposition to – Napoleon's attempt to conquer the Germanic lands, and they were able to reimpose their rule after the French emperor's defeat and the Congress of Vienna in 1814–15.

The French had in any case been anathema to most German nationalists both before and after the 1789 French Revolution. The eighteenth-century poet Friedrich Gottlieb Klopstock initially supported the French Revolution and had excoriated the *ancien régime* as frivolous and autocratic, contrasting it with German simplicity and piety.[14] By the beginning of the nineteenth century what support there was in the Germanic lands

for the French Revolution was complicated and generally discredited by Napoleon's subsequent territorial ambitions.

The painters Philipp Otto Runge (1777–1810), though he died in the middle of the Napoleonic occupation, and Caspar David Friedrich (1774–1840) were both caught up in the febrile atmosphere of the years after 1800 in the Germanic lands. They were part of what Jost Hermand has called 'the North German, Pietist-Protestant, Klopstockian, Christian-Germanic' tendency, as opposed to the more cosmopolitan, and in some instances pro-French, circles around Goethe, who himself talked contemptuously in 1817 of a 'neu-deutsche, religiös-patriotische Kunst'.[15] Both painters looked towards a religious revival after the expulsion of the French, but their views of history differed more than the above descriptions would suggest. Runge's masterpiece, initiated in a set of four engravings, the *Tageszeiten* (Times of Day, 1803), and culminating in the single completed painting from the series, *Morgen* (Morning, illus. 28), forms a complex allegory of rebirth that looks forwards to a new age of national – but also universal – spiritual renewal, tied to the cycles of nature.[16] The cycle of prints and paintings was clearly affected by Napoleon's dissolution of the Holy Roman Empire in 1801 and the events that followed, which provoked in Runge apocalyptic thoughts that made him look to the Last Judgement and the destruction of the earth, from whose ruins a redeemed world would arise.[17]

As revealed in his letters and early drawings, from his youth Runge had a healthy respect for the Italian Renaissance, Raphael in particular, and for Italianate artists such as Angelica Kauffman.[18] The Hamburger Kunsthalle's drawings collection has many sketches and details he made after casts of classical Greek and Roman sculptures, or from Renaissance paintings, which show a dogged desire to learn from them. This, as we will see, differentiated him from Friedrich, who seems to have defined himself from the beginning as a landscape artist broadly in the Dutch manner, without reference to the art of Italy or France. It must have been a conscious choice because his time at the Copenhagen Academy would have exposed him to classical casts and copies after paintings by Raphael and others, and much of the instruction was tied to their study.[19]

Runge's female allegorical figures in the *Tageszeiten* are inconceivable without reference to Raphael and his Italian contemporaries, and the omnipresent putti are decidedly Italianate in feeling, the most famous and most readily available to him being the two winsome ones in Raphael's Sistine Madonna in Dresden, which Runge studied on his visit to the city in 1801.[20] The Italian influence also speaks to a permanent tension in Runge's work

28  Philipp Otto Runge, *Der kleine Morgen*, 1808, oil on canvas.

between figuration and landscape, which was there from his beginnings as a student of the Danish painters Nicolai Abildgaard and Jens Juel in Copenhagen. But it is in the personification of nature that the fundamental distinctiveness of his art can be found. He was unwilling to define himself only as either a figurative painter in the Italian tradition or a northern landscape painter; there are almost no finished 'pure' landscapes in his oeuvre or indeed pure figurative paintings, despite his feeling for Italian and classical art. He shows, from his time as an art student, a particular interest in perspective and proportion which led to a habit of constructing geometric

lines in studies for his later compositions. Though he was initially disturbed at having to draw from casts of classical sculptures, he responds viscerally to the Laocöon: 'when I see his breast swelling as a frightful cry of pain is emitted, at that moment I feel: that is what art is.'[21]

The highpoint of his engagement with the cosmopolitan artistic circles in Weimar, presided over by Goethe, came with his entry into the Weimarer Preisaufgaben (Weimar Prize Competition) of 1802, which Runge famously described as that 'Schnickschnak in Weimar' (mishmash in Weimar). This was a competition set up by Goethe at the court in Weimar with the express aim of encouraging painters to attempt classical subjects, and it was explicitly directed to counteract the rising tide of Romanticism among younger artists, including Runge himself. The 1802 subject, laid down by Goethe, was Achilles and Scamander, and Runge entered a carefully considered finished drawing, now in the Hamburger Kunsthalle. Even so, Runge was highly equivocal about the competition, noting that 'we are no longer Greeks', but concluded that despite being 'a completely false road, unlikely though it might seem, [the competition] could cause some good things to happen.'[22]

The relationship between Goethe and Runge does not fall easily into the polarities of romanticism and classicism. They both wrote anti-Newtonian treatises on colour and their correspondence is cordial and mutually respectful, though the former tended to be exasperated by the younger man's independence and the latter by the older author's conservatism. One of Runge's principal objections to the Weimar Prize was Goethe's insistence on fixed subjects for the artists to treat, while Runge stood for the primacy of an 'eigenes Gefühl', or an inner feeling in the choice of subjects. That did not stop him entering the competition, however, and he also made extensive illustrations for the ancient mythical Scottish poet Ossian.[23] Goethe's view of Runge broadly seems to have been that he was a type of 'mad genius', rather like Beethoven, representing a kind of modern creativity that threatened the classical order to which the mature poet was devoted. He did not specifically see Runge as a nationalist in opposition to his own cosmopolitanism, though he would undoubtedly have included the painter, if he were then still living, in his 1817 fulminations against 'neu-Deutsche, religiös-patriotische Kunst'.

Though Runge was closely associated in Hamburg with the patriotic, anti-Napoleonic circles around the publisher Friedrich Christoph Perthes (1772–1843), his work was devoted to promoting not so much a German nation but Northern Europe as a whole, an idea expressed in the series of

drawings illustrating Ossian, which bring together spiritual revival with a vision of the redemptive power of nature.[24] The drawings were commissioned at the end of 1804 by Perthes to illustrate Count Friedrich Leopold von Stolberg's translation of Ossian's epic – a version that Runge was reading not for the first time. They were intentionally made in the outline style of Tommaso Piroli's engravings after John Flaxman's outline drawings, which were much admired in Germany and across Europe from their first appearance in 1793–4.[25] Runge had been given a set of the *Aeschylus* and *Iliad* engravings when he was a student in Copenhagen by his brother Daniel, to whom he responded enthusiastically: 'I thank you for them with tears. My God, they are like nothing I have ever seen in my life before.'[26] Flaxman continued to be invoked in Runge's letters, and the latter employed an outline style in most of his later drawings derived ultimately from the English sculptor.

What is distinctive in Runge's Ossian drawings is the way that the story and actions of the ancient heroes are fully integrated into nature and the diurnal cycle. In a letter to Ludwig Tieck of 29 March 1805, Runge describes in detail the connections of the three related heroes: Fingal, the great warrior; Fingal's son, the blind bard Ossian; and Ossian's son, Oscar:

> Oscar stands in a lower region on the horizon, his shield hangs off his shoulder and mirrors the circle of the sinking sun, like a narrow strip of the moon; the tip of his spear is the evening star; he is swaying and stands with one foot behind the horizon, he looks at the sun behind him throwing rays upon him, and the foreground which ends in a lake; Fingal's shield is the sun, he places one foot on the land, the deer leaps out of the bush.

So Fingal represents the rising sun and Oscar the setting, while the blind bard Ossian, with his harp, receives no light from the sun but is seated between heaven and earth on a rock under the north star. The three are identified by the artist elsewhere: Fingal is the sun and a giver; Ossian is the earth and a receiver; and Oscar is the moon and a messenger.[27]

In a drawing of *The Death of Comhal and the Birth of Fingal* (illus. 29), Fingal's birth at the moment of his father's death is depicted as the emergence of a child with the sun behind him, a miraculous birth which evokes the birth of Christ, and, though he almost certainly could not have known it, the advent of Orc as the infant Christ in Blake's *America a Prophecy* of 1793.[28] This has the effect of making Fingal into a Christ figure, tying the

idea of Christian redemption to the redemption of nature invoked in the images of Fingal, Ossian and Oscar. The other drawings in the series – only a fraction of the number that Runge originally intended[29] – show scenes of war and combat, and in one of them Fingal appears again with the sun behind him.

For Runge the ancient myths of the northern peoples are associated directly with nature, but it is not the organized nature represented in the classical or realist landscape painters of the day; rather, it is one infused with the rhythm of the world and the spirit. Runge reveals himself here as a pantheist, seeing nature in terms of the diurnal cycle and the birth and death of Christ. But how does he see these northern myths? Though he was beyond doubt a nationalist in relation to the conflict with the French, certainly by the end of his short life, late into the first decade of the century, he was equally concerned with a 'Northernness' that encompassed more than one existing nation. He must have been aware of the idea of Ossian as 'the Homer of the North', embodying a myth notionally as powerful as that of the Greek poet, but wholly northern in inspiration.[30] But the 'North' here does not map easily onto the Teutonic or the Germanic; the Ossianic myths were set in ancient Scotland but based on Irish sources. As a student of art at the Copenhagen Academy, and in the orbit of Abildgaard, who had painted scenes from Nordic myth, including Ossian,[31] Runge would have been aware also of the Scandinavian claim to 'Northernness'. This would have given Runge a supra-national view of the Ossianic myth, seeing it as underpinning a Nordic-Germanic identity, distinguished from its Greek equivalents by the idea of salvation through nature.

By the time Runge began to illustrate Ossian he would have had experience of the poems and their Christian implications, both from his teacher at the Wolgast school Ludwig Gotthard Kosegarten (1758–1818), who wrote poetry on the subject,[32] and through Abildgaard, though the latter would have been less sensitive to the theological implications of Ossian. But under the force of events connected with the French invasion, Runge moved towards a more specifically national patriotic position. His friendship in his last years with the fiercely nationalistic – though enlightened – Perthes led him to design two printed covers, with four designs of a more overtly patriotic kind, for the periodical tellingly named *Vaterländisches Museum*. Perthes, as the title of the publication suggests, was an opponent of the Napoleonic invasion, which he also saw in apocalyptic terms, envisioning a new Germany that would arise from the struggle between reason and religion in his own time.[33]

29  Philipp Otto Runge,
*Fingal*, 1805, grey pen and
pencil on paper.

In a letter to Joseph Görres of January 1810 Perthes writes of the 'geistigen Bande', the spiritual allies who for him – surprisingly to modern eyes – constitute the Germanic nation: 'Austrians, Prussians, Latvians and Estonians, Swiss' (Österreicher, Preussen, Kur- und Livländer, Schweizer).[34] The journal was initiated in difficult times. The French had occupied Hamburg since 1806, instituting censorship, so overt proclamations of German independence and anti-Frenchness had to be concealed – one reason, though not the only one, for the oblique nature of Runge's patriotic imagery.

The most elaborate and detailed design, though it never got beyond a finished pen drawing, is entitled *Fall des Vaterlandes* (1809, illus. 30). It is an elaborately framed scene of a woman with a child on her shoulders pushing a hoe, also dragged by a winged cupid. Beneath the topsoil is the extended Christ-like figure of a naked man who seems to be clinging on to life. Perhaps the key to the meaning of the image is the Janus head hanging

30  Philipp Otto Runge, *Fall des Vaterlandes*, 1809, black pen and pencil on paper.

like a flower basket from the arching branches above; it faces both the
past and the future, with the present represented by the scene beneath. The
past is the Germany of Dürer filtered through the writings of Wilhelm
Heinrich Wackenroder (1773–1798) and other German Romantic authors,
but the naked figure under the surface perhaps suggests an earlier, more

primitive Germany that will rise again from burial like an ancient hero. Such a conception thus presents soil, the surface of the earth, as the key to the revival of humanity, an idea that anticipates current ideas about the Anthropocene.[35] Görres makes clear in a letter to Perthes that the woman and the cupid ploughing up German soil are the present, while the seeds they plant are for the future, represented by the child the woman carries.[36]

It is significant that Runge, in his voluminous letters, does not mention Tacitus, Arminius or the German tribes of the Roman era, though he lived in hope of a revival of Germany's lost unity. (He died before the German victory at Leipzig in 1813 and the disillusion that set in following the reassertion of power by the princes at the Congress of Vienna.) Caspar David Friedrich's intellectual trajectory was intriguingly different from Runge's. He appears not to have responded to the classical aspects of the training he shared with Runge in Copenhagen, and he was fiercely anti-French from the beginning. He ticked off his wayward brother Christian in November 1808 for being in France, saying that 'as long as you are in France, do not write to me anymore.'[37]

Friedrich was closely associated and in sympathy with the most committed patriotic writers in the period from 1807 to 1815, including Ernst Moritz Arndt (1769–1860), who was born on the island of Rügen and taught for many years at the University of Greifswald, which was later named after him in 1933, though his name was removed in 2018. Arndt made a call in 1805 for a new Arminius to destroy Varus-Napoleon; he was violently anti-French and antisemitic, combining the two prejudices by calling the French 'the Jewish people' (*das Judenvolk*) or 'refined bad Jews' (*verfeinerte schlechte Juden*).[38] He also promoted the idea of the racial purity of the Germans by reference to Tacitus, claiming that 'The Germans have not been bastardized by foreign peoples, have not become half-breeds, they more than many other peoples have remained in their native state of purity.'[39] In a surviving letter from Friedrich to Arndt of March 2014, addressed to 'Hochgeschätzter Landesmann!' (Highly esteemed compatriot!), he discusses a monument to the 'noble Scharnhorst', the Prussian general, noting that 'As long as we remain under the princes nothing great in art can be done.'[40]

Also part of Friedrich's circle, at least from 1817 through to the 1820s, was the painter, physiologist and professor of gynaecology Carl Gustav Carus (1789–1869). He was one of the most accomplished painters to have frequented Friedrich's studio in the 1820s, but he was also a man of wide-ranging scientific activities, including authorship of an important treatise

on racial theory. This book, published to celebrate what would have been his late friend Goethe's hundredth birthday, has the title *Ueber ungleiche Befähigung der verschiedenen Menschheitstämme für höhere geistige Entwickelung* (On the Unequal Abilities of the Different Human Races for Higher Spiritual Development, 1849). Though clearly well read in the racial theory of Linnaeus and Kant, and in the skull comparisons of Camper and Samuel Morton, Carus's position on race owes much to the Romantic science of Lorenz Oken and others, which connected human variety to the cycles of nature and the human organs. The four 'great races' for him were, partially following Linnaeus, those of dawn (yellow, the stomach); day (white, the brain); sunset (red, the lungs); and night (black, the genitals). Africans are described as 'die Nachtvölker', the people of night, who are divided between 'die Atlasvölker' (North Africans) and Nubians, Abyssinians, Egyptians and Copts; Europeans are the 'Tagvölker', the people of day, who include twelve sub-variants, from Caucasians to Germans.[41] The inhabitants of the other two continents are the 'östlichen Dämmerungsvölker' (eastern twilight peoples) and the 'westlichen Dämmerungsvölker' (western twilight peoples). The sense of the connection of all things in nature gives Carus something in common with Runge; however,

31  Caspar David Friedrich, *Hünengrab im Schnee*, 1807, oil on canvas.

32 Caspar David Friedrich, *Felsental (Das Grab des Arminius)*, 1813–14, oil on canvas.

despite the other-worldly framework of the theory, it essentially reinforces conventional racial hierarchies that make Europeans the people of intellect, able to reach the highest development of the spirit ('höchste Entwicklung des Geistes'), and Africans to be governed by uncontrolled instincts.[42] Whether he had developed these ideas at the time of his friendship with Friedrich is unknown.

A number of paintings by Friedrich between 1807 and 1810 make subtle and intentionally indirect, but nonetheless unequivocal, allusions to the German struggle against Napoleon by invoking the Germanic lands in the age of Tacitus. A painting of 1807, a year after the Prussian defeats in the battles of Jena and Auerstedt, titled *Hünengrab im Schnee* (Burial Mound in Snow, illus. 31), shows an ancient tomb surrounded by three oaks, subtly calling, in a way that could avoid censorship, for the ancestral valour of ancient Germania to rise again and put to flight the present-day descendants of earlier enemies. There also exists a manuscript inscription in his hand from around this time, probably for an unknown or unexecuted tomb or painting, celebrating a fallen fighter for the 'Vaterland':

> The peace of the grave for a fighting warrior,
> Victorious and fallen for freedom and right!
> Peace be with you, striver in the fight
> Holy cause, Fatherland's joy![43]

Friedrich also painted two pictures that openly if discreetly refer to Arminius. The first, in Bremen, was badly damaged in the Second World War, *Felsental (Das Grab des Arminius)* (Rocky Valley (Arminius' Tomb), illus. 32). The sarcophagus in front of the sheer cliff was originally inscribed 'Deine Treue und Unüberwindlichkeit als Kriegersei uns ewig ein Vorbild' (Your loyalty and invincibility as a warrior will ever be an example to us), and probably dates to 1813, about the time of the victorious Battle of Leipzig (also known as the Battle of the Nations).[44] This was the high point of the German nationalists' hopes for real reform, and it was possibly originally paired with a lost or unexecuted painting of a monument to Scharnhorst, who had done much to restore the Prussian army.[45]

A more explicit reference to Arminius is to be found in the painting *Gräber gefallener Freiheitskrieger* (Tombs of Fallen Freedom Fighters) of 1812 (illus. 33).[46] The painting was completed shortly before the Battle of Leipzig, and it shows a kind of informal cemetery in front of a rockface with an opening beneath, into which two hapless French hussars enter. The sarcophagus to the left has the epitaph 'Peace be on your grave/ Saviour in time of need', and the obelisk is dedicated to 'G A F', who is presumably the 'Noble youth, Saviour of the Fatherland' of the epitaph; the initials may refer to friends of Friedrich who were killed in the war.[47] But most telling is the broken gravestone in the foreground bearing the word 'Arminius', with a snake in the colours of the French tricolour coiled around it; Arminius has yet to rise, but that moment in which he will destroy the French is surely imminent. As always in Friedrich's paintings, the world beyond is never more than intimated, and the past is brought into conjunction with the present and future; the ancient hero Arminius will rise again, in the spirit of the 'noble youth' who has given his life for his country, as destroyer of the external enemy and initiator of a new age of freedom and piety.[48]

In the aftermath of the German and allied victory at Leipzig in 1813, Friedrich wrote a prayer of thankfulness for the freeing of Dresden from the French (*Nach der Befreiung Dresdens von den Franzosen*).[49] It is couched in the language of Old Testament prophecy, thanking God for the victory: 'He has heard our cries and put flight to our enemies' (*Er hat erhört unser Schreien und verjaget unsere Feinde*); victory has removed not only the French yoke but the Russian. God is invoked to distance also 'the wild hordes who lay waste our fields and meadows' (*wilde Horden verwüsten unsere Felder und Fluren*). Piety and patriotism are here synonymous.

After 1819 the hopes of uncompromising patriots like Friedrich of a united, progressive yet pious German nation arising from the expulsion of

Napoleon were dashed by the reinforcement of laws reasserting the power of princes. A painting by Friedrich, *Huttens Grab* (Hutten's Tomb, illus. 34) of 1823, is full of references to those hopes yet still illuminated by intimations of national resurrection.[50] A patriotic veteran of the French wars, wearing the *Altdeutsche Tracht*, a nostalgic German cloak fashionable among young men in the last years of the 'Befreiungskrieg' (1813–15), reflects on the heroic period of German resistance to and victory over the French empire, and their disappointing consequences.[51] The painting explicitly draws together heroes present and past in a scene set in a ruined church containing the tomb of Ulrich von Hutten (1488–1523), the year in which it was painted – 1823 – being the tercentenary of his death. Hutten, as well as being a close follower of Luther, was author of the Latin dialogue *Arminius*, published after his death in 1529, and the overgrown tomb makes an unmistakeable comment on contemporary Germany. On the sarcophagus are the names and dates of recent heroes of the wars: (Friedrich Ludwig) Jahn 1813, freedom fighter and gymnast, who was in prison when the painting was made; (Ernst Moritz) Arndt 1813; Karl Freiherr vom) Stein 1813, reformer of the Prussian army; (Joseph) Görres 1821, anti-French journalist; and the Prussian general and army reformer (Gerhard von) Scharnhorst.

Though the golden light through the empty windows suggests ultimate redemption, the melancholy scene reminds the viewer of the lost hopes after Prussian successes against the French, and the reinstatement of princely rule.

33  Caspar David Friedrich, *Gräber gefallener Freiheitskrieger*, 1812, oil on canvas.

34  Caspar David Friedrich, *Huttens Grab*, 1823, oil on canvas.

Von Hutten acts as a bridge both chronologically and symbolically between
the Germany of Arminius and the patriotic and religious triumphs of the
previous centuries and decades, but the light and the setting suggest ineffably
the hope of a Christian-inspired national redemption.

Though Runge shared Friedrich's spiritual longings and hopes for a
revival of Christian Germany, he was by no means on the same political
wavelength. The touchstone of patriotism for Friedrich was Tacitus'
*Germania*, and the French invaders were Varus' Roman armies *redivivi*.
His paintings of tombs of ancient heroes, despite the tranquillity of their

settings, were covert calls to the primitive warrior Arminius to rise up in spirit to annihilate the French as he had the Roman legions. Runge, by comparison, was relatively cosmopolitan in his absorption of the classical tradition in his youth and his continued admiration for the British classical sculptor and designer John Flaxman, whose international fame rested on outline illustrations to Homer and Dante. He had learned from Perthes that the spirit also needed to work with reason. His idea of 'Northernness' is altogether more expansive than Friedrich's narrow nationalism, embracing the great geographical span represented by Ossian that gave the mythical northern poet a universality comparable to Homer. Runge's idea of the north undoubtedly has racial and sacramental underpinnings, but his vision of the world is ultimately more open and liberal than Friedrich's obsessive nationalism.

There has long been an unspoken assumption in Britain that the sacramental nationalism expressed in the paintings of Friedrich especially, but also in those of Runge, was distinctively German, or at least un-British. I want to argue that such a thing can be found nonetheless, if with completely different emphases, in the art of two English painters, William Blake and Samuel Palmer. There are intimations of it in Blake's *Joseph of Arimathea among the Rocks of Albion* (illus. 35), but a religious form of nationalism is most fully expressed in the hundred-page illuminated poem *Jerusalem* (1804–20). This work tells the story of the fall of Albion – who stands allegorically for both the English nation and mankind itself – and his prefigured redemption, which is of humanity, nation and the whole universe of creatures from insects to mankind (illus. 36).[52] Albion, who is in a state of abjection throughout almost all of the poem's four sections, his redemption only coming towards the end of the last one, represents the present state of England under the domination of war, materialism and the worship of nature. This contrasts with the impending 'real' world beyond, which for Blake was the world of the eternal spirit. The English are also identified with ancient Israel; following Milton, they – the present-day 'Chosen People' – have fallen into sinfulness and godlessness like their Hebrew predecessors, who ignored the Old Testament prophets with whom Blake claimed kinship.

This sense of the redemptive world not as temporal existence but as a state of mind that can be accessed in the right circumstances at any moment by a human being ('Whenever any Individual Rejects Error & Embraces Truth, A Last Judgment passes upon that Individual'[53]) would certainly have struck a chord with Runge, though he was a pantheist in a way that

35 William Blake, *Joseph of Arimathea among the Rocks of Albion*, c. 1803/10, 2nd state (1st state 1773), engraving.

Blake firmly repudiated; to the latter, the worship of nature was synonymous with surrender to the material world.[54] Blake's ideal for his country was that of 'a people of the spirit', a religious and social community, or *Volk*, but there is no obvious racial or ancestral component to his concept of nation.

Though Samuel Palmer was deeply in awe of Blake's spirituality in his later years, his own was of a different kind. While Blake was always a political radical, and a supporter of world revolution that he hoped would follow from the French Revolution, Palmer thought 'best of the old high tories' and was a consistent defender of the Church of England and its bishops.[55]

William Vaughan has argued that his Toryism was of the benevolent kind, which looked after the peasantry and feared the rise of the commercial classes in the wake of the Reform Act of 1832, but what is beyond question is his loathing for radicals who had supported the French Revolution, and above all for 'Poor, degraded, dishonoured, Atheistical France'.[56]

In *An Address to the Electors of West Kent* (1832), a political pamphlet in support of the Tory candidate Sir William Geary, Palmer makes a particular appeal to 'the Men of Kent' who, he claims, defied William the Conqueror,

36 William Blake, *Jerusalem*, 1804–20, pl. 41, relief etching printed in orange with pen and black ink and watercolour on paper.

urging them to 'Put on once more the invincible armour of Old English, of old Kentish loyalty . . . If we triumph our children will say of us: These were the sacred heroes, who amid the convulsion of the world, serenely held fast.'[57] His ferocity towards the radicals and the French evokes the anti-French writings of German rallying cries against the French invaders, though without the existence of an Arminius figure: 'Leave not your hearths and altars prey to the most heartless, the most bloody, most obscene, profane and atrocious faction, which ever defied God and insulted humanity.'[58]

His other concern is a defence of the Anglican church against the 'Sacrilegious plunderers', whose 'other cause is that of the Devil and his Angels'. Though he does not present a positive vision of society in his political pamphlet, it can perhaps be found in a tempera painting of the same period, *Coming from Evening Church* (illus. 37), which offers an image of an ideal polity derived from the late Wordsworth poem 'The Excursion' of 1814, in particular Book VI.[59] In it a pastor presides over a vision of village life that goes back to time immemorial, in which the church, with spires 'whose silent finger points to heaven' presides over a contented and united community, quite different from 'the thronged abodes of busy men' in the city, in frenzied pursuit of material things.

The painting, like others of Palmer's Shoreham period, is suffused with an otherworldly glow that invokes the spiritual world arising out of nature. In this respect Palmer has something in common with Friedrich, as does his fierce anti-Frenchness and his nationalism, but Palmer's vision is essentially a conservative and nostalgic one, looking back to the medieval past of a church at one with the people. Friedrich, by contrast, glances back both to the age of Luther and Albrecht Dürer and to the elemental age of Arminius. Blake and Runge also look more towards future redemption, but what all four artists have in common is a devotion to forms of nationalism that unite with religion while invoking an ancestral past. In each case there is a strong sense of time – of past, present and future. The past is always a time of unity, whether of the German tribes of the Roman era, Reformation Germany or, for Blake and Palmer, the age of the cathedrals and of Shakespeare in England. The present is a time of struggle, in order to regain that unity, and the future one of personal and national freedom and religious redemption in a fully energized Christian community, lost because of the decadent materialism and power-hungry autocrats and tyrants who have governed both countries since at least the seventeenth century. The artists' common devotion to the spirit is also a repudiation of what were seen to have been the materialistic and atheistic motivations

37 Samuel Palmer, *Coming from Evening Church*, 1830, tempera, chalk, gold, ink and graphite on gesso on paper.

and ambitions of the French Revolution, though of the four painters Blake alone seems to have thought it a necessary stage in the apocalyptic process of human redemption.

Can one discern a racial element in the work and attitudes of the four artists? Arguably it can be found in Friedrich's and Palmer's invocation of a nation that transcends time, suggesting that the 'people' are joined together by descent and blood, and are unchanged in essence over thousands of years, whether between contemporaneous Germanic lands and the age of Arminius in the case of the former, or between present-day English village communities and their forebears going back to early Christianity in the case of the latter. Blake, however, had a strong sense of the different peoples who made up and governed English history, from the Druids to the early Christians, to the domination of the Roman Catholics, and then the Anglican church. Runge is perhaps the most paradoxical of the four. He is, in one sense, the most racially conscious of the four artists. His idea of

the north encompasses a multitude of peoples united by myth, and perhaps by blood, rather than a political nation, yet he seems to lack the militancy and bitter hatred of the French shared by Friedrich and Palmer. In none of the artists is there any direct invocation of biological racism, except in so far as they invoke ancestry; ideas of racial science would have been of little interest to any of them, but the association of nationalism and religion can come close to the racial in its desire to exclude those who are outside the community of true believers.

## 'The Anglo-Saxon Race'

There were three legendary versions of the early history and formation of England and Britain current in the Middle Ages and the sixteenth century. The first to be discredited was the legend, told by Geoffrey of Monmouth in the twelfth century, that Britain was founded and given its name by the legendary figure of Brutus, son of Aeneas, who had made his way to Britain after fleeing the flames of Troy.[60] William Blake, who saw fable as true history, painted in his very earliest period (*c.* 1779–80) a small watercolour, *The Landing of Brutus*, as part of a series on English history. It is listed by Blake in a notebook between suggestions for images (either never made or lost) of 'Giants[,] ancient inhabitants of England' and 'Corineus throws Gogmagog the Giant into the Sea'.[61]

The second legend, also with medieval origins, is that of King Arthur and the Knights of the Round Table, who defended England and Wales against the Saxon invaders. This tale was told in multiple versions by Geoffrey of Monmouth in the twelfth century and definitively by Thomas Malory in the fifteenth century.[62] This legend was revived and popularized in the Victorian period, especially through the poetic versions of Alfred, Lord Tennyson.[63] Arthur and his knights were sometimes described as 'Celts' and associated with Wales, but they stood primarily for chivalric ideals that were eagerly taken up by the Victorian landowning classes.[64]

The third legend, one that has some historical plausibility, is that the 'English nation' or 'Anglo-Saxon race' was descended from the Saxons who invaded England following the departure of the Romans, and who were in turn descended from one of the German tribes described by Tacitus in his *Germania*. The idea of an Anglo-Saxon race – or English-Saxon, as it was called in the seventeenth century – often described in the nineteenth century as a sub-section of the Teutonic race, ties England to the history of Germany, thus differentiating itself from the 'Celtic' countries of Scotland,

Ireland and Wales. It implies that English history only really began not with the Ancient Britons, or with other pre-Roman peoples, but with the Saxon invasion under 'Hengist and Horsa' after the Romans left, and that the Saxon inheritance remained dominant in English life despite the Danish and Norman invasions. This idea remained potent from the sixteenth century until the late nineteenth century, when political rivalry gradually soured relations between Britain and Germany.

The idea of the English as an essentially Germanic people has its source in the early sixteenth-century Protestant Reformation, initiated by Martin Luther's defiance towards the hegemony of the Catholic Church. Henry VIII's break from Rome soon afterwards led to an established national church headed by the monarch, which required not only changes in ritual and observance but a rewriting of its history. One problem for the new Anglican order lay in the inconvenient fact that Christianity in Britain was usually understood to have been first established by a mission sent by Pope Gregory from Rome at the end of the sixth century that achieved the conversion of King Ethelbert of Kent. It became important, therefore, for the new national Church of England to substantiate the claim that British Christianity had a history both earlier than the intervention of the Roman Catholic Church and independent of it.

Long before Henry VIII's break from Rome, the legend emerged of a direct link between England and Christ in the first century AD, through some of the apostles – Joseph of Arimathea in particular – coming to England. Joseph of Arimathea, a wealthy man who was responsible for the burial of Jesus, was incorporated into the legend of the foundation of the Benedictine Abbey of Glastonbury in the mid-thirteenth century, and it was suggested that he had brought with him the Holy Grail, later the object of the quest of King Arthur's knights.[65] This story had the advantage of going straight to source, as it were, giving English Anglicanism and Protestantism a direct line to the Gospels without the Roman church as an intermediary. A further legend claimed that Joseph's visit to Glastonbury was not the first time he had come to England, and on an earlier visit he had brought the infant Jesus with him on his mission.

This story was particularly important to William Blake, who was a fervent Protestant of an individual and passionately anti-Catholic kind. While an apprentice to the engraver Joseph Basire in the 1770s he copied a sixteenth-century Italian engraving after the figure of Joseph of Arimathea in Michelangelo's *Last Judgement* in the Sistine Chapel, adding a setting for the figure on a rocky coast; the only impression of this early state was

recently left by the family of Sir Geoffrey Keynes to the Fitzwilliam Museum, Cambridge.[66] Then, around 1810, he re-engraved the plate, adding the title 'Joseph of Arimathea among the Rocks of Albion', showing Joseph on a mission to convert the pagan inhabitants (see illus. 35).

Blake broadens the meaning of the image in the re-engraved plate by adding a caption that reads: 'This is one of the Gothic Artists who built the Cathedrals in what we call the Dark Ages Wandering about in sheep skins & goat skins, of whom the World was not worthy such were the Christians in all Ages.'[67] Joseph's attempt to convert the heathen Britons becomes an allegory of all true artists' thankless task: converting the public to an understanding of the spiritual world. Joseph was a witness to the earthly fate of Jesus, and his melancholy and inward-looking stance suggest that converting the pagan population of England was a far from easy task. Joseph's missionary work is depicted more directly in a tiny luminous colour print, known only from two impressions in a collection known as 'A Large Book of Designs'. It shows Joseph thrusting his staff into the ground from which a hawthorn tree grew. His congregation is far from passive and exhibits a wide range of emotions, from puzzlement and detachment to spiritual fervour, invoking the public's mixed responses to all 'true art'.

There is a more allusive reference to Joseph's supposed time in England in what is perhaps Blake's most famous poem, popularly called 'Jerusalem' but in fact the preface to *Milton: A Poem*, apparently rejected by him from later printings of the book:

> And did those feet in ancient time
> Walk upon Englands mountains green:
> And was the Holy Lamb of God.
> On Englands pleasant pastures seen!
> And did the Countenance Divine
> Shine forth upon our clouded hills?

This is clearly a reference to the legend that Joseph brought the young Jesus on an earlier visit before he came back with the Holy Grail, a suggestion that would have bolstered Blake's claim in *Jerusalem* that the biblical story had been, and continues to be, re-enacted in Britain: 'All things Begin & End in *Albion's* Ancient Druid *Rocky Shore*.'[68]

BUT HOW DID TACITUS' PICTURE of Roman-era Germany come to be adopted in England, to the extent that the idea that the English belonged to the 'Teutonic', 'Saxon' or 'Anglo-Saxon' races became widespread from the seventeenth century onwards, especially in Victorian England and the United States? It followed from post-Reformation attempts by the English to rehabilitate the Anglo-Saxons, whose period in power followed the departure of the Romans from Britain and lasted through a fragmented England until its conquest by the Norman William the Conqueror in 1066. To fervent Protestants and political radicals like Blake and his fellow millenarians, King William had imposed Roman worship and an alien tyranny, the 'Norman Yoke', on the Anglo-Saxons, who were constructed as a freedom-loving people that had suffered under the tyrannical imposition of the Roman church and the kings they had converted, with the exception of the heroic and patriotic King Alfred.

A number of historians in the sixteenth century, led by Bishop Matthew Parker, began seeking out documents to bolster the idea that the English church and its distinctive forms of worship had a history independent of and preceding Roman intervention, a quest aided by the opening up and dispersal of libraries after Henry VIII's and Thomas Cromwell's dissolution of the monasteries. Bishop John Bale contrasted the Anglo-Saxon church, in its simple piety and apostolic inheritance through Joseph of Arimathea, with the Roman Catholic Church – 'the sinful synagogue of satan'.[69] The late sixth-century mission of Augustine was seen as an attempt to impose a foreign religion on the English, and this was continued by William the Conqueror, who had deliberately kept the native population out of political and spiritual power. This, of course, involved playing down the Viking invasions and simplifying the complexity of British societies between the departure of the Romans, during the divided rule of the Saxon kingdoms, and the eventual Norman transformation.

History also provided for Protestants a less bloodthirsty but otherwise Arminius-like hero in the form of the Anglo-Saxon King Alfred, who was given that role principally by John Foxe in his famous *Book of Martyrs* of 1563. Foxe commended 'the great and singular qualities in this king . . . godly and excellent virtues, joined with a public and tender care, and a zealous study for the common peace and tranquillity or the weal public', implicitly contrasting Alfred with the potentates of the Catholic Church and the autocratic continental rulers who adhered to it.[70]

Though it was understood that an unknown proportion of the population of England in the post-Roman and pre-Norman period was of

Germanic descent through the Angle and Saxon settlers, and that Britain and much of Germany shared Protestant beliefs, it was still a big step to claim common physical ancestry. This was taken in the late sixteenth and seventeenth centuries through a remarkable coming together of German humanists and English historians. The former, beginning with Konrad Celtis (1459–1508), had sought to challenge the domination of Greece and Rome by claiming a glorious past, an equally glorious present and an even more glorious future for the German nation.[71] He republished Tacitus' *Germania* in 1500, and it was to be the foundation document of his claim for a resurrected Germany. From then on *Germania* became essential to German nationalism and resistance to outside culture. Its seductive view of a manly, incorruptible German nation, seeking to free itself from the alien domination of sybaritic, tyrannical and impious peoples, was upheld by Luther and by Ulrich von Hutten, who had helped to publicize the fact that the famous document the Donation of Constantine, the written foundation of the papacy's political power, was discovered to be a forgery in the fifteenth century.[72] Luther traced the ancestry of the Germans back to Adam and Eve and proclaimed the superiority of the German language over all others.

It was only in the late sixteenth century that the idea of a common ancestry between English and Germans came to the fore, though the seed was planted by German humanists who had been involved in intense conversations with their English counterparts in the early part of the century. William Camden (1551–1623) first made a direct ancestral connection between the English and the Germans in his book *Britannia* (1586), which concentrates on the period between the advent of the Saxons and the coming of the Normans. The book describes the 'English-Saxons' as achieving an 'entire and absolute' victory over the previous inhabitants of England. As it happens, he knew Tacitus' *Germania* well – he was a friend of its translator Sir Henry Savile – and his view of the Anglo-Saxons was closely based on Tacitus' account of the Germans.[73] He also claimed a German derivation for the English language, noting that the 'English-Saxons' were demonstrably the same kind of warrior people, 'impatient of servitude, lovers of liberty, martiall and courageous'.[74]

But Camden did not state unequivocally that Tacitus' Germans were the *physical* ancestors of the Anglo-Saxons. It was Richard Verstegen (*c.* 1550–1640), a journalist, Catholic apologist of Dutch ancestry and the author of *A Restitution of Decayed Intelligence in Antiquities, Concerning the most noble, and renowned English Nation* (1605), who fully

proclaimed the ancestral connection, noting 'what a highly renowned and most honourable Nation the Germans have always been, that thereby it may consequently appear how honourable it is for English-men to be from them descended'.[75] His admiration for the Germans was again based on Tacitus; he claimed that no one but Germans had ever inhabited Germany: they had never been defeated or occupied, and had never interbred with foreigners.

Furthermore, he claimed that the present-day English were still essentially Anglo-Saxon, despite the Danish and Norman invasions: 'The main Corps and Body of the Realm . . . hath still consisted of the ancient English-Saxon people, wherein even unto this day it doth yet consist.'[76] As relations between the English king and parliament worsened in the seventeenth century, the division was increasingly seen in terms of a conflict between the royal and aristocratic descendants of the Norman conquerors and the liberty-loving people of Anglo-Saxon descent who had been responsible for the original English parliament – the Witenagemot – which, it was claimed, severely limited the king's powers. Despite these claims, Verstegen was not a Protestant but a proselytizing Catholic, who was clear that Christianity was brought to England by Augustine in the late sixth century.

Verstegen also provided a foundation myth for 'the English-Saxon people'. The titlepage image of the *Restitution* shows the dispersal of peoples from the Tower of Babel, and an illustration in the book shows 'The Arrival of the first Ancestors of English-men out of Germany into Britain'.[77] Two heavily armed warriors – one of whom is Prince Hingistus (that is, Hengist), the other being Horsa – arrive on shore, with their fleet behind them. Verstegen also claimed that twenty years previously invaders from a neighbouring and very similar people to the Saxons, from 'Frankenric', had come to France, 'the country of the Gauls', and taken possession of the kingdom as 'Franks'.

Verstegen's text bore unexpected artistic fruit in a remarkable series of seven full-size marble statues of the Saxon gods, representing the days of the week, by the great Flemish sculptor Michael Rysbrack. They were installed as a 'Saxon temple' in the grounds of Stowe about 1730, as part of a series of temples to, among others, 'British Worthies', 'Ancient Virtue' and the 'Gothick Temple', dedicated to 'The Liberty of our Ancestors'. The Saxon temple was moved around the gardens a number of times, and the statues were dispersed after the Stowe sale in 1921, but were gradually rediscovered in recent years and are now in a number of museums and other locations, including two in the Victoria and Albert Museum (illus. 38).[78]

38 Michael
Rysbrack, *Sunna*,
*c.* 1728–30,
Portland stone,
formerly at Stowe.

The gods are clearly derived from engravings in the many editions of the
*Restitution* that were published in the seventeenth century (illus. 39–45).
The sculptures were conceived as part of an elaborate scheme to fill the
gardens with temples and sculptural groups that promoted the political
ideology of Richard Temple, 1st Viscount Cobham, a committed Whig
landowner in opposition to the then prime minister Sir Robert Walpole.
The sculpted Saxon gods represent a Whig appropriation of ancient British
liberty embodied by the Anglo-Saxons, which was supposedly repressed
by the present tyrannical government that continued to impose the 'Norman
Yoke' on the people of Britain. According to Gilbert West, a kinsman of
Cobham, writing in 1731, the statues are

> Gods of a Nation, valiant, wise and free,
> Who conquered to establish Liberty!

39–45 The principal deities of the Saxons, from Richard Verstegen, *A Restitution of Decayed Intelligence in Antiquities, Concerning the most noble, and renowned English Nation* (1634).

To whose auspicious Care Britannia owes
Those Laws, on which she stands, by which she rose.[79]

This adoption of the Germanic gods as part of a patriotic scheme speaks
to the way that the idea of British descent from Germanic ancestors had
been absorbed into early eighteenth-century politics. It partly followed
from the offer of the throne of Britain to a Protestant Hanoverian, King
George I – 'a prince of our own blood' – in 1714, over the superior dynastic
claims of more than fifty Catholic pretenders to the throne.[80] It led to the
choosing of wives for British kings and a husband for a queen, as well as
for other members of the British royal family, from the Protestant prin-
cipalities of Germany – a tradition that continued well into the twentieth
century. The idea of the inherited genius of the English as a free Germanic
people became commonplace by the mid-eighteenth century; even
Montesquieu believed in the Saxon role in the foundation of British lib-
erty through the invention of parliament and the curtailing of royal power,
also claiming that in Anglo-Saxon times the king ruled only as *Dux
Bellorum* (war leader), and not by divine right.[81] Such ideas were taken
for granted by Hume and Gibbon, and even Thomas Jefferson, who was
very interested in the Anglo-Saxons as a liberty-loving people. He claimed
the authority of Saxon forebears for the American revolt against British
rule, which he saw as imposing the Norman yoke on free colonial
subjects.[82]

The first nineteenth-century author to argue for the virtues of Anglo-
Saxon ancestry was Sharon Turner in his influential *History of the Anglo-
Saxons*, published between 1799 and 1805. Turner asks: 'Why should he
then despise the first state, and the improving progress of his Saxon ances-
tors?' and answers by claiming that 'This nation exhibits the conversion
of ferocious pirates, into a highly civilized, informed, and generous people
– in a word, into ourselves.'[83] With Britain's extraordinary commercial and
political success in the nineteenth century, the idea of the British, or rather
the English, as the 'chosen people' – already proclaimed by such earlier
radicals as John Milton and William Blake – gathered apace, and is
expressed succinctly in Martin Tupper's doggerel verse of 1850: 'Break forth
and spread over every place/ The world is a world for the Saxon race.'[84] The
idea that the Saxons or Anglo-Saxons constituted a race became widespread
in the nineteenth century in Britain and the United States, to the point of
being a truism. Dozens of books, school speeches and commencement
addresses to u.s. colleges proclaiming the Anglo-Saxon race's superiority

were published and delivered, often in a hysterically triumphalist tone. The chief promoter of the Anglo-Saxon race in the United States was Ralph Waldo Emerson, who had learned much from the Germanophile Thomas Carlyle, who saw the German people through the eyes of Tacitus: '[they are] the only genuine European people, unmixed with strangers. They have in fact never been subdued . . . this fact at once demonstrates the masculine and indomitable character of the race.'[85]

Emerson picked up, ultimately from works influenced by Tacitus, the idea of German forebears passing on to the present-day English and Americans their physical characteristics.[86] Nonetheless Anglo-Saxonism did not prevail in all sections of society in Britain. It was challenged or side-stepped in royal and aristocratic circles that chose to see the Norman Conquest as a kind of civilizing mission that brought chivalry and the benign power of the landowning class to the whole of Britain. They preferred a version of the history of England between the departure of the Romans and the advent of the Normans that relied on the legends of King Arthur and the Knights of the Round Table, and on the conversion of England by the papacy.

The Arthurian legends at first seem completely opposed to the idea of the Anglo-Saxon race. In Malory's fifteenth-century account Arthur was a British king, more Celtic than Saxon, who fought *against* the Saxon invaders. The whole ethos of his court depended on chivalrous and loyal aristocrats grouped around a monarch, which was entirely at odds with the more democratic parliamentary ideal associated with the Saxon Witenagemot. In the 1840s the political group Young England, under the intellectual leadership of Benjamin Disraeli, then best known as a novelist, sought social reform by invoking in Arthurian terms the paternal and chivalric rule of the great English landowners.

From the 1840s onwards the impact of the Arthurian legends was rather greater on art than it had been on the wider English society, largely through Alfred, Lord Tennyson – whose influential Arthurian poems appeared from the 1830s to the 1880s to great acclaim – and through the influence of Prince Albert on the ambitious and ultimately inconclusive scheme to decorate the recently completed Houses of Parliament with wall paintings throughout the Gothic Revival interior.[87] Perhaps the most artistically successful of the finished wall-painting groups is the Queen's Robing Room, entirely painted by William Dyce with wall carvings by Henry Hugh Armstead, on the subject of the court of King Arthur (illus. 46). It was Prince Albert's idea to make the Arthurian legends the subject of the scheme, and Dyce

46  William Dyce, *Hospitality Admission of Sir Tristram to the Round Table*, 1864, fresco, Queen's Robing Room, Houses of Parliament, London.

eventually painted seven scenes, making the first public series of paintings based on Malory's account of the court of Camelot.[88]

The paintings themselves follow Dyce's suggestion to Albert that the Arthurian legend was a fitting equivalent to the *Nibelungenlied* in Germany. Dyce's idea was that 'the Companions of the Round Table [should be] personifications of certain moral qualities ... which make up the ancient idea of Chivalric greatness,' an idea fitting the purpose of the Queen's Robing Room, where Queen Victoria prepared her ceremonial self to address the nation in parliament.[89] The success of the Robing Room combined with Tennyson's Arthurian poems led aristocratic and royal circles to swing towards Camelot and away from the forests of Germany.

The process of decorating the Houses of Parliament began in the 1840s and continued into the twentieth century, but in the enormous scheme only a small minority of paintings are devoted to the Anglo-Saxon period. One reason is that much of the decorative painting was devoted to the House of Lords, which inevitably favoured chivalric subjects from the post-Norman period. The Anglo-Saxons appear in the larger scheme not as descendants of German tribes but as harbingers of liberty and the rule of law under King Alfred, despite Henry Hallam's plea that they 'should form a link in the sequence of causation and not be merely episodic.'[90] Among the subjects suggested in both the preliminary competition of 1841 and for the actual decoration of the Houses of Parliament was one based on the idea, already thought by many to be dubious (Macaulay

attributed it to the Vikings), that trial by jury had been invented by Alfred the Great. The subject of *Alfred and the British Jury* was attempted by Benjamin Robert Haydon, and the unfinished canvas was on the easel above his body after he committed suicide in June 1846, leaving only an oil study of the accused maiden on an adjoining easel.[91] C. W. Cope was awarded a £300 premium for the same subject, and his painting was among the most admired of the works submitted.

Artists and the commissioners also proposed pre-Anglo-Saxon scenes, such as George Frederic Watts's *Caractacus Led in Triumph through the Streets of Rome*, known from fragments of the cartoon in the Victoria and Albert Museum and an engraving; Edward Armitage's *The Landing of Caesar*, and J. C. Selous's *Boadicea*.[92] *The Baptism of Aethelred*, commemorating the papal conversion of the Anglo-Saxons, was assigned to William Dyce, but virtually all Anglo-Saxon subjects involved King Alfred, who represented the continuity of the monarchy.[93]

One reason that the Anglo-Saxon version of British history had relatively little impact on the most extensive painted series of historical scenes of the Victorian era was Prince Albert's role in choosing the works for the whole scheme, as chairman of the committee. He clearly took the view, despite his own German ancestry, that the Normans who settled in England were not alien invaders but direct ancestors of the current monarchy and aristocracy, who had inherited the traditions of Arthurian chivalry. Still, the ancestral connection with the Saxons through King Alfred clearly had some resonance with Queen Victoria, who commissioned a full-size memorial marble sculpture of Albert departing from her mourning self from William Theed in 1867, in which the former is wearing what was identified as Anglo-Saxon dress. This year was perhaps the *annus mirabilis* of Victorian Anglo-Saxonism, with the publication of Charles Kingsley's *Hereward the Wake, Last of the English* and E. A. Freeman's *History of the Norman Conquest*, which 'traced a direct line from Teutonic tribes to the Victorians'.[94]

Despite Malory's identification of Arthur as the enemy of the invading Saxons, and Edward Bulwer-Lytton's influential picture of him as a Cymrian king of the 'Dragon race' deriving from South Wales,[95] there were attempts in the Victorian period to find a place for the Saxons in the national story – not as a people of unmixed blood but as an element of the mixed ancestry of the present-day English. Sir Walter Scott's *Ivanhoe* (1820) is about the scion of a Saxon family living well into the Norman period. The larger theme of the book is of the ultimate reconciliation of the defeated Saxons and the victorious Normans, one that had a remarkable resonance

in the southern states before and after the American Civil War.[96] In Charles Kingsley's work we find a celebration of the blending of nations or races, with each contributing to the evolution of a sturdy national mix. As Tennyson proclaimed in his poetic welcome to Princess Alexandra of Denmark: 'For Saxon or Dane or Norman we,/ Teuton or Celt, or whatever we be,/ We are each all Dane in our welcome of thee,/ Alexandra!'[97]

George Frederic Watts: Having It All Ways

But was there a national/racial element in the turn towards Arthur as there had been with the Anglo-Saxons? I want to try to answer that by looking briefly at the career of George Frederic Watts (1817–1904), who was fully involved in ideas of the present-day nation. Watts knew and had opinions on the 'great men' of his day, producing *The Hall of Fame*, a series of portraits of his most famous contemporaries, which he presented to the National Portrait Gallery in London.[98] He was particularly devoted to humane causes, and was known to be an intellectual scavenger par excellence, who espoused simultaneously, creationism, humanitarianism, kindness to animals and birds, anti-materialism, Nietzschean ideas of heroism, Hellenism, evolution, patriotism, imperialism, Anglicanism and mysticism. He was the very opposite of such monomaniacs as Robert Knox, but for that reason perhaps more representative of the intellectual tenor of the Victorian period, which his career spanned.

Watts's interest in the Anglo-Saxons was expressed not only in his promotion of King Alfred, but in a hauntingly mysterious painting, *The Saxon Sentinels* (c. 1840, illus. 47). It is an early work of the painter's, at the time he was moving from realism to a more symbolic vision, and it may be connected with his heroic battle painting of the same period *Alfred Inciting the Saxons to Prevent the Landing of the Danes*, made for the Houses of Parliament. The mood of the former painting is quite different from the latter. It is contemplative, showing two men – one mature, the other young – at a moment of rest while defending the coast against invaders. It has an elegiac, even ominous, feel to it, suggesting the two are fearful and resigned to being overwhelmed by the superior seaborne force of the Vikings.

What little we know of the painting comes from his biography by his wife, Mary Watts.[99] It was painted at Dorchester House and, according to Mary, had an unfinished companion piece called 'Bayard and Aristides', a title which appears to pair a Renaissance warrior hero and an ancient Athenian statesman. There is a sketchy watercolour drawing inscribed

47   G. F. Watts, *The Saxon Sentinels*, c. 1840, oil on canvas.

with these names in pencil, currently in the Whitworth Art Gallery in Manchester, which shows two figures who do indeed correspond to the title: the one in armour is identifiable as Bayard, while the other, a sage in a toga, is clearly Aristides.[100] This suggests an allegorical painting of ancient heroes representing different virtues, quite different in genre from *The Saxon Sentinels*; thus, the connection between the two must have been due to a misunderstanding on the part of Watts's wife.

That Watts was also interested in the physical typology of the Anglo-Saxons is evident in his painting *A Fair Saxon* of 1868–70 (illus. 48), a portrait based on his favourite model, 'Long Mary', who is shown in his

48  G. F. Watts, *A Fair Saxon*, 1868–70, oil on canvas.

depictions of her as a severe figure, and whose 'noble proportions' were an inspiration to the artist. The title of the painting and its sitter seems to imply that Long Mary represented the continuity of the English female type from its Saxon origins.

There are also notable Arthurian paintings by Watts, the most famous being *Sir Galahad*, which was exhibited at the Royal Academy in 1861 (illus. 49). The model was Arthur Prinsep, who was wounded in the Indian Mutiny and who represented for Watts dignity and chivalry, 'the characteristics of the gentleman', echoing Tennyson's description of King Arthur as a 'gentleman of stateliest port'. Galahad was morally the purest of the Knights of the Round Table and the one privileged to find the Holy Grail; in the words Tennyson's gave to him: 'My strength is as the strength of ten,/ Because my heart is pure.'[101] The painting depicts the moment of epiphany when Sir Galahad first catches sight of the Holy Grail, after an arduous struggle beset by many dangers.

Watts had an elevated social purpose for a large version of the painting, which he presented to Eton College in 1897 to be hung in the chapel, in the fond hope that the boys would pass it on their way to daily prayers (as they still do) and – improbable though it might seem in the light of one more recent pupil of the school – learn from it the necessity of virtuous struggle to achieve their ultimate rewards. According to James Burns, writing in 1915 evidently without irony,

> the great artist['s] sole aim in art was to impress us with spiritual realities, in presenting this picture to Eton College. For there are gathered many of the youth of our great Empire who in coming generations are to guide its destinies. In these early and formative days young eyes look out upon life with wistful questionings, and young hearts receive their lasting spiritual impressions. It is then that the great decisions are made, and it is upon the nature of those decisions that the future character and stability of our Empire depend.[102]

Though those words are not Watts's, they conform to what is known about his commitment to the British Empire, and his hope that the ruling elite would run it through a sense of duty akin to Arthurian chivalry. But the physical ideal represented in his picture of Sir Galahad is more Grecian than anything else. The figure of Galahad, despite being covered in medievalesque armour, is close in its gentle youthful spirit to the *Apollo Belvedere*, as

is his perfectly straight profile, which corresponds broadly to the ideal typology established by Camper. His virtue is expressed not in his trappings or attributes but in his perfect physical form, which reflects his inner piety and virtue. His epiphany at the sight of the Holy Grail seamlessly combines patriotic and Christian sentiment, which Watts hoped will, through Galahad's example, prevail over the materialist tendencies of the present-day nation.

The idea that art, religion, patriotism and culture in general were threatened by materialism is a constant theme in his art and his writings, which were gathered and republished by his widow, Mary Watts.[103] They demonstrate the painter's adherence to older ideas of race and nation, combined with a belief in Darwinian evolution. His traditionalism is clear from his adherence to the spiritual division between northern and southern nations, and the division of peoples according to climate theory: 'The less perceptive, though perhaps more imaginative people of the north, who derive their conceptions more from habits imposed by an ungenial climate, from mists and darkness, display an inbred fancy and a grotesque arrangement of thought.'[104] Or, as he put it more pithily, 'Art, child of leisure and the sun, has never yet come to its full growth in our cold and cloudy north,'[105] arguing, perhaps unusually for his time and place, that the south was the natural home for the highest form of art: 'the birthplace and natural dwelling-place of art must be in a land of sun and leisure'; in other words Greece and also Italy, stressing particularly the importance of sunlight.

This idea recalls an eighteenth-century debate initiated by Johann Joachim Winckelmann, who denied the idea that a truly noble art was possible to achieve in a northern climate, because it was impossible for painters to study the unclothed human body in normal daily life as they could in a warm country like Greece.[106] But Watts's own desire for a great national school to compare with ancient Egypt, Greece and Renaissance Italy was under threat not only from the climate, but from the conditions of the modern age that were unfavourable to art.[107] British society, he claimed, was ruled by hard-headed practical men: 'the age is analytical and unsatisfied . . . Machinery is the most deadly foe to art and beauty.'[108] A sense of beauty was passing away, confronted by the ugliness of modern life. For those reasons British art was not up to the highest level, a victim of the philistinism of the present day.

But there were still grounds for hope, though Watts was equivocal about the Britain of his time. 'Let us be proud, but proud with anxious sense of responsibilities that make demand for the active exercise of all the

49  G. F. Watts, *Sir Galahad*, 1860–62, oil on canvas.

50  G. F. Watts, *Progress*, 1888–1904, oil on canvas.

highest qualities of human nature,' remembering that 'Her race, language, and institutions are spread over the whole habitable world,' and 'With all our faults . . . [the British are] a people [of] earnest and even noble aspiration, [endowed with] superabundant national energy.'[109] He also notes that 'We cannot question the progress of civilization, for it is easy to point to conquest over inferior races, impatience of injustice, and extension of sympathy, but . . . progress is not all clear gain. It destroys as well as constructs.'[110]

Despite these caveats, Watts still claimed to believe in progress and evolution – 'I trust in progress and believe in progress, the most liberal of all principles'[111] – painting in his last years a picture entitled *Evolution* (1898–1904), though its connection to Darwinism is opaque. More to the point is his painting entitled *Progress* (1888–1904, illus. 50), which shows an ideal male figure on horseback, carrying a bow and breaking through the sun's radiance. Beneath on the ground are three figures representing the intellectual passivity and materialism of the age inimical to progress: one old man absorbed heedlessly in a book while another digs with his hands in the ground, and a young man, looking towards the horseman, who represents hope for the future – if he can rouse himself from his indolence. At the same time Watts advocates looking back to the age of chivalry: 'Chivalry was infinitely gracious, not unpractical, nor in any way inimical to the Christian faith.'[112] It follows that great nobles 'must again become the leaders', and that 'Classes are not a bad thing, being natural. Classes will in reality exist till doomsday.'[113] Politically he appears to have been a Tory of the Ruskinian kind, combining chivalry with concern for the aesthetic life of the common man.

Watts says nothing about his own race, though his hero worship of King Alfred and his adherence to chivalry suggest that he sought to combine Arthurianism with an Anglo-Saxon identity. Mrs Russell Barrington speculated that he had a Celtic temperament, but also a Slav-like character, being patient, melancholy and secretive, with a taste for mysticism like the Russian composer Tchaikovsky.[114]

The idea for Watts's huge sculpture *Physical Energy* (c. 1880–1902, illus. 51) essentially derives from the painting *Progress* and had a similarly elevated purpose, concentrating this time directly on what was the central motif of the painting. It began life as a commemoration of the medieval Hugh Lupus, Earl of Chester, on horseback, commissioned by his descendant the 3rd Marquess of Westminster for the ancestral home Eaton Hall in Cheshire in 1870. The theme was 'the human will bridling in brute

51  G. F. Watts, *Physical Energy*, erected 1907, bronze, Kensington Gardens, London.

force' represented by the lively horse. The periodical *Athenaeum* describes presciently, in words that might have come from Watts himself, its 'world-subduing energy which conquers savagery and compels civilization'.[115] In *Physical Energy*, once freed from the commission, Watts reconceived the man on horseback not as a historical figure but as a youth, 'a symbol of that restless physical impulse to seek the still unachieved in the domain of material things', contrasting physical with intellectual energy but also incor-porating it. The man is looking ahead and beyond the present towards his next achievement. It was intended by Watts to be like his 'symbolic pic-tures', a national image influencing the nation.[116] He worked on the full-size plaster model on and off for many years, finally offering to the nation a bronze version in 1898, a second cast of which was eventually installed in Kensington Gardens, where it remains.

Later in the same year, when Watts was still working on the full-size model, Cecil Rhodes, the imperial exploiter of southern Africa, saw it in Watts's studio and was greatly impressed by it.[117] Watts, though equivocal about Rhodes's form of imperialism, had a Carlylean reverence for 'Great Men', and it is this that led him eventually to become, at first a little un-willingly, a fervent admirer of Rhodes, despite his own and his wife's humanitarian and Ruskinian views. Mary Watts remembers that initially her husband was quite wary of Rhodes and cast doubt on the imperial project, arguing that the 'supremacy of civilized man' was only achieved

by acting like 'the primitive savage'.[118] Even so, Mary seems to have been the less sympathetic of the two to Rhodes's ambitions in Africa.

Rhodes's first intention for a version of *Physical Energy* was that it should not be a monument to himself but to his hugely ambitious project for a Cape to Cairo railway. Lord Grey proposed that Watts make the rider resemble Rhodes, an idea successfully resisted by the sculptor. After Rhodes's death in 1902, Grey suggested to Watts that a version of the sculpture should be part of Rhodes's memorial in the Matopo Hills. Watts replied affirmatively, stating that the sculpture would be 'an emblem of the energy and outlook so peculiarly characteristic of him'.[119] As he noted on Rhodes's death, 'He was a great man even though making mistakes & perhaps to make mistakes I believe [King] Alfred himself could make mistakes in an age so full of complications as ours.'

We need not doubt that Rhodes himself was a proud member of 'the English race' at its most expansionist. In his will he proclaimed: 'I contend that we are the first race in the world, and that the more of the world we inhabit the better it is for the human race. I contend that every acre added to our territory means the birth of more of the English race who otherwise would not be brought into existence.'[120] Nor can we doubt his imperialist activities in southern Africa, or his confidence in Britain's right to exploit the land and mineral wealth of the continent, while dispossessing any Africans who stood in the way.

But what of Watts's beliefs and the role of *Physical Energy* as a monument to Rhodes? Whatever reservations the sculptor may have had when he met Rhodes, it is clear that he was won round to the idea of a monumental celebration of him and embraced it fully after the latter's death. Watts described the sculpture as 'my unfinished work to commemorate poor Rhodes's unfinished work', and he was very happy to have it placed in the Matopo Hills, facing in the direction of Rhodes's projected railway to Cairo, though in the end it was brought back to become part of the Rhodes Memorial completed in 1912 outside Cape Town.[121] Watts also said to Lord Grey that 'My statue is intended as an emblem of the energy & outlook so peculiarly characteristic of him,' but he avoided making a moral comment on Rhodes.

Watts's final withdrawal of his reservations about Rhodes's imperial ambitions for Africa is clear from an essay he wrote for the May 1901 edition of the periodical *The Nineteenth Century and After*, reprinted by Mary Watts, entitled 'Our Race as Pioneers'.[122] Though Rhodes is not mentioned by name in the essay, it is about southern Africa and is directed against the Boers, who are seen as a primitive pastoral people who have no business

grabbing land in Africa. Watts's grievance against the Boers is not that the land has been stolen from Africans, however, but that it has been stolen from the British, who, according to Watts, have an earlier, stronger claim to ownership of much of southern Africa. Stephanie Brown has argued that the essay was not an expression of imperialist beliefs because Watts excoriates the Boers not Africans, but that is disingenuous; he was implicitly arguing for the rights of Britain rather than the Boers to exploit African land and dispossess its inhabitants.[123] I have a similar reservation about the same author's suggestion that the sculpture cannot project 'whiteness' because it is not itself white in colour.

Brown's argument is clearly directed against Michael Hatt's essay on sculpture and the Victorian nude in the Tate catalogue of the exhibition 'Exposed: The Victorian Nude' (2002), which boldly asserts that 'Race and ideal sculpture are inseparably wedded to each other . . . western notions of bodily beauty did not simply carry aesthetic notions to other parts of the globe, but were coded ways of disseminating the racial hierarchy.' He gives *Physical Energy* as an example, noting that the sculpture's 'presence in Cape Town not only commemorates the act of colonisation and the recent events of the Boer War, but also purports to explain these phenomena'. This is undoubtedly true as an account of the sculpture's presence in Africa, and, if considering 'Our Race as Pioneers', there is no doubt that Watts himself would have consented to such a reading; however, Watts's own motives for creating it in the first place were more complex.

Watts was not, in fact, blindly loyal to all that Rhodes stood for. As we have seen, he had long been a critic of his compatriots' pursuit of materialism, but he did, under the influence of his reading of Darwin and other evolutionary thinkers of the time, believe profoundly in the idea of man and nations as energetic forces, and that this energy was a regrettable necessity for their progress and the triumph of civilization. As he put it in 'Our Race as Pioneers': 'In our ever probing onward, seeming to be so absolutely selfish, we, the English people, are perhaps the agents of the great law – Movement, Progress, Evolution.'[124]

If this chapter has demonstrated one thing, it is an obvious one: ideas of race are very often contingent on the political situations and intellectual conflicts of their time. German bitterness against the Napoleonic invasions fuelled a sense of German virtue and exceptionalism. The British imperial project created a need for its supporters to justify the seizure and exploitation of distant lands and their peoples by defining their settled populations as savages who were incapable of aspiring to human rights.

Race's boundaries with ideas of nation are particularly porous, and they can vary greatly both within and outside it. Counter-intuitive though it seems to us in the twenty-first century, ideas of race can also be more expansive than ideas of nation, encompassing, for example, the Nordic and Germanic countries, rather than a narrower focus on, say, the nations of England or Germany. Race in the nineteenth century can define itself by claiming rigorous and undefiled descent from a single tribe that has always procreated entirely within itself over millennia, or it can take pride in being a 'mongrel race' of mixed descent, deriving positive attributes from a variety of foreign invaders and settlers. If Disraeli, following Blumenbach, offers the most expansive view of the Caucasian race as encompassing Europeans, Jews, Arabs and Turks, then the narrowest can be found among those in Germany who took Tacitus' account most literally.

In the nineteenth century art and visual culture gave form to such speculations by presenting them in terms of ideal human representation and the possibility of redemption, but also in images of abjection. Images are perhaps at their most powerful and insidious when they claim to allow nature to tell the tale, but ideas of nation or race can be so much more affecting when they are naturalized by intimations of the divine, as they are in the work of Friedrich, Runge, Blake and Palmer, and perhaps even in the work of Watts.

# PART III

# ANCIENT EGYPTIANS, JEWS AND THE MODERN RACE

# 5

# Egypt's Land: Racial Determinism and the Art of the Ancient World

Race is everything: literature, science, art – in a word, civilization depends on it.
ROBERT KNOX, *Races of Men* (1850)

So conclusive is the recent evidence drawn from the monuments of Egypt and other sources, in support of the permanence of distinctly marked types of mankind, such as the Egyptians, Jews, Negroes, Mongols, American Indians etc., that we presume that no really well-informed naturalist will again be found advocating such philosophic heresies [as the belief that climate could account for the endless diversity of races].
J. C. NOTT AND G. GLIDDON, *Types of Mankind* (1854)

The early 1850s saw the rise among a few influential individuals of a more stringent racial determinism than had been seen hitherto in Britain and the United States. This was not unconnected with the move towards civil war in the United States, which gave a particular urgency to the need of the Confederate states to come up with an intellectual justification for their dependence on slave labour. It was also connected with the need to make sense of the problems in the British Caribbean colonies in the years after the ending by the British government of a slave-based economy in the late 1830s. Among the major assumptions shared by all those who became involved in racial science in the 1840s and '50s, on both sides of the Atlantic, was the idea that racial difference was a matter of biological inheritance, constant through the ages, and that environment and climate had a minimal effect on racial character. These might seem to lead inevitably to a polygenist position – a belief in the separate creation of each race, as opposed to the idea of 'the Brotherhood of Man', usually taken for granted

by all who claimed to be Christian. But in fact, the most prominent British racial determinist, Robert Knox (1791–1862), was a monogenist, believing in the common ancestry of all races (though he does not argue for it on Christian or creationist grounds).

## Robert Knox: 'Race Is Everything'

The monogenist position remained dominant in Britain throughout the first half of the nineteenth century, largely through the prestige of James Cowles Prichard (1786–1848), who was a passionate believer in mankind as a single species and in the biblical account of Creation. This meant that he became in later life a figure of ridicule in some quarters, for trying to reconcile his account of mankind's origins with the traditional chronology defined by Bishop Usher in the seventeenth century, which assumed the world to be only some 6,000 years old. He and the American ethnologists tended to hold out against the new geology that emerged in the late eighteenth century – and ran counter to the biblical story of Creation – which demonstrated that the world was many millions of years old and its existence had for an almost infinite stretch of time preceded the advent of human beings.

Prichard's thought evolved through the many editions of his great work *Researches into the Physical History of Man*, from the first edition of 1813 to the final volume added in 1847, moving from an aesthetic to a climatic and hereditarian position.[1] He took skull measurement seriously, but made cogent objections to Camper's profiles, preferring Blumenbach's emphasis on the skull seen from above and Richard Owen's comparison of skulls seen from 'the basis of the skull, or the under surface of the cranium'.[2] He also objected to Camper's simple identification of one skull with a unitary African 'race', noting the variety of Africans:

> The prognathous form of the skull is most strongly developed in some of the tribes of Western Africa. It prevails in a less degree in many of the native African tribes, who are commonly termed Negroes, but is by no means universal among the nations so named, if the designation is used as comprehending all those people of the African Continent who combine frizzled and crisp hair with a sable skin.[3]

Prichard's monogenism was challenged in 1818 by William Lawrence, who declared prophetically: 'I design . . . to consider man as an object of zoology',[4] and by Samuel Morton, whose *Crania America; or, A Comparative*

*View of all the Skulls of the Various Aboriginal Nations of North and South America* (1839) also contained a supporting appendix by the famous English phrenologist George Combe. Both of these authors argued for the biological separation of the races, but it is worth restating that polygenists did not necessarily reject entirely the biblical account of Creation, nor did creationists always reject skull comparison.

John Addington Symonds noted that Prichard 'had no decided aesthetical tendency, no such sensibility to the beautiful as would lead him to dwell on the enjoyments of poetry and the fine arts'.[5] But Prichard did highlight the role of 'taste' in a way that prefigures Darwin's idea of sexual selection, as discussed in the latter's *Descent of Man*. This is clear from his eccentric theory that 'the primitive stock of men were Negroes' who gradually turned white once the process of civilization set in, because, as they acquired a 'better taste', so they began to prefer light-skinned spouses over darker ones.[6]

Knox's *Races of Men*, which appeared in 1850, inaugurated a new era in the development of racial theory, based on an uncompromising rejection of Prichard's and others' arguments for the unity of mankind. It is in many respects an exasperating and ill-organized work, put together from a series of lectures, often mixing glib generalizations with anecdote. Yet Darwin took it seriously and cited it a number of times in *The Descent of Man*.[7] Knox embraced fully a biological view of mankind, emphasizing at all points racial difference rather than common humanity. To him and to contemporary American ethnologists, race was not, as it was to Prichard, a fluid product of climate and society. Rather, it was applied to a congeries of permanent collective entities that could nonetheless wax and wane through contact and intermingling with other races – though he claimed that mixed races could not sustain themselves for long.

Using his notorious catchphrase 'Race is everything' (repeated in different forms throughout the first chapters of *Races of Men*) as an intellectual battering-ram, Knox effectively took over the field of race from Prichard, moving it towards strictly biological, comparative anatomical and craniological approaches, which became an ever stronger presence in British intellectual life, despite there being some resistance from Richard Owen, Thomas Huxley and eventually Charles Darwin.

Knox is in all sorts of ways a paradoxical figure. The absoluteness of his views on 'the all-pervading, unalterable, physical character of race' puts him on the extreme edge of the most racially conscious thinkers of his age. His views on race make no concessions to the ideas of human brotherhood

that were fundamental to Prichard and most of his generation, and also to the enlightened natural scientists of the previous century, such as Georg Forster. Knox's reification of race puts him on the same part of the spectrum of belief in the value of heredity as ideologues of the Third Reich.[8] However, he was firmly anti-slavery and anti-imperialist, taking a cynical view of the hypocritical claims of the Anglo-Saxon race, and particularly of European imperial intervention in Africa: 'A wish to serve Africa forms the excuse for an expedition to the Niger, the real object being the enslaving [of] the unhappy Negro, dispossessing him of his lands and freedom. I prefer the manly robber to this sneaking, canting hypocrisy, peculiar to modern civilization and to Christian Europe.'[9]

Like many others Knox despised the Anglo-Saxon race's devotion to utility and materialism, and decried its lack of imagination. Though he falls back on the usual tropes of the period of Africa's lack of culture and history, he expresses admiration for 'the Negro's' qualities and resilience, which he believes would enable them to repel Africa's invaders:

> If there be a dark race destined to contend with the fair races of men for a portion of the earth . . . it is the Negro. The tropical regions of the earth seem peculiarly to belong to him; his energy is considerable: aided by a tropical sun, he repels the white invader. From St. Domingo he drove out the Celt; from Jamaica he will expel the Saxon; and the expulsion of the Lusitanian from Brazil, by the Negro, is merely an affair of time.[10]

As someone who had spent time in Africa, Knox is particularly hostile to the Dutch Boer's 'contempt and inward dislike to the Hottentot, the Negro, the Caffre; ask him for his warrant to reduce these unhappy races to bondage and to slavery; to rob them of their lands, and to enslave their children; to deny them the inalienable right of man to a portion of the earth on which he was born?'[11] But his anti-imperialism does not soften his absolute belief in the separation of races; he argues that even the wars in Europe between nations and regions in his own time were essentially racial. Race did not just happen in distant places like Tasmania or southern Africa, it was close to home: 'races of men, differing as widely from each other as races can possibly do, inhabit, not merely continental Europe, but portions of Great Britain and Ireland.'

Behind these claims was the idea that race was irrevocably attached to place; imperial occupation or the permanent colonization of a different

country with a different climate from one's own was bound ultimately to fail. Such a claim forced Knox into some bizarre and unlikely predictions. He claimed that the United States, for example, was only sustained by the continuous arrival of fresh European settlers, and that the population was already showing signs of decay. For that reason, he argues that the original inhabitants, the Native Americans, had 'the race implanted there by nature', and 'in unison with the forest and the climate, the soil, the air, the place' will ultimately prevail over the white man. His insistence on the permanence of races led him to argue for the then commonplace, but absurd, view that mixed-race relationships were unsustainable; he writes of a 'physiological law' that in the long term will extinguish 'mulattos' of all kinds.[12]

Prichard, as we have seen, had little interest in art, but Knox was passionately involved in it, to the extent that he added a lecture on the fine arts to *Races of Man* – though in reality the lecture contains very little discussion of art. He also wrote *A Manual of Artistic Anatomy* (1852), and a book entitled *Great Artists and Great Anatomists* in the same year, which contains essays on Cuvier and Geoffroy de St Hilaire, both of whom he admired hugely (though not uncritically), and on Leonardo, Michelangelo and Raphael.

The first role of art for Knox was to represent the appearance of races, based on the view that ancient sculptures were literal depictions of existing racial types that remained constant to the present day – a view he was to share with the American ethnologists Nott and Gliddon, and later with the great Egyptologist Flinders Petrie. He describes at length a visit to the British Museum, during which he examined the famous ancient Egyptian giant bust known as the 'Younger Memnon', a possible model for Shelley's Ozymandias, but now understood to be of the pharaoh Ramesses II (illus. 52).[13] He saw it as a perfect representation of the Coptic race, and he describes going to Amsterdam to observe Jews in the synagogue there: 'Near me, almost within reach, stood a youth about sixteen, and not far from him others, the perfect likeness of the young Memnon . . . Thus I learned that originally the ancient Copt and a large section of the Jewish people were one and the same race, with slight differences, which the Egyptian sculptor knew how to caricature.'[14]

The observed physical resemblance, based on the profile, between an ancient bust and a living person was to him conclusive. He claims that Jews were wanderers and old clothes sellers in Italy before Rome was founded, and that 'the present Jewish race is composed of Coptic, Chaldee and Phoenician races, with the Coptic often still dominant . . . their identity

with a great section of the present Jewish race cannot be doubted; the young Jew of London or Amsterdam might readily sit for a likeness of the bust of [pharaoh] Amenoph.' He mined ancient art – particularly Egyptian art – for evidence of the continuity of racial types from antiquity to the present day: 'On the tombs of Egypt, the most valuable of all existing records, there stands the Negro, the Jew and Copt, the Persian, the Sarmatian, nearly as we find them now.'[15] This idea of the plurality of still-surviving races in

52 'The Younger Memnon', head and upper body of pink/grey granite monumental statue of Ramesses II, Thebes, 19th dynasty.

ancient Egypt was central to the American ethnologists and their followers, and it lived on until the twentieth century in the writings of Flinders Petrie.

The American Ethnologists

The principal American racial scientists J. C. Nott, George Gliddon, Samuel George Morton and Louis Agassiz, the first two being ardent supporters of slavery, tended towards a polygenist outlook but still held to a version of the biblical account of the origins of mankind by arguing that the creation of Adam and Eve was but one of many creations.[16] Their polygenism was opposed by many clergymen in the Southern states, who instead used the Bible and the story of Ham and his son Canaan to justify slavery. They argued that Black people were not of a different creation but were merely inferior human beings, destined to be slaves.[17]

The 'father' of the North American school of ethnology was from a northern state: Samuel Morton (1799–1851), a polygenic natural scientist and physician of Philadelphia Quaker background. Morton made his reputation through craniometry based on a large collection of human skulls that he owned and which still survives today.[18] In his first major work, *Crania Americana* (1839), which also includes an essay by the English phrenologist George Combe, he emphasizes in the Preface the importance of phrenology to his study of 'forty Indian nations' and other inhabitants of North and South America.[19] Morton, following Blumenbach, divides the world into five races: Caucasian, Mongolian, Malay, American and Ethiopian, all subdivided into 'families', which are in essence sub-races.

Morton followed Cuvier and others in claiming that the intellectual capacity of a race could be measured by the volume of the interior of the skull: a large skull contained a large brain and therefore a high and capacious intellect, and a small skull the contrary. His method of calculating skull difference was to fill each skull with seeds then weigh them comparatively. It goes without saying that he concluded, as so many racial scientists had done before him, that those of European descent had collectively much larger brains than those of other descents, in a sequence that placed Africans at the bottom. He set out to directly contradict a paper already published in English by the German scientist Friedrich Tiedemann (1781–1861), a student of Cuvier, but one who remained undogmatic in his views. Tiedemann had collected skull data by an essentially identical method of filling skulls, in this case with millet, and weighing the contents. His conclusions were diametrically opposed to Morton's, however, and he argued

strongly against any conception of a racial hierarchy. He saw no difference in the potential brain weight of Caucasians and Africans.[20] According to Tiedemann's *The Negro's Brain Compared with the European and Orang-Outang* of 1837, 'The principal result of my researches on the brain of the Negro, is, that neither anatomy nor physiology can justify our placing them beneath the Europeans in a moral or intellectual point of view.'[21]

Like Knox, his own American ethnological colleagues and later Flinders Petrie, Morton believed that, when making a portrait, artists of the ancient past reproduced what was in front of them without the inevitable distortions caused by the individual approaches of the artists and the conventions by which they worked. On this assumption, it follows that in the ancient world image-makers would have objectively reproduced the real faces and bodies of the people of their time. It was understood in the eighteenth century that ancient Greek sculpture represented ideal human beings, beyond the experience of normal mortals, but this was in tension with the assumption that some athletic Greeks must have themselves been ideal in appearance.

Later writers such as Joshua Reynolds, however, claimed that ancient Greek sculptors, aware of the difference between real and ideal bodies and faces, sought to represent the latter by either a process of representing the average of many bodies considered to be beautiful, or by acts of imagination in conjuring up the ideal, or a combination of the two. To put it simply, all representations are inevitably mediated through the mind and hand of the artist, guided by the assumptions of their time. One can only compare the heads of people in ancient Egyptian paintings and sculpture and those of people living today if one makes the implausible assumption, nonetheless taken as axiomatic by nineteenth-century racial scientists, that present-day races have remained constant in formation and appearance from the ancient world, and back even further to the beginning of creation.

Morton also claimed that the Bible advocated polygenesis by postulating that it allowed for multiple Creations in different parts of the world.[22] This appealed to Southern upholders of slavery, under challenge from Northern abolitionists, who could argue that their slaves were of a separate creation and not descended from Adam and Eve. It goes without saying that Morton placed Caucasians at the pinnacle and Negroes at the lowest point, with other races in between.

One of Morton's most important contributions to American racial theory was to bring ancient Egypt into consideration as a forerunner of modern racial distribution. But this is something he would have learned

from Prichard, who in the 1813 edition of *Researches into the Physical History of Man* saw ancient Egypt not only as the world's first proper civilization, but as evidence that civilization came from the continent of Africa – something he later repudiated. Morton's attitude towards slavery was never explicit, but his reputation was such that it invited this revealing eulogy in an obituary of him in a Confederate-supporting newspaper, the *Charleston Medical Journal*: 'We of the South should consider him as our benefactor for aiding most materially in giving to the negro his true position as an inferior race.'[23] He himself was careful never to publicly proclaim a belief in slavery, however, though his faith in white superiority and Black inferiority is clear from his work.[24]

Morton's death in 1851 was followed by the publication of a massive work with a dedication to him, *Types of Mankind; or, Ethnological Researches* (1854). This book of over seven hundred pages is the Bible of American racial science, and is of particular relevance to the present enquiry because of its commitment to the fundamental role of Egyptian art and visual culture in ideas of race, as the subtitle reveals: *based upon the Ancient Monuments, Paintings, Sculptures, and Crania of Races, and upon their Natural, Geographical, Philological, and Biblical History.*

It was edited by Josiah Nott (1804–1873) and George Gliddon (1809–1857), who both believed that the differences between the races had been impressed upon humanity by the Creator himself at the world's beginning. It also had contributions from Louis Agassiz (1807–1873), an American of Swiss birth whose contributions to geology led him to become a notable professor at Harvard University. Gliddon was the author of several books on ancient Egypt,[25] and had become convinced by Morton's idea that the ancient Egyptians – or at least their upper classes – were members of the Caucasian race. Nott was a doctor and slave owner in Mobile, Alabama, who became a medical officer in the Confederate Army. He was, it hardly needs to be said, a passionate advocate for slavery, which he believed was supported by science.

## What Colour Were the Ancient Egyptians Thought to Be?

Ancient Egypt was believed during most of the nineteenth century to be the oldest of the great civilizations and was at times paired with the United States as the most modern. It was seen as an ancient country of high achievement and rational rule, with citizens capable of writing and art, all of which foreshadowed the sublime achievements of Greece and Rome.

Ancient Egypt adhered to the criteria set by Europeans of what an ancient civilization should possess. As Samuel Morton put it: 'Egypt is justly regarded as the parent of civilization, the cradle of the arts, the land of mystery.'[26] It was understood by advocates of slavery to have been a land in which the ruling classes created their social world bolstered by a population of slaves, most of whom were Black Nubians. This was regarded as an ideal precedent for Southern plantations owners and Confederate sympathizers, for it gave slavery a long history and association with this most ancient and much-admired culture.

But apart from the Nubians, for a time at least, according to the Bible, Egypt also kept in captivity the Children of Israel. This made Egypt problematic, especially to Black clergy and their congregations, who saw their own present-day plight foreshadowed not by the enslavement of the Nubians but the enslavement of the Israelites, as in the chorus of a famous spiritual song, sung in several versions by Paul Robeson:

Go down Moses,
Way down in Egypt's Land,
Tell old Pharaoh,
Let my people go.[27]

But these contrasting perceptions of the ancient Egyptians beg the question: what colour *were* they thought to be in ancient times? Prichard was convinced by Herodotus that the ancient Egyptians were dark-skinned:

It appears from the remark of Herodotus that woolly hair like that of the Negroes prevailed among the Egyptians, and by comparing this fact with the other characteristics mentioned by Lucian, we are led to infer that this nation had the distinguishing marks of the African race. This conclusion is confirmed by the observations of travellers, who have described some of the most ancient Egyptian monuments, and particularly the Sphinx which stands amidst the pyramids, and is probably coeval with those venerable fabrics. These figures have exactly the characteristic features of the Negro.[28]

This view, however, was to be challenged by the American ethnologists. Morton owned many skulls from ancient Egypt, and concluded from them, contrary to Prichard, that the ancient Egyptians were white and Caucasian, definitely not Black, as he attempted to demonstrate in his *Crania Aegyptiaca;*

*or, Observations on Egyptian Ethnography Derived from Anatomy, History and the Monuments*, published in Philadelphia in 1844.

The question of the skin colour of the ancient Egyptians was a matter of supreme interest to slaveowners and their intellectual supporters, and the connection that was made between the art of ancient Egypt and the intellectual case for slavery was based on a number of highly questionable assumptions. The first is that the ancient Egyptians were not really African, even though their territory, in ancient times as now, is firmly within the continental mass of Africa. It is true that Egypt was an *entrepôt* in the ancient world, and had always had trading connections with the countries around it and beyond the African continent; however, it also had an intimate relationship for almost all of its existence, including periods of occupation, with the land of Kush to the south: the land of the Nubians. The second assumption, following on from the above, was that the ruling classes of ancient Egypt were of the Caucasian race, and therefore similar to Europeans in skin colour. They were thus pictured as being diametrically opposed to, and different in every way from, the inhabitants of the land of Kush who, being Black, were defined as inferior beings. Thus, they were enslaved by the Egyptians, though Morton did make a clear distinction between Nubians and Negroes who lived further south and east.[29] Nott and Gliddon were responsible for making overt the connection with contemporary slavery; Nott was a slaveowner himself, and Gliddon was an Egyptologist prepared to go along with the idea.

Such assumptions are obviously highly tendentious, and despite conscientious attempts in *Types of Mankind* to substantiate them with data and images taken from a wide-ranging study of ancient Egyptian monuments, the case was hardly made, and it was gleefully demolished by Frederick Douglass. But what were the Egyptians really like according to modern scholarship? First of all, it is clear that the relationship between Egypt and Nubia ebbed and flowed over millennia, with Nubians and Egyptians often occupying each other's lands or coexisting with them in either country. Over the very long history of Egypt before the Roman Ptolemaic dynasty there were lengthy periods of alternating war and peace between the two peoples, which involved much intermingling and cultural and religious exchange. There was even a time when Egypt was under the rule of Nubians, the so-called 'Black Pharaohs' of the 25th dynasty from 744 to 656 BC.

There were of course differences of culture and customs, but evidently the relationship was not based on racial difference or on Egyptians permanently enslaving Nubians, except at certain periods and in circumstances of

war. There are paintings and reliefs, in which Egyptians are seen as fighting and capturing Black Nubians, but this would have been after successful battles (or they represent wish fulfilment rather than actual events). There is no reason to suppose that the Egyptians were in any way racially or socially homogeneous, or that they did not evolve in all sorts of ways before the Ptolemaic period. In any case it is clearly completely unhistorical to map the relationship between Egyptians and Nubians onto the slave system of the Confederate states in the mid-nineteenth century without the considerable distortions that were provided by Nott and Gliddon. This did not prevent their highly fanciful account of the relationship between Egyptians and Nubians from proving highly influential on the politics of the day, and traces of its assumptions remained in the scholarship of ancient Egypt up to recent years.

The claim that ancient Egyptians were Caucasian and white was entirely based on an extensive and extremely tendentious analysis of ancient Egyptian art, which aimed to point out wherever possible resemblances between ancient and contemporary races occurred. Driving their often desperately fanciful comparisons was the worry that if ancient Egyptians were seen as racially or culturally connected in any way to the rest of Africa, it would undermine the deeply held belief in the Confederate states at the time of the American Civil War that Africans were destined, by nature, to be enslaved.

If Egyptians were African rather than proto-European, then the whole premise of racial segregation and enslavement based on 'natural' intellectual difference and a history dependent on different racial levels of civilization would be impossible to sustain. Because Nott and Gliddon made the crucial, and highly doubtful, assumption that the supposedly different races depicted in ancient Egyptian art were visually comparable to their so-called descendants living today, ancient art could illuminate the history of races in the present age, and vice-versa; as the two authors claimed in language which is similar to Knox: 'The Egyptians, Canaanites, Nubians, Tartars, Negroes, Arabs, and other types, are as faithfully delineated on the monuments of the xviith and xviiith dynasties, as if the paintings had been executed by an artist of our present age.' This is a claim also accepted by Flinders Petrie and by pioneering eugenicists like Francis Galton. This claim of continuity applied not only to those races associated with the Middle East and Africa, but to the 'blond races', those races who originated in or settled in Northern Europe: 'we find upon Egyptian monuments, beginning from xviith dynasty, B.C. 1600, portraits in profusion, corresponding in all particulars with the blond races of Europe, whose written history opens

as far west as Gaul and Germany: and now Assyrian sculptures present us with the same blond races in the viith and viiith century before our era.'[30]

If one goes back to earlier Egyptian dynasties, such as the fourth dynasty, they produced what Nott and Gliddon claimed were the earliest surviving works of art; according to the Creationist chronology, that brings one very near to the actual origins of humanity. Nott and Gliddon took seriously the traditional view expressed by Bishop Usher that the world began in 4004 BC, with the Deluge occurring in 2348 BC. The authors use this as a further argument for polygenesis, for 'the monuments of Egypt remove every shadow of doubt, by establishing that not merely races but *nations* existed prior to either of those imaginary dates. If then the teachings of science be true, there must have been many centres of creation, even for *Caucasian* races, instead of one centre for *all* the types of humanity'.[31]

Though Nott and Gliddon argued that the Egyptians were white, they were also aware that ancient Egypt was a trading crossroads that attracted peoples from distant parts, so its art could represent the diversity of races, including the Caucasian and the Asiatic – by which was not meant Chinese or Japanese but what we now call the Middle East – whose inhabitants were identified by the authors as being of the Semitic race. Racial diversity in ancient Egypt was, later in the nineteenth century, located by Petrie particularly in Memphis, which he saw as the foremost *entrepôt* in the region for travellers from many lands, with Greek and Turkish quarters.[32] This, combined with the belief that racial appearance was constant throughout the ages, meant that Nott and Gliddon identified with complete confidence present-day races in ancient Egyptian wall paintings, relief and other sculptures.

An illustration to *Types of Mankind*, in a chapter entitled 'The Caucasian Types Carried through Egyptian Monuments', purports to show a 'group wherein *three* distinct *types* of mankind are grasped by a *fourth*, [Pharaoh] Ramses ii, in the fourteenth century B.C.' (illus. 53).[33] It shows the hand of the pharaoh brandishing a pole-axe over the heads of 'Negroes, Nubians, and Asiatics, each painted in their true colours: viz., black, brick-dust, and yellow flesh-color', while above runs a hieroglyphic scroll, translated by Gliddon as 'The beneficent living god [the pharaoh], guardian of glory, smites the *South*; puts to flight the *East*; rules by victory; and drags to his country all the earth, and all foreign lands.'

Though the illustration is a reasonably accurate rendering of a small section of a relief at Abu Simbel, shown here in Amelia Edwards's linear copy (illus. 54), there are significant problems of interpretation. First, there

is an attempt even in the monochrome illustration to differentiate skin colour; the heads are divided into completely black, a middle tone presumably to represent brown skin, and white, though the original relief is not coloured. There is certainly good reason to see the heads as representative of Egypt's enemies in recent wars against the Nubians, Asiatics, Libyans and Hittites,[34] but it is also clear that the illustrator has exaggerated the 'Negroid' features of three of the heads, no doubt to make the Nubians visible, and as different as possible from the Asiatics and the Egyptians. According to Gliddon's text, 'Ramses inclusive, here, to begin with, are *four* types of men – one mixed, two purely African, and one true Asiatic, co-existent at 1400 years B.C., or some 3350 years ago.'[35]

It is clearly implied that the pharaoh himself (his face not illustrated) represents the Caucasian race, though in the image Ramesses II was of a godlike size, concerned only with smiting his neighbouring enemies. Gliddon

53 'One group wherein three distinct types of mankind are grasped by a fourth, [Pharaoh] Ramses II', from J. C. Nott and G. R. Gliddon, *Types of Mankind*, 8th edn (1857).

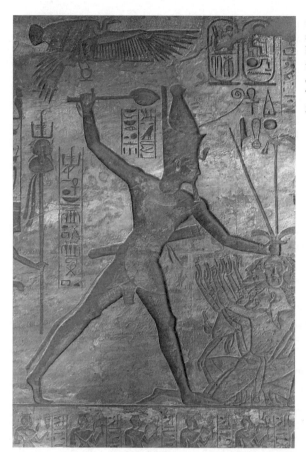

54 Ramesses II
slaying the Asiatics
before Ra, the
tutelary deity
of the Great
Temple of Abu
Simbel, Aswan.

also notes that 'Precisely the same four types occupy the same countries at the present day.' Furthermore, he claims that 'Egyptian ethnographers already knew of *four* types of mankind – *red, black, white and yellow* – several centuries before the author of *Genesis*, who . . . was acquainted with no more than three – "Shem, Ham and Japheth".' Thus, Gliddon invokes not only Linnaeus's pioneering mid-eighteenth-century racial categorization into four continents, each with its associated skin colour, but the much earlier Bible-based division of humanity into descendants of the three sons of Noah.

Nott and Gliddon argue that Egyptian art supports the case for polygenism against Prichard, whom they attack witheringly, along with 'the defenders of the *Unity*-doctrine' or monogenism, who know nothing of it.[36] They argue that the monuments of the twelfth dynasty, which were begun only eleven years after Usher's date for the Deluge, 'afford abundant evidence not only of the existence of Egypto-Caucasian races, but of the

Asiatic nations, as well as of *Negroes* and other African groups, at the said diluvian era'. The evidence that the ancient Egyptian were Caucasian comes from profiles on tombs and wall paintings that represent 'royal portraits of the xviith and succeeding dynasties.' The fact that such portraits are invariably in profile allows for comparison with racial skulls delineated by Samuel Morton in a tradition going back to Camper and his many successors.

According to Nott and Gliddon, not all pharaohs or upper-class Egyptians were purely Egypto-Caucasian: there are monuments of aristocratic families in the 4th to 6th dynasties that have 'African or Negroid, and Asiatic or Semitic' features. But 'two primordial types, one Asiatic [that is, Semitic] and the other Egyptian, stand conspicuous', which, if they existed in large numbers in the time of the fourth dynasty, must go back to peoples who lived far earlier than 4000 BC. In so far as Nott and Gliddon followed Bishop Usher's chronology of the world, then the three races go back to the time of the Aboriginal races that once inhabited the whole world, and which remain identifiable to this day. By locating the Caucasian race in images of one of the earliest dynasties of Egypt, the authors argue that the race's 'distinct physical features and separate national characteristics' place it among the very earliest peoples.[37]

But the actual profiles he presents in the aforementioned chapter tell a more complex story, and one that challenges any claims of the racial purity of more than a few of the Egyptians as members of the Caucasian race. There are several pages of profiles of pharaohs and their families that the authors claim show mixed-race pairings, in the seventeenth dynasty between pharaohs Amunoph I, of a 'Grecian countenance', and his son Thotmes I, of a 'strikingly Hellenistic' profile. Despite the latter's appearance, his mother, Aahmes-Nofre-Ari, had 'strong Semitic features', and his wife Aahmes was 'absolutely Jewish' (illus. 55).[38] Their descendants, however, unite 'Egyptian with Hellenic' through several generations, until Thotmes IV 'returns to the old Egyptian form'. But he marries a 'foreigner', Maut-Hemwa, evidently of Nubian or Cushite-Arab descent, and their son has 'foreign features' and is (so we are told) 'A hybrid, but not of Negro intermixture'.

The authors admit that the outlines of the Egyptian royal families they present 'not only demonstrate this commingling of races, but show that Asiatic intruders, at the foundation of the New Empire, to a great extent, supplanted, in the royal family at least, the indigenous Egyptians', noting that it was common for royalty to mate with foreign dynasties. In the chapter entitled 'Egypt and Egyptians' the authors argue for increasing racial mixture, caused by the invasion of Egypt by foreigners, from the first

dynasty, when the 'Egyptian type' transforms in the two subsequent dynasties into 'Egypto-Asiatic' followed by 'Egypto-Negroid'. By the eighteenth dynasty, the population of Egypt consists of 'Canaanites, Jews, Phoenicians, Assyrians, Tartars, Hindoos, Thracians, Ionians, Lydians, Libyans, Nubians, Abyssinians, Negroes'.

The nineteenth Ramesside dynasty is, according to Nott and Gliddon, even more mixed than its predecessors, though the pharaohs have only Jewish and never Nubian wives. But uncertainty is expressed in some cases of their racial identity. Ramesses II is the key figure here and 'His features are as superbly European as Napoleon's, whom he resembles', but his mother Tsira is described and depicted as 'Entirely Jewish', and his children are all described as partly Semitic (illus. 56). Nott and Gliddon run into serious difficulties with the 25th dynasty, that of the so-called Black Pharaohs,

55 Profiles of Amunoph I, Aahmes-Nofre-Ari, Thotmes I and Aahmes, from J. C. Nott and G. R. Gliddon, *Types of Mankind*, 8th edn (1857).

56 Profiles of Tsira and Ramesses II, from Nott and Gliddon, *Types of Mankind* (1857).

installed after a Nubian occupation of Egypt. They show three profiles designed to demonstrate by their 'un-Negroid' facial features that 'the so-called "Ethiopian" dynasty had no Negro blood in their veins,'[39] a conclusion emphatically not accepted by subsequent scholarship.

Nott and Gliddon are clear about the historiographic origins of their belief that the ancient Egyptians were Caucasian. It was entirely due to Morton in his *Crania Aegyptiaca*, of 1842. There Morton claims that the 'Valley of the Nile . . . was originally peopled by a branch of the Caucasian race', but 'the Egyptian race was at different periods modified by the influx of the Caucasian nations of Asia and Europe: Pelasgi, or Hellenes, Scythians, and Phoenicians'. For the Pharaohs to mate with Jewish women then was, strictly speaking, not a matter of racial mixing, but the union of different branches of the Caucasian race. But Morton is quite unequivocal about the role of Black Africans in Egypt: 'Negroes were numerous in Egypt, but their social position in ancient times was the same as it now is: that of servants and slaves.' This is not to say that there were not people of mixed Egyptian and Negro blood. Nott notes that out of a series of seventeen skulls analysed by Morton two were of an 'Egyptian form, with traces of Negro lineage', comparable to the number of skulls of 'Negroid, Pelasgic and Semitic form'.

In the chapter in *Types of Mankind* written by Nott alone, entitled 'Comparative Anatomy of Races', there is an exhaustive account of skull formations that ranges across the known world, but concentrates on American peoples. It goes without saying that skulls used for anthropometric research were never of white people, so to amass comparative data that included them for comparison Nott approached hat manufacturers in

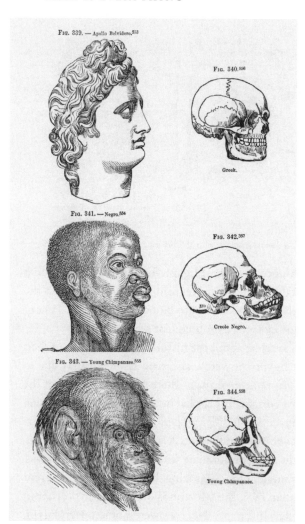

57, 58 Comparative series of likenesses, from Nott and Gliddon, *Types of Mankind* (1857).

Mobile, Alabama, and Newark, New Jersey, for measurements of their clientele's heads. These places were chosen because they were in areas settled heavily by German immigrants. The authors came up with an average circumference for 'the crania of white races in the United States' of 21 inches, which compares favourably with 'the aboriginal America races, whose average is 19 ½ inches'.[40] Comparable evidence of the small heads of African slaves came from an anecdote of a West Indian regiment supposedly only being able to wear the smallest sizes of hats provided for them.

For evidence that 'the Negro' is closer to the animal kingdom than the Caucasian, Nott reverts to visual evidence, reproducing Virey's infamous illustration comparing the skulls of the *Apollo Belvedere*, a 'Negro', and a

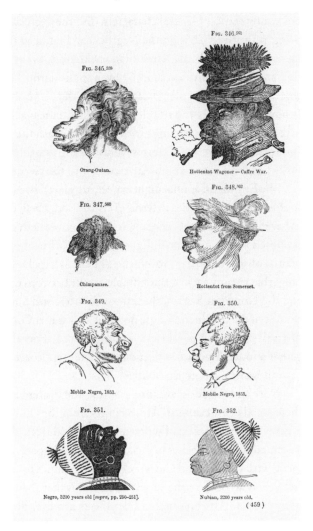

'Young Chimpanzee', comparing it on the opposite page with a rogues' gallery of caricatured heads of contemporary blacks, two from Mobile, interspersed with apes and ancient faces (illus. 57, 58). It supports unequivocally Frederick Douglass's claim that in comparative racial illustrations the ugliest people were taken to be the norm for Black people, while the most handsome were the norm for white people.

One might think that such committed believers as Nott and Gliddon in the 'naturalness' of enslaving Africans would present a grossly oversimplified picture of Africa, but in fact they were aware of the variety of the continent's inhabitants. The continent is described as 'from one extreme to the other, covered with dark-skinned races of various shades, and

possessing endless physical characters.' But these 'characters' are united by being 'primitive'. 'Though the Negroes can be traced on Egyptian monuments only back to the XIIth dynasty, there is every reason to suppose they are as old as any other race.'[41] Even so the authors adhere to the belief that 'there exists a regular *gradation*, from the Cape of Good Hope to the Isthmus of Suez'; as you travel south in Africa the blacker and more primitive the inhabitants become, with in the far south the 'Hottentot and the Bushman the lowest and nearest to the orang utan', a belief that coloured many generalizations about Africa well into the twentieth century.

The Egyptians, as one might expect, are placed by Nott and Gliddon on the highest level in Africa in terms of civilization, a belief that also continued to have traction in some scholarship into the twentieth century. One reason proposed for the extreme differences among Africans was the existence of natural obstacles to easy movement, like the Sahara Desert and a mountain range that creates, 'an insurmountable barrier between the Southern Deserts and the Northern Sahara', that cut off Central and Southern Africa from the rest of the continent. Those north of 'this stupendous natural wall' were of a well-formed physical type, 'improved cranial developments, and altogether a much higher intellectual character', approaching the Caucasian, than those who live to the south.[42]

Nott and Gliddon are insistent that the evidence necessary to make these racial distinctions in Africa comes from the study of Egyptian monuments, in the absence of written historical sources. *Types of Mankind* is sustained by a total belief in racial science and in particular skull measurement, with Camper and Cuvier very much in mind. In case one might think from their account of the variety of Africans that they accepted the possibility of some African intellectual prowess however limited, they fall back on the Egyptian monuments and the work of Samuel Morton, who 'has proven, that the Negro races possess about nine cubic inches less of brain than the Teuton . . . it would seem that the Negroes in Africa must remain substantially in that same benighted state wherein Nature has placed them, and in which they have stood, according to the Egyptian monuments, for at least 5000 years'.

The views expressed in *Types of Mankind* clearly draw on Nott's experience of living in a Confederate state of the United States in the period before the Civil War, and the picture of ancient Egypt, though enormously influential on both politics and historical writing, is, as modern scholarship has discovered, to put it mildly seriously flawed. The simple polarity of Egyptians as masters and Nubians as slaves is one of wish fulfilment and

not borne out by history. So what skin colour were the ancient Egyptians? The most likely answer and one that is to some degree borne out by the sheer variety of different faces in wall paintings and sculptures, is that they were not of a single consistent colour but varied according to period, place and social class; as Frederick Douglass pointed out they were likely to be as varied as Black people in the present-day United States. What we cannot do, however, is rely on the complex imagery produced in Egypt over the millennia to give us a clear answer, and particularly not one that gives us a simple division into black and white.

Any attempt to impose modern ideas of blackness and whiteness upon the ancient past is doomed to be misleading. Though there is some evidence from ancient Egyptian art that Nubians were predominantly dark skinned, it is surely likely that there would have been extensive sexual relations between Egyptians and Nubians given the political interconnections between the two. What can be said with some certainty is that relatively few ancient Egyptians would have been as light skinned as most Europeans, so Nott and Gliddon's idea that they were uniformly 'European' in race and colour is simply untenable, despite its enormous influence. This is not to say that Nubians did not sometimes appear in Egyptian wall paintings as black-skinned, but this would tell us no more about their actual skin colour than nineteenth-century caricatures of African Americans tell of theirs.

## The Grecian Ideal

It is significant that in an illustration to Knox's *Races of Men* 'Young Memnon' or Ramesses II is shown in profile for a 'scientific' comparison (illus. 59). The illustrations were by a well-known medical illustrator, Dr John Guise Westmacott, who also provided them for the famous medical textbook *Gray's Anatomy* (1860). The idea that the profile was the best vehicle for the scientific study of humanity goes back to Camper, but the profile itself has a history in antiquity when portraits of Greek, Assyrian and Roman rulers on coins validated their role as currency. The illustrations to *Races of Men* are generally not placed next to specific discussions in the text, but a number of them including the profile of Young Memnon are repeated throughout.[43]

In the introduction to *Races of Men* Knox describes himself as a follower of 'transcendental anatomy, which alone, of all systems, affords us a glimpse and a hope of a true "theory of nature"', citing Goethe and Lorenz Oken (1779–1851), the natural philosopher, and others.[44] Transcendental anatomy

is most familiar from Goethe and his search for the *Urpflanze* and *Urtier*, the archetypal forms of plants and animals, that may have only been an idea, but which provided stability for each species and a connection with a universe governed by laws, in which every living thing is connected to every other. It was based on a presupposition that there was a single ideal plan behind the great diversity of living things, and it was this plan that determined the way organisms functioned, and not the other way around.[45] As Knox put it 'As a living and material being, the history of man is included in the history of the organic world . . . He has his specific laws regulating his form, but these are in perfect accordance with all nature's works.'[46] In describing transcendental anatomy Goethe and Oken were not thinking about race, but just as the original idea of race came from applying Linnaeus' classification of plants and animals to human beings, so Knox was able to apply transcendental anatomy to his idea that there could exist for each race, if defined as a separate species, an ideal form.

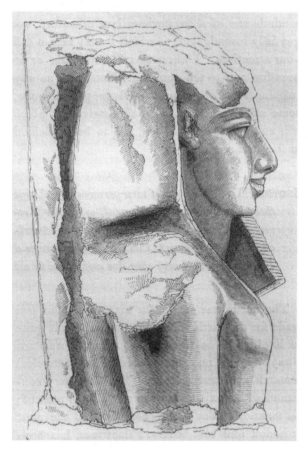

59 'The young Memnon', from Robert Knox, *The Races of Men* (1850).

60  Henry Fuseli, *The Negro Revenged*, 1806–7, oil on canvas.

61  Théodore Géricault, *Study of the Model Joseph*, 1818–19, oil on canvas.

62  Carolus-Duran, *Un Soudanien*, 1886, oil on canvas.

63  Charles Cordier, *Aimez-vous les uns les autres*, 1867, bronze.

64  François-Auguste Biard, *L'Abolition de l'esclavage dans les colonies françaises en 1848*, 1849, oil on canvas.

65  Frédéric Bazille, *Jeune femme aux pivoines*, 1870, oil on canvas.

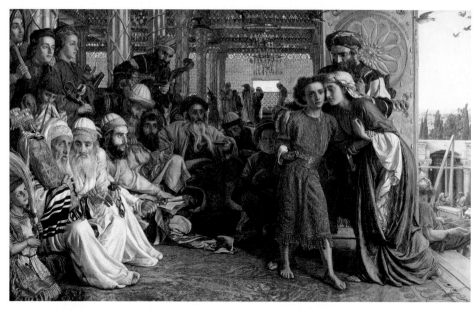

66 William Holman Hunt, *The Finding of the Saviour in the Temple*, 1854–5, oil on canvas.

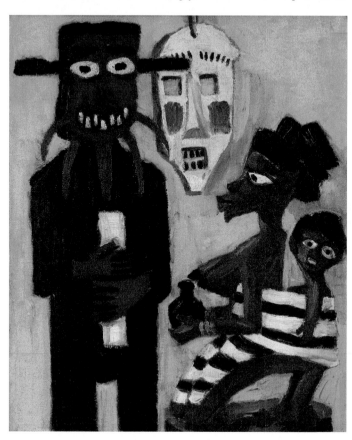

67 Emil Nolde,
*The Missionary*, 1912,
oil on canvas.

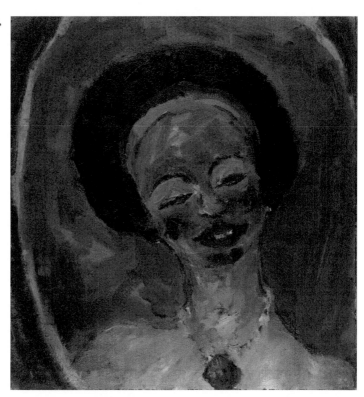

68 Emil Nolde, *Mulatto*, 1913, oil on canvas.

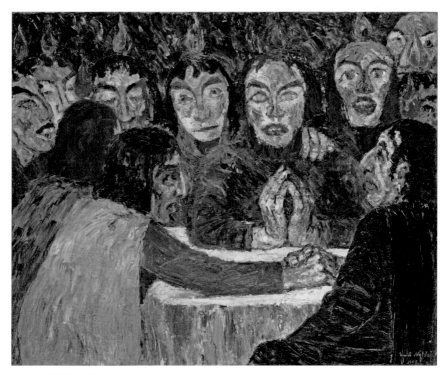

69 Emil Nolde, *Pentecost*, 1909, oil on canvas.

70  Malvina Hoffman, *Shilluk Warrior from the Upper White Nile*, 1931–2, bronze.

Such ideas are clearly analogous to and possibly even derived from academic art theory, expressed in its most accessible form in Joshua Reynolds's *Discourses to the Royal Academy*, the first seven of which were published in 1778, and which remained influential in Britain up to the mid-nineteenth century. Reynolds followed an international tradition of invoking antiquity in arguing that elevated art, to which all students of art should aspire, was by definition concerned with the ideal forms of things; it was the serious artist's duty to transcend mere observation of the world, which it was still necessary to master, to aspire to the level of the canonical sculptures of antiquity and to Raphael's Vatican frescoes and Michelangelo's Sistine Chapel ceiling.

Goethe's search for the *Urpflanze* and *Urtier* began on the Italian Journey of 1787 and represents a major shift in the poet's vision of nature and art, and the end of his youthful intellectual phase.[47] The *Urpflanze* and *Urtier* as ideal models for all living things led him to shift his attention towards ideal forms in Italian and classical art and away from art based on observation in the northern artistic tradition. In Knox's case it led him to argue that races had a primal existence, like plants and animals, but also that this idea was expressed most fully in works of art, particularly those of what he and others considered to be the most successful race in human history, the ancient Greeks of the fifth century BC: 'All races – I mean all civilizable races – have their fine arts peculiar to themselves.' The theory of the beautiful connects the history of race with perfection of form; and from it, too, laws of deformation, leading to the imperfect; or in other words, to connect the history of race with 'the great laws regulating the living organic world'.[48]

For Knox art was one of the measures of a successful society, just as lack of it, which he believed to be the case with African races, was a sign of unsuccessful ones. But when discussing either the beauty of ancient Greek men or women, or Greek sculpture, Knox tends, as did others, to elide the human being and the work of art, claiming perfect beauty for the Greek body in real life. At one point he claimed that the Greek sculptors were realists, for they had ideal human bodies in front of them, but this happy state lasted only a short time before their civilization decayed: 'the law of specialization has . . . produced the Venus, a real, not an ideal form.'[49] It is significant that Knox should mention the Venus as an example of the Grecian ideal because he was a pioneer in shifting the idea of ultimate beauty towards the female rather than the male: the *Capitoline Venus* rather than the *Apollo Belvedere*. This, as we will see in the next chapter,

had important consequences for Darwin in the development of sexual selection.

Knox is also at pains to dissociate art from the picturesque, which he sees as a 'Saxon' invention, characteristic of a people committed to utility; elsewhere he commends a famous comment attributed to Napoleon that 'Britain's [*sic*] were a nation of shopkeepers'. However, he is also clear that great art has an aesthetic charge that is independent of other emotions, suggesting a reading of Kant, if indirectly, as well as German philosophical naturalists. He notes that the *Venus of Knidos*, originally made by Praxiteles in the fourth century BC and known through many Roman copies, 'satisfies *the eye for form*, and by so doing the highest and deepest of all human feelings'.[50]

In his *Manual of Artistic Anatomy*, Knox spells out his theory of art, of which he had given hints in *Races of Men*. In harmony with transcendental anatomy, he argues that 'The beautiful and the perfect are absolute, fixed, and determined . . . a fragment of that mighty law or mind pervading, directing, creating the universe.' He also expands on his reasons for claiming that the ancient Greek sculptors were realists: great masters 'proved by these works that the pretended *ideal* was the *real*'. In effect, he is rejecting the Reynolds distinction between the mundanity of 'the real' and the metaphysical nature of 'the ideal' by claiming that the ideal as perfection could exist, if very rarely, in certain places and times on earth, most notably in ancient Greece, and can be applied equally to real women as well as works of art representing them: 'The absolutely beautiful and the perfect resides in the adult woman; in the statue of Venus, and in the living form from which it was copied.'

There is then for Knox strictly speaking no such thing as *ideal* beauty, but there is perfect form, which can be found in the undamaged parts of the Parthenon Marbles in the British Museum, and in the ancient Greek Niobe, who is described as a 'full-grown beautiful woman, the standard of all excellence, all beauty, all perfection'. Knox includes an illustration of the head and shoulders, which clearly refers to the famous full-length statue in the Uffizi, but the particular statue he recommends art students to study is the *Townley Venus* in the British Museum, one of a number of Roman copies of a lost Greek Praxitelean original. Such works are contrasted with the mundanity of current art: 'no mechanical-minded Saxon could have imagined or designed Egyptian Thebes,' and he attacks present-day British taste as the product of a 'grasping, calculating, commercial race, fettering their [artistic] genius'.[51]

In a separate chapter Knox, in discussing the importance of the skull for defining race, notes that with race 'it is mainly the head which interests the artist.' He falls back on Camper, whom he praises and whose racial angles he repeats in a curious diagram he claims has been 'copied from Camper's works', but is clearly taken from Virey in its emphasis on the animality of the African profile. But he also suggests that the antique Greek facial angle, referring to the straight profile of the *Apollo Belvedere* in Camper's chart, can be seen in real people in the present day in England:

> it is in England and in other countries inhabited by the Saxon or Scandinavian race that women resembling the Niobe, and the men the Hercules and Mars, are chiefly to be found. It is to the inheritance of Scandinavian blood that Greece owed her grandeur of forms, hence it is possible to see on the streets of London the Apollonian straight profile, while in Greece that has long disappeared: 'how Greece has fallen!'[52]

Present-day Greece had lost all connection with the Periclean age.

The idea of 'otherness' has tended to dominate the interpretation of racial history, contrasting the 'unmarked' category of 'whiteness' in opposition to the racialized other, but in the nineteenth century, discussion of whiteness often involved just as complex a series of negotiations as those of the other. Though Knox abhorred any kind of racial mixture as bound to lead to decline in the long run, his vision of England's racial inheritance is not straightforward; the 'Saxon race' appears to be part of the larger 'Scandinavian race', and he claims that there are, for instance, large settlements of people of Belgian descent in Kent. He never actually uses the epithet 'Anglo-Saxon', though by the 1840s it was widespread in Britain and in the United States.

The use and adoption of such racial terms as 'the Anglo-Saxon race' was perfectly compatible with a critical view of one's own country. Though there is a broad assumption of the superiority of the cultivated English gentleman of ancient descent in almost all Victorian writings on the subject, it could very well be combined with a pessimistic view of contemporary society. Knox, though an absolute believer in race, was not correspondingly xenophobic. He writes scathingly of the commitment to utility rather than imagination in the Saxon race, and though he did not live into the era of the 'Scramble for Africa', it is clear that he would not have supported it.

Nott and Gliddon have relatively little to say about the ancient Greeks in *Types of Mankind*, except to wonder 'what was there in climate and other local circumstances that could produce such intelligence, coupled with the noblest physical type?' They borrow the idea that the Greeks were divided into two races, the Hellenes and Pelasgi, whose monuments correspond to the heroic and historic ages of Greece.[53] The ideal heads of say the *Apollo Belvedere* and other gods are distinguished by 'a perfect oval contour, forehead and nose straight', while the historic philosophers, orators, warriors and poets are quite different and more like their equivalents in the rest of Europe. The former category is illustrated by a weak wood engraving copied from Tischbein's *Seven Heroes of the Iliad*, while the latter are represented by varied busts of Lycurgus, Eratosthenes and Alexander the Great. The Greek ideal makes a lonely appearance in the notorious double-page spread of illustrations, borrowed from Virey, in the chapter 'Comparative Anatomy of Races', where the head and skull of the *Apollo Belvedere* are compared with a 'Creole Negro' and a 'Young Chimpanzee' (see illus. 57).

## Agassiz and the Peabody Daguerreotypes

Louis Agassiz, whom we have already encountered as a contributor to Nott and Gliddon, has been the focus of recent attention because of fifteen deeply moving, yet horrifying, daguerreotypes, dating from 1850. These images, featuring slaves from Southern plantations, were found in 1976 in a drawer in the Peabody Museum of Harvard University, apparently left by Agassiz himself (illus. 71, 72).[54] They are in one sense a pure expression of the visual implications of the racial science from which they sprang, but they are also vivid and, to modern eyes, deeply poignant expressions of its human costs in the practice of enslavement in the Southern states. The data attached to the subjects and their presentation – their names and places of origin in Africa, and their nakedness – only serve to undermine their ostensible scientific purpose and emphasize by contrast their humanity and vulnerability, and their miserable fate at the hands of their owners, who made them available for Agassiz's studies.

To Agassiz, the scientific point of the daguerreotypes, and the nakedness of their subjects, was to show the difference between natives of Africa and people of 'the white race'. An account of his presentation of the images to Harvard colleagues in the *Newark Daily Advertiser* claims that Agassiz 'pointed out from them the many differences between the forms of the negro and the white race, a large proportion of which have not been previously

remarked; and in proof of his statements he exhibited a large number of daguerreotypes of individuals of various races of negroes'.[55]

It is clear that Agassiz believed in polygenesis – or the 'Diversity of Origin of the Human Races', to cite the title of an essay of his – and in the inferiority of Africans; he consorted willingly with slaveowners in the South to obtain his photographs. It is less clear that he actually fully *supported* slavery, though he certainly was not shocked by seeing it in the flesh. In the first place he was a very recent emigrant to the United States and so, unlike Nott, he had little to no experience of or stake in slavery.[56] Also his colleagues at Harvard, in particular the ones likely to be interested in his work, were almost all committed abolitionists, as John Stauffer has made clear, and would have been wary of any connection with Frederick Douglass's 'Notts and Gliddens'. Thus, at the time of his involvement in the daguerreotype project, he was in an ambiguous position. No wonder after presenting the photographs to his peers he failed to publish them, putting them in a drawer from which they were only removed over 120 years later.

As a contributor to *Types of Mankind* – but unlike such racial scientists as Nott, for whom racial science was primarily a way of providing an intellectual basis for the practice of slavery – Agassiz came to his work on racial science and his adoption of a polygenist position through his experience of and admiration for the work of Morton on racial skull comparison. Though he and Gliddon had both settled in the United States only a few years before the publication of *Types of Mankind* (Gliddon in 1842 and Agassiz in 1847), they both had good connections among Southerners looking to justify slavery scientifically under increasing pressure from abolitionists on both sides of the Atlantic.[57] *Types of Mankind* proclaimed itself as a patriotic project by emphasizing both its origins in American science and the respectability of a slave society, presenting it as a wholly rational institution. Gliddon, who had no academic post, also thought that the Southern states would be an excellent market for *Types of Mankind*, and was in friendly contact with the notorious politician John C. Calhoun, a powerful advocate of states' rights and of the belief that slavery was a 'positive good'.[58]

Agassiz made two contributions to *Types of Mankind*; the first is an essay entitled *Sketch of the natural provinces of the animal world and their relation to the different types of man*, which looks at 'the natural relations between the different types of man and the animals and plants inhabiting the same regions'. It is, therefore, quite different from the writings of Morton and the other authors of *Types of Mankind*, who were concerned

71  Joseph T. Zealy, *Renty, Congo*, 1850, daguerreotype.

with the ancient Egyptians as the original civilized people of Caucasian race, in its emphasis on earlier climatic theory. Agassiz divides the animal kingdom into 'grand divisions' independent of climate, and the 'local circumscription of species', which are very much tied to climate, for example the presence of polar bears in the Arctic. Corresponding to this wildlife are the Arctic's human inhabitants, 'a peculiar race of men, known in America under the name of Esquimaux'. Agassiz tabulates the connection between human forms and animal life in a large lithographed table, worked out in detail by Gliddon through eight 'Realms': Arctic, Mongol,

72 Joseph T. Zealy, *Drana* (country born of African parents, daughter of Renty), 1850, daguerreotype.

European, American, African, Hottentot, Malayan and Australian, each realm being represented by a head in profile, a skull and six examples of the fauna of each.

The head representing the European Realm is that of Cuvier himself, showing him to lack almost completely any hint of prognathism, like Camper's *Apollo Belvedere*, though with a sloping forehead emphasized by the skull beneath. He shares a column with a bear, stag, antelope, goat,

sheep and an aurochs (a primitive ancestor of modern cattle). The African Realm is represented by a head of a 'Mozambique Negro', but his head does not correspond to the skull beneath, which is of a 'Creole Negro'. The latter skull has a protruding jaw that creates a large, even exaggerated, angle of prognathism, while the former has a recessive jaw. The animals associated with the African Realm are entirely predictable: chimpanzee, elephant, rhinoceros, hippopotamus, wart-hog and giraffe.

Agassiz's main idea is basically climatic; the races are tied not only to particular regions of the world but to the particular fauna of each region. This, he claims, forms the basis of separate races: 'We must acknowledge that the diversity among animals is a fact determined by the will of the Creator, and their geographical distribution part of the general plan which unites all organized beings into one great organic conception: whence it follows that what are called human races . . . are distinct primordial forms of the type of man.'

In his essay Agassiz does not argue for the chimpanzee being a distinctively African animal, nor does he comment on its relationship with the 'African race', but in Nott's essay on 'The Comparative Anatomy of Races', later in the book, the latter discusses a conversation he had with Agassiz when he gave a lecture in Mobile. There he notes that 'Prof. Agassiz also asserts [no doubt to Nott's delight] that a particular conformation characterizes the brain of an adult Negro, [whose] development never goes beyond that developed in the Caucasian in boyhood; and . . . it bears, in several particulars, a marked resemblance to the brain of the orang-outan.'

From this conversation we can get a clear idea of what Agassiz expected to gain from the Peabody daguerreotypes. Though Nott does not give a date for the conversation, it occurred when he was working on his chapter in *Types of Mankind*, so we can assume a date two or three years later than the taking of the daguerreotypes. Nott provided Agassiz with 'two native-African men for comparison', and he notes the latter's close observation of the Africans' bodies:

> When examined from behind, the Negro presents several peculiarities; of which one of the most striking is, the deep depression of the spine, owing to the greater curvature of the ribs. The buttocks are more flattened on the sides than in other races . . . The pelvis is narrower than in the white race . . . In the Negress, the mammae are more conical, the areolae much larger, and the abdomen projects

as a hemisphere. Such are some of the more obvious divergences of the Negro from the white types.[59]

So Agassiz raises – admittedly, a little tentatively – the suggestion of a connection between the brains of Africans and apes. What is distinctive in his approach towards racial matters, however, and what sets him apart from the American ethnologists, is his concentration less on the skull and more on the racial body, and the differences not only between the African and the white body, but the African body's variety *within* Africa (hence his concern to know the parts of Africa, or elsewhere, from which the subjects of his daguerreotypes came).

The strong regional foundation of Agassiz's racial categories, including seeing southern Africa as separate from the rest of the continent, and his interests stretching even as far as Australia, has an important bearing on the Peabody daguerreotypes. One of their most striking features is that each one has a note attached with their name and geographical origin – for the most part in Africa, though some were born in the United States. The African origin of the people in the daguerreotypes is important to Agassiz in a way that it would not have been to Nott and Gliddon, though they were aware of the variety of Africans because of the connection between race and place, and the division of Africa into the 'African Realm' and the country of the 'Hottentot'. It was important because Agassiz wanted to demonstrate that Africans who came from different parts of the continent had major biological features in common but also relatively minor differences, depending on their place of origin. In the press account of the lecture in which he presented the daguerreotypes, Agassiz claimed that he procured them 'during his visit to the South last spring, during which he paid much attention to the anatomy of the negro race, as there exhibited in individuals of the purest African blood'.[60]

There is also a reference in the report to arguments that are made later in his essay in *Types of Mankind*, bearing on his connections between the human beings and the fauna of particular regions: 'his arguments upon this occasion were principally drawn from experiments which he has lately made . . . upon some of the lower animals.' As John Stauffer has pointed out, he used this human–animal connection to argue that the African 'black orang' was linked to the 'black human race', just as the 'chocolate-colored Malays' were connected to the 'brown orang', arguments that encouraged Nott to make the claim in *Types of Mankind* that Africans were nearer to apes than white human beings.[61]

*Types of Mankind* and *Races of Men* represent the high-water mark of polygenism and hard divisions between races, arriving at the beginnings of serious political conflict in the United States, but also in Britain, in the troubled years after the abolition of Caribbean slavery. *Types of Mankind* was much read in Britain, and Darwin had a copy by 1855, which he annotated extensively. What could Darwin, a fervent opponent of slavery and of rigid racial categories, have found interesting in Nott and Gliddon and Robert Knox? This will be addressed in Chapter Eight.

### Frederick Douglass: Ancient Egyptians and the African American Challenge to Racial Science

The 'cis-Atlantic' or North American school of ethnology – or the 'Notts and Gliddens' as Frederick Douglass contemptuously called them – has been forever associated, with good reason, with attempts to justify slavery in the fraught years that built up to the American Civil War by making an absolute distinction between those of European ancestry and 'Negroes'. Frederick Douglass, the great champion of the African American cause and opponent of slavery, described the authors derisively and accurately:

> A certain class of ethnologists and archaeologists, more numerous in our country a few years ago than now and more numerous now than they ought to be and will be when slavery shall have no further need of them, profess some difficulty in finding a fixed, unvarying, and definite line separating what they are pleased to call the lowest variety of our species, always meaning the Negro, from the highest animal.[62]

Douglass was not the first person of African descent to challenge racial science for erecting and reinforcing a hierarchy that placed people like himself at the bottom, to the point that they were barely removed from the animal kingdom.[63] In fact, resistance can be traced back at least to the eighteenth-century anti-slavery author Olaudah Equiano (*c.* 1745–1797), whose reference to 'the Oran Otang philosophers' was probably directed against David Hume's notorious footnote in the 1754 edition of *Of National Characters* – in which the latter claimed 'to suspect the negroes to be naturally inferior to the whites' – or Edward Long's racist *History of Jamaica* of 1774.[64] But most of the African American critique of racial science came

from a biblical standpoint, or was a response to Thomas Jefferson's writings on race.[65]

Douglass, however, confronted the American ethnologist authors of *Types of Mankind* directly and by name. He was aware of written evidence from ancient sources that at least some early Egyptians were dark skinned and had strong African features. He presented the case for Egyptians being Black, in the sense recognized by Southern compatriots, in the printed lecture *Claims of the Negro, Ethnologically Considered*, under the heading 'Ethnological Unfairness towards the Negro', delivered to the literary societies of Western Reserve College on 12 July 1854.[66]

In his critique of *Types of Mankind*, Douglass begins by agreeing that Egypt was a great civilization looked on indulgently by Greece and Rome and the more modern civilizations of Europe and America. He then points out unequivocally, albeit with wit and sarcasm, that 'Egypt is in Africa. Pity that it had not been in Europe, or in Asia, or, better still, in America!' His true target, however, is the much insisted-on assumption in American ethnology that the ancient Egyptians were not really African: 'Another unhappy circumstance is that the ancient Egyptians were not white people; but were undoubtedly just about as dark as many in this country who are considered genuine negroes.' Douglass complains that despite this fact Morton and the other ethnologists are determined to deny any similarity between Egyptian and Negro, even though ancient descriptions of the Egyptian physiognomy were recognizably similar to that of Negroes in America. He accuses Morton and the others of thinking that their own and their contemporaries' prejudice towards Blacks was exactly comparable to that in the ancient world: 'It assumes that a black skin in the East excites the same prejudice which we see here in the West'; in other words, Morton is applying contemporary American prejudice to a world which had no such concern with racial difference. Furthermore, according to Douglass, 'It is easy to prove, that whatever may have been the hue of their skin, they belong to the same race with ourselves.'

But in the end Douglass argues that it is art and its misuse that enables the ethnologists to make such an absolute contrast between the two races, for 'The European is drawn in harmony with the highest ideas of beauty, dignity and intellect,' while 'The Negro on the other hand, appears with features distorted, lips exaggerated, forehead depressed, and the whole expression of the countenance made to harmonize with the popular idea of negro imbecility and degradation,' a contrast amply demonstrated in *Types of Mankind* (see illus. 57, 58). His point is not that there are no such

individuals in Black communities, but that they are made to appear to be representative of Black people as a whole, just as the ideal type of European is treated as representative of their race though they may only represent a small elite. These remarks suggest that, for the time, Douglass had a highly unusual sensitivity to the mediated nature of visual representation; he realizes clearly that what is assumed to be a truthful representation is always guided by unconscious or deliberate choices made by the artist of the image, who inevitably channels her or his own prejudices and culturally determined attitudes, especially in matters involving race.

This sensitivity to the provisional nature and uncertain 'truth effect' of images may provide an explanation for a strange and much written about episode described in Douglass's second autobiography. Douglass describes puzzlingly 'the head of a figure [of ancient Egyptian pharaoh Ramesses II] the features of which so resemble those of my mother, that I often recur to it with something of the feeling which I suppose others experience when looking on the pictures of dear departed ones'.[67] He claims to have found this image in James Cowles Prichard's *The Natural History of Man* of 1843 (illus. 73).[68] At first it seems a joke, because the head has a formalized beard and, judging by the break on the top right of the head, it is taken from the very same British Museum head of Ramesses II known as the 'Younger Memnon', discussed by Robert Knox (see illus. 52). It is possible that, if one puts this identification out of one's mind, one could see in the wood engraving not the image of a pharaoh but a lively female face. It is freely drawn, and more of a virtuoso exercise of engraving technique than an exact and detailed picture of an ancient and monumental Egyptian sculpture. But what makes this image so confounding is that it appears to have been taken from the same sculpture as a further image in *Types of Mankind*, where Ramesses II is described as the most Caucasian in physiognomy of all the pharaohs – with a particular resemblance to Napoleon (see illus. 56).

Douglass obviously knew *Types of Mankind* well, and he was certainly familiar with the latter image. If he had mentally made a comparison between the two printed representations of the pharaoh it would have confirmed for him the variability and essential unreliability of such illustrations, upon which so many racial assumptions were based by Nott and Gliddon. I leave to others more qualified in psychology to say what the image in Prichard might tell us about Douglass's relationship to his mother, whom he hardly knew.[69] Harriet Beecher Stowe noted the episode in Douglass's autobiography and also Nott and Gliddon's claim of Ramesses II's resemblance to

Napoleon, but concluded from the image in Prichard that Douglass's mother was 'from the Mandingo tribe of Africans who were distinguished among the slaves for fine features, great energy, intelligence and pride of character', in others words characteristics more readily claimed by the Anglo-Saxon race.[70]

Douglass's problem with such identifications of racial types in ancient Egyptian portraits was shared by Charles Darwin, who comments on the issue in *The Descent of Man*, in a footnote in reference to the suggestion that 'negroes, apparently identical with existing negroes, had lived at least 4,000 years ago':

> Messrs. Nott and Gliddon state that Rameses II, or the Great, has features superbly European; whereas Knox, another firm believer in the specific distinctness of the races of man, speaking of young Memnon (the same as Rameses II, as I am informed by Mr. Birch), insists in the strongest manner that he is identical in character with the Jews of Antwerp.

Head of Rameses.

73 Head of Ramesses II, from James Cowles Prichard, *The Natural History of Man* (1843).

He also notes Nott and Gliddon's denial of the 'strongly marked negro type of features' of Amunoph III, for they describe 'him as a hybrid, but not of "negro intermixture"'.[71]

Douglass's attack on Nott and Gliddon in *Claims of the Negro, Ethnologically Considered*, as one might expect from such a fugitive publication, did nothing to inhibit the success of their large volume. He complains of the impact of 'the Notts, the Gliddens, the Agassiz, the Mortons', described as a 'phalanx of learned men – speaking in the name of science – to forbid the magnificent reunion of mankind in one brotherhood'.[72] In an article in his newspaper the *North Star* on 7 April 1849, he also astutely summarizes the scientific history behind the racial stereotyping of African Americans, subtly referring back to skull measurement: 'Negroes can never have impartial portraits, at the hands of white artists. It seems to us next to impossible for white men to take likenesses of black men, without most grossly exaggerating their distinctive features. And the reason is obvious. Artists, like all other white persons, have adopted a theory respecting the distinctive features of negro physionomy [*sic*].'[73] According to Douglass, such artists used science to give authority to the divisive idea of the separate creation of each race; above all they question the humanity of those of African descent by suggesting they are closer to the animal kingdom than their white racial superiors, a position fiercely rejected by Douglass.

Douglass's thoughts on art are contained in the manuscripts of four lectures on pictures kept in the Library of Congress, delivered between 1861 and 1865, that is to say during the American Civil War, which affected him greatly.[74] In practice they are not completely distinct from each other, and in their repetitions are perhaps best seen as different sketches for the same lecture. Douglass's main theme is 'that man is everywhere a picture-making animal, and the only picture-making animal in the world', and this in itself places the Negro firmly within the human race, whatever Nott and Gliddon claim: 'The rudest and remotest tribes of man manifest this great human power – and thus vindicate the brotherhood of man.' He goes on to argue poetically that 'this picture-making power accompanies religion . . . peopling the silent continents of eternity with saints, angels, and fallen spirits'; man, through image-making, gives form to all that is invisible, and 'form and body to all that the soul can hope and fear in life and in death'. By that he did not mean that humans just made paintings or drawings, but that they exercised their imagination: 'Poets, prophets, and reformers are all picture-makers – and this ability is the secret of their power and of their achievements.' However, he is not consistent in his use of the word 'art';

sometimes he clearly means physical works of art, at other times literary creations or acts of imagination.

This essentially aesthetic capability belongs not only to the educated classes but to all humanity at whatever stage of civilization they are in. In effect he anticipates a main theme in Darwin's *Descent of Man* in attributing even to so-called savages an aesthetic sense, citing Humboldt's observation of 'savage tribes of men . . . who nevertheless had coats and other garments, after European patterns, painted on their skin'. This fact, that *all* men are picture makers, 'may be safely commended to the Notts and Gliddens, who are just now puzzled with the question as to whether the African slave should be treated as a man or an ox'.[75]

Picture-making is then synonymous with the visual imagination: they are both products of the inner life, common to the savage and the child, and ways of absorbing nature in the pursuit of 'the Great Spirit of all'. Picture-making is also 'a chief element of all that is religious and poetic about us', and thus 'an important line of distinction between man and all other animals'; indeed, it is 'the highest attribute of man's nature. All that is really peculiar to humanity . . . proceeds from this one faculty or power.' But picture-making is also a means of self-formation: '[it is] the habit we adopt, the master we obey in making our subjective nature objective, giving it form, colour, space, action and utterance.'[76]

The practice of picture-making may be expressed in churches and states who 'all have their counterfeit presentments in paint', and Douglass singles out the Catholic Church as understanding 'this picture passion best', noting also that without its imagery and ceremonies 'her magical and entrancing power over men would disappear'. It is also the inner life that gave serenity to John Brown, who 'went to the gallows as serenely as other men go to church on Sunday morning'. This speaks to a belief in the almost mystical power of art: 'the love of pictures . . . is among the last to forsake us in our pilgrimage here. In youth it gilds all our Earthly future with bright and glorious visions, and in age, it paves the streets of our paradise with gold, and sets all its opening gates with pearls.'[77]

What is most unusual about Douglass's remarks on picture-making is that, though he mentions all types of media, whether it be physical image or text, at no point does he place them in a hierarchy of value – even photography, despite the controversies about its artistic status in Douglass's time, was not regarded as a lesser, separate or a merely imitative kind of art, even in relation to those practised by recognized artists. Picture-making for him is indivisible: whether it is altarpieces for the Catholic Church,

savages' painted bodies or a portrait photograph, it is a human activity and way of entering into the inner life. This immediately marks him as a person outside the world of learning in Britain, Europe and North America, where aesthetic hierarchies based on the superiority of ancient Greek sculpture over all other forms of art were inculcated in students as second nature. In fact, none of the other racial theorists discussed in this book would have had the least hesitation in proclaiming the artistic superiority of the ancient Greeks over all others. This is not to say that he was uninterested in Greek art; in fact, in later life, he owned a small collection of casts of Greek antiquities, including figures of Clytie, Mercury and Psyche as well as a Parian reduction of Hiram Powers's *Greek Slave*.[78]

He was, however, entirely aware of his outsider status in relation to classical learning. As he says, 'I have no learned theory of art to present, no rules of wise criticism to explain or enforce, no great pictures to admire, no distinguished artists, ancient or modern, to commend. I bring to the work before me only the eye and thought of a lay man.' He then claims that his 'discourse has more to do with the philosophy of art than with art itself . . . with the ideal forms of excellence floating before the eye of the spirit, rather than with those displayed upon dull canvass'.[79]

Nonetheless, Douglass's sense of art is powerfully idealistic: 'could the joy imparted by the contemplation of pictures be analyzed, it would be found to consist mainly in self tenfold much, a gratification of the innate desire for self-knowledge with which every human soul is more or less largely endowed. Art is a special revelation of the higher powers of the human soul.' It is necessary to emphasize his idealist aesthetics because almost all recent writing on Douglass has centred on his unusual commitment to photography, in which he had himself represented as a kind of icon; he was the most photographed American of the nineteenth century.

The one form of picturing that he omitted from his listing, as Henry Louis Gates Jr has pointed out, was caricature, which was so often directed towards demeaning Black people, especially in the United States. Douglass was fiercely opposed to the reductive approach of so much popular caricature, which he rightly saw as instrumental to the way that Black people were regarded in the United States. He wrote in 1870, 'we colored men so often see ourselves described and painted as monkeys, that we think it a great piece of good fortune to find an exception to this general rule', and in 1872 he complained about his own unsought-after participation in caricature: 'I was once advertised in a very respectable newspaper under a little figure, bent over and apparently in a hurry, with a pack on his shoulder, going

North.'[80] He is presumably referring to the caricature of him leaving for Canada after John Brown's raid on Harpers Ferry, in *Frank Leslie's Illustrated Newspaper* some thirteen years before, captioned 'The Way in Which Fred. Douglass Fights Wise of Virginia'. It is certainly personally disrespectful, but nowhere near as racist as so many caricatures of people of African descent from the period.

Even so, he was aware of the power of visual satire to do good as well as evil. In his 'Lecture on Pictures' of December 1861 he claims that 'As an instrument of wit, of biting satire, the picture is admitted to be unrivalled. It strikes human nature on the weakest of all its many weak sides, and upon the instant, makes the hit palpable to all beholders. The dullest vision can see and comprehend at a glance the full effect of a point which may have taken the wit and skill of the artist many hours and days.' He notes that in England '*Punch* [the most famous of satirical journals] is a power more potent than Parliament. He commands both Lords and Commons, and does not spare even Windsor Castle.' Though he laments the lack of an equivalent to *Punch* in the United States, he does note home-grown satirists' power to 'explode political shams more effectively than any other agency'. Such is its power that 'In the making of our presidents, the political gathering begins the operation, and the picture gallery ends it.'[81]

But it was photography towards which he devoted a remarkable amount of energy throughout his long career. He appears to have been unique in the nineteenth century in using photography as the starting point for his ideas of art and 'the picture-making faculty', rather than classical Greek art. He initiated a lifelong campaign of self-representation by a number of different photographers, some of whom were Black themselves. In the 'Lecture on Pictures' that took place in 1861, he spoke at some length about the importance of 'the wonderful discovery and invention by Daguerre', which had brought 'What was once the exclusive luxury of the rich and great ... within reach of all', to the extent that 'the humblest servant girl, whose income is but a few shillings per week, may now possess a more perfect likeness of herself than noble ladies and even royalty, with all its precious treasures, could purchase fifty years ago.'[82]

The main reason for his use of photography was to present himself to a wide public as a representative of African Americans in the most dignified light. Through the images of himself that he accumulated and distributed in his lecture tours around the United States – he notes that 'The smallest town now has its Daguerreian gallery' – he was able to express his own subjectivity through their variety of poses and style, demonstrating

in an easily comprehensible form that he was a fully rounded personality, in direct contrast to the two-dimensionality of the widely disseminated caricatures of his people and himself. As a contemporary put it, 'the very look and bearing of Douglass are eloquent, and are full of an irresistible logic against the oppression of his race.'[83] Photography was a way of avoiding the stereotypes that derived mainly from the scientific racism of the American ethnologists, though some refer to earlier traditions of representation. It also gave him control because, while Black artists were hard to find, there were a certain number of Black photographers who had grasped the new medium's possibilities from the beginning. Above all, the photographs of him, in both their sheer variety and the transformation they reveal throughout his long career, make a mockery of the whole idea of enslavement, which was necessarily predicated on imposing static and unchanging lives upon the slaves themselves.

What stands out in the many photographs taken of Douglass, and the care with which he had them composed, is his belief in the power of imagery and the necessity to control it; it is hard to think of anyone else in the nineteenth century who was so much invested in disseminating his

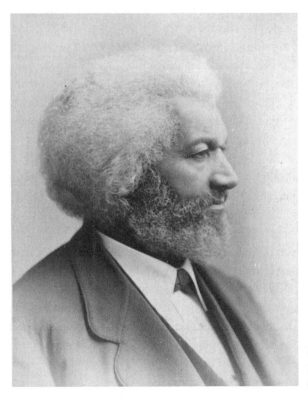

74 Frederick Douglass, 1875, cabinet card.

75 'Manefru the Proprietor', from J. C. Nott and G. R. Gliddon, *Types of Mankind*, 8th edn (1857).

own changing image. By controlling his own self-image, he distanced himself as far as possible from the idea of the slave's dependence on others. Though he was visibly of African ancestry through his frizzy hair and dark skin, in no other respect does he conform to the traditional stereotype. In fact, the beard he grew in his mature years, from the early 1850s onwards, emphasized his unusually straight and non-prognathic profile, one that in itself challenges racial science, as he well knew from reading Nott and Gliddon. Is it coincidental that the beautiful daguerreotype portrait of circa 1855 of him in full profile with neat beard in the Nelson-Atkins Museum (see later version illus. 74) would have been made around the time he had been reading Nott and Gliddon?[84] Certainly there is a clear resemblance between Douglass's profile and many Egyptian profiles in the book, but perhaps the most striking is the full-page fold-out plate of 'Manefru the Proprietor' from the sixteenth or seventeenth dynasty (illus. 75).[85] And it would have made sense at this time for him to claim kinship with the 'African' rather than the supposedly 'Caucasian' Egyptians of Nott and Gliddon.

In some ways Douglass's career encapsulates the larger themes of this study, for even in the nineteenth century he had the perception that visual representation was at the heart of the racism which had enabled and bolstered slavery. It was the visual perception of Africans and their descendants that had enabled slaveowners to force them into total subservience and

keep him there, both by controlling the apparatus of representation through racial science and by the mass dissemination of cheap and demeaning satires that reaffirmed and popularized it. But Douglass also saw that art and visual representation could be the way to redemption from slavery, beginning with the fashioning and refashioning of himself. Changing the image of African Americans was the hoped-for key to their liberation.

# 6

# Semites: Jews and the Orient

The nineteenth century represents a major turning point in European attitudes towards Jews. They had been, from the dawn of Christianity, the people of the Old Testament, whose escape from Egyptian captivity under the pharaohs into the promised land, led by Moses, was their most potent and sustaining myth. It was a story that resonated throughout other histories; the Pilgrim Fathers compared their flight from England to America to Israel leaving the bondage of Egypt, as did the founders of the American republic. Thomas Paine, in his revolutionary *Common Sense* of 1776, described George III as a 'hardened, sullen-tempered pharaoh'. African Americans were deeply attached to the story of Israel in Egypt as a forerunner of their plight and hopes, as is discussed in the previous chapter. The Jews were also the people from whom sprang the saviour Jesus Christ, though he was deemed by Christian tradition to have been condemned and denied stubbornly by them, for which they were endlessly persecuted, confined and uprooted until modern times.

During the eighteenth-century Enlightenment, Jews were seen as a collection of religious communities, who, like the Romani, had kept a uniform religious character and appearance, despite living in widely different lands and climates. Lavater in the late eighteenth century expressed traditional pre-Enlightened feelings towards Jews by challenging the philosopher Moses Mendelssohn to convert to Christianity. He imposed his own prejudices in a handwritten caption to a profile drawing of the latter with his friend the author and dramatist Gotthold Ephraim Lessing: 'Deeper, more delicate, cleverer, and more elegant, the Jew – manlier, sturdier, more cheerful, and more foursquare, livelier, Lessing.'[1]

In nineteenth-century Europe Jews increasingly had imposed on them dangerously contradictory identities. They became identified as a sinister

and unaccountable force controlling the financial system of international capitalism, through the Rothschilds and other plutocrats. But they were also seen as revolutionary socialists, intent on pulling down the social structures of every country. This is not to say that old attitudes disappeared; Jews continued to be reviled by many Christian believers owing to their refusal to recognize Jesus Christ as the Messiah prophesied in the Old Testament.

Christoph Meiners, a virulent German nationalist and supporter of the enslavement of Africans, who taught philosophy and was a colleague of Blumenbach's at Göttingen University, divided humanity into two *Stammen*, or races: the Caucasian and Mongolian, or 'beautiful' and 'ugly' races, which could include several varieties and subdivisions. The Germans, he claimed in 1790, belonged to the Celts within the larger Caucasian *Stamme*.[2] He describes them in their primitive stage in similar terms to Tacitus: blonde, blue eyed and never submissive to other peoples. Jews, on the other hand, were placed in the Mongolian *Stamme*, and described as 'Asian' along with Armenians, Arabs and Persians. Even so, Meiners does not suggest that the Jews constitute a race in itself, but only a subdivision of one, just as the Germans were a subdivision of the Caucasian race.

Ernest Renan effectively coined the word 'sémitisme' in opposition to the 'Indo-germanique' in *Histoire générale et système comparé des langues sémitiques* (The General History of the Semitic Languages, 1855), to express the close linguistic and spiritual kinship of Jews and Arabs, associating them both with the desert, in contrast to the ancient forests where Germanic Christianity was practised.[3] Judaism and Islam were both considered by Renan to be monotheistic religions that had atrophied, but he also used linguistics to argue for the basic racial unity of Jews and Arabs.

The 'Jewish race' came into existence, and then only partially, on the founding of the Antisemiten-Liga (League of Antisemites) in 1879 by Wilhelm Marr (1819–1904), who claimed that Germans and Jews were engaged in a racial struggle to control Germany. This chimed with the growing idea in the nineteenth century that the Jews were an 'Oriental' people, that is to say from the Middle East. The idea that Jews, despite their role in biblical history, were an Arabic people from a region of sexual and spiritual allure still had currency as late as the 1930s, as can be seen in Graham Greene's novel *Stamboul Train* (1932).[4]

This perceived connection between Jew and Arab is fully evident in early nineteenth-century art, for example in Delacroix's paintings and comments made on his visit to North Africa. The trip began in January 1832

as part of a diplomatic delegation under Comte Charles de Mornay, who was to make a treaty with the Sultan of Morocco at Meknes in March of that year. In a letter of 25 January to Jean-Baptiste Pierret, in which he gave his first impressions of Tangier, Delacroix was immediately struck by the exotic appearance of the Jews he saw there: 'The Jews are admirable. I feel it would be difficult to do anything but paint them; they are pearls of Eden.' He was looked after in Morocco by a key member of the retinue that visited the sultan, Abraham ben Chimol, a Jewish merchant and dragoman who was also an interpreter and advisor to visiting French dignitaries. He and the painter seem to have struck up a friendship, and the former allowed Delacroix to draw his wife and daughter, and also helped to enable his studies of Jewish ceremonies, including a wedding.

Delacroix's most important painting of a Jewish wedding was exhibited much later in the Paris Salon of 1841 at the Louvre, and it consists, as the artist tells us, of a mixed group of Jews and Muslims carousing while the bride is absent. There is, however, an earlier watercolour in a private collection, dated 28 February 1832, which shows the Jewish bride herself attended by a group of people who again seem to be made up of both Jews and Arabs (illus. 76).[5] The bride is a magnificently exotic figure, with a splendid hat as large as her face and strongly coloured garments. Everything suggests an

76  Eugène Delacroix, *Visit to a Jewish Bride in Tangier*, 1832, watercolour.

exotic world as distant as possible from France, and Delacroix himself compared the Moors to ancient Romans, implying perhaps that they belonged to an earlier stage of civilization. Through the intervention of ben Chimol, Jews allowed Delacroix into their ceremonies, and the bride was prepared to reveal her face to him. The Jews dressed differently from their Arab neighbours, but they shared, for Westerners like Delacroix, the exoticism common to the Arabic countries of the Middle East. It is also possible that Delacroix shared the views of the Swiss author Charles Didier, who wrote in 1834 of the ambiguity of the Jewess in uniting oriental splendour with European finesse.[6]

The idea of Jews as being closely allied racially with Muslims remained current throughout the nineteenth century and into the twentieth, especially in Germany, and was often referenced by Jewish thinkers and leaders themselves. This is evident from the large numbers of Moorish-type synagogues built throughout Europe and the United States in the nineteenth century and beyond. It is also expressed in Hegel's idea that both Judaism and Islam were religions of the east that were superseded by Christianity, an achievement partially of the Germanic *Volksgeist*.[7] Benjamin Disraeli, the Christian convert son of a Jewish father, began his career as a novelist before entering politics and rising to become British prime minister. In his early work *Tancred* (1847), an ambitious fantasy elucidating racial connections between the Jews and English Christians, he claimed – through his creation Sidonia, the Jewish mentor of the English aristocrat Tancred – that the Jews had been an 'Arabian tribe'; Arabs were 'only Jews on horseback'. An essay by the French historian of religion Ernest Renan of 1859 set up the 'Semitic' peoples as inferior to the 'Aryans', an attitude that the Talmudic scholar Moritz Steinschneider called for the first time in the following year 'anti Semitic prejudice'.[8]

Behind Disraeli's convoluted imperial fantasies was the traditional assumption that the Jews were the people of the Old Testament, which, in anticipating typologically the coming of Christ, provided the foundation for Christianity through the Jewish prophecies of the Messiah. Such typology was long established in European culture – the most famous example being Handel's oratorio *Messiah* – and especially in ecclesiastical art, where episodes in the Old Testament were often paired with equivalents in the New Testament. This was known as typology, and it governed the scheme for the unfinished project by Benjamin West who, on the orders of George III, was to paint a huge biblical cycle encompassing the Old and New Testaments for the Chapel of Revealed Religion in Windsor Castle,

initiated in 1780 and aborted abruptly in 1801 by the king. It was probably in connection with this project that Pieter Camper had the conversation with Benjamin West, then president of the Royal Academy, recounted in the introduction to his famous essay on the varieties of humanity: 'But there is no nation so distinguishable as the Jews. Men, women, and children, from their births, bear the characteristic marks of their race. Mr. West, the distinguished painter, with whom I have frequently conversed on the subject, confessing my inability to discover in what the national mark consists, places it chiefly in the crooked form of the nose.' It is interesting that Camper, through his translator, refers to Jews as a 'nation'.[9]

This is significant because for all of West's references to the Jewish nose, there were and are no universally agreed physical signs of difference between Jews and European or Middle Eastern peoples comparable to the skin colour of Africans. The desire was nevertheless strong in some circles in the eighteenth century to find such physical signs, as is suggested by the conversation between Camper and West. West would have been interested in having his Old and New Testament Jews conform to type, on the assumption that their physiognomy would have been consistent from biblical times to the present. But in practice, West's Old Testament Jews owe more physically to Italian Renaissance prototypes familiar from the Raphael Cartoons, which he would have known from their display in Hampton Court.

There was, however, a tradition going back to Giotto of Judas being singled out from other Jews by his red hair and yellow coat.[10] There is a representation of him in Hans Holbein's *Last Supper* of circa 1524–5, which shows a heavily distorted and scrunched-up face, with a long, hooked nose, that contrasts with the regular faces of the disciples. In a sense, the other disciples could be said to have renounced their Jewish identity by recognizing the Saviour, but Judas held onto his by his rejection of Christ and was therefore differentiated physically. It is interesting that Lavater reproduced this head in the editions of *Essays on Physiognomy* as a direct contrast to the face of Christ, and that the English translation mentions its 'Jewishness' (see illus. 3). Lichtenberg, who sharply debunked some of Lavater's published racist comments, pointed out that if Judas really did look like that he would not have passed as one of the disciples.[11] West also seems to have singled out Judas as different in stance and attitude from the other disciples in the large version of the *Last Supper*, now in the Detroit Museum of Fine Arts but originally commissioned by George III for Windsor Castle (illus. 77). Judas is the very large figure in the foreground with his head in

77  Benjamin West, *The Last Supper*, 1786, oil on canvas.

his hand, as in the Holbein, and though his face is partly covered he looks balefully and menacingly towards the spectator, in contrast to the open countenances of the disciples.

Holbein's image of Judas by way of Lavater seems to be behind the infamous caricatures of Jews in the Nazi periodical *Der Stürmer*, though there are differences. They share the long, hooked nose, the weak chin and the scrunched-up face, but in Nazi examples 'the Jew' shares a prognathism with those skulls in Camper's series that are more proximate to the ape, and the forms that make up the face are curvilinear and jowly, as opposed to both the Lavater image after Holbein and the sharp-edged Apollonian profile of the pure Aryan who confronts 'the Jew'. This type of physiognomic contrast between Jew and gentile, undoubtedly based on a reading of Lavater and possibly Camper, first appears in a caricature by the Hanoverian artist Johann Heinrich Ramberg (1763–1840). He was then based in London, where he became a follower of the great caricaturists Rowlandson and Gillray. It is a caricature of Lord George Gordon, a Scottish aristocrat and fervent anti-Catholic who led the 1780 Gordon Riots and disappeared shortly afterwards. After some years on the run, he reappeared in Birmingham as a Jewish convert and was imprisoned in Newgate, where he was served kosher food and occasionally serenaded by a Scottish piper. In Ramberg's caricature *Moses Chusing His Cook* of 1788/1803, and especially in the preliminary drawing (illus. 78), Gordon's

emphatically straight profile is contrasted with the broadly prognathic faces of the Jews seeking to be employed by him, who also have large and varied beards.

Jews were the subject of many caricatures across all European countries in the nineteenth century. A long, sharp face, which may owe something to the Lavater–Holbein Judas, is common to many of Thomas Rowlandson's caricatures of Jews, but the pointed rabbinic beard and the clothing define the Jew more than physiognomy. There are two dominant tropes of English anti-Jewish caricature in the nineteenth century: the sharp-faced, bewigged moneylender and the itinerant pedlar, who is very often shown carrying a bag with items for sale and a number of hats stacked on his head. Just as Edinburgh lawyers and intellectuals were parodied in eighteenth-century English caricature as primitive Highland paupers in rags and tatters, so the wealthy Jewish banker Nathan Mayer Rothschild was shown by 'A Sharpshooter' in 1829 as a Jewish pedlar, his face barely caricatured, with a bag over his shoulder containing 'French Rentes £20,000' and more than one hat on his head (illus. 79).

A baker in his shop in the background of Géricault's great lithograph *Pity the Sorrows of a Poor Old Man!* (1821, illus. 80), from the *London* series, appears to be a Jew on account of his long nose and overbearing posture;

78  J. H. Ramberg, *Moses Chusing His Cook*, 1788, preliminary drawing.

79  John Phillips (pseud. A. Sharpshooter), *The Man* [Nathan Mayer Rothschild]
*Wot Knows How to Drive a Bargain*, 1829, coloured etching.

he is evidently behaving rapaciously towards a poor woman buying bread
from him. As the nineteenth century progressed such a nose became increas-
ingly regarded as a defining feature of the Jew, and was central to attempts
by physiologists to define Jewish physiognomy in typological terms. In
Eden Warwick's *Notes on Noses* (1864), 'The Jewish Nose' is given its own

class, IV, between 'The Cognitive, or Wide-Nostrilled Nose' – which is effectively the Anglo-Saxon ideal – and 'The Snub and the Turn-up', otherwise 'The Celestial Nose', which is associated with the Irish and signifies insolence and weakness (illus. 81). 'The Jewish or Hawk Nose is convex, and preserves its convexity like a bow, throughout the whole length from the eyes to the tip.' This is, of course, in the tradition of nineteenth-century physiology, associated with the specific character of all Jews: 'It indicates considerable Shrewdness in worldly matters; a deep insight into character, and facility in turning that insight to profitable account.'[12]

The Hawk Nose can be seen clearly in George Cruikshank's depiction of Fagin in his illustrations to Dickens's *Oliver Twist*. Fagin is shown in profile in 'Oliver's Reception by Fagin and the Boys' (illus. 82) with a long, hooked nose that is broadly parallel to his low forehead, and the sharpness of the face is emphasized by a protruding rabbinic-looking beard. His physiognomy and his round-shouldered stance, contrasting with the upright postures of the boys, only emphasizes his inherent racial difference. Eden Warwick contrasts Fagin's Hawk Nose with Oliver Twist's 'fine Greek Nose', while the Artful Dodger and his criminal pals have 'characteristic Snubs and Celestials'.[13]

80 Théodore Géricault, *Pity the Sorrows of a Poor Old Man!*, 1821, lithograph.

It would not have occurred to a painter of West's generation to go to the Holy Land itself in pursuit of real Jews to achieve the kind of authenticity he sought for his biblical paintings. This practice seems to have been initiated by the Scottish painter David Wilkie (1785–1841), who in his last years pursued what he saw as a distinctively Protestant approach to biblical subjects, a conscious alternative to the Catholic domination of such iconography. As he noted as early as 1827, 'it was left for painting, with all its undefinable powers over colour and form, over light and darkness, to represent the mysteries of a spiritual revelation. The art of painting seems made for the service of Christianity; would that the Catholics were not the only sect who have seen its advantages.'[14] In going to the Holy Land he would be able to lay an authentic foundation for a modern iconography of Christ: 'a Martin Luther in painting is as much called for as in theology, to sweep away the abuses by which the divine pursuit is encumbered.'[15]

Wilkie's time in the Holy Land was, in the end, cut short. He was stranded for three months in Istanbul from October 1840, finally moving on in January 1841 to reach Jerusalem, where he made studies of Jewish life and ritual for unfinished and lost paintings of the *Nativity*, *Ecce homo* and the *Supper at Emmaus* before dying on his passage home. His main focus in Jerusalem was on the Jewish way of life, and he made sketches of groups of Jews praying at the Wailing Wall (illus. 83). Though he had painted a caricatured Jewish shopkeeper in the background of the *Chelsea Pensioners*, in his Jerusalem sketches he shows unusual sympathy not only for the Jews of Jerusalem but for those from Eastern Europe whom he had met on the ship to the Holy Land. The Jews at the Wailing Wall are shown very much

81 Illustration on the title page of Eden Warwick, *Nasology* (1848).

82 George Cruikshank, 'Oliver's Reception by Fagin and the Boys', frontispiece to Charles Dickens, *Oliver Twist; or, the Parish Boy's Progress*, vol. 1 (1838).

as 'Oriental', but there is great humanity in their sorrow and regard for each other. It is also interesting that he had in mind for the figure of Christ the Persian scholar and poet Halaku Mirza, whom he had met in Istanbul.[16] Had he lived to incorporate his experiences of the East into his biblical paintings, the works clearly would have been very different from the Catholic tradition.

William Holman Hunt (1827–1910) is the nineteenth-century artist most associated with incorporating 'real' Jews from the Holy Land into his painting. He was thoroughly steeped in the Old Testament and the Talmud, and his reasons for going to Palestine and the painterly results are notably more complex than Wilkie's; they relate to the particular ferment in the Church of England from the mid-nineteenth century onwards.[17] Holman

83  David Wilkie, *Jews at the Wailing Wall*, 1841, oil and pencil on board.

Hunt sought real religious change through his art, and like Wilkie he tried
to promote his version of Christianity by a greater authenticity in his depic-
tion of biblical subjects, representing not only the land of the Christian
revelation but the people from whom Jesus Christ emerged. In this, he
followed the common assumption of the time that the Jews of Palestine
were essentially unchanged from biblical times. The question that exercised
contemporary theologians, and Holman Hunt himself, was the relation-
ship of Christianity to the Old Testament. For many such Christians,
Christianity was seen as a spiritual renewal of Judaism in the face of its
degeneration; its Jewish roots were undeniable.

Holman Hunt grasped this theological connection most eloquently
in his famous painting *The Light of the World* of 1851–2 (illus. 84), which
shows Jesus knocking on a long-closed door that represents the human
soul. He is dressed in garments that clearly show him as a Jewish High
Priest, with what Hunt himself called 'the sacerdotal vestment, the priestly
office, &c.', and above all the clasp on his cloak, in which 'the Israelitish and
Gentile breast-plates [are conjoined].'[18] This allegorical representation of
the theological connection between Christianity and Judaism is an illumi-
nating contrast to the closely studied depiction of Jewish life in Jerusalem
in his extremely complex painting *The Finding of the Saviour in the Temple*

84 William
Holman Hunt,
*The Light of the
World*, 1853,
oil on canvas.

of 1856–60 (see illus. 66), which shows the youthful Jesus embraced by his mother after disputing with the rabbinic elders in the Temple.

These elders are shown as being very near to antisemitic caricatures. This would be in line with Holman Hunt's tendentious observation that 'Rabbis live in secret luxury. Keeping the poor continually croaking to procure further subscriptions,' and his suggestion that Jerusalem's multi-cultural society was 'accursed'. Yet there are some younger Jewish observers who are not caricatured, and they were evidently taken not from observation in Jerusalem but from models he found in Jewish schools in London. The figure of the boy Jesus was derived from several London models, some Jewish and some Christian.[19]

Hunt found Jews in Jerusalem generally resistant to being painted; he claimed they 'got the idea that the picture was destined to be put up in a church and worshipped'. He was forced to enlist missionaries and the distinguished Anglo-Jewish philanthropist Sir Moses Montefiore to persuade the rabbinate to let him paint them. Hunt came to his task with resentment towards Jews for not converting to Christianity, seeing them as a 'fallen' race, but whose salvation could be an antidote to the current crisis of faith in the Anglican church. In general, Hunt's attitudes towards Jews were, like so many of people in the nineteenth century, full of contradictions, a mixture of what Albert Boime has called 'admiration, fascination and prejudice'.[20]

The painters' response to Jews demonstrates the complexity of their inheritance. For painters, particularly those of historical subjects, they were still, as they had been in earlier centuries, representatives of the Old Testament and its complicated relationship to Christianity. For painters like Delacroix, Wilkie and Holman Hunt they were also indelibly associated with the Middle East, and therefore non-European in origin. But there was an increasing awareness that they also had a European presence, as immigrants to Britain from Eastern Europe, though many prominent Jews from different parts of the world chose to emphasize their roots in the 'Holy Land'.

PART IV

# CHARLES DARWIN: EVOLUTION AND THE AESTHETICS OF RACE

## 7

# The Aesthetics of Evolution: Race, Beauty and Ugliness

> Judging from the hideous ornaments and the equally hideous music admired
> by most savages, it might be argued that their aesthetic faculty was not so
> highly developed as in certain animals, for instance, in birds.
>
> CHARLES DARWIN, *The Descent of Man* (1871)[1]

I n Charles Darwin's *Descent of Man*, when for the first time he openly
brought mankind into the framework of his idea of evolution, the first
part is given over to 'The Descent or Origin of Man' and is about natural
selection, ending with the chapter 'On the Races of Man'; the second and
third parts are entirely about sexual selection, the former discussing the
animal kingdom and the latter devoted to 'Sexual Selection in Relation
to Man'. Darwin's ideas of sexual selection are particularly relevant to
the present enquiry because they involve both race and aesthetics. The
reason that Darwin developed a theory of sexual selection has everything
to do with his conception of the aesthetic faculty. Darwin derived much
from Knox and the American ethnologists, but he disagreed with them
on many fundamental issues, including their belief in the permanence
of racial characteristics – that each race had visible features, such as skin
colour, distribution of bodily hair and skull shape, that could be seen as
continuing from antiquity and especially from the world of the ancient
Egyptians.

Natural selection could account for those characteristics that helped
the survival and transformation of species and of human races, but it did
not explain their relative stability over millennia. Without this stability,
which ensured the endurance of recognizable types by mating within each
species or race, the world would have been inhabited by inchoate hybrids

without a coherent identity, rather like Odilon Redon's vision of randomly mixed creatures preceding the formation of humanity in his series of lithographs *Les Origines* (1883).[2] Goethe and German Romantic scientists had postulated that there was an archetype for all plants and animals, an *Urpflanze* or an *Urtier* respectively, for each species to provide stability for itself, but did not explain, at least in scientific terms, how species came about. For Darwin this stability could only be achieved by a sexual mechanism that confined mating within a particular race or animal species to ensure the transmission of relatively uniform characteristics.

If, say, the Fuegians, who were in Darwin's time and earlier a byword for 'savagery', were habitually sexually attracted to Europeans or people of other races, then their distinctive features would have died out within a few generations, so there must be something about their appearance that had a unique attraction to other Fuegians. The same must also apply to Europeans and all other peoples, and of course within the animal kingdom. Darwin was well aware that sexual attraction, based on a perception of the beauty of the opposite sex, had very often taken place across racial borders, especially in colonial settings where native women were regarded as fair game for sexual exploitation, but this does not affect his belief in the relative stability over time of the characteristics of races and species, which can be observed in the immense variety of both throughout the world.

Nor did this sense of relative stability affect the making of aesthetic judgments by white observers of other races and peoples, who could be placed in a hierarchy in which their relative beauty was correlated with their place on the ladder of savagery–civilization, always with the assumption that Europeans set the standard. One of the earlier attempts by a natural scientist to provide a comparative assessment of peoples previously unknown to Europeans can be found in the German biologist and traveller Johann Reinhold Forster's *Observations made during a Voyage Round the World*, published in 1778. This work is based on his presence on Captain Cook's second expedition to the South Seas, with his son Georg Forster, whom we have encountered already challenging Kant's racial categories and as a close friend and mentor of Alexander von Humboldt.[3] The elder Forster, whose view of the world was quite different from his son's, claimed to have contemplated the islands and their inhabitants with 'a philosophical eye' and described them 'by adverting to their different degrees of civilization'. Behind this was an implied criticism, in the name of methodical observation, of the French explorer Louis-Antoine de Bougainville's idyllic view of the islanders.

In a long section in his *Observations* titled 'On the Varieties of the Human Species', J. R. Forster divides the peoples of the South Seas into two 'varieties or races', placed on a scale according to their level of 'civilization' or 'animality', but his main criterion is aesthetic: of the first 'race', Tahitian men, 'The features of the face are generally, regular, soft, and beautiful', while the women have an 'uncommon symmetry . . . The arms, hands, and fingers of some are so exquisitely delicate and beautiful, that they would do honour to a Venus of Medicis.'[4] The inhabitants of the Friendly Isles are next in line; the men have 'not the most pleasing features', and the women 'are not quite disagreeable'. However, it goes without saying that even the Tahitian women must yield in beauty to 'Britannia's fair daughters'. The 'second race' is of inferior beauty but is also lower in the level of civilization. The women of Tanna are 'ill favoured, nay, some are very ugly', and in Mallicolo they are 'the most wretched savages, removed but in the first degree from absolute animality', though as a believer in Natural Religion J. R. Forster admits that although 'they border the nearest upon the tribe of monkies', they are still fully human.[5]

Accompanied by his son, Forster also spent some time on his voyage with Cook in Tierra del Fuego (as famously did Darwin in 1832–3), whose inhabitants he describes in similar terms to the Mallicolese, in a way entirely compatible with Darwin's view of them at the time of his visit: 'All have a countenance announcing nothing but their wretchedness . . . Human nature appears no where in so debased and wretched a condition, as with these miserable, forlorn, and stupid creatures.' He also describes their physical features: 'We found them to be a short, squat race, with large heads; their colour yellowish brown; the features harsh, the face broad, the cheek-bones high and prominent, the nose flat, the nostrils and mouth large, and the whole countenance without meaning.'

J. R. Forster's implicit concern to uphold the distinction between animal and human, and his relatively unsystematic view of race and variety, mark him as a man of the eighteenth century, but the interchangeability between personal beauty and level of civilization continued to resonate throughout the nineteenth century, both in harmony with and in opposition to ideas of evolution. There is a continuity, as Evelleen Richards has observed, from Forster's ranking of the inhabitants of the South Seas, and particularly his account of the Fuegians, to Charles Darwin in Tierra del Fuego on the *Beagle* voyage in 1832–3 feeling a comparable disgust towards them (illus. 85).[6] Darwin describes them as 'hideous savages', belonging to the lowest levels of humanity, along with the Khoikhoi of South Africa and Australian Aborigines.

85 Watercolour of a native from Tierra del Fuego, painted by Conrad Martens when he and Charles Darwin visited the area during the voyage of HMS *Beagle* (1832–4).

It is clear that Darwin had read Forster's book and was thoroughly versed in the history and literature of racial science. In fact, he cites all the major racial scientists of the time in *The Descent of Man*, from Cuvier, Prichard, Lawrence and Knox to Broca in France, and Nott and Gliddon and Agassiz in the United States. It is arguable that Darwin's whole intellectual formation was conditioned by his reading of contemporary texts in

which ideas of race were discussed as a vital part of the understanding of human beings' place in the natural history of the world. Though he had serious reservations about aspects of racial science and some of its practitioners, he was completely at home in its world, where European superiority in morality and intellect was a given; skull measurement was regarded as an exemplary scientific method of comparative analysis; size of brain was an index of intelligence; and there was a clear hierarchy from 'savage' to 'favoured' races.

Darwin read Knox's *Races of Men* after its publication in 1850, and he clearly took it seriously, but their views on race were very different. Darwin had known Knox as a charismatic presence at Edinburgh University in his student days in 1825–7, but his natural bent was much more towards the more liberal views of Prichard, though he moved well beyond the latter's unequivocal creationism. Unlike Knox, who argued for the absolute separation of the races, it is central to Darwin's mature evolutionary thought that 'even the most distinct races of man are much more like each other in form than would at first be supposed', though he does rather spoil it by adding 'certain negro tribes must be excepted'.[7]

In Darwin's earlier career it is evident that his attitudes towards racial difference were unresolved, but he clarified them as his career progressed. What remained constant, however, was his sense of biological and mental differences among races. In *The Descent of Man*, he claims:

> There is, however, no doubt that the various races, when carefully compared and measured, differ much from each other – as in the texture of the hair, the relative proportions of parts of the body, the capacity of the lungs, the form and capacity of the skull, and even in the convolutions of the brain . . . Their mental characteristics are likewise very distinct; chiefly as it would appear in their emotional, but partly in their intellectual faculties.[8]

He also noted, perhaps looking back to Linnaeus on the humours, that different races had contrasting temperaments, for example between 'the taciturn aborigines of S. America and the light-hearted talkative Negroes'.

Darwin's notes on Knox's *Races of Men*, made in 1856, contain his first reference to the concept of 'sexual selection'. It appears in comments on the fixity of races in very different climatic conditions, in which he notes 'The slowness of any changes explained by constitutions [*sic*] selection & sexual selection'.[9] Change was thus inexorable, but slowed down by natural

selection and sexual selection, by which he means the preference for mating with people of the same race through a process of aesthetic choice of persons of the opposite sex, who attract through the beauty of their persons or attributes. The notes show that he was taken with Knox's argument that races can retain the same character for centuries, even millennia: Africans can be clearly identified in the earliest art of the Egyptians, and they can, like Gypsies and Jews, keep the same physical features in widely different territories and climates. But for Darwin it was also necessary for evolution that races *could* change and merge, even if over an almost inconceivable length of time.

Though Darwin accepts an inherent preference for and attraction towards one's own race, he decisively rejects Knox's conventionally absurd arguments against the viability of mixed races, pointing out that 'In Brazil he would behold an immense mongrel population of Negroes and Portuguese,' and, in the same continent, 'most complex crosses between Negroes, Indians and Europeans'. From this he deduces that the races of mankind are not sufficiently distinct to inhabit the same country without fusion, and 'the absence of fusion affords the usual and best test of specific distinctness'. What is more, races are not uniform within themselves; 'savages, even within the limits of the same tribe, are not nearly so uniform in character, as has been often asserted' and – something that Blumenbach had pointed out – 'the shape of the skull varies much in some races'. Darwin concludes that 'the most weighty of all the arguments against treating the races of man as distinct species, is that they graduate into each other'.[10] In this he was invoking, consciously or not, Buffon's eighteenth-century ideas of race.

Darwin's hostility to the idea of separate creations based on racial difference, deriving from his reading of Prichard, made him an opponent of Agassiz, and he had particular objections to the latter's essay in *Types of Mankind*, to which he attached a note that reads 'oh pro pudor Agassiz!' (Oh for shame, Agassiz!). He also added a note to the volume in which he claims that it is irrelevant to him as to whether races are or are not called species or variations, as long as the principle of common ancestry is maintained: 'I shd look at races of man as deserving to be called distinct species, yet I consider as descended from common stock, so come back at common belief; only difference is name whether to be called species or variations.'[11]

He gives a further intimation of the nature of sexual selection by asking, rhetorically: 'What effect wd idea of beauty have on races and education[?] [I]t wd tend to add to each peculiarity. V. our aristocracy.' The reference to aristocracy came from the idea that it was self-perpetuating

and – so it was generally believed – maintained high standards of physical beauty through marital choice. His concern with the aesthetic differences between races could also have been, as Richards argues, prompted by the aesthetic hierarchy implicit in the illustration to Nott and Gliddon – citing and reproducing the page derived from Virey and ultimately from Camper and Cuvier – that features the *Apollo Belvedere*, 'Negro' and 'Young Chimpanzee' in a descending sequence, but in fact neither Nott and Gliddon, nor Agassiz, made nearly as much of the aesthetic differences of racial types as Knox, who had what they lacked: a strong grounding and interest in classical art and aesthetics. It seems likely, therefore, that the connection between beauty and marital choice was derived more from a reading of *Races of Men* than *Types of Mankind*. It is true that the latter work comments on the ugliness of 'Western Africans' and especially the 'Hottentot and the Bushman', but there is little sense of the idea of aesthetic beauty and its history in the writings of the American ethnologists; in fact they only allow two pages for its discussion, with line engravings of Greek monuments taking up some of the space.[12]

Darwin, in rejecting Knox's strictures against racial mixture, cites Broca in opposition to Nott and Gliddon to claim that 'Europeans differ but little from Jews who belong to the Semitic stock.' He notes that colour of skin is the most conspicuous marker of difference, but it is not influenced by climate or place. Nonetheless, way of life can affect appearance by the transmission of acquired characteristics: 'With civilized nations, the reduced size of the jaws from lessened use – the habitual play of different muscles serving to express different emotions – and the increased size of the brain from greater intellectual activity, have together produced a considerable effect on their general appearance when compared with savages.'

How far did Darwin buy into the ideas of the skull initiated by Camper and developed by Cuvier and by his own contemporaries in Britain, France, Germany and the United States? We have seen that he followed Blumenbach in rejecting the uniformity of skulls within each race, but in *The Descent of Man* he does accept that the size of the human brain is connected with intellectual prowess: 'No one, I presume, doubts that the large proportion which the size of man's brain bears to his body, compared to the same proportion in the gorilla or orang, is closely connected with his higher mental powers.'[13] Furthermore, he accepts the idea, derived ultimately from phrenology, that the frontal part of the skull is 'the seat of intellectual faculties', and that intellectual progress happened over time,

as the frontal part of the skull in the general population increased in size over the centuries, noting that 'Professor Broca found that the nineteenth-century skulls from graves in Paris were larger than those from vaults of the twelfth century, in the proportion of 1484 to 1426.'[14]

Race was a constant preoccupation for Darwin from his first encounter with the 'savage' natives of Tierra del Fuego: 'These were the most abject and miserable creatures I anywhere beheld . . . stunted in their growth, their hideous faces bedaubed with white paint.'[15] Note that in this remark he comments on their deviation from a normal height ('stunted') and on their physiognomy in aesthetic terms ('hideous faces'), but he also notes the adornment they have applied to their bodies ('bedaubed with white paint'). Yet he was aware of three Fuegians whom he met who had been 'cleaned and sent to England to be "civilized"', and had returned to Tierra del Fuego when Darwin was there. But – and this is significant for his future theory of sexual selection – he notes that it was necessary for Fuegians, and others at the same evolutionary stage, to be attracted to their own kind for the sake of their evolutionary survival.

Darwin was thus clear that the Fuegians could be 'converted' to a more civilized way of life. Fitzroy, the *Beagle*'s captain, was a missionary, and had the three Fuegians sent to England where they were converted to Christianity and inducted into 'civilized' ways with some success, as Darwin observed, recalling that time in 1871 in *The Descent of Man*: 'the Fuegians rank among the lowest barbarians; but I was continually struck with surprise how closely the three natives onboard H.M.S. "Beagle," who had lived some years in England, and could talk a little English, resembled us in disposition and in most of our mental faculties.'[16] If the Fuegians were, according to the idea of evolution, like our distant ancestors, the barrier between them and educated Englishmen may have been initially enormous, but not insuperable with the passage of a long stretch of evolutionary time. As Darwin put it:

> nor is the difference slight in moral disposition, between a barbarian . . . and a Howard or Clarkson; and, in intellect, between a savage who uses hardly any abstract terms, and Newton or Shakespeare. Differences of this kind between the highest men of the highest races and the lowest savages, are connected by the finest gradations. There it is possible they might pass and be developed into each other.[17]

This lack of an absolute barrier between the animal, the savage and the civilized was expressed also in the aesthetic faculty, which was in varying degrees shared by animals – even down to the glow worm – savages and civilized men:

> the taste for the beautiful, at least as far as female beauty is concerned, is not of a special nature in the human mind; for it differs widely in the different races of man, and is not quite the same even in the different nations of the same race. Judging from the hideous ornaments, and the equally hideous music admired by most savages, it might be urged that their aesthetic faculty was not as highly developed as in certain animals, for instance, as in birds.[18]

As he also remarked, 'Heavens at night, a beautiful landscape or refined music' are appreciated through culture and are not 'enjoyed by barbarians or uneducated persons'.

The Fuegians remained at the centre of Darwin's thoughts from the voyage of the *Beagle* in the early 1830s until *The Descent of Man* in 1871, because they stood at the confluence of many of the debates surrounding Darwin's theories of evolution. One of the most contentious points, which attracted the most dissent among his contemporaries, came precisely at the point of the emergence of humanity from the animal kingdom. Apart from Christians who stood by a literal belief in the biblical account of the creation, scientists like Alfred Russel Wallace believed strongly in evolution but still felt that man, with his brain power, moral consciousness and mastery of language, could not simply have emerged from the simian world without the intervention of some kind of deity.[19]

The intermediate stage for Darwin between the ape and the civilized Englishman was 'the savage', who was initially close to the animal kingdom but could over many generations gradually became 'civilized' through a process of natural selection. The savage was both an 'ancestor' of the civilized and a relatively recent descendant of the ape. But it was necessary for Darwin's theory of natural selection that apes, and indeed all of the animal kingdom, had, even in vestigial form, human-like feelings and moral and aesthetic senses previously thought to separate mankind from the animal. The question for Darwin was: was the Fuegian, in all his savagery, a throwback to the early existence of mankind, bearing in mind that 'The ancestors of man were, no doubt, inferior in intellect, and probably in social disposition, to the lowest existing savages'?

In *The Descent of Man* Darwin first established publicly the physical continuity between man and animals – 'man bears in his bodily structure clear traces of his descent from some lower form' – something he had only hinted at in *The Origin of Species* but was taken for granted by readers of the time as a consequence of evolution. He then argues that although mental and moral nature is similar in form between animal and man, it is different in degree; reason, imagination and social instincts can be found in animals, and even speech has its equivalent, but obviously in much less developed forms. Savages act as a link between animals and cultivated Europeans, but there is still a difference in social, moral and intellectual qualities, particularly between the last two. Savages – and he is once again thinking of Fuegians here – lacked the capacity for abstract thought, and were greatly inferior to 'a Newton or Shakespeare'; indeed, the mental and moral capacities of savages could be scarcely greater than animals. He even compares a savage's belief that natural objects are animated by spirits with a dog barking at a parasol in a breeze, as if 'movement without any apparent cause indicated the presence of some strange living agent'. Dogs are thus a short step from the Australian Aborigine, 'who uses hardly any abstract words and cannot count above four'. The comparison between an illiterate and innumerate savage and Newton echoes a passage in Lavater in which the latter makes a similar point.[20]

Darwin also noted in *The Descent of Man* the wide variety in the number of races identified by the most famous authorities on the subject, and once again the Fuegians are key to his argument, though with a different emphasis from his earlier comments on them:

> The American aborigines, Negroes and Europeans are as different from each other in mind as any three races that can be named; yet I was incessantly struck, whilst living with the Fuegians on board the 'Beagle', with the many little traits of character, shewing how similar their minds were to ours; and so it was with a full-blooded negro with whom I happened once to be intimate.[21]

He notes also the 'close similarity between the men of all races in tastes, dispositions and habits . . . shown by the pleasure they all take in dancing, rude music, acting, painting, tattooing, and otherwise decorating themselves'. Humanity reveals its common origins, particularly by comparison with monkeys, in the fact that stone arrowheads are found all over the world, as is fire-making.

Natural selection was premised on the idea that the biology of the human body was conditioned by the need for survival in a hostile world, something that only the fittest could achieve in the long term. Did racial differences come about as a means to promote the survival and development of humanity, or, as Wallace argued, act as a form of protection from predators? In *The Descent of Man*, Darwin drew the momentous conclusion that they did not:

> none of the differences between the races of man are of any direct or special service to him. The intellectual and moral or social faculties must of course be excepted from this remark. The great variability of all the external differences between the races of man, likewise indicates that they cannot be of much importance; for if important, they would long have either been fixed and preserved or eliminated.[22]

He deduces therefore that racial difference is to be explained not as contributing to the survival of human beings, but as part of sexual selection, to which he devotes the later and lengthier part of *The Descent of Man*, signalled in the subtitle *Selection in Relation to Sex*: 'the differences between the races of man, as in colour, hairiness, form of features, &c. are of a kind which might have been expected to come under the influence of sexual selection.'[23]

Evelleen Richards has argued that Darwin's racial aesthetics was fundamental to his ideas of sexual selection, and has seen a continuity between the Fuegians at the bottom of the ladder of civilization with educated Englishmen like himself on the top, and the development of the theory of sexual selection, based on the visual perception of beauty, where females of all species, including the human, compete through display to seduce males and thus procreate successfully. The theory also requires animals of all kinds to have at least a vestigial aesthetic sense, an idea alien to creationists and those who associated beauty with the divine.

Darwin notes that a sense of beauty has been declared to be peculiar to mankind: 'I refer here only to the pleasure given by certain colours, forms and sounds, and which may fairly be called a sense of the beautiful; with cultivated men such sensations are, however, intimately associated with complex ideas and trains of thought.' But he also notes that the male bird displays plumes or colours before the female, so that she can admire the beauty of her male partner, and this is analogous to the mating rituals of

contemporary women: 'As women everywhere deck themselves with these plumes, the beauty of such ornaments cannot be disputed.' This implies a difference between the animal kingdom and human beings in terms of gender and aesthetic response. Aesthetic display to attract the opposite sex is associated with the male in the former and the female in the latter; it is the human female who adorns herself to attract the sexual attentions of the male, ironically often by adorning herself with peacock feathers, the prime example of male display in the animal kingdom.

As Jane Munro has pointed out, the effect is to anthropomorphize birds themselves, giving them human-like emotions and forms of courtship that are positively Victorian. They 'fall in love', become 'eager wooers', sing 'melodious love-songs' and 'pay court' to potential mates.[24] Despite challenges from Wallace, who argued that plumage was to do with protection rather than attraction, Darwin claimed to have proved that a sense of beauty is associated with mating in animals, especially birds: 'If female birds had been incapable of appreciating the beautiful colours, the ornaments, and the voices of their male partners, all the labour and the anxiety exhibited by the latter in displaying their charms before the females would have been thrown away.'[25]

The transformation as humans evolve from the animal, from female to male sexual choice and female subservience to it, is based entirely on Darwin's claim for male superiority, expressed in greater physical strength and a larger brain that enabled the exercise of rationality and the imagination.[26] The process by which the change supposedly came about is never explained, and is perhaps the weakest link in Darwin's argument for sexual selection, as was frequently pointed out at the time. But it is entirely compatible with Robert Knox's elevation of the goddess in Greek sculpture, the *Venus de Medici*, as the ultimate locus of the highest beauty, rather than the *Apollo Belvedere*. To Knox, women were simply 'more beautiful than men', and in Darwin's comparison between men and women there is an echo of Edmund Burke's contrast between the Sublime and Beautiful in his book of the same name, which we know Darwin read around the same time as Reynolds's *Discourses*.[27]

According to Darwin, a universal element in all perceptions of beauty is to be found in a liking for symmetry. It is prized by animals, birds, savages and the civilized alike: 'the eye prefers symmetry or figures with some regular recurrence. Patterns of this kind have been developed by even the lowest savages as ornament.'[28] But Darwin – unlike Knox, who saw ancient Greek sculpture as the highest expression of all mankind embodied in the

marble figure of Venus – challenged the idea of a single universal standard of beauty: 'the taste for the beautiful, at least as far as female beauty is concerned, is not of a special nature in the human mind; for it differs widely in the different races, and is not quite the same even in the different nations of the same race.' On the other hand, he continues to insist on privileging the taste of educated people such as himself over 'savages': 'Judging from the hideous ornaments, and the equally hideous music admired by most savages, it might be urged that their aesthetic faculty was not as highly developed as in certain animals, for instance, as in birds.' Savages in particular are seen as fetish worshippers who 'imagine natural objects [to be] animated by spiritual or living essences'.[29]

Where did Darwin get this idea of the relativity of beauty according to race? Richards is clear that he read Joshua Reynolds's *Discourses*, written from 1769 to 1790, in 1838, and derived from him both a belief in a single (Western) idea of beauty, centred on such canonical works as the *Venus de Medici* and the *Apollo Belvedere*, and a certain relativism that derives from the belief that beauty is a property of the mind rather than contained within objects. Nonetheless Reynolds accepts the existence of a 'secondary' beauty, allied to fashion, the particular and 'deformity'. In an earlier essay in *The Idler*, which Darwin almost certainly read, Reynolds also accepts that different cultures might also have different standards, though this is not to deny the superiority of the classical canon: 'It is custom alone determines our preference for the colour of the Europeans to the Ethiopians, and they, for the same reason, prefer their own colour to ours. I suppose nobody will doubt, if one of their painters were to paint the Goddess of Beauty, but that he would represent her black, with thick lips, flat nose, and . . . he would act very unnaturally if he did not.'[30] Such aesthetic relativism is sometimes expressed in the eighteenth century, as in Joseph Spence's *Crito* (1752), which also claims that Europeans and Africans have different standards of beauty. As Darwin remarked in a notebook, presumably shortly after reading Reynolds: 'we have our notion of beauty & negroes another,' though he is in no doubt of which one is preferable.[31]

Darwin's final and fully considered account of the Fuegians in *The Descent of Man*, though still full of contempt, marks a significant change from his account at the time of his confrontation with them on the *Beagle* voyage. He focuses now on the vulgarity of their self-presentation – in other words, on decisions made according to their own aesthetic judgement. 'Civilized' man's descent from savages such as the Fuegians remained

problematic to him. As he noted in the last pages of *The Descent of Man*, 'The astonishment which I felt on first seeing a party of wild Fuegians . . . will never be forgotten by me . . . such were our ancestors. These men were absolutely naked and bedaubed with paint, their long hair was tangled, their mouths frothed with excitement, and their expression was wild, startled, and distrustful.' He would 'rather be descended from monkeys and baboons as from a savage who delights to torture his enemies, offers up bloody sacrifices, practices infanticide without remorse, treats his wives like slaves'. It is significant that he no longer describes their features as 'ugly in themselves'. Their savagery is not expressed in their physique or physiognomy, but in their *choice* of nakedness, their forms of display and their behaviour; that is, the consequences of their own aesthetic judgement applied to their bodies.

The very idea of an aesthetic faculty that can exercise judgement, which Darwin attributes to the Fuegians as well as to all other creatures whether animal or human, was first described as separate from cognition by K. P. Moritz and Kant, but it was still a live issue in Darwin's mature years.[32] This was because of the influential idea that art should be promoted for 'art's sake', which goes back ultimately to a reading of the latter German philosopher. It was very much current in the late 1860s and '70s, associated with the poet Algernon Charles Swinburne and with the paintings of Dante Gabriel Rossetti and James Abbott McNeill Whistler. The idea also carried with it the unspoken implication that the disinterested appreciation of art was a mark of the highest level of civilization, distinguishing those who possessed it from lesser beings.

Had Darwin read Kant? There are no copies of Kant listed in his library, but a connection had already been noted in 1875 with the publication of *Kant und Darwin: ein Beitrag zur Geschichte der Entwicklungslehre* by Fritz Schultze, published in Jena, though there are no references to *The Descent of Man* or sexual selection in the book, and indeed very few to Darwin at all. A relationship between Kant and Darwin was suggested by John Stowell in a 2017 article titled 'On the Origins of Beauty: Aesthetics and Method in the Works of Charles Darwin', in which he argues that 'Although Darwin appears to have had some dim knowledge of Kant, this seems to have been entirely mediated by his reading of Coleridge. Beyond this I can find no evidence that Darwin had first-hand knowledge of Kant's work.' He does claim, however, that 'In the similar logic of their consideration of beauty, there appears to be a genuine convergence of thought between Kant and Darwin.'[33]

Why then does Darwin withdraw from applying aesthetic judgements to the actual physical characteristics of savage peoples? I suggest that sexual desire was eventually perceived by Darwin in terms of a post-Kantian aesthetic judgement applied to the opposite sex. It was essential for Darwin's theory of sexual selection that human beings should exercise such judgement so that mating could take place within each race to preserve its stability. This also applied to 'savages', because the Fuegians' survival as a people was dependent on what Darwin regarded as their 'vulgar taste' being shared by both sexes, and it could be an evolutionary advantage to be repellent to other races. This suggests that Darwin's claim of the relativity of aesthetic judgement fits comfortably with his assumption of the superior aesthetic judgement of his own race and social class. But the unspoken conceptual merger between a sense of beauty and sexual desire seemed to ally him less with the tradition of Kant, which implicitly separated the aesthetic from material perceptions, and more with artists of the time who belonged to what the critic Robert Buchanan in 1871 called the 'fleshly school of poetry'. Buchanan also included painters in his condemnation, particularly Dante Gabriel Rossetti, who highlighted the erotic in their paintings, a cause of some embarrassment to Darwin's outward respectability, and one seized upon by his opponents.[34]

PART V

# FROM RACE TO EUGENICS: NATIONS UNDER THREAT

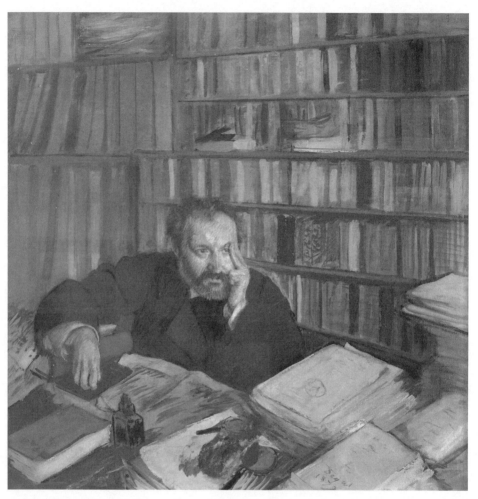

86  Edgar Degas, *Edmond Duranty*, 1879, gouache with pastel enlivenment on linen.

## 8

# France Divided: From the Franco-Prussian War to the Dreyfus Affair

The trauma of the French defeat in the Franco-Prussian War of 1870–71 had important ramifications for racial attitudes in France. Those who recognized the Franks as ancestors of the French nation were troubled by their Germanic origins, so alternative genealogies were sought, particularly in the southern parts of the country, which led to an emphasis on the French people's classical and Mediterranean roots. But perhaps more influential was the national shame at the defeat, and a sense of cultural crisis that took many forms, including antisemitism.

### Degas: 'Forests of Ebony' and Jews

Of all the artists linked to Impressionism and Post-Impressionism, Degas was the one most interested in and influenced by the ramifications of racial science. Anthea Callen has noted his application of the Camperian facial angle to people of the lower classes, as in, for example, the sculpture *Little Dancer of Fourteen Years* (1880).[1] Contemporary commentaries emphasize the figure's animality, associating it with societal decadence. In Degas' portraits there is a tendency to construct physiognomies differently according to gender, which seems to show an awareness of Broca's analyses of the skull. In, for example, a portrait of Louis Edmond Duranty (1879, illus. 86), we are made conscious of the sitter's large forehead, the size of which is emphasized by his fingers almost resting on it. The forehead is not only large; it has a sense of weight that dominates the face, which seems to taper down from it. Let us compare it at random with a female portrait, the *Portrait de jeune femme* (1867, illus. 87), for example; there, the forehead is largely covered by the sitter's hair and the face is fuller towards the jaw, as if the weight were distributed in a contrasting way to the portrait of Duranty.

Furthermore, in his female portraits Degas often prefers a three-quarter angle, which allows almost as much emphasis on the back of the head as the front. This distinction in emphasis between such samples of male and female portraits suggests that Degas has thoroughly absorbed what were, by the second half of the nineteenth century, conventional assumptions derived from phrenology and long-standing theories of physiognomy.

Degas' antisemitism in his later years and his fierce reaction to the Dreyfus Affair have been much written about, but perhaps less attention has been paid to his deep colonial connections through his mother, born Marie-Célestine Musson (1815–1847), who belonged to a prominent French Creole family from New Orleans, the Mussons, and through her own mother the Rillieux family. Furthermore, Degas' two younger brothers, René and Achille, both emigrated to New Orleans, and Degas himself visited them at a critical period in his artistic career, from late 1872 to early 1873, staying for five months.[2] This period in New Orleans is well documented; from that time there are several paintings, including one of his greatest works, *A Cotton Office in New Orleans* (1873, illus. 88), as well as many letters, some of which bear on racial matters. At that time Degas was far from famous, desperately concerned with making money from his paintings and still contemplating matrimony. (Though very conscious of the attractions of the women of New Orleans, he was not at all sure that they were as suitable for him as their Parisian counterparts.)

Degas could hardly avoid an awareness of the extreme complexity of race relations in an important and only recently former slave-holding city in the South, restlessly under Federal military occupation that had begun in 1862, in the years during and after the Confederate defeat in the Civil War. The well-established French Creole community in which his uncle's family were prominent was under pressure from 'American' outsiders, who successfully challenged their financial and political domination. The politics of race in the post-Civil War period were infinitely intricate. Degas' maternal grandfather, Germain Musson, had fled to New Orleans from the uprising in Haiti in the early years of the nineteenth century; he had certainly owned slaves and may have brought some with him. His fortune was partly in cotton, which suggests either the ownership of or dependence on slave plantations; the family traditions and politics seem to have been entirely aligned with the Confederacy.

Degas' two brothers joined the Musson family cotton-factoring business, Musson, Prestidge & Co., which had prospered as a product of slave plantations, so the defeat of the Confederacy was a disaster for them.

87  Edgar Degas, *Portrait de jeune femme*, 1867, oil on canvas.

At the time of Degas' visit, the business was conspicuously failing, and on
1 February 1873 it was dissolved, while the painter was still in the city.[3] We
know that Michel Musson, Degas' uncle, in whose house he stayed in the city,
was as a cotton trader actively hostile to the Reconstruction government of
'carpetbaggers' and freed slaves. He was involved with the Crescent City
White League, a white supremacist militia that took part in pitched battles
in the streets. One of his daughters, Estelle, was married on 24 January 1862
to Joseph Davis Balfour, thought to be a nephew of Jefferson Davis, presi-
dent of the Confederate States from 1861 to 1866, but a study of his
genealogy shows that the two were not related. Balfour was killed in the

88  Edgar Degas, *A Cotton Office in New Orleans*, 1873, oil on canvas.

Civil War, fighting on the Confederate side, at the Battle of Hatchie's Bridge in Tennessee on 5 October 1862, and his widow subsequently married one of Degas's brothers.[4]

Adding to the complexity of New Orleans at this time were the large numbers of people of mixed race as well as recently freed slaves. Some of the former were wealthy, but they were always in an ambiguous social position in the city. Almost all Creole families would have had relations of colour, whether they accepted them as family members or not. It is conceivable, though impossible to verify one way or another, that Degas had some Black ancestry through his maternal line, going back through the Mussons to Haiti – indeed it would be a little surprising if he did not – but what is known for certain is that his mother's family, the Rillieux, had close relatives of known mixed ancestry. One prominent and well-documented cousin of Degas was the famous engineer Norbert Rillieux, who was subject to the restrictions on free people of colour brought in before the Civil War in 1855 in New Orleans. Norbert was the son of Vincent Rillieux, whose daughter, Maria Desirée, married Degas' grandfather Germain Musson, but his other son, also Vincent, had a long liaison – marriage across the colour line being illegal – with Constance Vivant, who came from a wealthy family of free Black people; Norbert, described on his 1806 birth certificate as a

'quadroon libre', was one of their many children. After a successful career in New Orleans following his invention of a major improvement to the sugar-refining process and contribution to urban projects, Norbert retired to Paris in the early 1860s, living there until his death in 1894. Did he and Degas ever meet? There is no record that they did, but Degas was likely to have been aware of this exotic relative and, if so, given his own social conservatism, it might well have disturbed him.

Even so, it is clear from his letters that Degas was astonished and stirred visually by the presence of so many Black people in the city; indeed, as many visitors to New Orleans remarked, it was the one thing that made the city different from other large cities in the United States or Europe. In a letter to Henri Rouart of 5 December 1872 he remarks on the 'New things [that] capture your fancy and bore you by turns. The beautiful, refined Indian women behind their half opened green shutters, and the old women with their big bandanna kerchiefs going to the market can be seen in a different light to Biard.' By the 'Indian women' he probably meant the mixed-race 'belles mulâtresses' who were such a notable feature of French colonial life. The reference to Biard is interesting, for it is to François Biard, the painter famous for his scenes of slavery and abolition in which Black people were shown either in a state of dramatic abjection under slavery or exultation if they were being freed (see illus. 64). Degas seems to be making the point that these women going to market were of a dignity and self-possession that belied their slave past or ancestry. He is also stirred not only by the orange gardens and painted houses, but 'the children all dressed in white and all white against black arms'.[5] As he notes in a letter to the Danish painter Lorenz Frølich on 27 November 1872: 'I like nothing better than the negresses of all shades, holding in their arms little white babies, so white, against white houses with columns of fluted wood . . . and the contrast between the lively hum and bustle of the offices with this immense black animal force, etc. etc. And the pretty women of pure blood and the pretty 25-year-olds and well set up negresses!'[6]

These comments show a remarkable combination of visual impressions, the contrast of black and white skin, with barely concealed racial tropes. The offices inhabited by white men are characterized as having the 'lively hum and bustle of productive work', while the ubiquitous Black servants and labourers are described as an 'animal force'. Yet it is also clear that Degas was not entirely comfortable in New Orleans and was longing to return to his 'ordered life' in France, in contrast to the disorderly life of Louisiana.

The English painter and printmaker Walter Sickert, a great admirer of Degas, made a drawing entitled *The Artist's Home in New Orleans* (1911).[7] The setting is plainly in Sickert's art school, the Wellington House Academy in Camden Town, but the title invokes the New Orleans family mansion of his mentor (illus. 89). The male model in the painting, posed with his back to a fireplace, is clearly standing in for Degas, and there is a female figure lounging in a chair, but the dominant figure in the foreground is a Black butler carrying a drinks tray. Not only is it likely that there would have been such a person in the Musson household where Degas stayed in New Orleans, but we know that there were many other Black people in the household. He remarks himself in his first surviving letter after his arrival, to his musician friend Désiré Dihau of 11 November 1872, that his young nephews and nieces were 'watched over by negresses of different shades'.[8]

89 Walter Sickert, *The Artist's Home in New Orleans*, 1911, pen and black ink and charcoal with white heightening on grey paper.

In a letter of 18 February 1873 to the painter Tissot, shortly before he left New Orleans, Degas remarks:

> What lovely things I could have done, and done rapidly if the bright daylight were less unbearable for me . . . The black world, I have not had time to explore it; there are some real treasures as regards to drawing and colour in these forests of ebony. I shall be very surprised to live among white people only in Paris. And then I love silhouettes so much and these silhouettes walk.[9]

Degas himself thus notes that Black people in New Orleans were a constant and attractive, even eminently paintable, presence both indoors and outdoors, yet they are almost completely absent from the many paintings and drawings that are known from his five months in New Orleans. In fact, there is only one painting in which a Black person is identifiable, and that is the almost indistinct and broadly painted figure of a nurse in the left-hand corner of the painting *Children on a Doorstep*, which shows her looking after the children of the Musson household.

In what is the undoubted masterpiece of his visit to New Orleans, the painting *A Cotton Office in New Orleans* (1873) there are no Black people at all; there is no sign of the 'black, animal force' he mentions, though it is inconceivable that there were not Black employees bustling around business premises in the city, carrying materials, clearing up or ministering to the people on the floor. His concern with 'hum and bustle', the way that a modern productive business worked under his two brothers, of whom he was openly proud, and the centrality of cotton, the would-be chief generator of prosperity, means that it was more of a modern History painting than it at first appears. It perhaps aspires to transcend the everyday reality, in order to attempt to capture the spirit of modern American capitalism, under the aegis of his two enterprising brothers. In which case a Black presence might have appeared to be a sign of an older, obsolete or even feudal order of society.

It is surely entirely intentional on the artist's part that cotton is at the centre of the painting, as it was in conversation in New Orleans. He noted in his letter to Tissot that 'Here one speaks of nothing but cotton.' Though not everyone is working, most of the activity is constructive. Degas' two brothers, despite the artist's pride in their dynamism, are shown at relative leisure; Achille is evidently the man on the far left, surveying the scene, while René is the seated man reading his newspaper as others bustle around him. Could their apparent idleness be a brotherly joke?

Despite Black humanity being absent, there is still a striking interplay between black and white masses in the painting that gives it an almost monochromatic feel. The stark whiteness of the cotton spread on a table contrasts with the black suits of the men standing and sitting around it, and the edge of the painting is cut into dramatically by the top hat of the man in the foreground, probably the artist's uncle, Michel Musson. Could this contrast between black and white be in any way related to the one he notes in the street, between Black nurses and the white babies they hold? Does it act as a nod towards the absences in the painting? Even though this remains only a speculation, it does suggest something of the complexity of Degas' response to the post-Civil War but still racially segregated city he was visiting, and the presence within it of his own family, deeply implicated in a slave society that had only just ceased to exist but of which traces could be found everywhere in the city.

Degas was clear in his letter to Tissot of 18 February 1873 to whom he wished to sell the painting. He described it as 'destined for Agnew [the great picture dealers, then based in Manchester, later in London] which he should place in Manchester, for if a filateur [literally 'spinner', but a colloquial term for a cotton manufacturer] ever wished to find his painter, he really should hit on me'. So Degas intended it to appeal to the kind of people in the painting, but those who were concerned with the next stage of the process, the transformation of raw cotton into clothing. He goes on to specify a particular cotton manufacturer he was hoping to reach: 'In Manchester there is a wealthy spinner, de Cotterel, who has a famous picture gallery. A fellow like that would suit me and would suit Agnew even better.'[10]

Degas is here referring to the cotton manufacturer William Cottrill, whose collection is documented in an art journal that Degas must have seen. Cottrill owned a painting by W. P. Frith, among many others, but by the time Degas conceived his plan Cottrill was in financial trouble, and his collection was sold in April 1873.[11] Ironically, he was a victim of the same cotton slump that brought the Degas' family business to its knees at the time that the artist was painting his *Cotton Office*. But Degas also hints that he was seeking to appeal to the well-established British taste for narrative realism, though he claimed that French painters could do it better because of their inherited art traditions associated with the seventeenth-century Le Nain brothers and the medieval period: 'Our race will have something simple and bold to offer . . . This English art that appeals so much to us often seems to be exploiting some trick. We can do better than they and be just as strong.'[12]

Degas clearly had in mind a generic sense of British realist art, which he would have known from visits to London, engraved versions of successful paintings exhibited at the Royal Academy and paintings of English life by Tissot himself. Perhaps the most successful of all was W. P. Frith, and it is very likely that Degas envied the fame and wealth he had achieved from realist paintings that appealed to a wide public. If we take as an example – that Degas must have known – one of Frith's most popular works, *The Railway Station* (see illus. 26), exhibited at the Royal Academy in 1862 and engraved shortly afterwards, one can see the force of Degas' desire to make a painting that has something of its contemporaneity but without such a time-consuming profusion of figures and inconsequential fussiness of detail. Degas replaces this 'Dutch' detail with a formality that was, as he put it to Tissot, 'worthy of the great schools'; in other words, he wanted what he saw as the thematic coherence and noble simplicity of the greatest Italian and French painting, but still with a sense of the dynamism of the contemporary world. This meant removing all that was peripheral to the larger theme, which may have been another reason to eliminate the Black presence in the painting.

At no point does Degas make derogatory remarks about Black people, and he had a distinct feeling for the aesthetic effect of their presence on the streets of New Orleans, but it would be disingenuous to imagine that he was free of prejudice or opposed to slavery, given the strong commitment to the defeated Confederacy among his closest New Orleans relations. Nor is there any evidence that he wished to dissociate himself from his slave-owning ancestors in Haiti. There is only one painting by him in which a Black subject is central, and that was made a few years after his return from New Orleans: *Miss La La at the Cirque Fernando* of 1879 in the National Gallery, London.[13] She is clearly dark skinned in the painting, and some of the names adopted for her – La Mulâtresse-Canon, Venus of the Tropics and the Black Venus – play on her African descent. Even so, her skin colour was probably not central to Degas' interests here, though he emphasizes it and her shock of black coiled hair. She also would have been part of a lower class of entertainer, like his ballerinas, her relative facelessness in the painting emphasizing her anonymity to the painter.

His attitudes towards Jews were of a different order, but he had equally strong – if contradictory – feelings towards them. He had close Jewish friends throughout most of his life, particularly the Halévy family, but he became notoriously antisemitic in his later years. Anthea Callen has noted that in a brothel monotype a male voyeur and a female brothel-keeper are given stereotypical features. The obviously Jewish voyeur is given

a prominent nose that forms a meeting point from lines running from a low forehead and receding chin, so the face forms a kind of incomplete triangular shape, giving it a simian-like profile that is at the opposite poll from the straight Grecian profile of Camper's European ideal.[14] The brothel monotypes present a vision of depravity, and the animal-like forms of the naked prostitutes contrast grotesquely with the Grecian ideal in their splayed limbs and total lack of gracefulness and modesty. The profiles of the voyeur and the brothel-keeper are in harmony with the dystopian setting of the brothel, where only physical desires prevail.

Linda Nochlin has claimed that Degas' portraits of Jews he encountered in daily life make little concession to racial stereotypes, but the portraits of those that he knew tell a more equivocal story. The double portrait of Ludovic Halévy with Albert Boulanger-Cavé (illus. 90) at first seems sympathetic to the former, but there are disturbing contrasts in the depiction of the two figures. Halévy is clearly a more unstable, even ungainly, figure. One foot is behind the other and he props himself up with his umbrella, while his counterpart stands squarely on his two feet. There are also contrasts in the physiognomy: Halévy has a more emphatic, hooked nose, while Boulanger-Cavé, in profile, has an almost 'Celestial' uplift to his nose, and an open countenance. The contrast is even more striking in the painting *At the Bourse*, which shows the Jewish financier Ernest May being accosted by another top-hatted figure, who whispers in his ear. The suggestion that the two are conspiring is palpable, with the hint, as Nochlin notes, that it is inherent in their way of doing business. In these works of the late 1870s Jewish difference is only suggested, and it would not have made Degas exceptional, or precluded friendships with Jews that he had known for a long time.

His prejudice became more overt with the rise in antisemitism in France at the turn of the century, and the Dreyfus affair, the great *cause célèbre* of the day, which divided artists as much as any group in society.[15] Alfred Dreyfus was a French Jewish artillery officer who was convicted of treason in December 1894 for passing military secrets to the German embassy and imprisoned on Devil's Island for five years. Evidence came to light of his innocence, and that the culprit was another officer, but the army suppressed it and laid further charges against Dreyfus, based on forged documents. Émile Zola, a novelist and childhood friend of Cézanne, made a public intervention that caused a huge public outcry, and another trial took place in 1899. Dreyfus was convicted again, but then pardoned, and he was finally exonerated in 1906. The prolonged affair was hugely divisive, and it brought out bitter tensions in the newspapers between the

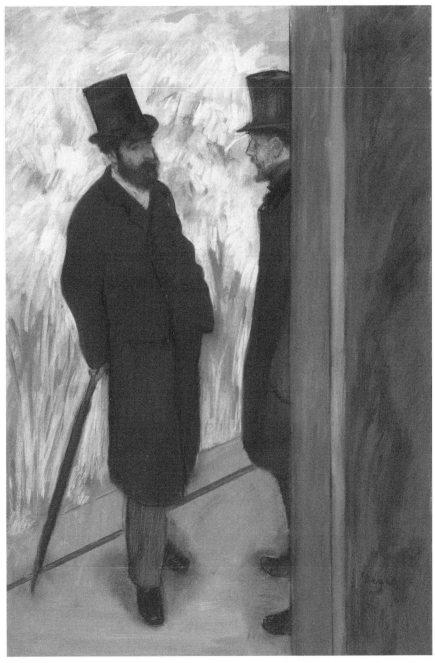

90  Edgar Degas, *Ludovic Halévy and Albert Boulanger-Cavé Backstage at the Opera*, 1879, tempera and pastel on paper.

anti-clerical left and the Catholic and right-wing supporters of the army. In that febrile atmosphere a position of compromise was almost impossible; you were either for Dreyfus or against him.

Artists were unavoidably caught up in the furore, and it effectively shattered the unity of the avant-garde. Among the Dreyfusards were Camille Pissarro, who was Jewish and much admired by Degas, and Claude Monet, while among the anti-Dreyfusards were – with varying degrees of intensity – Degas, Cézanne, Forain and Émile Bernard. The effect on Degas was particularly striking, though it is clear that by 1895 he had already been influenced by the deeply scurrilous and widely distributed antisemitic literature he is known to have read, such as Édouard Drumont's *La Libre Parole*, Henri Rochefort's *L'Intransigeant* and possibly Drumont's *La France Juive* (1886), in which the Jew is identified by 'the well-known hooked nose, the blinking eyes, clenched teeth, projecting ears, fingernails that are square instead of round and almond-shaped, an excessively long torso, flat feet, round knees, extraordinarily turned-out toes, and the soft, velvety hand of a hypocrite and a traitor'.[16] The effect of the Dreyfus affair led Degas to break off relations with the Halévy family completely, for a time at least, and to become notorious in his last years for making bilious antisemitic remarks that made very clear which side of the Dreyfus affair he was on.

The question remains: does Degas' voluble antisemitism impinge on his art? Nochlin, in her classic account of Degas and the Dreyfus affair, insists that 'Degas has made it easy for us by keeping, with rare exceptions, his politics – and his antisemitism – out of his art.'[17] Though Degas' greatness as an artist is beyond dispute, I think that the artist's adherence to forms of biological determinism, which can be deduced from his paintings of human physiognomy, means that, in almost all cases, he cannot avoid referring to or even heightening the 'Jewishness' of his Jewish subjects. His friendship with Jews such as the Halévy family did nothing to restrain his later outbursts against 'the Jew', and in that he was not alone in the period.

Degas' mercurial and secretive personality makes it difficult to get a clear picture of his racial attitudes, though his social conservatism is a constant. However, perhaps as much as any artist in the nineteenth century, he was susceptible to the intellectual aura surrounding racial science. His attitudes towards race are those of a conservative, even reactionary, Frenchman of the post-Franco-Prussian War period, but he was also someone who had absorbed the leading ideas of racial science. As was the case for so many in France at that time, nationalism and racial science came together in national trauma.

## The Provencal, Latin and Mediterranean Races:
## Puvis de Chavannes and Cézanne

Rise up, Latin race, under the canopy of the sun!
The brown grape is seething in the vat, the wine of God will soon gush forth.
With hair all loosened to the sacred breeze
From Tabor's mount thou art the race of light,
That lives of joy, and round about whose knees
Enthusiasm springs and pure delight;
The apostolic race, that through the land
Sets all the bells a-ringing again

Frédéric Mistral, *A la Raço Latino* (1879)

Calls for national regeneration in France that came to the fore in the later years of the nineteenth century often had explicitly racial elements. After all, who *were* the French? At its northern extremities France stretches from the English Channel, only 32 kilometres (20 mi.) from England, and has long borders with Belgium and Germany, both of which have a comparably cold climate, while at the southern end of the country is the much warmer coast of the Mediterranean, which borders on North Africa, Italy, Spain and Greece. Were the French then descended from the Franks, who were known to have been a Germanic people, allied racially to the English and the Germans? Or were they essentially Mediterranean, with their origins in the warm south, natural heirs to Greek and Roman culture, basking in the same physical climate?

It was firmly believed by Arthur de Gobineau and others that the French were descendants of the Franks and were predominantly Germanic in origin; this was tied to the Gothic style in art and architecture in the Middle Ages. In the second half of the nineteenth century, however, an idea increasingly took hold in the southern parts of the country: the French were at least partly a Mediterranean people, essentially Latinate, culturally akin to the countries of Greece, Italy, Spain and perhaps even to North Africa. Some were concerned with emphasizing the unity of the French nation, but influential attempts were also made to assert the separate cultural credentials of southern France, Provence in particular. The idea of Provence as the home of an independent people, with its own language and rich history, was promoted by the foundation in 1854 of the Félibrige society in Aix-en-Provence by a group of poets including Frédéric Mistral and Jean Moréas.[18] The latter argued that writers must return to the purity and dignity of the

Provençal language, then in urgent need of reclamation – a task that was eventually forwarded by Mistral's great Provençal dictionary, *Lou Tresor dóu Félibrige* (1878–86).

The Félibrige became a multi-faceted and ever-changing organization, devoted to all aspects of Provençal culture as forms of resistance in the face of the increasing political encroachment on the region by the Paris-based government, facilitated by the building of railways. In a period of rural economic decline, the members of Félibrige were concerned not only with the revival and preservation of the Provençal language but the restoration of ancient buildings, particularly those of Roman origin, the retrieval of folklore of all kinds and the founding of museums to preserve traditional artefacts. They were deeply conscious of Provence as the home of a distinct and ancient people who had, in the past, voluntarily agreed to join the kingdom of France as equals, rather than through coercion.

The chief organ of the Félibres was the 'Provençal Almanac', in which, according to Mistral, 'The essence of the spirit of our race was to be found ... with its traditions and characteristics, and were the people of Provence once day to disappear, their manner of living and thinking would be re-discovered, faithfully portrayed, such as they were in this Almanac of the Félibres.'[19] According to Paul Mariéton (1862–1911), a writer in the Provençal language, Mistral gave 'a national tendency to the movement. It was by raising the ambitions of a race, and annexing the sympathy of the *"Félibres"* among them, by showing them their ancestry from remotest times, and bringing to light their inalienable rights, that Mistral evolved out of a liter-ary renaissance a great patriotic cause.'[20] There was also a claim of 'racial brotherhood' between Provençals and others, especially Catalans – 'breth-ren both of race and tongue' – that was celebrated at a gathering in Barcelona in 1868.

There was a major question that was never entirely resolved: was the Provençal race confined to Provence within the borders of France, or was it part of a larger race, described by racial scientists as the Mediterranean race, which encompassed the countries bordering the Mediterranean: Spain, Italy, Greece and even North Africa? The Mediterranean race first appears in an essay by Thomas Huxley in 1870 as the 'Melanochroi': a darker south-ern European people than the northern equivalent, the 'Xanthochroi'.[21] The idea was taken up widely by anthropologists at the end of the century and beyond. It raised important issues for the Félibriges and Provençal nation-alists because of the Roman monuments so prevalent in Provence: were they the products of an occupying power, or were they an integral part of

Provençal culture, racially connected with the great classical cultures of the ancient world? In other words, were Greece and Rome us or them?

The poets and writers associated with the Félibrige incorporated a wide view of their common inheritance with Greece and Italy into their idea of the Provençal, seeing themselves as belonging to a 'Latin race' rather than the anthropologically confined Mediterranean one of the racial scientists. The idea of the unity of the Mediterranean world goes back to Strabo (64 or 63 BC–*c.* AD 24), who conceived the Mediterranean as 'Mare Nostrum', our sea, and the centre of the world. This is an idea that came back to life in the nineteenth century as the Ottoman Empire lost control of the colonies on the southern Mediterranean. Elisée Reclus, in his *Géographie Universelle* of 1876, defined the Mediterranean as a 'liquid continent', surrounded by 'the dry lands that man inhabits'.[22]

The specific racial claims of the Félibrige are made clear in the refrain of Mistral's poem in Provençal 'A la Raço Latino': 'Rise up, Latin race, under the canopy of the sun! The brown grape is seething in the vat, the wine of God will soon gush forth.'[23] But what did Mistral actually mean by race? Fortunately, we have an answer elicited by someone who asked him that very question. According to an interview with his American biographer, Charles Alfred Downer (1866–1930),

> Mistral is well aware that there is no Latin race, in the sense of blood relationship, of physical descent; he knows that the so-called Latin race has for the base of its unity, a common history, a common tradition, a common religion, a common language. But he believes that there is a *race méridionale* that has been developed into a kind of unity out of the various elements that compose it, through their being mingled together and accumulating during many centuries common memories, ideas, customs and interests.[24]

Mistral is thus claiming that the Provençal race is not a race in the ancestral sense, but a *Volksgeist*, in the sense defined by Herder, based on a common culture and history and not on biological descent. At the same time the Provençal race had a foreign policy, as it were, finding brotherhood with adjoining regions like Catalonia, revelling in the Italian poet Petrarch's sojourn in Avignon, and the Roman viaducts and other remains in the Provençal landscape. This had the advantage of allowing Provençals to still regard themselves as French, and even French patriots, despite their disaffection from and resentment towards Paris. Even so, despite Mistral's

unusual clarity of definition, the pull of ancestry and race was very much alive in the Félibrige, particularly through archaeology and the discovery of ancient skulls.

Paul Cézanne strongly identified himself as Provençal, and he returned from Paris to Provence for the last twenty years of his life. He had known people involved in Félibrige from his boyhood, and he was deeply conscious of the difference between northern and southern France, and of the natural fecundity and deep history of the latter. His sense of being Provençal is clearly racially tinged, but he was equally aware of cultural connections through the land and its history with Italy, Spain and Greece. The Impressionist and Post-Impressionist generation that emerged in the 1870s and '80s was mostly brought up in the northern parts of France, but often had a strong aesthetic sense of Provence, emphasizing the luminosity and the intensity of colours in the Mediterranean region. This led to seasonal visits from painters like Claude Monet and Pierre-Auguste Renoir, followed by the Pointillist painters Georges Seurat and Paul Signac, and later Henri Matisse.

France's crushing defeat by Germany in the Franco-Prussian War of 1870–71 gave an impetus to those who, even though they may not have lived or been brought up in the southern parts of France, wished to define France as a Latin rather than a Germanic country. This can perhaps be seen most clearly in the career of Pierre Puvis de Chavannes (1824–1898) and especially in the response to his paintings, which were believed to have made a unique contribution to national unity. France from the 1870s onwards was broadly politically divided between the left of the Third Republic, who looked back to the 1789 French Revolution as a new beginning for France, and the monarchist right, who looked longingly at the *ancien régime* and further back to the age of chivalry, which emphasized heredity and continuity. Puvis' reputation at the time was as an artist with an unusual ability to appeal to both sides of a highly polarized and politicized society. The Symbolist Gustave Kahn claimed that 'Puvis was the great painter who divided us the least.'[25] Puvis was always a classical artist, even *Poussiniste* in his formality, but his earlier works, such as the *History of St Geneviève* in the Pantheon, make a claim to be national paintings based firmly in the milieu of Paris itself, through the story of the city's patron saint. His later works, however – even those on national themes, such as the Sorbonne Hemicycle – adopted a pastoral idiom that is strongly Mediterranean in feeling and often set by the sea, depicted with an appropriately strong blue.

Most of Puvis' later paintings conjure up a decidedly southern environment, with classically dressed women in diaphanous robes depicted in an idyllic world. In this world, philosophers and muses conjure up a vision of France as inheriting a stable and peaceful Mediterranean past based on an ideal vision of ancient Greece, a vision that implicitly contrasts with the primitive past of the German forests. Three large wall paintings installed in the Musée des Beaux-Arts in Lyon, *Le Bois sacré cher aux arts at aux muses* (The Sacred Wood Devoted to the Arts and Muses), *Vision antique* (Vision of Antiquity, illus. 91) and *Inspiration chrétienne* (Christian Inspiration), completed in 1884, allude to France's culture as the natural heir to ancient Greece and Rome, but also to medieval Italy. *Vision antique* is explicitly Mediterranean, with pastoral figures, male and female, languishing on a rocky outcrop by the blue sea, while *Inspiration chrétienne* shows a scene in a fourteenth-century Italian church with a painter at work on a fresco. Puvis' unassailable reputation as a national painter makes it clear that these paintings were intended to show the continuity of the classical past as integral to the identity of France.

As far as we know, Puvis revelled in the fact that such paintings appealed to left-wing utopians as much they did to right-wing believers in

91  Pierre Puvis de Chavannes, *Vision antique*, 1884, mounted oil on canvas, staircase of the Musée des Beaux-Arts, Lyon.

the French as a predominantly Mediterranean race, connected biologically as well as culturally with Greece, Rome and Italy.[26] Even so, it is unlikely that he would have associated himself with *la cause félibréenne*; he is known to have been proud of his Burgundian aristocratic ancestry. He is not known to have had any direct connection to Félibrige, but he was held up as an exemplary French artist by one of its most prominent members, Charles Maurras (1868–1952), who in 1908 became a founder of the daily newspaper *Action Française*, the organ of a post-Dreyfus trial right-wing and fascist-leaning political movement that flourished into the 1940s. Maurras wrote an essay, 'Le Gout de Puvis de Chavannes', in the *Gazette de France* published 8 January 1895, in which he contrasted Puvis' art – based on a direct connection to France's 'Latin' past – with Dutch realism and the pallid Gothicism of German art. The painter, according to Maurras, represented the calm and order of traditional French life before the 1789 revolution. Maurras saw his art as an antidote to the triad of Romanticism, Revolution and the Reformation, to which, in Manichean fashion, Maurras opposed classicism, monarchy and Catholicism, though it is not clear that Puvis saw his own art in that light.[27]

Maurras uses the word 'race' frequently, and was openly antisemitic, but it is interesting that he denied the biological nature of race, explicitly separating it from racial science. In *Etang de Berre* (1928) he makes his meaning clear: 'There is surely no Latin *race*. And yet, who knows? The *homo mediterraneus* of the anthropologists does not correspond to this ancient idea? The essential point is that a Latin *civilization* exists, as does a Latin spirit as a vehicle and complement of Hellenism, interpreted through reason and Athenian beauty, a durable monument of Roman power.'[28]

THAT PUVIS HAD A REPUTATION in some quarters as a hero of the Aryan race is evident from a poem recited to him by Émile Bergerat, at a banquet arranged by Auguste Rodin and attended by many notabilities in his honour in 1895: 'Artiste de la race immortelle, Aryen! . . . Maître national et traditionnel.'[29] The honorific title of 'The Painter of France' was bestowed upon Puvis at the same banquet. Above all he had managed to be both quintessentially French yet also be fully classical. As André Michel wrote in 1896: 'His art is French art, clear and open, without foreign alloy, and it is classical art.'[30]

Mistral's call for independent, self-sustaining communities of small numbers of people communing with nature in the Mediterranean setting

of Provence and Languedoc certainly found an echo in Puvis' work. The literary critic Élie Fourès wrote in *La revue félibréenne*: 'M. Puvis de Chavannes saw another heaven and another earth from the common run of painters . . . a beautiful vanished dream, a lost Eden, a golden age which no longer exists.' It would not be unexpected to find, given the time he lived in and the people he knew, that Puvis de Chavannes was attracted to a racial idea of the Mediterranean, however there is no evidence that this was true.

The re-energizing of a distinctively Mediterranean racial conscious-ness in the 1890s is to be found in a special issue of *La Plume* in July 1891 devoted to Félibrige, with Charles Maurras as guest editor. The poetry of Jean Moréas was linked to the Provençal regional movement, which was to be given a new more openly right-wing political direction by Maurras and his fellow *Jeunes Félibres*. The same issue of *La Plume* reprinted poems by Mistral, including 'A la Raço Latino', which celebrate the language and the earth of Provence, as well as the deep inheritance from the classical world. The aims of what was often called the *École Romane* were less dramatically, if just as uncompromisingly, set out in clearly anti-German terms by Ernest Raynaud in the *Mercure de France* in May 1895:

> The return in thought to the style of equilibrium and harmony . . .
> We have undertaken to defend the patrimony of the Latin muses,
> of opposing the taste of order, measure and harmony of our race
> to the monstrous imagination, to the inconceivable chaos of the
> foreign, and to struggle, according to the measure of our forces, for
> the health of the French spirit and the reign of beauty.[31]

Maurras, in the same spirit, wrote the essay 'Barbares et Romans', which called for the purification of French culture, rejecting the Romantics and their 'German and English souls'.[32] Maurras and other right-wing nation-alists appropriated Puvis because the artist's allusions to Latin ancestry confirmed their racial definition of 'Frenchness'. But the artist was also admired by socialists like Jean Jaurès, who saw in Puvis' paintings a pro-gressive idyll where individuals lived in the kind of collective state that was universal before the rise of capitalism. Puvis' development can be seen as running parallel to an ideological shift from a universalist, civic classicism to a naturalistic and ethno-racial one that privileged the countryside and nature.[33] This change derived from nationalist and colonialist politics, bol-stered by racial science, following the Franco-Prussian War, leading some scholars to interpret artistic production, in Neil McWilliam's words, 'in

uncompromisingly ethnic terms, with racial essentialism serving as a basic analytical category'.[34]

In the first years of the new century, a racial and increasingly xenophobic post-Dreyfus, antisemitic ideology is clear in the writings and statements of Maurras and Raynaud, but it is inevitably harder to pin down in the works of the many painters who subscribed to an idea of *Mediterranité* in varying ways. Cézanne was sensitive to the classical inheritance of his native Provence, which he invoked in his approach to landscape. What is more, his paintings were the *locus classicus* of the new formal techniques that were so influential on early twentieth-century painting in France, especially in his late versions of the *Bathers*, which evoke antiquity within the context of a modern approach to form.

Cézanne returned to Provence following a long sojourn in Paris upon the death of his father in 1886, and he remained there for the rest of his life. It was clearly seen by him as a homecoming, a return to the land of his birth and childhood, and the rest of his career can be described in terms of his ever-deepening feeling for the land, history and ancient remains of Provence.[35] Nina Athanassoglou-Kallmyer suggests that he and Émile Zola may well have been aware of Félibrige pageants when they were boys.[36] Another close friend from Cézanne's youth was Antoine-Fortuné Marion (1846–1900), a distinguished naturalist with interests in biology and geology, and an early Darwinian who was famous for discovering prehistoric human skulls and artefacts beneath the soil of Provence, in close proximity to Mont Sainte-Victoire.[37] He also recognized the remarkable skill of the first Provençals in fashioning objects from bone and antler, claiming them to be not mere craftsmen but *ouvriers-artistes*.[38] There are two notable late paintings by Cézanne, featuring groups of skulls that he kept in his studio, which might have been connected, at least in Cézanne's mind, with Marion. The paintings are quite different from each other in spirit, though they are near in time – around 1900, the year of Marion's death. One, *Pyramide de Cranes*, shows four skulls piled up in a pyramid, rather like a charnel house, while the other shows three skulls facing forward neatly spaced, as if for racial comparison (illus. 92).

The contrast between the two seems deliberate. *Pyramide de Cranes* shows a group of skulls as they would have been found by archaeologists, mixed up in a burial, while the three skulls that feature in the second work could be part of a demonstration of their origins within a lecture. To Cézanne's generation, such skulls might have appeared to be ancestors of the present population; Provençals who represent a continuity from earliest

92  Paul Cezanne, *The Three Skulls*, *c*. 1898, oil on canvas.

times to today. They were dug up in disorderly heaps, but it was possible to order them into scientific categories and present them as examples of continuity between past and present. As Marion put it, emphasizing direct physical ancestry, 'Despite the great variety of its origins, the Provençal population presents a remarkable physical and psychological consistency through the ages. Consequently, today's Provençal resembles, who, in turn, resembled the Provençal of antiquity; and so on, all the way back to at least the Stone Age, if not earlier.'[39] This emphasis on the continuity of the Provençal people going back to the beginnings of time is explicitly ancestral, and it is possible that Cézanne identified with its implications.

This endless interplay between past and present and mythological and mundane in Provençal life can be said to dominate Cézanne's later paintings. The eternal Provençal is expressed in his Arcadian pastorals of groups of men and women, but also in his paintings of impassive and monumental peasants, who belong to the present but also have a geological solidity that connects them directly back to prehistoric times. This is especially the case with the paintings of peasants dating to the first decade of the twentieth century, such as the *Paysan assis* (*c*. 1900, illus. 93), who is shown fully frontal and entirely impassive, as if carved out of rock. These noble peasants are anchored to the geology of Provence, and in their monumental forms geological and historical time become synonymous. This cult of the peasant is entirely Félibrigien; Mistral himself, despite being from a wealthy family, claimed to be a peasant – though, needless to say, of a Virgilian kind.

There is a strong element of nostalgia in Cézanne's late paintings of peasants posing or playing cards, for in the 1890s and beyond Provence

93  Paul Cézanne, *Paysan assis*, 1900–1904, oil on canvas.

was beset by an agricultural slump that caused a migration from the land
of countless agricultural workers. The pathos of Cézanne's peasants lies in
the knowledge of their present-day insecurity, which contrasts with their
monumental presence in Provence from the earliest times; Marion's skulls
were figuratively the skulls of these peasants' ancestors. They are powerful
not as individuals but as archetypes, living embodiments of Provence's
history going back to the beginning of time. As the son of a wealthy banker,
Cézanne may or may not have identified racially with the Provençal
peasantry, as did the young author Joachim Gasquet and some other
members of the Félibrige, but he would have recognized and admired
their deep-rootedness in Provençal society and history.

The paintings of peasants understandably caught the eye of Gasquet – who would later write a biography of Cézanne, published in 1921, five years after the artist's death – on a visit to the Cézanne family house, Jas de Bouffon. He noted 'canvases in which robust peasants rest from their toil, their faces tanned, their shoulders powerful, their hands consecrated by the hardest labours'. Gasquet unequivocally identified himself with the Provençal race – and with its Greek, Latin and Mediterranean elements – in a poem of 1899:

> The men of my race are linked to their blood.
> In the golden Provence floats the air of Hellas,
> The pines give a faintly bitter taste to the wind.
> At the foot of a sacred mountain,
> My town was falling asleep,
> I climbed it as a child, so I could view the dazzling sea.[40]

Cézanne became once more involved with the Félibrige in the 1890s, a few years after his return from Paris, through his friendship with Gasquet. Gasquet first met Cézanne in 1896 when he was beginning to make a reputation in the Félibrige, sharing its ambitions to revive the Provençal nation by reclaiming its Latin heritage, and taking a Virgilian view of the landscape. Gasquet, for all the problems that his biography of Cézanne throws up, provides a useful corrective to the idea of the painter as an avant-garde formalist devoted single-mindedly to his 'sensations sur le motif'. Gasquet was a fervent *Félibre*, and in an essay on the artist of 1898 characterized him as the incarnation of the movement in painting.[41] In the biography of 1921, Cézanne appears as an artist deeply rooted in the soil of Provence, but one who channelled Poussin in his deep awareness of the classical history of the Provençal landscape. He is also seen as an artist wholly detached from the commercialism of Paris, though in reality he remained beholden to Paris to the end and maintained a close relationship with the art dealer Ambroise Vollard.

Did Cézanne accept the premises of Félibrige in its foregrounding of the landscape as the repository of Provence's Greek and Roman heritage, in sympathy with Gasquet? It seems that at first Cézanne was greatly taken with Gasquet's account of the movement's aims. He wrote to Gasquet's father, Henri, on 23 December 1898:

> Please thank your son as well, getting to know him is a heaven-sent gift, and his friendship is very precious to me . . . I wholeheartedly

support the artistic movement that they are establishing and making their own. You have no idea how invigorating it is to find yourself surrounded by young people gracious enough not to bury you on the spot, so I can only extend my most sincere wishes for their success.[42]

The friendship of Cézanne and the younger Gasquet clearly thrived for some years, and they went walking in the Provençal countryside reading Virgil, all of which would have confirmed their mutual appreciation for the classical aspects of Provence. But eventually the relationship with Gasquet cooled, and after 1900 there are very few signs that they were still in regular contact. Though Cézanne was clearly enthusiastic at first about Gasquet's commitment to Félibrige, he was still fond of people who would have been seen as outside of Provençal values, like Claude Monet and Vollard, and eventually tired of the earnestness of the Gasquets and their friends. In an affectionate letter to Vollard of 9 January 1903 he expressed exasperation with the Gasquets in particular, and the Félibrige in general: 'I regret the distance that separates us, for more than once I would have turned to you for moral support. I live alone, the Gasquets, the Demolins, are priceless, the clan of intellectuals, good god, they're all the same. If I'm still alive we'll talk about all this again.'[43] Among 'the clan of intellectuals' was presumably Maurras and Cézanne may well have objected to his growing xenophobic influence on the Félibrige.

What is not clear, however, is how far Cézanne would have seen himself as *racially* connected to Provence. He certainly saw the peasantry as connected by ancestry to prehistoric Provence, but he may have seen himself, being from a prosperous bourgeois family, connected more culturally than racially to the area; perhaps closer in attitude to Mistral, though the distinction between a racial and cultural Provençal was, in practice, a subtle one. Athanassoglou-Kallmyer has highlighted Cézanne's consciousness of being a provincial, resisting the sophistication of Paris throughout his life.[44] This can be seen in the particular roughness of handling in his early paintings and in his characterizations of both himself and his son. It is especially clear in the satirical humour of his earlier paintings of traditional and classical subjects, which defy and even satirize the elevated style of the Salon. His paintings of carnival and Harlequin subjects are particularly telling due to the involvement of the Félibrige, through Mistral and others, in the revised Mardi Gras carnival procession in Aix of 1889.

It is, in practice, hard to see where on the spectrum of political and racial issues Cézanne actually stood, and it is likely that he did not hold

a consistent position on such matters. Though no direct statement of his views on race has survived, it is clear that as a Provençal Félibrige sympathizer and a strong Catholic he was anti-Dreyfus, and others attributed such sentiments to him.[45] Of course, Zola, Dreyfus's most vocal supporter, had been a childhood friend of Cézanne's in Aix, but by the time of the Dreyfus affair the friendship between them had lapsed. It is likely that he shifted from a more cosmopolitan to a conservative position under the influence of Félibrige members, perhaps as Gasquet had done, though he seems to have resisted going as far as the Maurras of the Action Française. Gasquet suffered no such inhibitions, stating in a lecture in Paris in 1901: 'I was a Dreyfusian but am no longer. I was republican and it must be admitted, anarchist. The thoughtful investigation of our friend Maurras has made me a royalist.'[46]

If Puvis de Chavannes was seen by those both inside and outside of Félibrige as the principal painter of *Mediterranité*, the idea of it had a powerful effect on other French artists in the early years of the twentieth century. It is perhaps seen in its fullest form in the work of the sculptor Aristide Maillol (1861–1944). Maillol was born at Banyuls, near the Spanish border on the Mediterranean coast, and believed that his art was part of an unbroken tradition going back to Greek antiquity. His first major exhibited sculpture of a female nude in contemplation, at the Salon d'Automne in 1905, was eventually called *La Méditerranée* (illus. 94).[47] This figure was earlier known variously as *Femme accroupie*, *Pensée* and *La Pensée latine*,

94 Aristide Maillol, *La Méditerranée*, 1905, bronze, Tuileries Garden, Paris.

which he claimed was a 'phrase that needed to be understood in the sense intended by Charles Maurras'.[48] This makes clear Maillol's adherence at this time to the kind of Mediterranean classicism advocated by Maurras, who gave it a strong political thrust by the founding of the newspaper *Action Française* in 1908. After his success at the 1905 Salon Maillol continued to develop his idea of Mediterranean classicism in his sculpture through the image of the female nude, consciously evoking Greek and Latin sculpture in the service of an idea of *Mediterranité* that linked ancient Greece to Provence. This was confirmed by Maurice Denis in his 1925 book on the sculptor, who wrote that 'Maillol constructs . . . classical syntheses . . . By birth, by race, he belongs to the French Midi; he comes to us from the shores of the Mediterranean whose blue depths gave birth to Aphrodite.'[49]

The 'Latin', 'Provençal' or 'Mediterranean' races that emerged in Provence and elsewhere from the 1850s into the twentieth century were invoked less rigorously by non-scientists than the usual categories of racial science; they were often discussed more in cultural and nationalistic terms than the strictly ancestral. The only person in the circles of the Félibrige and Cézanne to bridge ideas of Provence and racial science was Marion, who was a professional zoologist and, being fully aware of Darwin and racial ideas, would have applied such categories more rigorously. Marion's archaeology and vision of Provençal history is at the point where Cézanne comes closest to racial science, but in general his and other artists' and poets' ideas of race came from more romantic and literary sources.

# 9

# Eugenics and the Defence
# of the White Races

> Don't you really know, Durbeyfield, that you are the lineal representative of the
> ancient and knightly family of the d'Urbervilles, who derive their descent from
> Sir Pagan d'Urberville, that renowned knight who came from Normandy with
> William the Conqueror, as appears by Battle Abbey Roll?'
>   'Never heard it before, sir!'
>   'Well it's true. Throw up your chin a moment, so that I may catch the profile
> of your face better. Yes, that's the d'Urberville nose and chin – a little debased.'
>
> THOMAS HARDY, *Tess of the D'Urbervilles* (1891)

The passage from *Tess of the D'Urbervilles* above does not specifically
refer to eugenics, but it does express the importance attached to hered-
ity and its visual consequences at the time of the work's advent in the late
nineteenth century. Eugenics, as it was conceived in 1888 by the polymath
Francis Galton (1822–1911), founder of the Galton Laboratory at University
College London, was essentially concerned with the 'improvement' of a
population by applying theories of heredity to reproductive practice, at the
expense of education or the amelioration of social conditions.[1] He and most
eugenicists in Britain and the United States believed completely in the
superiority of the Anglo-Saxon race, but eugenics was not always defined
by race; it could be applied to the labouring or 'dangerous' classes within a
country or society, or to questions of hereditary illness. In Britain and the
United States, however, it was almost always seen by its proponents in terms
of 'Racial Betterment', a term first used by John Harvey Kellogg (1852–1943),
the American health reformer.[2] Ironically given eugenics' central role in
the racial policies of the Third Reich, in Germany it was easier, at first, to
separate the concern with social and physical improvement from race.

Alfred Ploetz (1860–1940), the founder of the first eugenic society, the Gesellschaft für Rassenhygiene – though he was not without antisemitic attitudes – believed that antisemitism would eventually fade away. A number of Jewish scientists were involved with eugenic societies for whom race was not central, until they were removed from their research posts on the advent of the Nazi dictatorship in 1933 and in subsequent years.[3]

The founding principle of eugenics, laid down by Galton, was that those who were more useful to society through their intelligence and moral capacity, the 'Fit', should be encouraged to breed more actively with each other, and those less useful, the 'Unfit', were to be discouraged from procreation by birth control, abortion or sterilization. Its application to race came through the belief, beginning with the major Western powers in a time of growing colonial expansion, that the 'inferior' members of the race or population were growing in numbers because of their inability to restrain their sexual desires. There was a perceived danger that they would eventually overwhelm their intellectual superiors, who, being more controlled in their sexual desires, had a lower birth rate. Despite the horrors that were later associated with eugenics, it was sincerely believed by its promoters to be a humane way of improving society and eliminating the inevitable conflict between the educated and uneducated classes. Like earlier forms of racial science, it was adopted by both the politically conservative and the progressive.

Galton, who was a cousin of Charles Darwin, saw himself as taking over and adapting the latter's idea of natural selection – which he believed 'rest[ed] upon excessive production and wholesale destruction' – for the improvement of society and the racial stock, on the assumption that the evolutionary process in human beings was still active in the present and would be, too, in the future. He maintained that eugenics should 'replace Natural Selection by other processes that are more merciful and not less effective. This is precisely the aim of Eugenics.' In 1908 he noted that 'Its first object is to check the birth-rate of the Unfit ... The second object is the improvement of the race by furthering the productivity of the Fit by early marriages and healthful rearing of their children.'[4]

In effect, eugenics sought to improve the human stock by the same methods used from the early eighteenth century onwards to improve racehorses and cattle: a close attention to heredity and control of breeding. According to eugenic theory, heredity was the only way morality and intelligence could be acquired. It offered an alternative to contemporaneous beliefs in social reform and improvement by education; morality, intelligence and criminality were believed by those sympathetic to eugenics to

be hard-wired into individuals and could not be improved or mitigated by societal means. Without intervention, the superior breeding power of the Unfit could only lead to the degeneration of the race or nation (hence Galton's later preoccupation with what became known as 'negative eugenics', that the Unfit be prevented by all means from breeding).

Galton's closest disciple, Karl Pearson (1857–1936), the first Galton Professor of Eugenics at UCL, took a Manichean view of eugenics. He argued that humanity was in a life-or-death struggle for supremacy: the superior races could not cohabit the earth with their inferiors, and thus must in the end extirpate them. The nation, as he put it in 1901, needs to be 'kept up to a high pitch of internal efficiency by insuring that its numbers are substantially recruited from the better stocks, and kept up to a high pitch of external efficiency by contest, chiefly by way of war with inferior races'.[5]

Galton was endlessly experimental in many spheres. He is perhaps most famous for the invention of fingerprinting, and at the centre of all his research was the application of statistics to questions of inheritance and to all forms of public utility. He was the inventor of several methods of photography, including one that has racial implications, which he called 'Composite Portraits'.[6] Galton's method in his composite portraits was to photograph series of physiognomies according to types of race, criminality, disease and ancient rulers on coins consecutively onto the same photographic plate, underexposing each one so that the common features emerged more distinctly than the individual in the final print. By focusing on the outward appearance of people, Galton was essentially following in the tradition of Lavater in relating visible physiognomy to the mind of both the individual and the group. As Pearson put it in his exhaustive biography of Galton:

> He belonged to a generation in which the influence of Lavater and the belief in some form of phrenology were appreciable. He accordingly sought to isolate types, and to measure deviations from physical type in order to determine whether facial variations were correlated with mental variations. He was really attempting to make a true science out of physiognomy. The anthropologist up to Galton's [time] had employed portraiture to distinguish if possible between mental types.[7]

The method was explained in his first pamphlet on the subject, 'Composite Portraits' (1878). Galton's ambitious claim was that he was able to represent

not the individual but the type to which the individual belonged, aiming for a method of extrapolating an ideal form from the many heads he transposed photographically. As he explains it, the process

> enables us to obtain with mechanical precision a generalised picture; one that represents no man in particular, but portrays an imaginary figure possessing the average features of any given group of men. Nobody who glanced at one of them for the first time, would doubt it being the likeness of a living person, yet . . . it is no such thing; it is the portrait of a type and not of an individual.

He then makes an explicit comparison with the practice of artists, whom he views as seeking to achieve ideal forms, in the manner laid down by Joshua Reynolds:

> A composite portrait represents the picture that would rise before the mind's eye of a man who had the gift of pictorial imagination in an exalted degree. But the imaginative power even of the highest artists is far from precise, and is so apt to be biassed by special cases that may have struck their fancies, that no two artists agree in any of their typical forms. The merit of the photographic composite is its mechanical precision, being subject to no error beyond those incidental to all photographic productions.[8]

Thus, Galton accepts the notion, associated with academic art, that the artist's real province is not the observable world but the world of ideas – although, as Reynolds said, it can only be reached by a thorough process of observation. Just as Darwin is known to have read Reynolds's *Lectures* attentively, it is likely that Galton would also have been familiar with them, though they were outdated in artistic circles by his time.

Galton's composite portraits proved to be unsuccessful in representing criminals, so much so that Pearson, in his biography, claimed that all they accomplished was a show of the subjects' common humanity. But with race, ideal typology seemed to make more sense: 'when composite photography is applied to a physically differentiated race, i.e. the Jews, it does in a marked manner indicate a type. And therein, I think, its future usefulness lies.' Two plates of the 'Jewish type' of male adolescent were published in Galton's 1885 paper, and they show the composites in profile and full face (illus. 95). Pearson believed his composites of Jews worked in

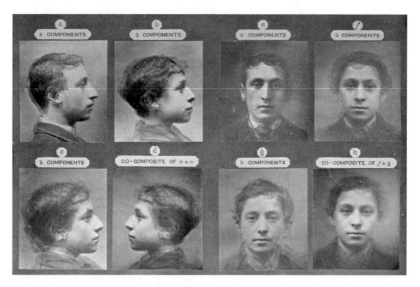

95 Francis Galton, *The Jewish Type*, 1885, composite photographs, reproduced in Karl Pearson, *The Life, Letters and Labours of Francis Galton*, vol. II (1924).

a way that those which he had attempted of families and illnesses did not because they were based on 'physiognomically like constituents': 'Galton's portraiture brings him [the Jewish boy] before us in a way only a great work of art could equal – for the artist would only idealise from one model.'[9] Both Galton and Pearson make the grand suggestion that the resultant composite photographs were themselves works of art, ones that had reached the ideal only achieved by great artists, but also had the additional and unprecedented virtue of scientific precision.

In the photographs themselves of the Jewish Type, it is the one in the right-hand corner of each that is the composite of ten images, combining two separate groups of five each, with the top left on both sides representing an older boy. What he produced was not a composite portrait of 'the Jew' but rather of Jews at a certain age, in this case boys around the age of fifteen. Even so, one has to ask from what sort of sample were they chosen: were they in reality just chosen from the Jews that lived in a particular part of London? Or were they deliberately selected to be, say, of recent Eastern European origin? Nonetheless Galton believed that the success of the composite portrait of the Jewish Type meant that his photographic method's future lay in ethnological and genetic work. Behind such composite portraits was also the idea of a 'genus', coined by Thomas Huxley, which was derived from a kind of averaging process that conformed to a racial ideal. Pearson cited Adolphe Quetelet, a Belgian sociologist whose highly

influential book, *Sur l'homme et le développement de ses facultés, ou Essai de physique sociale* (1835) was translated as *Treatise on Man*. Quetelet describes the 'average man' (*l'homme moyen*) who is characterized by the mean of measured variables that follow a normal distribution. Pearson describes the type as 'clustering towards a common centre', which could be seen as a form of racial essentialism.

Galton also made composite photographs from ancient coins of Alexander the Great, Antiochus I of Syria and Cleopatra, among others, using the same method. In the case of the last, he claimed that though the profile portraits were individually 'to an ordinary English taste hideous', the composite process nonetheless gave an inkling of Cleopatra's beauty by producing an equivalent to an ideal portrait of her.

The influence of Lavater, as Pearson noted, remained in a later work by Galton that was not fully published before he died. Always concerned with the practical applications of his discoveries to a modern society, he tried to find a way of reconstructing profiles so they could be reduced to numerical formulae, and thus, in the case of criminal types, transmitted by telegraph by the police if necessary. The method was meant to be a more accurate way of achieving Lavater's insights: according to Pearson, 'He [Galton] had collected data for a work that would have eclipsed Lavater's, being based on much more accurate methods; there is material and suggestions enough for a scientific treatise on physiognomy.'[10] There are many drawings in his papers, including a group based on 68 of George Dance the Younger's *A Collection of Portraits*, published from 1804 to 1814, and other engravings. The idea was to divide the profile into four sections – for example, the forehead could be no. 3; nose, no. 6; lips, no. 23; and chin, no. 12. Thus, with the addition of measurements, the profile of a criminal could be reconstructed from a series of numbers sent on a telegram.[11]

A later attempt by the Galton Laboratory to bring racial skull profiling in the tradition of Camper and Lavater up to date is an article by Ida McLearn, G. M. Morant and Karl Pearson in a 1928 issue of *Biometrika*, on 'the importance of the type silhouette for racial characterisation in anthropology'.[12] The study was based on silhouettes, a method pioneered by Lavater himself.[13] The idea was to compare a 'Negro profile', derived from a German study 'based on 100 West African Negroes' from a published photographic campaign, with one based on '50 English undergraduate profiles' (illus. 96). The African heads were based on those of French prisoners captured by the Germans in the First World War, and it was known that they came from different countries in West Africa.

96  Type West African Negro silhouette, in Ida McLearn, G. M. Morant and Karl
Pearson, 'On the Importance of the Type Silhouette for Racial Characterisation in
Anthropology', *Biometrika*, xx(b)/3/4 (December 1928).

The single full-page profiles of the two types are accompanied by
transparent printed sheets, so that it is possible to make comparisons by
superimposing one onto the other in order to demonstrate not only the
different shapes of the skull but the larger size of the English head. Interest-
ingly, the conclusions go against some traditional assumptions behind
racial science. The article makes the point that 'the Negro race' is a 'high
brow' race; the relative height of the Negro forehead does not correlate
with the belief that intellect is expressed in a strong forehead, if one follows
the almost universal assumption in Europe and the Americas at that time
that the white race was by definition stronger in intellect. It also concludes
that where the profile of the white female differs from that of the white

male, it is broadly in the way the Negro profile differs from the white one, leading to the conclusion that the female intellect was weaker than the male in a way comparable to that of the Negro and the European.

The article concludes with the admission that 'we probably gain little by speaking of the Negro races as more "primitive" than the European,' but then claims that 'those who believe this word carries some significance, may feel themselves justified in affirming that the Englishwoman is more "primitive" than the Englishman,' neatly eliding racism with misogyny. But the main intention of the essay is to demonstrate that the method provides a standardized approach to racial profiling, one that can replace the supposedly less systematic methods which had been used by anthropologists for more than a century.

Galton's last work was in the unlikely genre of the novel of the then fashionable utopian/dystopian kind. Its title is an elaborate pun, *The Eugenic College of Kantsaywhere*, and it only survives in a few pages, kept in the UCL Library Special Collections, evidently after being brutally bowdlerized by Galton's niece, who we can only assume had a prudish objection to the discussion of procreation.[14] This subject appears to have been discussed in the context of a romance between the hero and a Miss Armbruster, which is briefly alluded to but is absent from the surviving text. What survives, chapters V–VIII, is largely concerned with the admission procedures and life at the eponymous college, which is entirely devoted to the eugenic education of privileged youth who have passed the ultimate test: ancestry. According to the founder, the college was to grant diplomas for those 'with heritable gifts, physical and mental to encourage the marriages of highly-diplomaed parents by the offer of appropriate awards of various moral and material advantages'. The practice of charity 'in the sense of protecting the feeble' was no business of the college; everyone was rigorously assessed, and only the heritable characteristics were of interest.

The narrator notes that the college 'thinks more of the race than the individual', since one person, in procreating, could have a disproportionate effect over generations on the population. The first test for the students is to measure their genetic qualities in order to determine whether they should be allowed to procreate or not: a pass in the test meant that they were fit for the task; a fail, that they were unfit. The process involves investigating each student to uncover a deep knowledge of their ancestry, and the student must provide evidence of their character, ignorance being no excuse. Those who failed the test were to be treated with kindness – as long as they did not intend to procreate, at which point 'kindness was changed

into sharp severity.' The ultimate idea was that, over time, the college 'shall have evolved a superior race of men'.

The part of the novel that includes the syllabus and various forms of data is still intact in the manuscript, so it is possible to look at the college's curriculum. Apart from the genetic component, it is fairly standard for the times with its emphasis on a healthy mind in a healthy body, balancing physical and mental attributes. The examination covers four divisions: the 'aesthetic', the 'mainly anthropometric', the 'medical' and the 'ancestral'. The examination for aesthetics is particularly interesting in the present context. Part of it is performative, requiring the male candidate to sing and recite poetry and prose, and to demonstrate a polite demeanour. The other part consists of athletic exercises and a march past the college authorities, both of which are intently observed by the examiners. The candidates are expected to conform in their athleticism to Greek aesthetic ideals, but also to those of manliness and self-discipline. Females, on the other hand, are expected to conform to the ideals of 'Grace and Thoroughness', words inscribed over one of the houses and frequently reiterated elsewhere. The class- and gender-based ethos behind the aesthetics is crystal clear, to the extent that Galton claimed: 'A loutish boy and an awkward girl hardly exist in the place', or, as the author cringingly put it, 'The 'arry and 'arriet class is wholly unknown in Kantsaywhere.'

Galton's eugenics, as *The Eugenic College of Kantsaywhere* makes clear, was strongly utopian in its idealism and its belief in classification and exact measurement, but it also made strong aesthetic claims, with the aspirational Greek ideal always in the background, foreshadowing what was to come in Germany during the Third Reich. However, it hardly needs saying that enormous efforts were made to put negative eugenic principles into practice in several countries in the earlier part of the century and even after the Second World War, with terrible consequences for humanity.

## Eugenics, Ancient Egypt and the Old Testament: Flinders Petrie and A. H. Sayce

The archaeologist Sir William Matthew Flinders Petrie (1853–1942) was, among many other things, the founder of the modern classification of ancient Egyptian artefacts. He was also a friend, colleague and collaborator of Francis Galton at University College London, with whom he shared a strongly racialized view of the ancient past, with a particular interest in skull formation as a way of identifying race.[15] He supplied Galton with large

numbers of skulls dug out of Egyptian graves, for they were both interested not only in their measurement but in the way Egyptian works of art could provide evidence of the early history of the different races at the beginning of civilization.

Petrie's first examination of human depictions in ancient Egyptian art was commissioned by Galton himself in 1887 as chairman of a committee

97 'Ancient races portrayed on the Egyptian monuments', frontispiece to A. H. Sayce, *The Races of the Old Testament* (1891), with illustrations taken from W. M. Flinders Petrie, *Racial Photographs from the Egyptian Monuments* (1887).

of the British Association for the Advancement of Science, of which the archaeologist General Augustus Pitt Rivers (1827–1900) was also a member. The brief was 'to take racial photographs from the ancient Egyptian paintings and sculpture'. It was agreed that, where necessary, paper casts could be taken instead of photographs. He spent six weeks in Egypt, mainly working around the great complex of Karnak. The result was a collection of some 150 casts, 22 of which were given by Galton to the British Museum. Forty photographs were also taken and eventually annotated by Galton with races identified, and a privately printed – and now extremely rare – volume entitled *Racial Photographs from Egyptian Monuments* was produced in 1887.[16] This work included photographs of the casts, and was only obtainable by application to the printer: Mr Browning Hogg, 75 High Street, Bromley, Kent (illus. 97).[17]

The complete volume consists of 190 photographs arranged in two rows, with each 'race' identified beneath. All the heads are from the nineteenth dynasty and are from Thebes. All but a handful are in profile, and each is photographed from a plaster cast, some of which have survived.[18] The plaster casts all sit within a moulded frame, which effectively decontextualizes them from their original setting in multi-figural compositions, enabling the heads to be placed in a uniform format and equal size, and treated separately and comparatively according to the principles of racial taxonomy going back to Camper. According to the prefatory introduction, 'The order of arrangement is such as to bring together the various peoples who have resemblances worthy of notice . . . the Punites and Philistines' and others less well known.

The first photographs are of the Egyptian royal family and their servants, followed briefly by 'High Egyptians', then the 'Pun' people, who take up the first two sections, and lastly the 'Philistines', who seem to be classified as a sub-race of the Pun people. The Philistines take up about half of section III and are followed by peoples whose identification is less specific. Only towards the end of section IV do we get a single image of a 'Greek of Europe or Asia', followed by a tentatively identified 'Etruscan'. The final section contains 'Amorites' and 'Arabs', among others. Perhaps what is most significant to us are the omissions: no Jews or Semites are identified, nor are there Black Africans from Kush or elsewhere. The volume thus represents an early phase in Petrie's studies of ancient Egypt; despite his friendship with Galton, it was probably put together before he had fully absorbed eugenic thinking.

Petrie nonetheless became a passionate believer in eugenics and remained on close terms with Galton until the latter's death in 1911. Two

of Petrie's books had an explicit eugenic theme: *Janus in Modern Life* (1907) and *Revolutions of Civilisation* (1922). In the former he lamented the fact that many of the mentally fit of Western Europe were being lost to emigration to America: 'At first we succeeded in getting rid of some amount of less desirable stock along with the capable stock; but in later years most countries will not admit any but good stock, and we lose the valuable examples of national character without any compensation.' As befits a believer in eugenics and a person fully at home with conservative ideas, he was sceptical of social welfare and strongly approved of competition, concluding that the promotion of 'vigorous strains' of heredity would produce the men of 'greatest industry and greatest individuality', which in turn would lead to the greatest social advance for Britain.[19]

Petrie regarded himself primarily as a historian, devising a cyclical theory of human development: 'ancient civilizations teach . . . that mankind does not continually progress, but rather that each civilization in turn has its phases of excellence.'[20] Furthermore, 'the earlier settlements of this [Egypt] and other lands were the result of the mixture of half a dozen races fighting for supremacy.'[21] From the earliest times, he argued, Egyptian culture was born out of conquest by outsiders from the north, who repeatedly invigorated what we now call the local gene pool as it fell into the cyclical process of cultural decay. This is compatible with his attitude towards the contemporary world. He shared Galton's sense of the current decadence of Britain and its need for national action in restricting the birth rate of the 'Unfit' to reassert its national supremacy. In 1906 he took the unusual view that migrations of civilizations 'are a means of supplanting the less capable by the more capable', using a number of examples, not the least of which was the measurement and analysis of the shapes, sizes and types of skulls from an Egyptian cemetery.[22] He was not, however, a believer in racial purity or exclusiveness, and he even claimed that foreign migration had been the making of Britain; in 1939 he argued for Jewish refugees to be allowed into the country, because they would regenerate the national stock as previous migrants had done.[23]

Petrie carried out photography of exhumed remains, live subjects and ancient portraiture to study facial features. His 1906 Huxley Lecture to the Anthropological Institute dealt with the reconstruction of demographic changes over 10,000 years of Egyptian history, based primarily on 'variations in skull measurements', which he saw expressed in, for example, the 'Tasian beaker people' who must derive from either Spain and North Africa, or Germany, on the basis of artistic styles.[24] He brought back from Egypt

98 Head from Memphis, Egypt, described by Petrie Museum as 'the type . . . of the Semite', Graeco-Roman Period (332 BC–AD 395), terracotta.

a number of small and fragmentary heads from Memphis, a city that he believed to have been exceptionally cosmopolitan in ancient times.[25]

One head from the city of Memphis in the Ptolemaic period (*c.* 330 BC), currently on display in the Petrie Museum, was labelled by Petrie as 'Hebrew': 'the type is that of the Semite, as shown in the chief of the Amu at Benihasan, but sturdier and fatter owing to a settled life. It probably represents the Syrian or Jewish trader' (illus. 98).[26] He then compared it to a famous painting on the twelfth-dynasty tomb of Knunotep at Beni Hasan, which shows a caravan of traders, supposedly Jewish. This identification was based once again on the assumption that the Jewish physiognomy, and indeed all racial physiognomies, were unchanged across the millennia; a Jew in the ancient world would be recognizable from Jews today, and vice-versa – a point, as we have seen, made more than fifty years previously by Robert Knox. As Challis has noted, the museum's card catalogue description (now changed) was riddled with antisemitic stereotypes: 'Terracotta head with black and red paint, showing typical Semitic profile – hooked nose, splayed nostrils, wide up-turned mouth and flat eyebrows. He wears his dark hair short in tight curls round his head, and a closely trimmed beard confined to the

chin-line.'[27] Such identifications reach back to Galton's racial photographs of Jews, but they also bear on the vital relationship for Christians of biblical Jews in Egypt.

In an essay of 1901, 'The Races of Early Egypt', Petrie describes his method of interpreting the racial content of very early Egyptian art, noting that it was not a simple process.[28] He is also at pains to point out that the races of the ancient world were not 'pure' but every bit as mixed as they are today. He defends the care and accuracy of the ancient artists, but maintains that 'It really needs a training of the eye and judgment to make any use of the figures, or to give any opinion worth hearing about them.' It is also necessary to be clear about the dates of the objects, 'as the condition of the peoples represented was changing from hostility to captivity, and lastly to union with the spreading government of Egypt'. Characteristically he is very clear about the dates he cites, no doubt reflecting his close studies of the dating and sequence of ancient cylinder jars.

In classifying races, he warns that some figures are likely to be of mixed race, so the first step is to classify the physiognomies, beginning with 'the aquiline type'. This is almost universal in prehistoric figures; characteristically they have high, domed heads, pointed beards and long noses. But this type is also familiar on later Egyptian monuments, where they are identified by Petrie as 'Libyans', 'a term which covers many allied races'. The Libyans were, according to Petrie, 'a fair people', so 'from physiognomy we reach the simple conclusion that North Africa, Egypt, and Syria were occupied by allied tribes of a European character', a conclusion that would have made sense to Nott and Gliddon. But he also notes that one head is 'apparently of the same race crossed with negro, which has made the hair curly, the lips weak, the beard short and the outline less orthognathous'.

Petrie notes that his identification of the early Egyptians with Libyans or Kabyles has been challenged, and he defends his case by resorting to three measurements known to Paul Broca: the cephalic, or the ratio of length to breadth of the skull; the alveolar, or the ratio of breadth to length of the upper jaw; and the nasal index, the ratio of height to width of the nose, though he admits it means bringing together the measurements of prehistoric Egyptian skulls of 7,000 years ago with the heads of living Kabyles. The point for Petrie was that physiognomic measurements supported the archaeological evidence of the connection between Libya and Egypt.

In addition to the aquiline type there was the 'plaited-beard type', characterized by 'close curly hair, a plaited hanging beard, thick straight

nose rounded at the end, rather thick lips, and receding chin'. These are seen by Petrie as 'an invading race, which was exterminated in Egypt'. The others are the 'pointed nose', who are seen as tributaries to conquerors; 'Tilted nose', who were both conquerors and conquered; 'Forward beard', also conquered; and finally 'Straight bridge', who were to Petrie the 'conquering dynastic race', and included the early pharaoh Narmer, thought to be the first unifier of Egypt.

Petrie had a particular influence on his friend and fellow scholar Reverend Archibald Henry Sayce (1845–1933), a clergyman who held the chair of Assyriology at the University of Oxford from 1891 to 1919. His 'Sunday school book' *The Races of the Old Testament* (1891) used photographs taken by Petrie in 1887 of different racial types from Egyptian monuments, originally published in *Racial Photographs from Egyptian Monuments*. Sayce is clear from the beginning that it is a 'fact that mankind is divided into races', and that race is the equivalent of species 'in the case of the lower animals'. Race is also different from nationality: 'The British nation is a mixture of various races; the political union which has existed among them for centuries has made this mixture a nation.'

One of Sayce's main purposes, as befits an Anglican clergyman, was to put flesh on the bones of the interminable genealogies in the tenth chapter of Genesis, in effect tying each name to a people or place. We learn from him that 'The northern frontier of the sons of Joktan was Mesha or Mash. Mash, as we learn from verse 23, was one of the four sons of Aram, Uz the land of Job, being another.' As also befits a clergyman, he sees the history of Egypt and the Jews as inextricably interwoven: 'Egypt forms the centre of the history of Joseph, and it became the house of bondage of the children of Israel. In Goshen they first grew into a nation, and the exodus out of Egypt is the starting-point of Israelitish history.'

In differentiating race from nation or community Sayce argues that language 'is no test of race'. Using Jews as an example, he maintains that wherever they settled, they adopted the local language, though they were in his view a distinct race.[29] Sayce claims that skull shape is one of the most important 'characteristics that distinguish races from one another', and that 'it is startling to see how unchangeably the same type of skull is reproduced, generation after generation, in the same race'. Apart from the shape of the skull the projection of the jaws 'is perhaps the most valuable of ethnological texts', referring back to Camper without mentioning him through his claims that 'the facial angle of the European averages 80°, that of the negro averages 70°, and that of the orang-outang 40°'.[30]

Petrie's *Racial Photographs* was the basis of the chapter entitled 'The Semitic Race', which Sayce begins by challenging the very idea of a Semitic race; 'Semitic' makes sense only as a group of languages of which Hebrew and Aramaic form part, though he consents to use it as a racial term, describing the Jews as a desert people who avoided mixing with other races in Northern Arabia. He does talk of a 'Jewish Race', claiming that it is 'by no means a pure one', intermarrying with a number of other races, and he notes the 'two grand divisions' between the Sephardi of Spain and Italy and the Ashkenazi from Eastern Europe. But more than the Bible it is Egyptian monuments that afford proof of the mixed character of the Jews.

He notes how little the 'modern Jewish type' has changed since antiquity, by reference to figures on an Assyrian obelisk of black marble that was 'Among the spoils which the British Museum has received from the ruins of Nineveh', which he dates to 842 BC. This must be the 'Black Obelisk', a twelfth-dynasty obelisk from Nimrud, now in the British Museum, which shows a caravan of traders who were generally taken to be Jewish. The work is a Neo-Assyrian sculpture erected in honour of Shalmaneser III, king of Assyria (859–824 BC), with a procession in five separate scenes bringing gifts 'Among them are the servants of Jehu, King of Samaria. Each is portrayed with features which mark the typical Jew of to-day. No modern draughtsman could have designed them more characteristically. The Israelite of the northern kingdom possessed all the outward traits by which we distinguish the pure-blooded Jew among his fellow men.'[31] These servants are depicted in full profile which would have made physiognomic comparisons easier, but these profiles are hardly clear enough for such a sweeping judgement.

Even so Sayce argued that modern Jews were so mixed racially that such judgements could no longer be made, though he did describe how to spot contemporary Jews of the purest race, arguing that their traits include not only physical characteristics but mental and moral qualities as well.

> More especially does it concern us to know what were the affinities and characteristics, the natural tendencies and mental qualifications of the people to whom were committed the oracles of the Old Testament. Theirs was the race from which the Messiah sprang, and in whose midst the Christian church was first established.[32]

Sayce finds the idea of a 'Semitic Race' to be particularly problematic, because it 'owes its name to a confusion of ethnology with philology', claiming that one can only really talk about a Semitic family of languages, not a Semitic

*race*, for language does not map onto race; many Semites do not speak Semitic languages, and many non-Semites do. He also argues that the 'Jewish race is by no means a pure one', distinguishing between the 'black Jews' of Malabar and the 'white Jews . . . whose type is European rather than Jewish'. He also claims that intermarriage caused the division between the Sephardi and Ashkenazi Jews, the former intermarrying with Spaniards and the latter with inhabitants of Germany, Poland and Russia. This mixing he notes goes back to biblical times, and that 'it is the Egyptian monuments which have afforded us the most convincing proof of the mixed character of the population in the Jewish kingdom.'[33]

EVEN SO, HE IS CLEAR that 'The true Semite . . . is distinguished by ethnological features as definite as the philological features which distinguish the Semitic languages.' He is also clear that 'He belongs to the white race, using the term "race" in its broadest sense.' But the division of the white race of which the Semite is a member has characteristics of its own so marked and peculiar as to constitute a special race – or more strictly speaking, a sub-race. Sayce then falls back on the idea that there are features common to all of the 'pure' Jews – the 'hair is glossy-black, curly and strong, and is largely developed on the face and head' and 'the nose is prominent, and somewhat aquiline' – though he admits that in Central Europe 15 per cent of Jews are blonde and that 60 per cent are of an intermediate colour between black and blonde. He then repeats the usual stereotypical tropes of the time about Jewish mental proclivities, that 'Jews are clever . . . with a special aptitude for finance' and so on.

Sayce argued for the Egyptian artists' exceptional accuracy in distinguishing race in representations of prisoners brought into Egypt:

> The Egyptian artist had an innate gift for portraiture; he seized at once the salient traits in an individual face, and reproduced them with almost photographic fidelity. Doubtless at times he may have exaggerated some striking feature in the head of a foreigner . . . But such exaggerations only bring into stronger relief a racial peculiarity, and it may after all be questioned whether the exaggeration is as great as it seems.[34]

In the third chapter Sayce discusses the tomb in the Theban Necropolis of Rekh-ma-Ra of Rekhmire, the Governor of Thebes, which he claimed

preceded the Book of Exodus by a century, and – in the spirit of Nott and Gliddon – showed 'the races of the known world each depicted with its own peculiar characteristics': 'The black-skinned negro' representing the south; 'the white-skinned European and Libyan, with fair hair and blue eyes' representing the north and west; 'the Asiatic, with olive complexion and somewhat aquiline nose' the east; and 'a race whose skin has been burnt red by the sun . . . who display all the traits that distinguish the Egyptian of to-day'. A look at the original paintings, which are rather different from the schematic colour drawings made after them, suggest a more complex picture. The Nubian tribute-bearers are identifiable from their skin colour and the goods that they bring – ivory and a giraffe, which were associated with southern Africa – but they are shown as an equal mixture of black and brown bodies, while others are either red or relatively light skinned, though enveloped in cloaks. In the colour drawing, which dates to the 1830s, it is easy to see why Sayce was able to make such categorical racial distinctions, owing to the divisions imposed on the processions by the use of clear and distinct colours, but it is not clear from studying the original wall paintings that such marked differences were intended. Presumably either the 'Europeans' or the 'Asiatics' are the cloaked figures, but that also seems unlikely, while the red figures are taken by Sayce to be Egyptians. Again the representational fallacy comes into play, assuming that the artist had reproduced wholly objectively the skin colour of all the people he depicted.

This racial or ethnological division is contrasted with the geographical distribution of peoples in Exodus, in which the descent of individuals in the Old Testament is seen as standing in for the genealogy of peoples or nations. Sayce sees the Nile valley – which includes representatives of all the world's races, except 'the American, the Australian, and the Chinamen' – as 'the world of Genesis . . . the cradle of culture, [where] the seeds of science were first sown, and the first harvests of human thought and invention were gathered in'. This means that 'More than one variety of the white race had its representatives,' including 'the Semite of Arabia and Assyria' and of course 'the Egyptian with his thick lips and good-tempered smile'. These were set against the case that '[a]mong the natives of "Cush" [Nubia] were black-skinned negroes and Nubians', though the main bulk of the population was of Semitic or Egyptian descent. It is interesting that he regards 'Semites, Aryans, and Alarodians [to] belong to the white stock, and may thus said to be but varieties of one and the same original race'.

It is also interesting that he makes a clear distinction between 'the two black races', the Nubians and the 'negroes': 'The Nubians, in spite of their

black skins, are usually classed among the handsomest of mankind, just as the negroes are among the ugliest.' The latter are described, in terms that partly go back to Camper, as 'dolichocephalic and prognathous' – that is to say, having a long narrow skull and projecting lower jaw.

With the ancient Egyptians, he claims that despite the enormous amount of evidence of their appearance from the presumed lifelikeness of statues in the museums of Europe and the scenes of daily life on tomb walls, their precise characteristics are not easy to determine; indeed, 'It is but recently that ethnologists have discovered that the Egyptian is a member of the white race.'[35] He attributes this 'discovery' to the great German doctor and anthropologist Rudolf Virchow, the founder of social medicine,[36] though Nott and Gliddon had made the same claim almost forty years previously. Even so, he talks about the Egyptians as having white skin, on the grounds that they were so often represented as such in wall paintings.

But faced with the fact that Egyptians are just as often actually represented with *red* skin Sayce asserts that 'the ordinary Spaniard or South Italian is darker-skinned than the pure-blooded Egyptian'; at any rate, the redness must be due to sunburn. As is so often the case in nineteenth-century discussions on race, any otherwise inexplicable variants are attributed to those who are *ipso facto* not racially pure, a tactic particularly favoured by Nott and Gliddon. Sayce does accept, however, that there are darker-skinned Egyptians on the southern frontiers of Egypt 'due to long-continued intermixture with the dark-skinned Nubians, who once occupied the whole of this region.'[37] Sayce is evidently reading back from experience of present-day Egypt to ancient times to describe a full picture of the appearance of 'the Egyptian', whose personality and characteristics he believes to have remained constant for more than 3,000 years. He quotes Virchow in stating that from 'the close of the Sixth Dynasty, the racial type presented by the statues and mummies of Egypt is that of the existing peasantry.'[38]

Despite Sayce's religious interest in the ancient Egyptians as an Old Testament people and as pioneers of civilization, he is still *au courant* with skull comparison, which remained a continuous thread in anthropology from the beginnings of racial science in the late eighteenth century to well into the twentieth century. The Egyptians are described as 'dolichocephalic', or long-headed, which means that their skulls' transverse diameter is in a proportion of 70 and 80 to 100, whereas a skull that is 'brachycephalic', or short-headed, would be in a proportion 80 and 90 to 100, with the medial, or 'mesocephalic', being 80 to 100. These calculations are based

on assumptions shared by Camper, Lavater and Cuvier, that 'the shape of the skull is one of the most marked and permanent characteristics of race . . . unchangeably the same type of skull is reproduced, generation after generation, in the same race.'[39]

Strictly speaking, Sayce was not a eugenicist – that is to say, he was not concerned with the problem of the 'Fit' versus the 'Unfit' in society. As a clergyman his concern was with the way that history can shed light on the Old Testament and vice versa. But he shares with Petrie a total commitment to racial science in its purest form, and a belief in the continuity of race from the ancient world to the present day, based on the belief that the artists of ancient Egypt gave an exact picture of the racial types who inhabited Egypt at different times.

### Ideal Americans

Eugenics rests on the assumption that evolution is an ongoing process, and that the body can be transformed progressively into a more advanced or even ideal form. Camper's comparative racial skulls had as its ideal the head of the *Apollo Belvedere*; this and other canonical classical marble statues retained their aesthetic prestige well into the twentieth century and through the Third Reich in Germany. When promotors of eugenics from Galton onwards visualized their 'new man' or 'new woman' to be created by the eugenic state, they did so by invoking ancient Greece and the ideal classical body. That this ideal body could become a 'type' of the dominant race was anticipated by Galton's racial photographs, which in effect attempted to extrapolate an ideal form from an averaging process, thus notionally creating an aesthetic ideal out of composite images, that was both traditional and proleptic.

But achieving the ideal from an averaging process had a fundamental problem. What if the image derived from a composite of average images fell short – as one might think it was bound to do – of the ideal? A good illustration of this problem is provided by the 'Typical Americans' project, initiated at Harvard by Professor Dudley Allen Sargent, which resulted in an exhibition at the Chicago World's Fair in 1893 (illus. 99).[40] The statues of a single male and female are now in the Peabody Museum at Harvard. The project was motivated fundamentally by a belief in eugenics: 'Better bodies', Sargent argued in 1889, were necessary to 'insure a higher development of the individual, and advance the condition of the race'. There was also a comparative element, for Sargent's two sculptures of 'Typical Americans'

99  Henry Hudson Kitson and Theo Alice Ruggles, *The Typical Americans*, 1892, bronze, project initiated by Professor Dudley Allen Sargent.

were to be compared to 'individuals of other nations and races', who, 'If [they] can be induced to make similar contributions, and if the experiment is repeated every 25 years – we should, soon have visible evidence of our physical progress or degeneracy,' though the international and inter-racial comparison appears not to have happened.

But this broad ambition was undermined by its own methods. First, the figures were based not on a truly widespread sample but on 'statistical mean measurements from 10,000 white male and female college students from Harvard, Radcliffe, and other universities'. Thus, it was a carefully selected group, who can be presumed to be almost uniformly white Anglo-Saxon Protestants, well-fed and brought up with an ideal of physical fitness and the means to achieve it: very far from typical Americans, if one includes

the more recent immigrant population. Furthermore, the sculptors who were commissioned, Henry Hudson Kitson (1863–1947) and Theo Alice Ruggles (1871–1932), a married couple, were well-established academic sculptors, accustomed to providing elevated and heroic renderings of their chosen subjects. Kitson had specialized mainly in military monuments in Massachusetts, including the famous *Minute Man* in Lexington, but he also sculpted a number of Confederate leaders, including Jefferson Davis in Vicksburg in 1927. Ruggles was, if anything, more famous than her husband: she was the first American woman to win an award for sculpture at the Paris Salon, and her bronze statue of a heroic soldier, *The Hiker*, was erected at more than fifty sites throughout the United States.

Set in the Anthropology Building of the Chicago Worlds' Fair, in explicit contrast to the peoples and cultures displayed around them, the 'Typical Americans' statues' striking portrayals of ideal white masculinity and femininity drew large crowds. The woman looks down demurely, her genitals erased, her back foot lifted tentatively and leg slightly bent, in a pose borrowed from classical sculpture. The man stands erect, gazing straight ahead with his feet planted firmly on the ground, his genitals concealed but also emphasized by the fig leaf covering them.

So the 'Typical Americans' were an amalgam of real and ideal elements: the male figure is a modern version of the *Apollo Belvedere* as the female is of the *Venus de Medici*, and they are based on what Sargent called ideal measurements: the man is 'about 5ft. 8 in. in height, weighing 150 pounds', and the woman '5ft. 3in. in height, weighing 125 pounds'. In the 1893 World's Fair, the male statue was exhibited in front while the female stood behind him. The slippage between the real and the ideal is something we have seen already going back to Camper and beyond to Winckelmann. It was a utopian view of the past and the hoped-for future, and it lives on in the 1920s and '30s in attempts in the United States to project eugenics into the future as the fulfilment of Darwinian evolution.

It was also conditioned by anxiety regarding the 'degeneracy' of the American male, particularly during the First World War. This concern was intensified by a study conducted by Harvard professor Robert Yerkes, who measured the bodies of army recruits and was alarmed at the fitness levels of men expected to go into battle.[41] His measurements provided the basis for a plaster statue titled *The Average Man* (1921), made by Jane Davenport Harris – daughter of Charles Davenport, the founder of American eugenics – for the American Museum of Natural History. The statue is almost entirely without the idealizing features of the 'Typical Americans': it shows

a round-shouldered and unmuscular figure that represents, one assumes, white Americans outside the disciplinary regimes of Ivy League colleges, and is depicted without the assertive stance of academic sculpture. Nonetheless there is an 'Aryan' cast to the face and hairstyle that hints at least at a racial ideal.

If we turn to the most famous examples of sculptures of ideal Americans, we can see the seriousness with which the search was undertaken in the 1930s and '40s. As Christina Cogdell notes, 'The murky relationship between a racial norm and the ideal is well expressed in the plaster figures of *Norma* and *Normman* of 1942' (illus. 100).[42] The pair were a collaboration between a doctor, Robert Latou Dickinson, and the sculptor Abram Belskie, a student of the artist Malvina Hoffman. Like the other statues we have considered, they were based on statistical measurements derived from many sources. It was noted at the time that, even if they fell short of the ideal, the average represented by the sculptures was altogether more perfect than any actual Americans – a point also made by Galton when talking about his photographic composites of young Jewish men. Once again, the artist has, consciously or not, idealized the figures by straightening the stances and raising the shoulders. They may still correspond with average measurements, but they now hint at a superhuman presence.

If evolutionary change was not only historical but proleptic, then it could, and indeed should, be harnessed by would-be progressive forces to create an ever-higher level of humanity. The aimed-for superior human being is depicted in an illustration brought to light by Cogdell in an issue of *Popular Science Monthly* of 1929.[43] In it, scientists are shown hard at work in what appears to be a sculptor or a phrenologist's workshop, with one scientist measuring a gigantic, almost naked man in a pose shadowing the cast of the *Apollo Belvedere* behind him. This invocation of the Greek ideal, plus the centrality of measurement, ties the image atavistically all the way back to Camper, while at the same time projecting it into a utopian future. Accompanying the illustration is a smaller diagrammatic version of the human figure, in which almost every aspect of the figure is pictured in a distinctively racial way: large head, high forehead, narrow nose, jutting chin, short arms and so on; the man of the future, one should not be surprised to see, is definitively white.

A similar article in the *New York Times* of Sunday, 8 December 1929, also found by Cogdell, is headed: 'SCIENCE PICTURES A SUPERMAN OF TOMORROW: Biologists See Him a Man of Superior Intellect, Immune From Many Diseases, with a Greater Span of Life and Power to Choose the

100  Robert Latou Dickinson and Abram Belskie, *Norma and Normman*, 1942, white alabaster.

Sex of Children . . . A Higher Intelligence . . . A Superior Race in View'. It is illustrated by a scene in a laboratory in which a researcher peers into a microscope, while behind him there is a gigantic naked male figure holding one hand to his forehead, as if exercising enormous brain power.[44]

These two articles and their illustrations represent the more speculative reaches of eugenic thinking, but it is remarkable how they fuse so many elements of racial science as it developed in the nineteenth century through Darwinism: the belief in racial and aesthetic hierarchy; the control of breeding; the belief in the measurability of intelligence and moral worth; male superiority and the power of science; the continuity with the ancient Greek world; and, above all, the dominance of the white race.

# INTO THE TWENTIETH CENTURY: RACE IN THE WORLD

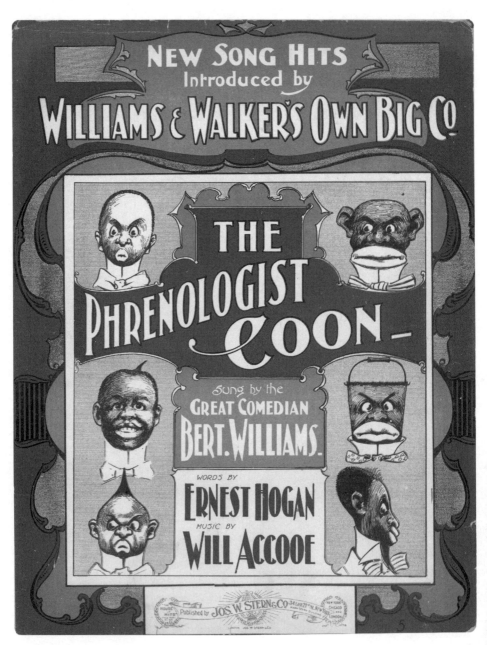

101  Ernest Hogan, 'The Phrenologist Coon' (1901), sheet music.

# 10

# The Ape, the Coon and the Savage:
# From Racial Science to Racist Imagery

Dat's the reason why they call me the phrenologist coon:
I was born on Friday mornin',
With the 'clipse of the moon:
After feelin' of your bump, and your face I've read,
By just feelin' in your pocket,
I can tell what's in your head;
Dat's de reason why they call me the phrenologist coon.

ERNEST HOGAN AND WILL ACCOOE
(sung by Bert Williams), 'The Phrenologist Coon' (1901)

'The Phrenologist Coon' (illus. 101) was written by the Black song-writer Ernest Hogan, author of the notorious song 'All Coons Look Alike to Me', and by the musician Will Accooe, and sung by the great minstrel performer Bert Williams. Though it contains some of the usual tropes of minstrel songs, it is an unexpectedly penetrating critique of the basic arguments of racial science and the importance of its visual aspects. The invocation in the song of phrenology, though by 1901 almost completely discredited, and ethnology, as well as psychology, was an unmistakable challenge to racial science, as is the suggestion that feeling the head and face can (with a questing hand in the pocket) enable the 'scientist' to tell the nature of the character of the person he is examining. In the mocking language of minstrel song, the lyrics suggest that a 'scientist' has the power, through phrenological examination of the skull and physiognomy, to identify a person's inner thoughts and aptitudes, and their future prospects:

I can tell you what you are by the feeling of your bump,
And in the myst'ries of the future I can certainly make you jump;
When I has an inspiration, all the future I can see,
I can tell you what you are and wus,
And what you're gwine to be.

The second verse emphasizes the shape of the skull and the way it is supposed to dictate character in a comically exaggerated but direct way:

Now by us scientists 'tis often said,
If a coon has an egg-shaped head,
Means chickens he will steal! . . .
If his head's shaped like a razor,
You can bet that coon will cut;
If his head looks like a billy goat,
Beware! dat coon will butt.

The reference to bumps evokes phrenology, but it is possible that the song is more directed at an ethnology of the kind made famous by Morton, Nott and Gliddon in *Types of Mankind; or, Ethnological Researches* (1854), the bible of Confederate racial theory and, as we have seen, a long-drawn-out attempt to give Southern slavery an ancient Egyptian pedigree. But what is striking about 'The Phrenological Coon' is that it does more than just identify the racial possibilities of phrenology and ethnology; it goes to the heart of racial science, which is premised on linking external appearance to a person's inner being. By lampooning the way that racial scientists move from the shape of the racialized skull to a judgement of essential character, it challenges not just racial prejudice but the whole scientific basis of racism, and the immense amount of literature and visual culture devoted to supporting it.

Equally significantly, it challenges the separation of the intellectual world of racial science from that of popular culture, expressed in millions of demeaning racial images, as has been made by Peter Fryer and Tzvetan Todorov. Their distinction between 'high' and 'low' racism is a cogent one, based on the fact that race as a theoretical concept is of eighteenth-century origin.[1] However, it is in danger of oversimplifying the relationship between intellectual and popular racism, which became particularly fraught in the nineteenth century when new technology enabled the production of an immense amount of popular racial imagery. What we see in the nineteenth

century is not only the eruption of racial ideas in popular consciousness but the popularization of racial ideology that claimed the authority of science. As we have seen, the emphasis on an animal-like physiognomy in nineteenth-century images of Africans is derived ultimately as much from the writings of Cuvier and others, and the illustrations to their works, as it is due to popular belief.

However, it is also possible to look at popular racism another way. Douglas Lorimer has argued that racial scientists should be seen not as directing public consciousness but rather as receiving it, taking over unconsciously its assumptions. The easy recourse of scientists to stereotypical racial psychology, such as the idea that Black people were lazy despite the backbreaking work they did on plantations, derives from the fact that scientists themselves were influenced by popular opinion, or at least prevailing orthodoxies of the particular time. The fixity and frozen nature of these characterizations was aided by the prevalence of photographic representations.[2]

In popular nineteenth- and twentieth-century racist imagery, the dominant trope is one of difference. This may mean, in the case of those of African descent, difference from the social norm: the 'white race', genteel behaviour or from measured responses in social situations. In the 1820s there arose a new genre of satirical engraving in England and North America, largely devoted to mocking urban Black populations, showing them imitating ineptly the social interactions of their white social 'superiors'. The genre was initiated in the late 1820s by Edward W. Clay's lithographic series *Life in Philadelphia*, which was very loosely based on Pierce Egan's comical monthly publication *Life in London* (1823), illustrated by George and Robert Cruikshank, in which the central characters, Tom, Jerry and Logic, are young men about town, exploring both the high life and the poorer districts of London.[3] Their travels through the spaces of London belong to a genre that goes back ultimately to William Hogarth's *Harlot's* and *Rake's Progress* engravings, a genre satirizing mainly those who aspired beyond their divinely ordained station in society.

*Life in Philadelphia* was initially made up of fourteen images, not all of which were of Black people, though as the series went through revisions in London, eventually to be republished in 1834 by Gabriel Shire Tregear under the title *Tregear's Black Jokes*, the satires that were not directed towards Black people were gradually eliminated. Their figuration was strongly influenced by the fashion plate; clothes are as much the vehicle of satire as the Black people wearing them. The clothes are often grotesque in

102 Charles Hunt, 'How you find yourself dis hot Weader Miss Chloe?', *Life in Philadelphia*, no. 8, London, *c.* 1830, etching with aquatint.

themselves, though made more ridiculous by the deliberately heightened incongruity of their wearers. In addition to their pretentious clothes, the Black people engage also in faux genteel and inept conversation, with comically poor pronunciation, as in plate number 8: 'How you find your-self dis hot Weader Miss Chloe?' 'Pretty well I tank you Mr Cesar only I aspire too much!' (illus. 102). The male figure's stance is deliberately inel-egant, despite the fashionable clothing, revealing a telling bow-leggedness. Aspiration beyond one's social rank was regarded by satirists as early as Hogarth as a major form of transgression, and this became even more tell-ing in the case of the 'free Negro'. By the 1830s there was clearly enough of a relatively prosperous Black presence in both London and some eastern

cities of the United States – though actual numbers were very small – to attract the derision of satirists.

This kind of imagery reflects at a number of removes the early to mid-nineteenth-century scientific debates around the capability of the 'savage' to be taught to behave in a 'civilized' manner, a question that exercised Darwin when he met the three Fuegians who had been taken to England to be educated, and who returned to Tierra del Fuego in the time he was there. *Life in Philadelphia* and its successors made the implicit claim that outward show, elegant clothes and imitation of civilized manners could not disguise the 'real' nature of the person, but only produce an effect of humorous incongruity.

Such printed scenes of Black people ineptly imitating their white social superiors, though deeply repellent to more modern eyes, had a remarkable success and great longevity in the United States through the enormous popularity of the 'Darktown' lithographs published by Currier and Ives from 1857 to the turn of the century.[4] Though the publisher produced a staggering variety of images of American life and landscape, racial caricatures constituted about one-third of their total production, suggesting an enormous public for them in the northern states as well as in the south. This profusion and the increasingly hysterical racist tenor of the images

103 Thomas Worth, *A Literary Debate in the Darktown Club – Settling the Question*, c. 1885, lithograph.

represent the climate of the post-Civil War period of Reconstruction, when the gains made by African Americans in the years after the abolition of slavery in 1865 were systematically and brutally overturned by resurgent Southern landowners, aided by a complacent and often prejudiced Northern reaction. Increasingly, visual satire became a means of undermining Black emancipation under a very thin veneer of patronizing humour.

One example, taken from a great many produced, is a pair of Currier and Ives lithographic prints entitled *A Literary Debate in the Darktown Club* (illus. 103). The prints depict a debate between two Black men, one colourfully dressed and fat, the other thin, dressed in crumpled coat tails. In the first one, 'Settling the Question', the two protagonists gesture heatedly before a heavily stereotyped Black audience in a venue with portraits of U.S. presidents on the wall, including 'A. Linkum'. The second print, 'The Question Settled', shows that the debate has descended to blows and extreme chaos, with the two orators seated in total disarray as a policeman enters the room. The humour – such as it is – lies in the idea that their 'savage' nature has broken through the civilities of formal debate, but it is really a cynical and tendentious comment on the doubts of white ruling elites in the post-slavery period that recently freed Black people could be educated to become articulate citizens.

The *Life in Philadelphia* prints can claim to be the distant ancestors of what is now generally known as 'Sambo Art', based on the satirical figure of the 'Coon'. Some have seen this figure as an urban type, contrasting him with his supposedly more rural cousin 'Sambo', but the distinction is not at all clear in practice.[5] The Coon was an essential part of the minstrel show, performed by both white and Black performers in blackface. Thomas D. Rice, a white minstrel performer who created the persona of Jim Crow in the late 1820s as a comical Black man, performing the eponymous dance, is visually the ancestor of the Coon, who had a growing presence in the minstrel show up to the 1890s and eventually in the cinema.[6] The song sheet for 'All Coons Look Alike to Me' by the author of 'The Phrenologist Coon', the Black musician Ernest Hogan, who lived to regret his authorship of the former, though the song is not quite as racist as it sounds, has on the cover by an unknown artist a number of stereotypical black figures of both sexes. They are all conspicuously elegantly dressed, with minstrel-like physiognomies: completely black faces and frizzy hair. They also have a characteristic feature of turn-of-the-century racist satire, very prominent red lips, as if they had been painted on.

This visual trope, in which the Black face is effectively reduced to a kind of ideogram of large red lips on jet-black skin, remained a feature of popular representation in racial postcards, advertisements and cinema cartoons well into the 1940s. In addition to its roots in minstrelsy it also picked up elements from grotesquely stereotyped images of native Africans, who were often displayed in person in World's Fairs and theatres in Europe and the Americas from the mid-nineteenth century onwards. This form of representation also derived from tales of encounters in Africa itself, as Western powers competed to occupy and exploit parts of the continent itself. Sadiah Qureshi describes the displays in London, from the Great Exhibition of 1851 onwards, of Zulus and other South Africans brought over to enact

CRYSTAL PALACE—SOME VARIETIES OF THE HUMAN RACE.

104 'Crystal Palace – Some Varieties of the Human Race', in *Punch's Almanack for 1855*.

their life in Africa, with particular emphasis on savage behaviour, in mock battles and war dances.[7] The absurdity of such reconstructions and their difference from European norms is brought out wittily in a *Punch* cartoon of 1855 entitled 'Crystal Palace: Some Varieties of the Human Race' (illus. 104), which shows two well-dressed and demure young women taking tea, while Zulu warriors enact battles in the background.

Such images clearly contributed to a repellent but popular trope of cannibalism that emerged in the late nineteenth century and remained current until the 1940s, despite seeming to have no basis at all in fact. Missionaries and explorers were shown as being boiled in large cauldrons surrounded by naked warriors dancing, sometimes with bones through their noses. Such cauldrons were made at Coalbrookdale Ironworks in Shropshire from the nineteenth century onwards, and to this day are known as 'missionary pots', though certainly they were not intended as such, and are highly unlikely ever to have been used for boiling any human being. The cannibals in twentieth-century cartoons and comic strips are invariably reduced to an almost-naked black body and a standardized physiognomy, consisting of a round black skull (sometimes with crinkles, suggesting hair) with enormous lips, red or yellow in coloured versions, a joined patch of white containing dots for eyes, varied only occasionally by a broad grin.

This reached its internationally most popular form in a comic-strip book, produced in Belgium initially: the cartoonist Hergé's *Tintin in the Congo* (1930–31), which gives an unashamedly colonialist view of the Belgian colony, with grotesquely and reductively caricatured 'natives' as a backdrop to the white hero's adventures, in line with the colonialist attitudes of the proprietors of the newspaper in which the story originally appeared. Though the book is still in print, it cannot be reproduced here because the copyright holders do not allow it to be shown in the context of discussion of its racial attitudes.[8]

Such visual ideas fed into popular racist imagery in the United States and not infrequently appeared in cartoon films in the 1920s and '30s. Perhaps the most chilling example is a Betty Boop film of 1932, *I'll Be Glad when You're Dead You Rascal You*, which shows Betty Boop and a companion travelling in Africa, only to be captured by grass-skirted 'natives' who prepare them for the cauldron.[9] The pair escape and are followed by a disembodied stereotypical head of an African who morphs into the great jazz trumpeter Louis Armstrong, playing his instrument and singing the title song. Equally notorious is *Coal Black and de Sebben Dwarfs* (1943), which

takes racist caricature to the limit in its portrayal of Prince Charming as a classic city Coon, and the dwarfs as soldiers represented by extreme 'African' caricatures with brown faces and enormous mobile lips.[10]

In every case, the popular imagery we have seen so far attempts a semblance of humour, though it is only a thin veil over the true derisory intent. There were also openly racist books wholly devoid of any humour that claimed the authority of 'Science, Reason and Revelation'. One is a chillingly unpleasant book by Charles Carroll, entitled *'The Negro a Beast'; or, 'In the Image of God [?]'* (1900).[11] The biblical Book of Revelation is clearly at the forefront of those cited, but the author also mentions Darwin approvingly, though he claims that 'the terms "human species" and "Races of men" belong exclusively to "the atheistical school of Natural Development", which teaches that man is a highly developed species of ape.' Nonetheless, the author has read widely in racial science and quotes Broca and Haeckel, going into detail on comparative cranial capacity and brain weight.

The author, while denying the descent of man from apes, revives – citing an extremely selective group of many authorities – the argument we have encountered many times in this book: 'the Negro' is closer to an ape than to other human beings and is therefore not human at all; in other words, 'a Beast'. The idea of Africans as a species incapable of being civilized is carried through the illustrations, which make a series of contrasts between white people and a brutally caricatured Black man or child. The frontispiece shows Adam and Eve in the Garden of Eden in a ray of light emanating from heaven, while looming in the darkness is a large spectral Negro head with gigantic lips and a menacing expression. Two of the illustrations make the point that Christ and the Virgin Mary are, by definition, white skinned, and therefore the Negro cannot be one of God's children; others make the argument, designed to put a chill in Southern hearts, that if the Negro is descended from Adam and Eve then white couples can expect on occasion to produce Negro children.

It is telling that the last illustration in the book should show a scene of a caricatured Black man in the process of raping a formally dressed white woman in a forest clearing, with the hysterical caption 'NATURAL RESULTS. The screams of the ravished daughters of the "Sunny South" have placed the Negro in the lowest rank of the Beast Kingdom.' This anticipates by five years Thomas Dixon's novel *The Clansman*, which contains a comparable scene of rape by a Black man of a white woman, and D. W. Griffith's *Birth of a Nation*, which came out in 1915. The latter has a notorious scene where a young Southern woman, threatened with rape by a Black suitor, throws

herself off a cliff to her death; there were rumours that the film itself was originally to contain an actual scene of rape.[12]

'The Negro a Beast', though Creationist in argument, bases much of its case for relegating the Negro to the animal kingdom on nineteenth-century racial science, which the author knew well, and it is further evidence of the way, following Nott and Gliddon, that racial science penetrated into the consciousness of the American South at the turn of the twentieth century, and contributed to the myth of the 'Lost Cause'. There were also other deeply racist works, such as Paul Brandon Barringer's *The American Negro: His Past and Future* (1900), that made even greater claims to scientific authority in their use of racial science, but still argued that the abolition of the 'controlled environment of slavery' had released the 'black beast rapist', and that slavery should be reinstated if white 'race suicide' was to be avoided.[13] But such works also lie behind, and provide a rationale for, the crude and would-be-humorous demotic racial images that dominated consciousness not only in the United States but throughout Europe and South America for at least a century of racial repression.

# Responses to Racial Science and Eugenics

The battle-cry of the eugenicists, 'Nature not nurture', has been raised to the rank of a dogma, and the environmental conditions that make and unmake man, physically and mentally, have been relegated to the background.

FRANZ BOAS, *Scientific Monthly* (1916)

In the final section of this book, to show something of the spectrum of responses to ideas of race, I want to look at case studies of resistance to, affirmation of and avoidance of racial science, and the part played in all three by visual culture in the first half of the twentieth century. Racial science had provided, among other things, an intellectual justification for European and American nations to carry out open repression of other cultures and implement brutal policies of acquisition of land and goods, but there was growing intellectual resistance to its premises, mainly – but not exclusively – from members of subject peoples who had suffered because of racial ideas imposed upon them. By the 1930s academic fields like anthropology were divided between those who were still heavily invested in racial science and those who questioned it, but also those who, in varying degrees, accepted some of its premises and challenged some of its biases.

The great African American sociologist and philosopher W.E.B. Du Bois (1868–1963) is a good example of the last, for in his early years he both accepted and challenged eugenic premises. In the second decade of the twentieth century, however, the German-born anthropologist Franz Boas (1858–1942) challenged the fundamental premises of racial science. Many people who were not academics, such as Malvina Hoffman, sought to find a path between conflicting ideas of race, while Germany, following the collapse of the Weimar Republic, came under the rule of extreme eugenicists

in the National Socialist Party, a political shift that dramatically impacted the German art and aesthetics of the time. This impact is looked at here through the extraordinary career of the Expressionist painter Emil Nolde, which raises the question of the nature of art made by an artist with a strong commitment to National Socialism, despite the works not being acceptable to the National Socialist leadership.

## W.E.B. Du Bois: Raising Up the 'Negro Race'

Du Bois, who was educated at Harvard and in Berlin, where eugenic ideas were at the leading edge of modern science in his time, had been under the supervision of Rudolf Virchow, the most liberal of the human scientists of his time.[1] Du Bois' complex and evolving ideas on race and eugenics need to be seen against the background not only of his German intellectual formation – he felt liberated by his time in Germany[2] – but of the racial aggression towards African Americans, discussed in the previous chapter. Du Bois' claims for the 'Negro race' ran directly counter to the prevailing American belief in the superiority of the Anglo-Saxon race over all others; however, unlike Boas, he did not challenge the racial essentialism that formed the basis of Anglo-American eugenics until later in his long life. At the same time, as Kwame Anthony Appiah has pointed out, Du Bois was beholden to Herder's idea of the *Volksgeist*, the communal spirit of each people that is expressed most characteristically in folk songs. Hence the importance Du Bois ascribes to what he called the 'sorrow songs', which were then called 'Negro Spirituals' but are now known as 'African American Spirituals'.[3]

For Du Bois, art and photography had a central role in presenting an alternative to the domination of 'Jim Crow' attitudes at the beginning of the twentieth century, when hostility and derision directed towards Black Americans, following the period of Reconstruction after the Civil War, was at its height. His own interest in photography would have been stimulated by Frederick Douglass's exercises in portraiture. Du Bois was well aware that science was being used to reinforce the 'colour line', and he saw art and photography as means to challenge its visual basis.

Du Bois' most substantial use of the visual arts was the production of three albums of over three hundred photographs: *Types of American Negroes, Georgia, USA* and *Negro Life in Georgia, USA*, together with a transcription of Georgia state laws, all designed for the American Negro Exhibit in the 1900 Paris Exposition.[4] Their broad aim was to detach the image of

African Americans from that of an underclass of menials, former slaves and current Southern sharecroppers and field workers. He therefore presented a carefully selected group of young, respectable and well-dressed people of varied appearance, who differed from their middle-class white counterparts only in skin colour. This, he hoped, would directly challenge the bigotry behind Jim Crow society and its caricatural view of Black people, and thus gradually dispel colour prejudice. As Henry Louis Gates Jr put it, photography was to represent 'the human face of blackness' hidden behind 'representations of blackness as absence, as nothingness, as deformity and depravity'.[5]

The subjects are almost all young men and women, well dressed and turned out, with sober expressions – neither grinning inanely nor scowling, as Black people were so often represented in caricature – and inhabiting their clothes with elegance. Their natural ease is in deliberate contrast to, among other representations, the *Life in Philadelphia* prints discussed in the previous chapter: they are presented as a new generation of educated Black Americans who will demand, as of right, an equal position in a white-dominated society. Some of them represent what Du Bois called in 1903 the 'Talented Tenth' of the Black population, who would become leaders of the uneducated majority of their race, but they are also the public face of the 'New Negro'.[6] The uniformity of the format, and the fact that some of the subjects are shown in both full-face and profile against a neutral background, invoke not only the studio photograph but the anthropometric photography used to identify racial and criminal types, which goes back ultimately to Camper's comparative racial skull types. However, the point of Du Bois' selection of sitters was to counteract racial stereotyping by emphasizing the *variety* of African American physiognomy in skin tone, hair texture and skull shape; in Du Bois' eyes, the New Negro had broken free of demeaning stereotypes and could no longer be defined as physically different from his white counterparts.[7]

This photographic project is undeniably connected to eugenics. Du Bois, like almost every other intellectual of the period in Europe and the Americas, believed firmly in the concept of race – though, obviously, he was strongly opposed to the idea of the 'natural' superiority of the Anglo-Saxon race. The 'Negro race' was for him 'an historic race', both separate from and complementary to the white race. As he noted: 'The idea of fostering and developing the traits and talents of the Negro ... [is] in order that some day on American soil two world-races may give each to each those characteristics both so sadly lack.' His famous introduction to his classic work

*Souls of Black Folk* (1903) emphasizes the worldwide importance of race in a characteristically nineteenth-century manner: 'The problem of the twentieth century is the problem of the colour-line – the relation of the darker to the lighter races of men in Africa and Asia, in America and in the islands of the sea.'

What is more, Du Bois' ambitions for the Negro race were decidedly eugenic. The whole idea of the 'Talented Tenth' is clearly an adaptation of Galton's idea of the 'Fit' and 'Unfit'; the Talented Tenth were 'exceptional men, the best of the race', who must 'guide the Mass away from the contamination and death of the Worst'.[8] In 1922, in the journal he edited, *Crisis*, he lamented that 'The Negro has not been breeding for an object', and should train and breed 'for brains, for efficiency, for beauty'.[9] Already in 1899 he had described the fourth and lowest class as the 'submerged tenth', made up of 'criminals, prostitutes and loafers'.[10] In 1926 he lamented in another editorial in *Crisis* that 'There are . . . not enough children in the families of the better class,' echoing Galton's and his eugenicist followers' worry that the lower classes were outbreeding their superiors: 'We in America are becoming sharply divided into the mass who have endless children and the class who through postponement of marriage have few or none.'

The photographic display for the American Negro Exhibit for the 1900 Paris Exposition shows what the present and future 'Talented Tenth' look like. They are models of respectability, exuding an air of quiet competence. They are resolutely urban and have left behind any trace of their slave or rural ancestry (illus. 105, 106). Above all they are young, because, in Du Bois' eyes, they are the future of the race. Though the methodical production of the photographs and the reliance on full-face and profile connect them with the 'mug shots' characteristic of photographs of racial types and criminals, they go beyond that tradition. If racial photographs were primarily concerned with the unadorned physical structure of the skull, in every case the impact of Du Bois' photographs is dependent on the subjects' clothing and even hair styles. Each is defined not just by their innate physical characteristics but by artificial adornments to the body.

It is this high level of grooming and sartorial elegance that sets his subjects apart from the derogatory image of African Americans. They are a direct challenge to the ill-dressed and ungainly Coon of caricature, who is depicted as uncomfortable in formal clothing (see illus. 103): their bearing and the natural way they inhabit their clothing are signs of their worthiness to be seen in polite company. Above all, they look different from each other; the racial typing based on generalization from a small number of skulls

105, 106 W.E.B. Du Bois, portraits of a young man and woman, part of the 'American Negro' exhibit at the 1900 Exposition Universelle in Paris.

visibly does not apply to the people selected by Du Bois. In any case, their variety of physical features stems in reality from the almost universal sexual exploitation of female slaves under slavery, which meant that almost all African Americans had a proportion of white – or in rarer cases, Native American – ancestry.

It was, therefore, possible for Du Bois to accept the basic premises of eugenics, while at the same time dissociating his own race from the common assumption that they were inherently Unfit, in the eugenic sense. In effect he was making similar claims for the Negro race as Galton had made for the Anglo-Saxon race: each had a minority elite and a larger majority of those beneath, who were a potential threat to the dominant class because of their breeding capacity.

Du Bois was primarily concerned with the fate and prospects of African Americans, as were the writers of the Harlem Renaissance, who were equally beholden to eugenics. However, as the twentieth century progressed, they increasingly defined themselves more in terms of African ancestry and of the 'African race'. Despite his mission to raise up the African American community, Du Bois remained committed to European high culture, making

THERE ARE TALL ONES AND SHORT ONES IN ALL COLORS.

107  Ad Reinhardt, 'There are tall ones and short ones in all colors', from Ruth Benedict and Gene Weltfish, *The Races of Mankind* (1943).

an exception only for 'the sorrow songs'. On the other hand, the younger writers associated with the Harlem Renaissance, such as Langston Hughes, took full ownership of jazz, that great African American invention with unmistakeable origins in Africa.

A turn towards Africa also lies behind the remarkable sculpture by Meta Vaux Warrick Fuller (1877–1968) entitled *Ethiopia* (c. 1921, illus. 108), which deliberately emulates the appearance of an ancient Egyptian mummy. According to the sculptor, referring to African Americans of her generation: 'Here was a group who had once made history and now after a long sleep was awaking, gradually unwinding the bandage of its mummied past and looking out on life again, expectant but unafraid and with at least a graceful gesture.'[11]

The sculpture is based on the trope of the body awakening – in this case unravelling the cloth which encloses her – that essentially goes back to Rodin's *Age of Bronze*, an image of awakening to thought, here taken as an analogy of the rise of Africa from the sleep of history. But the direct reference to ancient Egypt in the mummy-like figure suggests an expansive view of the African past, implicitly appropriating ancient Egypt into Africa. This, as we have seen in earlier chapters, went against the grain of the academic beliefs of the time – exemplified by Nott and Gliddon – which saw Egypt as just as much a part of Europe culturally as it was of Africa, and as highly influential on ancient Greece. By claiming unequivocally that ancient Egypt was an integral part of Africa, Warwick Fuller not only gave credence to the idea of Africa as an ancient civilization seminal for Western culture but alluded to a myth of origin for the Negro

race, that was, according to Afrocentric thinkers, also a myth of origin for white civilizations.[12]

Franz Boas and Ruth Benedict:
Undermining the Premises of Racial Science

The German-born and -educated American anthropologist Franz Boas is generally credited with undermining the fixity of nineteenth-century ideas of race by emphasizing the fluidity of relationships between peoples, making culture and social life rather than heredity and 'blood' the central determinants of difference between peoples. This perception did not come to him instantly, but rather grew out of his experiences in the United States as a working anthropologist. On the Jesup North Pacific Expedition to Siberia, Alaska and British Columbia in 1897–1902 he took photographs and made skull measurements in pursuit of the origins of Native Americans in Asia. He had twelve photographers in Siberia, taking mainly general rather than anthropometric shots. More than 3,000 photos were taken that 'would form part of a data bank for the history of evolution, migration and diffusion.'[13] He also measured the cephalic index of the Native Americans he encountered, but the variability of physical types he observed undermined his belief in the separation of races. At the same time, he began to develop reservations about the concept of ideal types and became sceptical of the scientific uses of photography because of the limited angle of each shot.

It is clear that, from the beginning, he was guided by the emphasis in some German academic circles on environmental influences rather than inheritance, which led him to question the evolutionary hierarchy of races. In this he was clearly influenced by Virchow, who represented – at least in some areas of study – traditions of German liberalism that went from Alexander von Humboldt back to his own mentor Georg Forster. Nonetheless, Virchow was fiercely anti-Darwin. He believed that his student Ernst Haeckel's propagation of a kind of social Darwinism was dangerously anti-democratic, and he was sceptical of ideas of cultural superiority and militarism. His 1885 study of craniometry contradicted current theories of the 'Aryan race', leading him to denounce 'Nordic mysticism'. He declared that the 'results of craniology' led him to a 'struggle against any theory concerning the superiority of this or that European race' over others. His analysis of the hair, skin and eye colour of schoolchildren in Berlin, published in 1886, concluded that there was no such thing as either a Jewish or a German race.[14]

After leaving Germany, Boas entered into an intellectual journey that led him eventually to challenge eugenics directly. In 1916 he noted in an essay in the *Scientific Monthly* that 'the battle-cry of the eugenicists, "Nature not nurture", has been raised to the rank of a dogma, and the environmental conditions that make and unmake man, physically and mentally, have been relegated to the background.' He argued that there is a difference between 'the biological eugenist [*sic*] and the student of human society', that is to say the anthropologist. The former seeks 'an anatomical basis for all differences of function', while 'the anthropologist . . . is convinced that many different anatomical forms can be adapted to the same social functions. He believes that different types of man may reach the same civilization, that better health may be produced by better bringing up of any of the existing types of man.'[15] He maintained furthermore that 'we must assume that all complex activities are *socially* determined, and not hereditary; that a change in social conditions will change the whole character of social activities without influencing in the least the hereditary characteristics of the individuals concerned.'

Boas further takes the view that eugenics is bound to fail 'in view of the fundamental influence of environmental causes . . . it is perfectly safe to say that no amount of eugenic selection will overcome those social conditions by means of which we have raised a poverty and disease-stricken proletariat, which will be reborn from even the best stock, so long as the social conditions persist that remorselessly push human beings into helpless and hopeless misery'. He argues furthermore that though the eugenic ideal of eliminating unnecessary suffering is an attractive one it can easily shade into a desire to eliminate *all* suffering. This 'beautiful ideal' is unattainable, for suffering is always part of mankind's labours. He makes a romantic-modernist argument that 'Many of the works of sublime beauty are the precious fruit of mental agony; and we should be poor, indeed, if the willingness of man to suffer should disappear.' He concludes by what proved to be the prescient but poignant wish that 'Eugenics should . . . not be allowed to deceive us into the belief that we should try to raise a race of supermen, nor that it should be our aim to eliminate all suffering and pain.'

Boas's closest disciple and partial successor at Columbia University was Ruth Benedict (1887–1948), who was associated with the Herderian idea that human cultures are 'personality writ large', that individual personality and culture are closely allied; though she accepted into the 1940s the existence of the 'great races', the Caucasoid, Mongoloid and Negroid, she denied that there were Aryan and Jewish races.[16]

On the whole there is little art that can be associated with the Boas school, but one exception is the booklet Benedict wrote with Gene Weltfish, *The Races of Mankind*, published in 1943 by the Public Affairs Committee to be distributed to American troops.[17] The pamphlet uses simple language to emphasize similarities between races and the brotherhood of man, and the eleven illustrations are in a humorous mode associated with comic books, in effect countering directly the widespread use of derisive humour to demean other races. Especially intriguing is the identity of the artist, Ad Reinhardt (1913–1967), who is famous for being the most reductive of post-Second World War American abstract painters, whose late works appear at first sight to be made up of an unmodulated black, but on prolonged looking reveal various tones and variations. In the 1930s and '40s, however, he had a considerable career as a satirical cartoonist, which accounts for the commission.[18]

Reinhardt's illustrations scattered throughout the text are highly simplified, each one illustrating a proposition. 'There are tall ones and short ones in all colors', shows representatives of Africa, ancient Egypt and Europe/United States, schematically differentiated in shade and clothing, but each figure has an identical bulbous upward-pointing nose, a version of the Victorian 'celestial' (illus. 107). In 'The peoples of the earth are one family', a middle-toned Adam and Eve stand by a tree which has on top of its branches four men representing four different skin colours and races, united by identically comical large eyes with pupils at the bottom of each.

What is surprising given the pamphlet's anti-racism and denial, for instance, that Jews constitute a race, and that there is any meaning in the word 'Aryan', is the way racial ideas that run counter to the text enter into the visual illustrations as a kind of shorthand. In the illustration 'The peoples of the earth are one family', the four men fall clearly into racial stereotypes: a black African and a brown figure are almost naked, while a Chinaman is identified by a conical hat, and a white man by a suit and a trilby hat. Such illustrations point to something paradoxical in the title of the pamphlet *The Races of Mankind*, given that the whole argument of the pamphlet is to deny that race had any real meaning. But then it is perhaps impossible to deny race or demonstrate the brotherhood of man in visual terms without invoking the simplification that racial divisions can provide. Picasso, for instance, in his 1958 wall painting in the Temple of Peace at Vallauris, *Mankind Holding the Symbol of Peace*, falls back on a racial scheme that goes back to the roots of racial theory in Linnaeus in the eighteenth century, showing the whole of mankind as made up of abstracted black, yellow, red and white figures.[19]

108  Meta Vaux Warwick Fuller, *Ethiopia*, *c.* 1921, painted plaster.

Conflicting views: *The Races of Mankind* display
for the Chicago World's Fair, 1933

We have seen with Du Bois and Boas two different responses to the prob-
lem of eugenics. Du Bois, at least in his early years, accepted many of its
premises but sought to find a way within them to argue for the positive
identity of 'the Negro race'. Boas, on the other hand, by 1916 was prepared
to challenge eugenics' basic assumptions head on. But though Boas was
undoubtedly highly influential and became a celebrity in the United States,
many of those working in anthropology and related fields were attached
enough to racial categories to seek a compromise between an affirmation
of the primacy of heredity and the primacy of environmental causes of
human difference.

The most ambitious though far from unique American attempt in the
twentieth century to demonstrate in visual terms the racial variety of the
world was Malvina Hoffman's huge *Races of Mankind* exhibit, made ini-
tially for the Chicago World's Fair of 1933, and then installed as a permanent
display in the Field Museum, though it was eventually broken up and scat-
tered. It consisted of 104 bronze statues, and its outcome was neither fully
compatible with racial science nor in denial of it. The final exhibition was
the result of compromises negotiated by the artist between the views of the
powerful eugenicist Sir Arthur Keith, the most famous British anatomist
and anthropologist of his day, who was an outside advisor to the project,
with a member of the founding family Henry Field, on one side, and on
the other the Field Museum curator involved in the exhibition, Berthold
Laufer, who accompanied Franz Boas as a photographer on the Siberia
expedition.

Laufer, who had learned from Boas of the intellectual pitfalls attendant
on racial classification, claimed in the pamphlet accompanying the exhibi-
tion, 'The behaviour of a nation is not determined by its biological origin,
but by its cultural traditions.'[20] Keith, on the other hand, was a firm
believer in the central historical importance of race. In a book he pub-
lished in 1931 entitled *Ethnos; or, The Problem of Race considered from a
New Point of View* he argued that 'The further back we go the greater do
we find the degree of racial divergence to be.' He was a Darwinian, but
unlike Darwin, who saw race as part of sexual rather than natural selec-
tion, he saw racial difference and conflict as an evolutionary mechanism:
'It was, and still is, Nature's way of evolving higher types; for success there
must be rivalry and competition.'[21] 'I regard race-feeling as part of the

evolutionary machinery which safeguards the purity of a race.'[22] He also believed as an eugenicist that the white race was at a critical point of danger, and he thought it necessary for it and other races to retain their ancient tribal instincts.[23] But he also saw races as eternally evolving, always in different stages of differentiation. For this reason, and others, Keith was opposed to skull measurement and the use of statistical data. In his view everyone was an anthropologist by nature; racial difference could be observed by anybody, however unqualified, with certainty.[24]

Hoffman herself also had a decisive role in the overall conception. She was clearly a forceful personality and insisted on making the figures from the traditional artistic medium of bronze, emphasizing their artistry and permanence. Perhaps influenced by Keith, she did not regard skull shape or measurement as critical to the definition of a particular race, but saw it in terms of movement, action, gesture and pathognomy rather than physiognomy. She claimed that 'I chose the moment at which I felt each one represented something characteristic of his race and no other.'[25] Hence, many of Hoffman's sculptures show figures in movement, emphasizing whole bodies and their characteristic gestures and facial expressions, not skull shapes.

In almost all cases, therefore, the conception of each racial figure was performative, as if caught at a moment in which their race was enacted in its essential form. She sought out, where possible, not physical types but distinctive attitudes – notably that of the Shilluk warrior from the Upper White Nile (see illus. 70), whose extraordinary single-legged stance had been commented on by many before, and the Ubangi woman with her mouth distorted into the famous 'duck bill', which was created by progressive insertion of wood into her mouth. Despite Hoffman's claims to have discovered her subjects in their native habitat, she did not return to Africa, which she had visited for a short time before she received the Field commission. In fact, she had met the Ubangi woman in Paris, where they both attended the World's Fair of 1931.[26]

As can be seen from the original plan, Africa is paired with Oceania in hall A, which suggests the grouping together of the most 'primitive' societies, while Asia is in hall C and contains twice as many sculptures, perhaps in tribute to the relatively more 'advanced' societies of China and India. But what of Europe, which is only represented by six sculptures? These are placed in the central hall in two corners with representatives of America and Asia in the other two corners. According to an essay written by Henry Field (under Keith's influence), Europe is divided into three basic stocks, the

Mediterranean, Alpine and Nordic;[27] Europe is given a central place in the main hall, however, and the small number of its representatives make it like the still centre of an unruly world. The Hall of the Races of Mankind was, like the study of anthropology itself in that period, always about subject peoples rather than the 'master races'.

The Hall of the Races of Mankind was dominated by a central sculptural group, also by Hoffman, which consisted of the Three Great Races as represented by three ideal and heroic statues, each 'embodying the highest physical qualities of his race'. They were of a white or Caucasian male, a yellow or Mongolian male and a black or African male, each carrying different weapons – a sword, an axe and a spear, respectively, though Hoffman's original idea was for the Caucasian man to hold a book, an obvious allusion to the role of literacy in achieving European racial dominance. This division into three races was Keith's idea, and it represents a fairly conventional view in the 1930s. He claimed, not unfairly, that 'The recognition of these three prevailing types . . . represent the central crux of modern anthropology.'[28] This central group is purely symbolic in its monumentality, and it contrasts with the naturalism of the other sculptures in the hall.

Despite the presence of a disciple of Boas in the production of the *Races of Mankind*, by representing each race by a single life-size figure in bronze, the exhibition gives a permanent form to the idea of race, bolstering its claims to scientific probity. Though Hoffman's gathering of data for her representations of each race was not based on a consistent method – in fact it was quite idiosyncratic – the intention was to reify and make permanent the reality of race within a respectable institutional space. It is scarcely to be wondered at that the display became an increasing embarrassment to the museum from the mid-1940s onwards. In 1969 the display was broken up, and some of the figures were disposed of randomly around the museum, while others were sent out on loan. In 2018 the museum put on an exhibition in order to contextualize *The Races of Mankind* entitled 'Looking at Ourselves: Rethinking the Sculptures of Malvina Hoffman', emphasizing that the sculptures were based on individuals whose names could in some cases be retrieved, but it is highly unlikely that the original project will ever be fully rehabilitated.

Despite the arbitrariness that Hoffman brought to the selection of the actual races to be represented, the Races of Man was highly successful at the time as a contribution to the reputation of racial science in the 1930s. Though Hoffman consciously differentiated her project from the ever-more-public racism of the Third Reich – and the fact that it was partly moderated by a disciple of Franz Boas – it demonstrated the continuing

public respectability in 1930s America of such racial schemes, and they were common in natural history museums in other countries, though very few have been actively studied.

### A True Racial Artist? The Complex Career of Emil Nolde

The case of Emil Nolde raises an issue that is latent in many of the discussions in the present book: what is the relationship between the racial content of a work of art and the artist's expressed views on race? This is a particular conundrum raised by the art of the Third Reich in Germany. It is arguable that the official art of the regime had no inherent racial content, but was based on the most anodyne and bloodless academic art that had long preceded the rise of Nazism.[29] It was both heroic and romantic, but even a sculpture as imbricated in politics as Arno Breker's *The Great Torchbearer*, which represents allegorically the Nazi Party (Die Partei), openly follows ancient Greek precedents.[30] Despite its grandiosity, it can be argued that its Nazi attributes were expressed in its context rather than in its style; to put it another way, racial attitudes are not a property of the work itself but rather lie in the ineffable circumstances of its intention, production and reception.

Emil Nolde (1867–1956), in recent years posthumously exposed as a fervent Nazi supporter, represents an unusually complex case. His support of Nazi ideals and policy dates from Hitler's rise to power in 1933 and continued with added fervour throughout the later 1930s and the Second World War, though Hitler disliked his work intensely.[31] To the artist's great chagrin, he featured largely in the first iteration of the 'Entartete Kunst' exhibition in 1937, alongside his 'decadent' avant-garde contemporaries, and his work was suppressed as theirs had been, though he was able to have his paintings removed from the exhibition when it went on tour. On the basis of his entirely unwilling association with the avant-garde, he was able after the war to re-present himself as an artist persecuted by the Nazi regime and forced into internal exile, while he – and, after his death, the custodians of a museum devoted to his work – suppressed any reference to his Nazi sympathies, though they are completely evident in two autobiographical volumes produced in the 1930s.

What complicates his position is the fact that he was in his mid-sixties by the 1933 advent of a National Socialist government and had enjoyed a full and successful career as a painter. Like many German Expressionists of the early twentieth century, he was interested in and emulated the art

of 'primitive' peoples, and claimed kinship with the common people of the borderlands between Denmark and north Germany. His art could not have been further from the overblown yet vapid classicism characteristic of the official state-supported style brought in by Hitler after 1933. But given that he was a mature artist when the Nazis came to power, are there intimations of his later beliefs before then? Though early in his career Nolde expressed antisemitic views, and had a particular resentment towards Max Liebermann and those Jewish dealers who imported French Impressionist paintings, he had early Jewish patrons, some of whom later complained to him about his views.[32]

But his association with the Die Brucke painters in the first two decades of the century reveals more complex attitudes towards the representation of race. Between 1911 and 1913, when Nolde went on a visit to the South Seas, he spent much time in the Berlin Ethnographic Museum and made many paintings based on the objects he saw there. He was influenced by the art historian and philosopher Julius Langbehn (1851–1907) in his dislike for the prevailing scholarly approach to other cultures, and he protested against the colonial oppression and looting that allowed the formation of such museums at the one in Berlin. Some of his paintings of African scenes are based on close study of objects on view in the Berlin Ethnographic Museum. Many of them, however, appear to be deliberately humorous, even derisory, and blatantly mix ethnographic categories. In each case they depict known objects in the museum, however the 'African' female body shapes are exaggerated, and male figures sometimes bear toothy grins. *The Missionary* (1912, see illus. 67), for example, mixes cultures by showing a Christian missionary inhabiting the form of a Korean roadside idol, while an African woman in profile, based on a nineteenth-century north Yoruba figure, kneels meekly before him.

Nolde expressed early in his career a dislike of racial and cultural mixture, a common attitude of his time. In his second volume of memoirs, the *Jahre der Kampfe* (Years of Struggle) of 1934, he notes, no doubt in reference to the Weimar Republic: 'Some people, and especially those who are already of mixed race, have the pressing desire that everything – people, art, cultures – should become mixed, as a result the earth's human community will ultimately consist of half-breeds, bastards and mulattoes; of people of impure countenance and with negative characteristics.'[33] This hostility to racial mixing clarifies the meaning of one of his most famous paintings, *The Mulatto* of 1913 (see illus. 68), which was also displayed prominently in the 'Entartete Kunst' exhibition. This seemingly joyful image is, in reality,

not joyful at all. It was almost certainly intended as a study of disgust at a mixed-race person, whose made-up face is at odds with the skin of her neck and shoulders; with a knowledge of his attitude towards those he thought of as mulattos, it becomes a deeply unsettling image.

At the heart of Nolde's public reputation from the beginning of the twentieth century were his large-scale religious paintings, beginning with *Pentecost* of 1909 and culminating in *The Sinner* of 1926. They were consciously *retardataire*, even primitivizing, looking back to early sixteenth-century German painting, particularly the work of Grünewald; their religious subjects were not out of line with other German Expressionist painters. But Nolde's Nordicism was not confined to Germany's national borders. He was born a Danish subject in what were the German–Danish borderlands since the wars over Schleswig-Holstein that had come to an end with the Danish surrender of the lands to Germany in October 1864, nearly three years before the painter's birth in August 1867. He remained a Danish citizen at least until the Third Reich, though he no doubt would have identified himself as an ethnic German. His own birth name, Hans Emil Hansen, suggests Danish ancestry, and he evidently spoke Low Danish at home. In his early years he worked mainly in Germany, but he also spent time in Copenhagen, where he met and married his wife Ada Vilstrup, the daughter of a Danish pastor, in 1902. (This was the same year that he changed his name to Nolde, the village of his birth.)

His earliest identification as an artist was in fact with Rembrandt, the subject of the highly influential book *Rembrandt als Erzieher* (Rembrandt the Educator) by Julius Langbehn, first published in 1890.[34] The book was largely a rant against internationalism and especially the naturalism associated with the French Impressionists, whose paintings were being bought at the time for the Berlin Nationalgalerie. Though Dutch, Rembrandt was for Langbehn 'the most German of all German painters', a 'low-German and soil-loving artist' who could provide a model for the rebirth of the German *volk*, which was opposed in every way to the French. By claiming Rembrandt as an archetypal German artist, Langbehn and, by extension, Nolde himself were expanding the Nordic beyond the narrowly national. Rembrandt was, for Nolde, an artist of religious profundity, but also of a spontaneous proletarian spirit, opposed to the self-conscious sophisticates who dominated the German art institutions and promoted French artists. Nolde linked his fate to earlier artists like Grünewald and Rembrandt but also to Runge and Friedrich who, he claimed, 'only passed into public consciousness after they had died'.[35]

If we take his most famous early religious painting, the *Pentecost* of 1909 (see illus. 69), the two apostles in the foreground, tellingly in profile with black hair, could be seen as making a nod towards Jewish stereotypes; that is not so of the apostles in the background, however, who are speaking in tongues. With their red hair they could be from anywhere in northern Europe, but they are in no sense caricatures. In such paintings we can begin to see why reservations were held about his racial attitudes by Hitler, who had a deeply conservative taste in art, and clearly reacted against the lack of the ideal or heroic in Nolde's figures. While Nolde could invoke the artists of the German Renaissance as his spiritual ancestors, he could not readily claim his figures as proleptic templates for the ideal German of the future.

In fact, from at least 1911, he saw his whole career as the lonely fight of a deeply German idealist and son of the soil, against the hegemony of a French art-loving Jewish elite that controlled the art world, and ensured the neglect of 'true' German artists. Of course, he was not neglected or persecuted by Jews, a number of whom were his patrons and friends, though he did suffer rejection from the Berlin Secession under Max Liebermann. It is also true that a number of Jewish dealers and critics were supportive of French painting, but they were not necessarily hostile towards his art.

Despite Nolde's considerable reputation as an artist, and his friendships in high places, he presented himself increasingly in the 1910s and '20s as a martyr to the Jewish taste for French art. His 1921 painting *Experts* consists of six sinister figures who represented predominantly identifiable Jewish art critics. Though staring intently and unsympathetically towards the artist/observer, they are not, however, wildly caricatured, nor do they approach the Jewish phenotype favoured by the Nazi periodical *Der Stürmer*. In a letter of 1911, which he sought to recall and destroy in the late 1920s in the last years of the Weimar Republic, he put his expulsion from the Secession and his quarrel with Liebermann into a wider context: 'The leaders of the Secession, Liebermann, Corinth, Pechstein, Segal are Jews, the art dealers are all Jews, likewise the leading art historians and critics, the whole press is at their disposal and the art publishers too are Jews.'[36] He admitted that it was only true then of Berlin but that their tentacles were spreading throughout Germany.

While his attempt in 1929 to take back his letter of 1911 suggests a reluctance to appear to be publicly antisemitic during the Weimar Republic, like many others he lost all inhibitions as the Nazis moved towards power. Nolde had undoubted antisemitic feelings towards Liebermann and the Secession, but he had, at least before the 1930s, a more complex view of the

Jews who inhabit his religious paintings. He is completely clear that in his paintings the people of the New as well as the Old Testament were Jews – 'The Jews have as an accomplishment the Bible and Christianity' – and he took pride even in the 1930s in claiming to be the first artist to depict them as they really were: 'I rendered Jewry as it was and as it had never before been painted in art.' As he noted in his second autobiography, the *Jahre der Kampfe* of 1934, all human beings in his religious paintings are Jews: 'Christ and Apostles are "simple Jewish country folk and fishermen".' He links his own personal rejection and martyrdom as an artist to his religious paintings, claiming that he was also persecuted for painting Jews as Jews by Christians who wanted to see the people of the Bible as Aryans.

Such antisemitic feelings that Nolde had towards certain groups in the Berlin art world were transformed into more general and abstract hostility with the rise of the Nazi Party from the beginning of the 1930s; he worked tirelessly and ultimately fruitlessly to be accepted as the premier German artist by Adolf Hitler. Hitler, in fact, could not stand Nolde's paintings and resisted all attempts – some coming from his inner circle – to recognize him as anything other than a decadent modern artist. Nolde's sense of the Nordic peoples by the 1930s was clearly influenced by Nazi propaganda, and not only included the Germans, Dutch and Scandinavians but also the English, an idea shared with Hitler and his circles. As he wrote in a draft for the third volume of his autobiography under Nazism in 1936, invoking the human typologies of Tacitus' *Germania*: 'In themselves the borderlines between Germanic peoples can mean little, or even disappear. Englanders, Scandinavians and the German, these three tall, mostly blonde blue-eyed peoples, with their ardent and profound natures, their fantasy, their strength, and the emotional warmth which reaches its purest expression in the works of its greatest individuals, they ought to be a united defensive unit.'[37]

We are familiar with the Nazi state-supported art that followed Galton's eugenics to its most racist and inhuman conclusions, under the name of *Rassenhygiene*. *Rassenhygiene*, initiated in Germany at the beginning of the twentieth century, became central to the whole National Socialist project from 1933 to 1945, and its official expression in art, supported by Hitler and other Nazi leaders, was a highly academicized concentration on the ideal Nordic body, both male and female, but with clear reference back to the sculpture of ancient Greece, from which it claimed direct descent.[38] This was accompanied by a vicious campaign against the avant-garde in all

its forms, which was associated with Jews and to a lesser extent Africans, though German Expressionism, and especially Nolde, always had supporters among the Nazi elite.

Nolde deluded himself that, if only it were properly seen by Hitler and his close advisors, his art would be adopted as the official style of Nazism, though it could not be more different from the one that prevailed. Far from concentrating on the ideal sculptural body on the ancient Greek model as representing the Nordic master race, Nolde conjures up a barbaric distant world of primitive emotions among peoples living in stormy and turbulent shorelands. They are demonstrably 'primitive', owing sometimes more to Africa than to the Saxon racial ideal, and his claim that his biblical works were based on authentic Jewish types would not have endeared him to Hitler.

Despite extraordinary efforts to ingratiate himself with Hitler, and the powerful support he attracted from museum directors such as Ludwig Justi, director of the Berlin Nationalgalerie, and prominent politicians, he was only able to mitigate in small ways his position of lonely isolation, around which he was able in the post-war period to weave a successful fantasy version of his life that claimed he had been in a state of profound alienation from and silent opposition to Nazism.

Nolde's representation of modern races in his paintings and prints postulates that their origins were in a universal primitivism, in line with most anthropological theory. His insistent proclamation of Nordicism, though itself compatible with Nazi ideology, was of a highly controversial kind among Nazi sympathizers themselves. As Nolde's detractor the Nazi critic and admirer of the ancient Greeks Paul Schultze-Naumburg pointed out in 1931, his art is at the opposite pole from elevated German archetypes, like the thirteenth-century 'Bamberg Rider', taken as a symbol of the noble masculinity of the medieval Nordic warrior.[39] Schultze-Naumburg cites by contrast Nolde's stunted figures of Adam and Eve in *Paradise Lost* (1921), which are quite without the appearance of nobility.

Schultze-Naumburg was only applying to Nolde the anti-modernism shared by those behind the 'Entartete Kunst' exhibition of 1937 and indeed by Hitler himself. Their idea of German art came from a completely different place; an organic and ancestral connection was made between the ancient Greeks and modern Germans as warrior peoples who nonetheless occupied the highest level of civilization, as in the case of the response to Thorvaldsen's restoration of the Aegina marbles in the Munich Glyptothek.[40] For Hitler and the dominant Nazi theorists, art was a way of defining the ideal future of the Third Reich, which involved eugenic improvement of

the race to achieve a physical as well as a mental ideal. Hence the emphasis on ideal sculptural bodies, such as those by Arno Breker, which looked forward to the German archetype that would ultimately define the race that they believed would emerge from an application of pure eugenics to society.

Nolde's first autobiography, *Das Eigene Leben*, which appeared in 1932, as Hitler was in the process of being elected to power, was in effect an apologetic response to Schultze-Naumburg's attack on him. He first associates himself with paintings by the German old masters, 'the brilliantly clear severity and rigour of the earliest Germans', whose austerity he contrasts with the popular and ingratiating banality of the French Impressionists. He characterizes himself as a countryman from the remote Danish borders, rooted in what a critic called 'the true soil of pious German farm life', contrasting himself with patronizing urban sophisticates like Liebermann, who sat in hostile judgement on him and his art.

There seem to have been no limits to which Nolde and his wife would not go to ingratiate themselves with the regime. As early as 1933 he produced a plan to rid Germany of Jews which he tried to circulate among the government, and he was tireless in his attempts to get approval for his art from the regime and Hitler himself. In the later 1930s he openly supported the restriction and deportation of Jews, gaining for himself a reputation for being an opportunist. Though he was accused of hypocrisy, he claimed to the Nazi elite that he had been a long-misunderstood pioneer of antisemitism.[41] He remained convinced that Hitler would come around, but despite writing personally to the Führer he was still expelled from the Reich Chamber of Fine Art.

The twists and turns of Nolde's personal racial politics, and the self-delusion and malevolence that underlay them, are so complex that it is hard to believe they all took place within a single head. Yet for no other artist of his time were matters of race so central. Perhaps most remarkable of all is the fact that, though he could not have been more open about his passionate support for Nazi ideology at the time, he was able (admittedly with the help of effective supporters controlling his archives) to conceal the unpleasant truth and live for many years as a greatly honoured victim of the very people he had supported so enthusiastically.

As with Runge and Friedrich, whom he invoked as predecessors, there is a strong Danish connection both from the places they were born but also to Copenhagen, where the former also studied. Runge and Nolde both gave weight to a more Ossianic and mythical sense of the North that transcends

the national borders of Germany and Austria. They also have in common a strong sense that ideas of race reach back to the ages of primitive man, yet can be invoked as the key to the future. But this romantic idea of the future is of a different order from the eugenicist vision of most of the ruling National Socialists, who also proclaimed the racial superiority of the Aryan or Nordic races.

The very slipperiness and complexity of the relationship between Nolde's racial ideas and his art make an account of his career a fitting conclusion to a book on art and race in the nineteenth and twentieth centuries. It might seem unavoidable to label him as a Nazi artist, but, though he was undoubtedly a Nazi sympathizer in his later years, his art simply does not fall into a neat correlation with his political attitudes; to be a Nazi and an artist is not the same as being a Nazi artist. It is something we have seen time after time in this volume: though ideas of race can affect the production and appearance of a work of art or visual artefact, and they in turn can affect the dissemination of racial ideas, there is always an excess in works of art and visual culture that cannot be contained by a simple correlation between race and imagery.

# Postscript

Working on this book has been a journey through the darker side of European culture. I knew beforehand that intellectual life in nineteenth-century Europe and the Americas was dominated by ideas of racial superiority and inferiority, but I was not fully prepared for the uninhibited way it was talked and written about, even by people with otherwise impeccable liberal views. Racial hierarchies were taken for granted even by most of those who campaigned vigorously against slavery. To give one example, Ralph Waldo Emerson, despite his anti-slavery views, proclaimed the superiority over all others of the Anglo-Saxon race, in particular those who lived in New England. There is at least one reason for this apparent contradiction: the nineteenth-century prestige of science that provided the authority for a measurable hierarchy which could place each race in order of intelligence and moral character, with white Europeans firmly on top and 'savages' at the bottom.

Despite such self-confidence, racial attitudes in nineteenth-century Europe and the Americas were complicated, variable and inconsistent. The idea that 'Race is everything', expressed with brutal dogmatism by Robert Knox and Benjamin Disraeli, rested on the belief that Europeans had been able to evolve and become civilized beyond others because of their superior mental powers, which included a taste for beauty that reached its highest level in the canonical sculptures of ancient Greece. The ancient Greeks were constructed as spiritual and sometimes actual physical ancestors of the white, Caucasian, Aryan or Teutonic races. The production of art was for European intellectuals a sign of civilization and a taste or appreciation for it separated them from lesser races.

It is a central premise of this book that the science on which such racial hierarchies were based was essentially visual. One measure, going

back long before the period covered by this book, was skin colour, though this was hard to quantify and did not apply to all identified races. From the late eighteenth century, the skull became the focus of racial distinctions, because it was susceptible to comparative measurement. Systems of skull measurement evolved throughout the nineteenth and twentieth centuries, but they all rested on the claim that skull shape had an indexical relationship to intelligence and to moral character. It was believed that the skull's shape was governed by the size and activity of the brain, which meant that a prominent forehead was a sign of a strong intellect, while a more prominent back of the head was a sign of a weaker one, an idea that still lingers on in the words 'highbrow' and 'lowbrow'. The first systematic comparative racial study of skulls was devised by Pieter Camper within a study directed towards artists, and a connection between physiognomy and moral character was worked out by Johann Caspar Lavater in one of the most magnificent illustrated books of the eighteenth century, while Cuvier made explicit the presumed connection between skull shape and intellect. Their kind of systematization was a godsend to artists re-enacting in paint and marble moral dramas in ancient or modern settings, and it remained relevant to them throughout the nineteenth century.

There are countless examples of artists who were influenced by Camper and Lavater in their depiction of racial types, for they helped to create a kind of shorthand for a visual language to represent European and non-European races. Just as Francis Galton tried to rationalize skull measurement to the point that a profile could be reduced to a numerical formula that could be sent on a telegram to identify a criminal suspect, so caricaturists were able to devise formulae to produce recognizable images of people of different races just by a few lines.

The visual evidence that was believed to indicate the underlying character and intellect of a particular race could involve not only skull shape and skin colour but posture, the texture and coverage of hair, relative beauty or ugliness, personal adornment, the language spoken and the way clothing was worn. Art and visual culture impressed on viewers archetypes for each race that showed its ideal form; they became a way of enforcing aesthetic hierarchies that ran parallel to the civilizational ones, in which Europeans were always the most beautiful and Africans the ugliest. Frederick Douglass noted that in racial science Europeans were seen through the lens of the Grecian ideal, the gods of ancient Greece, while Africans were always represented by their ugliest members.

We are likely to be bemused in retrospect by the confidence that intellectuals in the nineteenth century had in a Greek sculptural canon made up of what we now know to be largely Roman copies of Greek originals, often added to in modern times, just as we are likely to be distressed by the confidence they showed in classifying non-Europeans according to their apparent aesthetic shortcomings. Even though Darwin admitted that 'savages' had an aesthetic sense, he was withering about their physical ugliness and the 'vulgarity' of their adornment.

What is striking in retrospect is the resilience of the idea that classical Greece had set the absolute and unchallengeable standard for human beauty of both sexes, and that this formed one of the bases for the superiority of white European races, though the ancient Greeks neither identified themselves as white nor as European.[1] Ideas of racial superiority and inferiority were and are the products not only of misguided science but of misguided history. History as well as aesthetics provided the bedrock of nineteenth-century racial science, for if race was to have the importance ascribed to it, it had to have properties that were permanently part of human evolution.

In order to have the permanence attributed to it by their proponents, each race had to have a long history, going back even to the beginning of time. This led, in the nineteenth century, to research into the origins of each race that looked for forebears of present races in the most ancient art. The main driving force for the rediscovery of ancient Egyptian art was the desire to find in its plentiful surviving images the earliest representations of racial types. Ancient Egypt acted as a kind of Ur-civilization, going back to the earliest history of man, as a guarantor of the ancient probity of current races. Several scholars saw the inhabitants of ancient Egypt, whether permanent or temporary, as encompassing all present-day races, including the Caucasian and African. Egyptian art did not act as an aesthetic ideal worthy of emulation by contemporaries, but as an index of racial types that could be taken from the profiles on wall paintings or sculptural reliefs. It also had the advantage for Christian scholars of having a major role in the Bible, though an equivocal one. If Europeans could see Egyptian art as foreshadowing the Greek tradition, for Black Christians the Egyptians were the tyrannical oppressors of the Jews of the Old Testament, with whom they identified.

At the same time, Europeans appropriated to themselves the right to make aesthetic judgements of others. This they had inherited from the eighteenth century, when it was commonplace to rank peoples entirely according to European standards of beauty. It was taken for granted that so-called

primitive peoples could be placed on a scale of ugliness, according to their closeness to the animal kingdom, and it is only with Darwin that they were allowed to own their own aesthetic judgement along with non-human creatures.

But ideas of racial differentiation also demanded the creation of stereotypical images of particular races, and visual culture became particularly adept in creating persuasive generalized types of each race. 'The Anglo-Saxon', 'the Negro', 'the Jew' could be reduced to a clear picture of their supposedly essential appearance, though always at the expense of the actual variety of real people who supposedly belonged to each race. Above all they made it easy for people to read moral and intellectual character from the outward appearance and images of other people. This, of course, chimes in neatly with the desire of painters of historical and religious subjects in the nineteenth century to reveal the inner life of their protagonists through the studied depiction of outward appearance, and perhaps lives on in the contemporary concern with facial recognition technology, which has also been demonstrated to be susceptible to racial bias.[2]

Members of a race, whatever that might mean, could thus be given a common identity for those outside of it by a series of simple visual signs, but the nineteenth century also saw a massive increase in the ability to produce cheap images by the new technologies of lithography and wood engraving. The result was that grotesque, demeaning or patronizing stereotypical images became universal, in newspapers, periodicals, music sheets, theatrical performances and advertisements, and eventually films. By the end of the nineteenth century, urban life in Europe and the Americas was saturated with racial images, and this lingered on well into the twentieth century, leaving traces today. But as Frederick Douglass recognized, that was because 'Artists, like all other white persons, have adopted *a theory respecting the distinctive features of negro physionomy*' – and, he might have added, of other so-called races as well.

It would be fitting to end this book, as it began, with the words of Frederick Douglass, but I feel I must acknowledge the omissions in the present work. There is clearly urgent work to be done, for example, on the visual characterization of people of Asian descent, who have been the recent victims of racial violence in several countries, often committed by strangers on the basis of their appearance. There is a comparable history of racial stereotyping that goes back to the eighteenth century, and the same may be said of other peoples. This book, then, should be taken as the beginning of an enquiry rather than its completion.

# REFERENCES

## Foreword

1 Wulf D. Hund and Charles W. Mills, 'Comparing Black People to Monkeys has a Long, Dark Simian History', *The Conversation*, 28 February 2016, https://theconversation.com.
2 Nina Jablonski, 'What Is It About Skin Color?', *The Root*, 16 February 2013, www.theroot.com.
3 Jorge Felipe, email to author, 3 August 2022.
4 Frederick Douglass, 'Negro Portraits', *The Liberator*, 20 April 1849.

## Preface

1 Éric Michaud, *The Barbarian Invasions: A Genealogy of the History of Art* (Cambridge, MA, 2019), pp. 12–13.
2 Ibid., pp. 40f.
3 There are too many names to mention, but, among others, Shearer West, Jan Marsh, Angela Rosenthal, Adrienne Childs, Anne Lafont, Hugh Honour, Victor Stoichita, Debbie Challis and Charmaine Nelson, and the authors of the exhibition catalogue *Le Modèle noir: de Géricault à Matisse at the Musée d'Orsay* (2019) have written on aspects of race and art in the period.
4 L. D. Burnett, *Washington Post*, 26 April 2021.
5 Christina Caron, *New York Times*, 2 August 2018.
6 David Olusoga, *The Guardian*, 26 December 2021.
7 'Shadow of the Guillotine', British Museum, London, 1989.
8 Published by Reaktion Books in the UK and Cornell University Press in the U.S.
9 Nell Irvin Painter, *The History of White People* (New York, 2010).
10 Herrick Chapman and Laura L. Frader, *Race in France: Interdisciplinary Perspectives on the Politics of Difference* (New York, 2004), p. 4.
11 Elizabeth Edwards, 'Evolving Images: Photography, Race and Popular Darwinism', in *Endless Forms: Charles Darwin, Natural Science, and the Visual Arts*, ed. D. Donald and J. Munro (New Haven, CT, 2009); Deborah Willis, *Reflections in Black: A History of Black Photographers, 1840 to the Present* (New York, 2000).

Introduction: Racial Science and Visual Culture

1 Review of Wilson Armistead, A Tribute for the Negro, in *North Star* [Rochester, NY], 7 April 1849. Present author's italics.

2 For an excellent account of the British contribution to racial science, see Nancy Stepan, *The Idea of Race in Science: Great Britain, 1800–1960* (London, 1982).

3 Mary Halliwell, ed., *A Guide to the Hawstead Panels at Christchurch Mansion, Ipswich*, Friends of the Ipswich Museums pamphlet, 2013; H. L. Meakin, *The Painted Closet of Lady Anne Bacon Drury* (Aldershot, 2013).

4 David Bindman, *Ape to Apollo* (London, 2002), pp. 114–17.

5 The theory was first fully expounded in a posthumous edition of his works, published in several languages in the 1790s, and in English as *The Works of the Late Professor Camper* (London, 1794).

6 Cited in Paul Wolff Mitchell and John S. Michael, 'Bias, Brains, and Skulls: Tracing the Legacy of Scientific Racism in the Nineteenth-Century Works of Samuel George Morton and Friedrich Tiedeman', in *Embodied Difference: Divergent Bodies in Public Discourse*, ed. J.A. Thomas and C. Jackson (Washington, DC, 2019), p. 81.

7 Mary Cowling, *The Artist as Anthropologist* (Cambridge, 1989), p. 14.

8 Bindman, *Ape to Apollo*, pp. 17–18.

9 Strictly speaking it was François Bernier in 1684 who first used the word 'race' in its modern meaning, by dividing the world into four races; Mechthild Fend, *Fleshing Out Surfaces: Skin in French Art and Medicine, 1650–1850* (Manchester, 2016), pp. 156–7.

10 Peter Hulme, *Colonial Encounters: Europe and the Native Caribbean* (London, 1986), p. 21.

11 Bindman, *Ape to Apollo*, p. 59.

12 Ibid., pp. 125–50.

13 Johann Kaspar Lavater, *Physiognomische Fragmente zur Beförderung der Menschenkenntniß und Menschenliebe*, published between 1775 and 1778; translated into English as *Essays on Physiognomy for the Promotion of the Knowledge and the Love of Mankind*, 5 vols (London, 1789–98).

14 *The Works of the Late Professor Camper, on the Connexion between the Science of Anatomy and The Arts of Drawing, Painting, Statuary, etc.*, trans. Thomas Cogan (London, 1794).

15 The company heads of Aunt Jemima, Uncle Ben's and Land O'Lakes all agreed to give up racially stereotypical images on their packaging in 2020.

16 Frederick Douglass, 'Pictures and Progress' [1861], in John Stauffer, Zoe Trodd and Celeste-Marie Bernier, *Picturing Frederick Douglass* (New York, 2015), p. 349.

17 Douglass, 'Lecture on Pictures' [1861], ibid., p. 126.

18 Ibid., p. 350.

19 Christoph Meiners, *Grundriss der Geschichte der Menschheit* (Outline of the History of Mankind) (Lemgo, 1785); see Bindman, *Ape to Apollo*, p. 251, n. 61.

20 A view shared with Paul Broca. See Chapter Two.

21 Ruth Benedict and Gene Weltfish, *The Races of Mankind* (New York, 1943).

22 Johann Gottfried Herder, *Auch eine Philosophie für die Geschichte der Menschheit* (Yet Another Philosophy of the History of Mankind) (Berlin, 1774); Bindman, *Ape to Apollo*, p. 165.

23 Rogers Brubaker, 'Ethnicity, Race, and Nationalism', *Annual Review of Sociology*, XXXV (2009), pp. 21–42.

24 Werner Sollars, 'Ethnicity and Race', in *A Companion to Racial and Ethnic Studies*, ed. David Theo Goldberg and John Solomos (Malden, MA, and Oxford, 2002), p. 98.

25 Peter Mandler, '"Race" and "Nation" in Mid-Victorian Thought', in *History, Religion, and Culture: British Intellectual History 1750–1950*, ed. S. Collini, R. Whatmore and B. Young (Cambridge, 2010), pp. 226–7.

26 Henry Mayhew, *Great World of London* (May 1856), pp. 4–5.

27 See Chapter Two.

28 Charles Darwin, *Descent of Man* (London, 1871), p. 326.

29 Rudyard Kipling, 'The White Man's Burden: The United States and the Philippine Islands', *The Times*, 4 February 1899.

30 Emilie Bickerton, 'How the Africa Museum Is Facing Up to Belgium's Colonial Past', *Apollo* (January 2019).

31 Jean Muteba Rahier, 'The Ghost of Leopold II: The Belgian Royal Museum of Central Africa and Its Dusty Colonialist Exhibition', *Research in African Literatures*, XXXIV/1 (2003), p. 59.

32 See for instance, Thomas Carlyle, *Occasional Discourse on the Nigger Question* (London, 1853); and Emerson's lecture 'The Genius and National Character of the Anglo-Saxon Race' [1843], in *The Later Lectures of Ralph Waldo Emerson*, ed. Ronald Bosco and Joel Meyerson (Athens, GA, 2010), pp. 8–18.

33 Arthur de Gobineau, *The Inequality of Human Races*, trans. Adrian Collins (London, 1915), pp. 23f.

34 Francis Schiller, *Paul Broca: Founder of French Anthropology* (Berkeley, CA, 1980), p. 81.

35 José Martí, *Our America* (New York, 1977).

36 See Chapter Nine.

37 Linda Nochlin, 'Degas and the Dreyfus Affair', in *The Politics of Vision* (London, 1991), p. 148.

38 Peter Fryer, *Staying Power: The History of Black People in Britain* (London, 1984), pp. 133–4.

39 Tzvetan Todorov, *On Human Diversity: Nationalism, Racism, and Exoticism in French Thought* (Cambridge, MA, 1993), p. 90.

40 By Richard Henry Pratt in 1902: 'Segregating any class or race of people apart from the rest of the people kills the progress of the segregated people or makes their growth very slow. Association of races and classes is necessary to destroy racism and classism'; quoted in *Proceedings of the Twentieth Annual Meeting of the Lake Mohonk Conference of Friends of the Indian, 1902* (1903), p. 134.

41 I owe this thought to the late Ian Jenkins.

42 Bindman, *Ape to Apollo*, pp. 61–2.

43 See David Bindman, Alejandro de la Fuente and Henry Louis Gates Jr, eds, *The Image of the Black in Latin American and Caribbean Art* (Cambridge, MA, 2023).

44 Quoted in Philip S. Foner, 'Alexander Von Humboldt on Slavery in America', *Science and Society*, XLVII/3 (Fall 1983), pp. 330–42.

45 Bindman, *Ape to Apollo*, pp. 124–50.

46 Firman is a relatively recent rediscovery, and his work was virtually forgotten for nearly a century. He took particular aim at the Linnaean division of the

world into four races, and notes that this was followed by both Samuel Morton and Carus, though others proposed three or five races. He also claimed that all of these schemes were 'based only on arbitrary and idiosyncratic principles' (Anténor Firmin, *The Equality of the Human Races* (New York, 2002), p. 19); Carolyn Fluehr-Lobban, 'Anténor Firmin: Haitian Pioneer of Anthropology', *American Anthropologist*, CII/3 (2000): pp. 449–66; Frederick Douglass, *The Claims of the Negro Ethnologically Considered* (Rochester, NY, 1854).

47 Angela Rosenthal, 'Visceral Culture: Blushing and the Legibility of Whiteness in Eighteenth-Century British Portraiture', in *Art: History: Visual: Culture*, ed. Deborah Cherry (Oxford, 2005).

## 1 Measuring Racial Difference

1 Mary Cowling, *The Artist as Anthropologist* (Cambridge, 1989), pp. 27–32.
2 In *Systema naturae*, 10th edn (Stockholm, 1758–9); David Bindman, *Ape to Apollo* (London, 2002), pp. 61–2.
3 Thomas Cummins, 'New Spain: The African Presence in Mexican *Casta* Paintings', in *The Image of the Black in Western Art*, ed. David Bindman and Henry Louis Gates Jr (Cambridge, MA, 2012), vol. III, part 3, pp. 246–59; S. Collini, R. Whatmore and B. Young, eds, *History, Religion, and Culture: British Intellectual History 1750–1950* (Cambridge, 2000).
4 In M.L.E. Moreau de Saint-Méry, *Description topographique, physique, civile, politique et historique de la partie francaise de l'isle Saint-Domingue*, 2 vols (Philadelphia, PA, 1797); Dorris Garraway, 'Race, Reproduction and Family Romance in Moreau de Saint-Méry's *Description . . . de la partie française de l'isle Saint-Domingue*', *Eighteenth-Century Studies*, XXXVIII/2 (Winter 2005), pp. 227–46.
5 For Camper see Miriam Claude Meijer, *Race and Aesthetics in the Anthropology of Petrus Camper, 1722–1789* (Amsterdam, 1999).
6 See *The Works of the Late Professor Camper*, trans. Thomas Cogan (London, 1794).
7 Meijer, *Race and Aesthetics in the Anthropology of Petrus Camper, 1722–1789*, pp. 69, 77–8.
8 Johann Kaspar Lavater, *Physiognomische Fragmente zur Beförderung der Menschen-kenntniß und Menschenliebe* (Physiognomic Fragments for the Promotion of Human Knowledge and Love), 4 vols (Leipzig and Winterthur, 1775–8).
9 Bindman, *Ape to Apollo*, p. 112.
10 Ibid., pp. 112–13.
11 Gerda Mraz and Uwe Schögl, *Das Kunstkabinett des Johann Caspar Lavater* (Vienna, 1999), fig. 90, pp. 184–5.
12 Julien-Joseph Virey, *Histoire naturelle du genre humain* (Paris, 1801), fol. iv, p. 134.
13 Josiah Clark Nott and George R. Gliddon, with contributions from Samuel George Morton, Louis Agassiz, William Usher and Henry S. Patterson, *Types of Mankind; or, Ethnological Researches* (Philadelphia, PA, 1854); Éric Michaud, *The Barbarian Invasions: A Genealogy of the History of Art* (Cambridge, MA, 2019), pp. 65–8.
14 Anne Lafont, *L'Art et la Race. L'Africain (tout) contre l'oeil des Lumières* (Paris, 2019).
15 Bindman, *Ape to Apollo*, p. 214.

16 Ibid., p. 215.

17 Ibid., pp. 161–2.

18 John Carson, *The Measure of Merit: Talents, Intelligence, and Inequality in the French and American Republics, 1750–1940* (Princeton, NJ, 2006), p. 84.

19 Dorinda Outram, *Georges Cuvier: Vocation, Science, and Authority in Post-Revolutionary France* (Manchester, 1984), p. 135.

20 Ibid., pp. 133–4.

21 Georges Cuvier, *Le règne animal* (Paris, 1817), p. 95.

22 See S. J. Gould, *The Mismeasure of Man* (New York, 1981).

23 Francis Schiller, *Paul Broca: Founder of French Anthropology* (Berkeley, CA, 1980), pp. 155–6.

24 For an illuminating account of Duval see Anthea Callen, *Looking at Men: Anatomy, Masculinity and the Modern Male Body* (New Haven, CT, 2018), pp. 29f.

25 I owe this thought to Esther Chadwick.

2 Bumps on the Head: From Phrenology to Physiognomy

1 John van Wyhe, 'The History of Phrenology', The Victorian Web, https://victorianweb.org, accessed 5 December 2022.

2 Martin Staum, 'Physiognomy and Phrenology at the Paris Athénée', *Journal of the History of Ideas*, LVI/3 (July 1995), pp. 443–62.

3 James Poskett, *Materials of the Mind: Phrenology, Race, and the Global History of Science, 1815–1920* (Chicago, IL, 2019).

4 George Combe, *System of Phrenology* (Edinburgh, 1830), pp. 299–300.

5 Ibid., p. 300.

6 Ibid., p. 607.

7 Ibid., pp. 615–16.

8 David Bindman, *Ape to Apollo* (London, 2002), fig. 20.

9 Quoted in Nathan R. Elliott, 'Phrenology and the Visual Stereotype in Charlotte Brontë's *Villette*', *Nineteenth Century Studies*, XXII/1 (2008), pp. 41–55.

10 Quoted in T. R. Wright, 'From Bumps to Morals: The Phrenological Background to George Eliot's Moral Framework', *Review of English Studies*, New Series, XXXIII/129 (February 1982), pp. 34–46.

11 Staum, 'Physiognomy and Phrenology at the Paris Athénée', p. 458.

12 Ibid., pp. 443–62.

13 Ibid., p. 460.

14 Francis Schiller, *Paul Broca: Founder of French Anthropology* (Berkeley, CA, 1980), pp. 135–6.

15 Ibid., pp. 176–7.

16 A. Harrington, 'Nineteenth-Century Ideas on Hemisphere Differences and "Duality of Mind"', *Behavioral and Brain Sciences*, VIII/4 (1985), p. 623.

17 Ibid., p. 626.

18 Paul Broca, *Instructions craniologiques et craniométriques* (Paris, 1875), pp. 2–3.

19 Ibid., p. 171.

20 Ibid., p. 177.

21 See Chapter Nine.

3  Head and Body, Skull and Skeleton

1  Norbert Borrmann, *Kunst und Physiognomik* (Cologne, 1994), especially chapters I–IV.

2  Hugh Honour in *The Image of the Black in Western Art*, ed. David Bindman and Henry Louis Gates Jr (Cambridge, MA, 2012), vol. IV, part 1, pp. 43–4.

3  There is much writing on the sexual politics of race in the French colonies. Perhaps the most useful are: Sue Peabody, *'There are no slaves in France': The Political Culture of Race and Slavery in the Ancien Regime* (New York, 1996); and John D. Garrigus, *Before Haiti: Race and Citizenship in French Saint-Domingue* (New York, 2006).

4  Frédéric Régent, 'Le Châtiment des quatre piquets dans les colonies', *Le Modèle noir: de Géricault à Matisse*, exh. cat., Musée d'Orsay (Paris, 2019), pp. 100, 80.

5  Laure de Margerie et al., *Facing the Other: Charles Cordier, 1827–95, Ethnographic Sculptor* (Paris, 2004), p. 28, citing Charles Cordier, 'Objets offerts à la Société: Types ethniques représentés par la sculpture', *Bulletin de la Société d'anthropologie de Paris*, 3 (1862), p. 66.

6  Henri Valentin, *Trois types de la race humaine d'après les bustes de M. Cordier* (1857), discussed in Margerie et al., *Facing the Other*, p. 147.

7  For other titles applied to it see ibid., p. 144.

8  From *The Life of the Virgin* series of woodcuts, circa 1502.

9  David Bindman in *The Image of the Black in Western Art*, ed. David Bindman and Henry Louis Gates Jr (Cambridge, MA, 2011), vol. III, part 3, pp. 9–10.

10  Martin S. Staum, *Labeling People: French Scholars on Society, Race, and Empire, 1815–48* (Montreal, 2003), pp. 120–21.

11  Margerie et al., *Facing the Other*, p. 196.

12  See Denise Murrell in *Le Modèle noir: de Géricault à Matisse*, exh. cat., Musée d'Orsay (Paris, 2019), pp. 180–82.

13  Ibid., pp. 108 and 114–15.

14  Elizabeth Edwards, 'Evolving Images: Photography, Race and Popular Darwinism', in *Endless Forms: Charles Darwin, Natural Science and the Visual Arts*, ed. Diana Donald and Jane Munro, exh. cat., Fitzwilliam Museum, Cambridge (New Haven, CT, 2009), p. 168.

15  *Le Modèle noir*, pp. 142–7.

16  Ibid., pp. 126–37.

17  Ibid., p. 128.

18  First name unknown. For Wilson see Hugh Honour in *The Image of the Black in Western Art*, ed. David Bindman and Henry Louis Gates Jr (Cambridge, MA, 2012), vol. IV, part 2, pp. 26–33.

19  See ibid., vol. III, part 3, pp. 143–6.

20  Ibid., vol. IV, part 2, p. 26.

21  Aris Sarafianos, 'B. R. Haydon and Racial Science: The Politics of the Human Figure and the Art Profession in the Early Nineteenth Century', *Visual Culture in Britain*, VII/1 (June 2006), pp. 79–106.

22  W. B. Pope, ed., *The Diary of Benjamin Robert Haydon* (Cambridge, MA, 1960), vol. I, p. 263.

23  Ibid., pp. 182–3.

24 Ibid., p. 185.

25 Ibid., p. 183.

26 A comparison suggested by Brigid von Preussen; see Helen Slaney, 'Pots in Performance: Emma Hamilton's Attitudes', *Bulletin of the Institute of Classical Studies*, LXIII/1 (June 2020), pp. 110–22.

27 Pope, ed., *Diary of Benjamin Robert Haydon*, p. 188.

28 Ibid.

29 Acquired between 1794 and 1802. *Recorded in A Catalogue of the Library in the Royal Academy* (London, 1802).

30 Mary Cowling has presented overwhelming evidence of the popular reach of physiognomy in England: Cowling, *The Artist as Anthropologist* (Cambridge, 1989), pp. 34–40.

31 Samuel R. Wells, *New Physiognomy* (London, 1866), cited ibid., p. 123.

4 Germans, Teutons and the Anglo-Saxon Race

1 Peter Mandler, '"Race" and "Nation" in Mid-Victorian Thought', in *History, Religion, and Culture: British Intellectual History 1750–1950*, ed. S. Collini, R. Whatmore and B. Young (Cambridge, 2000), pp. 226–7.

2 An acronym first devised by Edward Digby Baltzell (1915–1996) in his book *The Protestant Establishment: Aristocracy and Caste in America* (New Haven, CT, 1964).

3 Nell Irvin Painter, *The History of White People* (New York, 2010), p. 165.

4 Hugh A. MacDougall, *Racial Myth in English History* (Montreal, 1982), p. 46.

5 Mary Cowling, *The Artist as Anthropologist* (Cambridge, 1989), p. 361.

6 Christopher B. Krebs, *A Most Dangerous Book: Tacitus's Germania from the Roman Empire to the Third Reich* (New York, 2011).

7 'Ipse eorum opinionibus accedo, qui Germaniae populos nullis aliis aliarum nationum connubiis infectos propriam et sinceram et tantum sui similem gentem exstitisse arbitrantur: unde habitus quoque corporum, quanquam in tanto hominum numero, idem omnibus; truces et cacrulei oculi, rutilae comae, magna corpora et tantum ad impetum valida.' (Tacitus, *Germania*, Loeb Classical Library (Harvard, MA, 2022), pp. 134–5.)

8 Tacitus, *Annales* II, 88.

9 Martin M. Winkler, *Arminius in National Socialism* (Oxford, 2015), p. 97.

10 'It's claimed that women have no creative genius. But there's one extraordinary woman, and it irritates me that men don't do her justice. Angelica Kauffmann was a very great painter. The most illustrious of her own contemporaries admired her.' Cited in Hugh Trevor-Roper, *Hitler's Table Talk, 1941–1944* (New York, 2000), p. 209.

11 *Arminio*, first performed Covent Garden Theatre, 1737.

12 It was not published until 1821, and was first performed in 1860.

13 David Bindman, *Warm Flesh, Cold Marble: Canova, Thorvaldsen and Their Critics* (New Haven, CT, 2014), pp. 37–41 and fig. 13.

14 Walter Silz, 'On Rereading Klopstock', *PMLA*, LXVII/5 (1952), pp. 744–68.

15 Jost Hermand, 'Dashed Hopes: On the Painting of the Wars of Liberation', in *Political Symbolism in Modern Europe: Essays in Honor of George L. Mosse*, ed. Seymour Drescher, David Sabean and Allan Sharlin (Abingdon, 1982), pp. 216–38; Johann Wolfgang von Goethe, 'Neu-deutsche religios-patriotische

Kunst', *Ueber Kunst und Alterthum in den Rhein und Mayn Gegenden*, Band 2 (1817), pp. 5–6.

16 Victor H. Miesel, 'Philipp Otto Runge, Caspar David Friedrich and Romantic Nationalism', *Yale University Art Gallery Bulletin*, XXXIII/3: *Correlations between German and Non-German Art in the Nineteenth Century* (October 1972), pp. 37–51.

17 Letter to Marie Bassenge, 5 December 1809, cited in Peter Betthausen, ed., *Philipp Otto Runge: Briefe und Schriften* (Berlin, 1983), p. 219.

18 Bettina Baumgärtel, *'Lasset die Kindlein zu mir kommen*. Philipp Otto Runge und Angelika Kauffmann', in *Kosmos Runge: Das Hamburger Symposium*, ed. Markus Bertsch and Jenns Howoldt (Munich, 2013), pp. 283–98.

19 Regina Schubert, 'Runges Lehrzeit and der Kopenhagener Akademie', *Kosmos Runge*, pp. 129–46.

20 Betthausen, ed., *Philipp Otto Runge*, p. 62f.

21 'Wenn sich seine Brust mit einemmal anschwellte, un ein fürchterliches Angstgeschrey auszustossen; in dem Augenblick fühlte ich's, was die Kunst ist' (26 November 1800). Cited ibid., p. 39.

22 'Einen ganz falschen Weg, auf welchem es unmöglich ist, irgend etwas Gutes zu bewürken', quoted in *Kosmos Runge*, p. 112.

23 Beate Allert, 'Goethe, Runge and Friedrich', in *The Enlightened Eye*, ed. Evelyn K Moore and Patricia Anne Simpson (Amsterdam, 2007), p. 84.

24 Saskia Pütz, 'Philipp Otto Runge zwischen Aufklärungstheologie und Erweckungsbewegung', in *Kosmos Runge*, pp. 229–37; Markus Bertsch, 'Jenseits der Illustration. Runge als Ossian- Interpret', in *Kosmos Runge*, pp. 207–20.

25 Peter-Klaus Schuster, 'Flaxman, der Abgott aller Dilettanten', in *John Flaxman: Mythologie und Industrie,* ed. Werner Hofmann, exh. cat., Hamburger Kunst-halle (Munich, 1979), pp. 32–5.

26 Letter to Daniel Runge, 23 August 1800: 'danke ich Dir mit Tränen. Mein Gott, so etwas habe ich doch in meinem Leben nicht gesehen', cited in Betthausen, ed., *Philipp Otto Runge*, p. 46.

27 Ibid., pp. 171–2.

28 Wiliam Blake, *The Illuminated Books*, vol. IV: *The Continental Prophecies*, ed. D. W. Dörrbecker (Princeton, NJ, 1995), pp. 81–138.

29 *Kosmos Runge: Der Morgen der Ronantik*, p. 306.

30 Howard Gaskill, 'The Homer of the North', *Interfaces*, 27 (2007–8), pp. 13–24.

31 Thomas Lederballe, Martin Myrone and Sven Bjerkhof, *Nicolai Abildgaard: Revolution Embodied*, exh. cat., Statens Museum for Kunst (Copenhagen, 2009), pp. 75–82.

32 For Runge's continued connection with Kosegarten see Betthausen, ed., *Philipp Otto Runge*, p. 198.

33 *Kosmos Runge: Der Morgen der Romantik*, pp. 332–7.

34 Konrad Feilchenfeldt, 'Runge – ein patriotischer Künstler', in *Runge: Fragen und Antworten: Ein Symposion der Hamburger Kunsthalle* (Munich, 1979), p. 32.

35 See Joseph Koerner, 'Geognosy', 'Self Portrait in Distress' and 'Nature Painting', in *Critical Zones: The Science and Politics of Landing on Earth*, ed. Bruno Latour and Peter Weibel (Karlsruhe and Cambridge, MA, 2020),

pp. 114–17, 312–16 and 330–41; and his forthcoming essay for the catalogue of the exhibition *Blake and Europe,* Fitzwilliam Museum, Cambridge, and Hamburger Kunsthalle, 2024

36 'Die Zeit ist mit dem Pfluge uber Teuschland hingefahren und hat tiefe Furchen eingeackert, die bereit sind jeden guten Samen aufzunehmen.' (Time is driving the plough over Germany and has ploughed deep furrows, ready to plant good seeds.) Cited in Feilchenfeldt, 'Runge – ein patriotischer Künstler', p. 36.

37 'So lange Du in Frankreich bist, *nicht* mehr an mich zu schreiben', cited in *Caspar David Friedrich in Briefen und Bekenntnissen*, ed. Sigrid Hinze (Munich, 1974), p. 21.

38 E. M. Arndt, *Noch ein Wort über die Franzosen und über uns* (Leipzig, 1814), pp. 13ff.

39 'Die Deutschen sind nicht durch fremde Völker verbastardet, sie sind keine Mischlinge geworden, sie sind mehr als viele andere Völker in ihrer angeborenen Reinheit geblieben', cited in Werner Ripper, *Weltgeschichte im Aufriss* (Frankfurt, 1978), p. 191.

40 'So lange wir Fürstenknechte bleiben, wird auch nie etwas Grosses der Art geschehen', cited in Hinze, ed., *Friedrich*, p. 24.

41 Carl Gustav Carus, *Denkschrift zum hundertjährigen Geburtsfeste Goethe's: ueber ungleiche Befähigung der verschiedenen Menschheitstämme für höhere geistige Entwickelung* (Leipzig, 1849), p. 14.

42 Ibid., p. 18.

43 'Friede der Gruft streitender Krieger,/ Siegend und fallend für Freiheit und Recht!/ Friede mit euch, Kämpfer im Streit,/ Heiliger Sache, Vaterlands Glück!' Cited in Hinze, ed., *Friedrich*, p. 80.

44 Werner Hofmann, ed., *Caspar David Friedrich 1774–1840, Kunst um 1800*, exh. cat., Hamburger Kunsthalle (Munich, 1974), p. 194, n. 106.

45 The lost painting was titled *Stadtansicht mit Scharnhorstdenkmal* (Town View with the Scharnhorst Memorial), ibid., p. 194.

46 Ibid., pp. 194–5.

47 Ibid., p. 194.

48 For the presence of anthropomorphic rocks in this painting and others by Friedrich, see Nina Amstutz, *Caspar David Friedrich: Nature and the Self* (New Haven, CT, 2020), pp. 70–71.

49 Hinze, ed., *Friedrich*, pp. 79–80.

50 Hofmann, ed., *Caspar David Friedrich, 1774–1840*, pp. 270–71, n. 181.

51 There are several other instances of the Altdeutsche Tracht in Friedrich's paintings, the most famous being *Man and Woman Observing the Moon* (*Mann und Frau den Mond bethrachtend*) in the Berlin Nationalgalerie.

52 Wiliam Blake, *The Illuminated Books*, vol. 1: *Jerusalem*, ed. Morton D. Paley (London, 1998).

53 William Blake, 'A Vision of the Last Judgement' (1810), in *Blake Complete Writings with Variant Readings*, ed. Geoffrey Keynes, 2nd edn (Oxford, 1969), p. 613.

54 See, for example, his annotations to Wordsworth's *Poems*, ibid., pp. 782–3.

55 R. Lister, ed., *The Letters of Samuel Palmer* (Oxford, 1974), vol. 1, p. 24.

56 William Vaughan, *Samuel Palmer: Shadows on the Wall* (New Haven, CT, 2015), p. 197; Samuel Palmer, *Address to the Electors of West Kent* (1832), cited

in David Bindman, 'Samuel Palmer's *An Address to the Electors of West Kent, 1832* Rediscovered', *Blake: An Illustrated Quarterly*, XIX/2 (1985), p. 59.

57 Ibid., p. 62.

58 Ibid.

59 Ibid., p. 57.

60 Geoffrey of Monmouth, *Historia Regum Britanniae*, parts 1.3–18, 2.1

61 David Bindman, 'Blake's "Gothicised Imagination" and the History of England', in *William Blake: Essays in Honour of Sir Geoffrey Keynes*, ed. Morton D. Paley and Michael Phillips (Oxford, 1973), pp. 29–49.

62 Sir Thomas Malory, *Le Morte Darthur*, first printed by Caxton at Westminster in 1485.

63 Alfred, Lord Tennyson, *Idylls of the King* (London, 1859 and 1885).

64 See Chapter Six.

65 Juliette Wood, *The Holy Grail: History and Legend* (Aberystwyth, 2012); see also S. J. Barnett, 'Where Was Your Church before Luther? Claims for the Antiquity of Protestantism Examined', *Church History*, LXVIII/1 (March 1999), pp. 14–41.

66 See the forthcoming entry for the object in the exhibition 'Blake and Europe', Fitzwilliam Museum, Cambridge, and Hamburger Kunsthalle (2024).

67 Geoffrey Keynes, *Engravings by William Blake: The Separate Plates* (Dublin, 1956), pp. 3–5, plates 1–3.

68 William Blake, *Jerusalem*, p. 27, cited in Keynes, *Blake Complete Writings*, ed. Keynes, p. 649.

69 Hugh A. MacDougall, *Racial Myth in English History* (Hanover, NH, 1982), p. 34.

70 Ibid., p. 37.

71 Ibid., pp. 42–3.

72 Lorenzo Valla, *On the Donation of Constantine* [1440], trans. G. W. Bowersock (Cambridge, MA, 2007).

73 MacDougall, *Racial Myth in English History*, p. 45.

74 Ibid., p. 47.

75 Ibid.

76 Ibid., p. 48.

77 See Richard Verstegen, *A Restitution of Decayed Intelligence* (London, 1628), p. 69.

78 John Kenworthy-Brown, 'Rysbrack's Saxon Deities', *Apollo*, CXXII (September 1985), pp. 72–84.

79 Ibid., p. 80.

80 Edmund Gibson, Bishop of London, in his dedication to George I in William Camden, *Britannia, or a Choriographical Description of Great Britain and Ireland . . . with additions and improvements by William Gibson*, 2 vols (London, 1722), cited in MacDougall, *Racial Myth in English History*, p. 77.

81 Montesquieu, *De l'esprit des lois* (Geneva, 1748), book XI; Eng. trans. as *The Spirit of Law* (London 1750).

82 Marcus Cunliffe, 'Thomas Jefferson and the Dangers of the Past', *Wilson Quarterly*, VI/1 (1982), pp. 96–107.

83 Sharon Turner, *The History of the Anglo-Saxons*, 3 vols (London, 1799–1805), vol. II, p. xii; T. A. Shippey, 'The Undeveloped Image: Anglo-Saxon in

Popular Consciousness from Turner to Tolkien', in *Literary Appropriations of the Anglo-Saxons from the Thirteenth to the Twentieth Century*, ed. Donald Scragg and Carole Weinberg (Cambridge, 2000), p. 225; John D. Niles, 'The Idea of Anglo-Saxon England, 1066–1901: Remembering, Forgetting, Deciphering and Renewing the Past', *Review of English Studies*, LXVIII/284 (April 2017), pp. 369–71.

84 Martin Tupper, 'The Anglo-Saxon Race', *The Anglo-Saxon* (1850).

85 Nell Irvin Painter, *The History of White People* (New York, 2010), p. 160.

86 Ibid., p. 165.

87 *Works of Art in the House of Lords* (London, 1980), p. 25.

88 Ibid., pp. 44–59.

89 T.S.R. Boase, 'The Decoration of the New Palace of Westminster, 1841–1863', *Journal of the Warburg and Courtauld Institutes*, XVII/3/4 (1954), pp. 319–58.

90 Ibid., p. 325.

91 David Blayney Brown, Robert Woof and Stephen Hebron, *Benjamin Robert Haydon, 1786–1846*, exh. cat., The Wordsworth Trust (Grasmere, 1996), p. 176, n. 179.

92 Boase, 'The Decoration of the New Palace of Westminster', p. 325.

93 The scheme for the central corridor (unexecuted) is perhaps the most intriguing: 'Six subjects have been selected: in three Britain appears sunk in ignorance, heathen superstition and slavery; in the other three she appears instructing the savage, abolishing barbarous rites, and liberating the slave.' Among the subjects were a *Druidical Sacrifice, British slaves being offered for sale in Rome* (non Angli sed Angeli), and the last three modern scenes of empire and liberation, but none from the Anglo-Saxon period.

94 Inga Bryden, 'Reinventing Origins: The Victorian Arthur and Racial Myth', in *The Victorians and Race* (Aldershot, 1996), p. 153, n. 2, and p. 155, n. 20.

95 Ibid., pp. 144–7.

96 For Mark Twain's amusing account of *Ivanhoe*'s influence on life in the South before the Civil War in *Life on the Mississippi,* see Scott Horton, 'How Walter Scott Started the American Civil War', *Harper's Magazine* (29 July 2007); available at https://harpers.org, accessed 5 December 2022.

97 Alfred Tennyson, *A Welcome to Her Royal Highness the Princess of Wales* (London, 1863), ll. 31–4; see also Damian Love, 'Hengist's Brood: Tennyson and the Anglo-Saxons', *Review of English Studies*, LX/245 (June 2009), pp. 460–74.

98 Leonée and Richard Ormond, *G. F. Watts: The Hall of Fame*, exh. cat., Watts Gallery (Compton, Surrey, 2012).

99 Mary Watts, *George Frederic Watts*, vol. I: *The Annals of an Artist's Life* (London, 1912), p. 131.

100 *Bayard and Aristides*, 1845–9, drawing, Whitworth Art Gallery, Manchester, D.2002.7.

101 Tennyson, 'Sir Galahad', in *Poems* (London, 1842), pp. 174–8.

102 James Burns, *Sir Galahad: A Call to the Heroic* (London, 1915).

103 Mary Seton Watts, ed., *George Frederic Watts: Annals of an Artist's Life*, vol. III: *Writings on Art* (London, 1912).

104 G. F. Watts, 'The Present Condition of Art', *Nineteenth Century* (1879), cited in Watts, *George Frederic Watts*, vol. III, p. 24.

105 Ibid., p. 262.

106 David Bindman, *Ape to Apollo* (London, 2002), pp. 83–4.

107 Watts, *George Frederic Watts*, vol. III, p. 141.

108 Ibid., pp. 168, 264.

109 Ibid., pp. 185, 157.

110 Ibid., p. 166.

111 Ibid., p. 296.

112 Ibid., p. 172.

113 Ibid., pp. 312, 314.

114 Mrs Russell Barrington, *G. F. Watts: Reminiscences* (London and New York, 1905), p. 39.

115 Stephanie Brown, *G. F. Watts, Physical Energy, Sculpture and Site*, exh. cat., Watts Gallery (Compton, Surrey, 2007), pp. 15–19.

116 Watts, *George Frederic Watts*, vol. III, p. 271.

117 Brown, *G. F. Watts*, p. 28.

118 Ibid., p. 27.

119 Ibid., pp. 28–9.

120 W. T. Stead, ed., *The Last Will and Testament of Cecil Rhodes* (London, 1902).

121 Brown, *G. F. Watts*, pp. 30–31.

122 G. F. Watts, 'Our Race as Pioneers', *Nineteenth Century and After* (May 1901), repr. in Watts, *George Frederic Watts*, vol. III, pp. 280–81.

123 Brown, *G. F. Watts*, pp. 32–3.

124 Watts, *George Frederic Watts*, vol. III, p. 280.

5 Egypt's Land: Racial Determinism and the Art of the Ancient World

1 Evelleen Richards, *Darwin and the Making of Sexual Selection* (Chicago, IL, 2017), pp. 144–6.

2 Franziska A. Augstein, *James C. Prichard's Views of Mankind: An Anthropologist between the Enlightenment and the Victorian Age* (Amsterdam, 1999), p. 313.

3 Ibid.

4 William Lawrence, *Lectures on Physiology, Zoology, and the Natural History of Man, Delivered at the Royal College of Surgeons* (London, 1822), p. 16.

5 Franziska Augstein, *James Cowles Prichard's Anthropology: Remaking the Science of Man* (London, 1999), p. 15.

6 James Prichard, *Researches into the Physical History of Man* (London, 1813), pp. 25, 233.

7 Richards, *Darwin and the Making of Sexual Selection*, pp. 313–31.

8 Richard Weikart, 'The Role of Darwinism in Nazi Racial Thought', *German Studies Review*, XXXVI/3 (2013), pp. 537–56.

9 Robert Knox, *Races of Men* (London, 1850), p. 38.

10 Ibid., p. 306.

11 Ibid., p. 39.

12 Ibid., p. 42.

13 British Museum, EA19, acquired 1817.

14 Knox, *Races of Men*, p. 136.

15 Ibid., p. 71.

16 The central work which incorporated contributions by all mentioned above is Josiah Clark Nott and George R. Gliddon, *Types of Mankind; or, Ethnological Researches, based on the Ancient Monuments, Paintings,*

*Sculptures, and Crania of Races, and upon their Natural, Geographical, Philological, and Biblical History* (Philadelphia, PA, 1854).

17 Manisha Sinha in *To Make Their Own Way in the World: The Enduring Legacy of the Zealy Daguerreotypes*, ed. Ilisa Barbash, Molly Rogers and Deborah Willis (Cambridge, MA, 2020), pp. 239–41.

18 They are in the Physical Anthropology section of the Penn Museum in Philadelphia, but are no longer displayed.

19 Samuel Morton, 'Preface', in *Crania Americana* (Philadelphia, PA, 1839), p. iii.

20 P. W. Mitchell and J. S. Michael, 'Bias, Brains, and Skulls Tracing the Legacy of Scientific Racism in the Nineteenth-Century Works of Samuel George Morton and Friedrich Tiedemann', in *Embodied Difference: Divergent Bodies in Public Discourse*, ed. Christina Jackson and Jamie Thomas (Lanham, MD, 2019), pp. 77–98.

21 Quoted ibid., p. 89.

22 Katja Nummelin, 'Varieties of Human Species: Human Races and Polygenism in Samuel Morton's Crania Americana, 1839', PhD thesis, University of Helsinki (2019), pp. 69–89.

23 Stephen Jay Gould, 'Morton's Ranking of Races by Cranial Capacity', *Science*, CC/4341 (1978), pp. 503–9.

24 Mitchell and Michael, 'Bias, Brains, and Skulls', pp. 77–98.

25 *Ancient Egypt* (New York, 1850); *A Memoir on the Cotton of Egypt* (Philadelphia, PA, 1841); *An Appeal to the Antiquaries of Europe on the Destruction of the Monuments of Egypt* (Philadelphia, PA, 1841); and *Otia ægyptiaca: Discourses on Egyptian Archaeology and Hieroglyphical Discoveries* (Philadelphia, PA, 1849).

26 Samuel George Morton, 'Observations on Egyptian Ethnography, Derived from Anatomy, History, and the Monuments', *Transactions of the American Philosophical Society*, IX/1 (1846), p. 93.

27 Version sung by Paul Robeson. Sometimes it is spelled 'Egypt Land' as in the title of Scott Trafton's book *Egypt Land: Race and Nineteenth-Century American Egyptomania* (Durham, NC, 2004).

28 Prichard, *Researches into the Physical History of Man*, p. 379.

29 Morton, *Crania Americana*, p. 26.

30 Nott and Gliddon, *Types of Mankind*, pp. 88 and 108.

31 Ibid., p. 89.

32 Debbie Challis, *The Archaeology of Race* (London, 2013), pp. 208–9.

33 Nott and Gliddon, *Types of Mankind*, p. 153.

34 Anthony J. Spalinger, 'Historical Observations on the Military Reliefs of Abu Simbel and Other Rameesside Temples in Nubia', *Journal of Egyptian Archaeology*, LXVI (1980), p. 88.

35 Nott and Gliddon, *Types of Mankind*, p. 153.

36 Ibid., p. 169.

37 Ibid., pp. 179–80.

38 Ibid., p. 145.

39 Ibid., p. 150.

40 Ibid., pp. 452–3.

41 Ibid., p. 180.

42 Ibid., pp. 186–7.

43  There is an irony in the fact that Memnon was described as an Ethiopian and a great warrior in Greek mythology.

44  Alan Bates, *The Anatomy of Robert Knox: Murder, Mad Science and Medical Regulation in Nineteenth-Century Edinburgh* (Eastbourne, 2010), pp. 23f.

45  Philip F. Rehbock, 'Transcendental Anatomy', in *Romanticism and the Sciences*, ed. Andrew Cunningham and Nicholas Jardine (Cambridge, 1990), pp. 144–60.

46  Knox, *Races of Men*, p. 16.

47  Dorothea Kuhn and Wolf von Engelhardt, *Goethe: Die Schriften zur Naturwissenschaft*, vol. X: *Aufsätze, Fragmente, Studien zur Morphologie* (Weimar, 1964), p. 334.

48  Knox, *Races of Men*, pp. 418–19.

49  Ibid., p. 419.

50  Ibid., p. 414.

51  Robert Knox, *A Manual of Artistic Anatomy* (London, 1852), pp. 1 and 3.

52  Knox, *Races of Men*, p. 262.

53  Nott and Gliddon, *Types of Mankind*, p. 103.

54  For an exhaustive account of the Peabody daguerreotypes see Barbash, Rogers and Willis, eds, *To Make Their Own Way in the World*.

55  Ibid., p. 289.

56  L. Menand, 'Morton, Agassiz, and the Origins of Scientific Racism in the United States', *Journal of Blacks in Higher Education* (2001), pp. 110–13.

57  George M. Fredrickson, *The Black Image in the White Mind* (New York, 1971), p. 77.

58  Daniel Walker Howe, *What Hath God Wrought: The Transformation of America, 1815–1848* (Oxford, 2007), pp. 58, 480.

59  Nott and Gliddon, *Types of Mankind*, p. 415.

60  Barbash, Rogers and Willis, eds, *To Make Their Own Way in the World*, p. 287; from the *Newark Daily Advertiser*, 4 October 1850.

61  Ibid. p. 287.

62  Frederick Douglass, 'Pictures and Progress' (1861), in John Stauffer, Zoe Trodd and Celeste-Marie Bernier, *Picturing Frederick Douglass* (New York, 2015), p. 353.

63  Barbash, Rogers and Willis, eds, *To Make Their Own Way in the World*, pp. 250–51.

64  David Bindman, *Ape to Apollo* (London, 2002), pp. 69–70.

65  Manisha Sinha, 'Of Scientific Racists and Black Abolitionists', in *To Make Their Own Way in the World*, pp. 241–4.

66  John Stauffer and Henry Louis Gates Jr, eds, *The Portable Frederick Douglass* (Harmondsworth, 2016), pp. 223–47.

67  Ibid., pp. xxvii–xxviii.

68  James Cowles Prichard, *The Natural History of Man* (London, 1848), vol. IV.

69  Philip Kadish, 'Pharaohs, Mandingos, and Saxons: The Afrocentric Auto-Ethnologies of Frederick Douglass and Martin Delany, and the Counter-Auto-Ethnology of Harriet Beecher Stowe', African Diaspora Conference, College of Staten Island, City University of New York, 19 October 2014, available at www.academia.edu, accessed 6 December 2022.

70  Ibid.

71  Darwin, *Descent of Man*, p. 168.

72 Stauffer and Gates, eds, *The Portable Frederick Douglass*, p. 228.

73 Stauffer, Trodd and Bernier, *Picturing Frederick Douglass*, p. xv.

74 All are reprinted ibid., pp. 123–74.

75 Ibid., p. 131.

76 Ibid., p. 171.

77 Ibid., p. 168.

78 Elizabeth S. Humphrey, 'American Classicism and Frederick Douglass's Sculpture Collection', *Magazine of the Decorative Arts Trust* (Winter 2021–2), available at https://decorativeartstrust.org, accessed 6 December 2022.

79 Stauffer, Trodd and Bernier, *Picturing Frederick Douglass*, p. 166.

80 Ibid., p. 83, plate 2.10.

81 Ibid., p. 129.

82 Ibid., p. 127.

83 Ibid., p. xiii.

84 Ibid., p. 12, plate 10.

85 Nott and Gliddon, *Types of Mankind*, pp. 240–41.

6 Semites, Jews and the Orient

1 David Bindman, *Ape to Apollo* (London, 2002), pp. 118–19.

2 Ibid., p. 219.

3 Ernest Renan, *Études d'histoire religieuse, suivies de Nouvelles études d'histoire religieuse* (Paris, 1992), p. 15.

4 'In stray corners here and there, in western Europe, the Jew could show that other quality he shared with the Arab, the quality of the princely host, who would wash the feet of beggars and feed them from his own dish.' (Graham Greene, *Stamboul Train* (London, 1932). See also Ivan Kalmar, 'Jews, Cousins of Arabs: Orientalism, Race, Nation, and Pan-Nation in the Long Nineteenth Century', in *Is There a Judeo-Christian Tradition?: A European Perspective*, ed. Emmanuel Nathan and Anya Topolski (Berlin, 2016), pp. 53–73.

5 Lee Johnson, 'Delacroix's "Jewish Bride"', *Burlington Magazine*, CXXXIX/1136 (1997), pp. 755–9.

6 Julie Kalman, 'Sensuality, Depravity, and Ritual Murder: The Damascus Blood Libel and Jews in France', *Jewish Social Studies*, New Series, XIII/3 (Spring–Summer, 2007), pp. 35–58.

7 Kalmar, 'Jews, Cousins of Arabs'.

8 Ernest Renan, 'Nouvelles considérations sur le caractère général des peuples sémitiques, et en particulier sur leur tendance au monothéisme', *Journal asiatique*, 13 (1859), pp. 214–82 and 417–50; M. Steinschneider, *Hebräische Bibliographie. Blätter für neuere und ältere Literatur des Judentums*, III/13 (January–February 1860), p. 16.

9 *The Works of the Late Professor Camper*, trans. Thomas Cogan (London, 1794), p. 20.

10 Victor Stoichita, *Darker Shades: The Racial Other in Early Modern Art*, trans. Samuel Trainor (London, 2019), p. 106.

11 Bindman, *Ape to Apollo*, p. 116.

12 Mary Cowling, *The Artist as Anthropologist* (Cambridge, 1989), p. 82.

13 Ibid., p. 118.

14 Nicholas Tromans, *David Wilkie: Painter of Everyday Life* (London, 2002), p. 28.

15  Ibid.
16  For an image of Mirza, see *Sir David Wilkie's Sketches in Turkey, Syria & Egypt, 1840 & 1841* (London, 1843).
17  Albert Boime, 'William Holman Hunt's "The Scapegoat": Rite of Forgiveness/Transference of Blame', *Art Bulletin*, LXXXIV/1 (March 2002), pp. 94–114.
18  Judith Bronkhurst, *William Holman Hunt: A Catalogue Raisonné*, vol. I: *Paintings* (New Haven, CT, 2006), p. 153.
19  Ibid., pp. 175–6.
20  Boime, 'William Holman Hunt's "The Scapegoat"', p. 113.

7  The Aesthetics of Evolution: Race, Beauty and Ugliness

 1  This chapter is greatly indebted to Evelleen Richards's *Darwin and the Making of Sexual Selection* (Chicago, IL, 2017), though I come to slightly different conclusions.
 2  Diana Donald and Jane Munro, eds, *Endless Forms: Charles Darwin, Natural Science and the Visual Arts*, exh. cat., Fitzwilliam Museum, Cambridge (New Haven, CT, 2009), plates 154–62.
 3  See the Introduction to this book.
 4  David Bindman, *Ape to Apollo* (London, 2002), p. 126.
 5  Ibid., p. 127.
 6  Richards, *Darwin*, pp. 8–9.
 7  Charles Darwin, *Descent of Man*, revd edn (London, 1874), p. 174.
 8  Ibid., p. 216.
 9  Richards, *Darwin*, pp. 323–4.
10  Charles Darwin, *Descent of Man* (London, 1871), p. 226.
11  Richards, *Darwin*, p. 307.
12  Josiah Clark Nott and George R. Gliddon, *Types of Mankind; or, Ethno-logical Researches, based on the Ancient Monuments, Paintings, Sculptures, and Crania of Races, and upon their Natural, Geographical, Philological, and Biblical History* (Philadelphia, PA, 1854), pp. 103–5.
13  Darwin, *Descent of Man* (1871 edn), p. 54.
14  Ibid., p. 146.
15  Charles Darwin, *Beagle Diary*, 25 Febuary 1834, available online at http://darwinbeagle.blogspot.com.
16  Darwin, *Descent of Man* (1871), p. 34.
17  Ibid., p. 35.
18  Ibid., p. 64.
19  Richards, *Darwin*, pp. 402–3.
20  Bindman, *Ape to Apollo*, p. 114.
21  Darwin, *Descent of Man* (1871), p. 178.
22  Darwin, *Descent of Man* (1874), p. 198.
23  Ibid., p. 199.
24  Jane Munro in *Endless Forms*, ed. Donald and Munro, pp. 257–8.
25  Darwin, *Descent of Man* (1871), p. 64.
26  Ibid., p. 276.
27  Richards, *Darwin*, p. 80.
28  Darwin, *Descent of Man* (1874), p. 93.
29  Darwin, *Descent of Man* (1871), p. 67.
30  Joshua Reynolds, *The Idler* (London, 1816), p. 332.

31 Richards, *Darwin*, pp. 99–102.

32 Bindman, *Ape to Apollo*, p. 184.

33 John Stowell, 'On the Origins of Beauty: Aesthetics and Method in the Works of Charles Darwin', *Cambridge Quarterly*, XLVI/4 (December 2017), pp. 364–85.

34 Richards, *Darwin*, pp. 497f.

8 France Divided: From the Franco-Prussian War to the Dreyfus Affair

1 Anthea Callen, *The Spectacular Body: Science, Method and Meaning in the Work of Degas* (New Haven, CT, 1995), pp. 21–9.

2 Much of what follows is indebted to the superb *Degas and New Orleans: A French Impressionist in America*, ed. Gail Feigenbaum, with catalogue by Jean Sutherland Boggs, exh. cat., New Orleans Museum of Art (1999); and to Christopher Benfey, *Degas in New Orleans* (Berkeley, CA, 1999).

3 Marilyn R. Brown, 'Franco-American Aspects of Degas's *A Cotton Office in New Orleans*', in *Degas and New Orleans*, ed. Feigenbaum, p. 56.

4 Ibid., p. 8. See also www.familysearch.org. I am grateful to John Clegg for his help.

5 Ibid., p. 294.

6 Ibid., p. 292.

7 This drawing was last recorded at Sotheby's, 2 May 1990; Wendy Baron, *Sickert: Paintings and Drawings* (New Haven, CT, 2006), pp. 409–10, cat. no. 419.

8 Feigenbaum in *Degas and New Orleans*, ed. Feigenbaum, p. 290.

9 Ibid., p. 297.

10 Ibid., p. 296.

11 Marilyn R. Brown, 'Degas and *A Cotton Office in New Orleans*', *Burlington Magazine*, CXXX/1020 (March 1988), pp. 216–21.

12 Feigenbaum in *Degas and New Orleans*, ed. Feigenbaum, pp. 296–7.

13 Linda Wolk-Simon, *Degas, Miss La La, and the Cirque Fernando*, exh. cat., The Morgan Library & Museum (New York, 2013).

14 See Callen, *The Spectacular Body*, fig. 57 and pp. 107–8.

15 Robert Lethbridge, 'Rethinking Zola and Cézanne: Biography, Politics and Art Criticism', *Journal of European Studies*, XLVI/2 (2016), pp. 126–42.

16 Cited by Linda Nochlin, 'Degas and the Dreyfus Affair', *The Politics of Vision* (London, 1991), p. 165, n. 15.

17 Ibid., p. 170.

18 The name *Félibrige* derives from the Provençal word 'Félibre', which meant a doctor responsible for interpreting the law. For the early history see Philippe Martel, *Les Félibres et leur temps: Renaissance d'oc et opinion, 1850–1914* (Bordeaux, 2010).

19 Frédéric Mistral, *Memoirs of Mistral* (London, 1907), p. 199.

20 Ibid., p. 308.

21 Thomas Huxley, 'On the Geographical Distribution of the Chief Modifications of Mankind', *Journal of the Ethnological Society of London*, II/4 (1870), pp. 401–11.

22 Paul Claval and Colette Jourdain-Annequin, 'For Whom the Mediterranean Sea Is "Our Sea"?', *Athens Journal of Mediterranean Studies*, III/2 (April 2017), pp. 99–120.

23 'Aubouro te, raço latino/ Souto la capo dou soleu!/ Lou rasin brun boui dins la tino Lou vin de Dièu gisclara leu.' Marilyn McCully, 'Mediterranean

Classicism and Sculpture in the Early Twentieth Century', *Catalan Review*, v/1 (July 1991), pp. 145–67.

24 Charles Alfred Downer, *Frédéric Mistral: Poet and Leader in Provence* (New York, 1901), pp. 30–31.

25 Geoffrey Neil David Thomas, 'Visions For The Viewer: The Influence of Two Unique Easel Paintings on the Late Murals of Pierre Puvis De Chavannes', Master's thesis, University of South Carolina, 2018, p. 9.

26 Ibid.

27 Gaetano DeLeonibus, *Charles Maurras's Classicising Aesthetics* (Bern, 2000), p. xi.

28 'Il n'y a sans doute pas de race latine. Et encore! Et qui sait! L'*homo mediterraneus* des anthropologistes ne correspondrait-il à cette ancienne idée? L'essentiel est qu'il existe une civilisation latine, un esprit latin, véhicule et complément de l'hellénisme, interprète de la raison et de la beauté athénienne, durable monument de la force romaine.' Ibid., p. 8.

29 Émile Bergerat, 'À la gloire de Puvis de Chavannes', repr. in the special Puvis de Chavannes issue of *La Plume*, 138 (15 January 1895), p. 55.

30 André Michel, 'L'Oeuvre de Puvis de Chavannes', in *Notes sur l'art modern* (Paris, 1896), p. 159.

31 'Le retour dans la pensée comme dans le style à l'équilibre et à l'harmonie . . . Nous avons entrepris de défendre le patrimoine des muses latines, d'opposer le goût d'ordre, de mesure et d'harmonie de notre race aux imaginations monstrueuses, à l'inconcevable chaos de l'étranger, et de lutter, dans la mesure de nos forces, pour le salut de l'esprit français et le règne de la Beauté.' Ernest Raynaud, 'L'Ecole romane française', *Mercure de France* (May 1895), pp. 132 and 145.

32 McCully, 'Mediterranean Classicism and Sculpture in the Early Twentieth Century', pp. 145–67.

33 Athena Leoussi, *Nationalism and Classicism: The Classical Body as National Symbol in Nineteenth-Century England and France* (Basingstoke, 1998).

34 Neil McWilliam, 'Towards a New French Renaissance: Memory, Tradition and Cultural Conservatism in France before the First World War', *Art History*, XL/4 (August 2017), pp. 724–43; June Hargrove and Neil McWilliam, eds, *Nationalism and French Visual Culture, 1870–1914*, Studies in the History of Art (New Haven, CT, 2005), pp. 269–92.

35 Nina Athanassoglou-Kallmyer, *Cézanne and Provence* (Chicago, IL, 2003), pp. 1–5.

36 Ibid., p. 8.

37 For a recent account of Marion and Cézanne, see Faya Causey in *Cézanne: The Rock and Quarry Paintings*, ed. John Elderfield (Princeton, NJ, 2020), pp. 41–66.

38 Ibid., p. 54.

39 Athanassoglou-Kallmyer, *Cézanne and Provence*, p. 184.

40 'Les hommes de ma race à leur sang sont liés./ Dans la Provence d'or flotte l'air de l'Hellade,/ A peine si les pins rendent le vent amer,/ Au pied d'un mont sacre s'endormait ma bourgade./ Enfant, je le gravis pour voir blanchir la mer.' Joachim Gasquet, 'Chant filial', *Les Pays de France*, 1 (January 1899), p. 17.

41 See letter to Joachim Gasquet, 22 June 1898 (Alex Danchev, *The Letters of Paul Cézanne* (London, 2013), p. 187).

42 Alex Danchev, *The Letters of Paul Cézanne* (London, 2013), pp. 292–3.

43 Ibid., p. 315: 'Demolins' here refers to Marie Joseph Demolins, editor with Gasquet of the journal *Les Mois dorés*, which became in 1899 *Les Pays de France*.

44 Athanassoglou-Kallmyer, *Cézanne and Provence*, pp. 1–14.

45 Philip Nord, 'The New Painting and the Dreyfus Affair', *Historical Reflections/ Réflexions Historiques*, XXIV/1 (Berghahn, 1998), p. 166.

46 'J'ai été dreyfusien, je ne le suis plus. J'étais republicain et, disons le mot, un peu gros, anarchiste. L'enquête méditée de notre ami Maurras m'a fait royaliste.' Athanassoglou-Kallmyer, *Cézanne and Provence*, p. 293, n. 105.

47 Elizabeth Cowling and Jennifer Mundy, ed., *On Classic Ground: Picasso, Léger, de Chirico and the New Classicism 1910–1930*, exh. cat., Tate Gallery (London, 1990), pp. 150–52.

48 '[Un] terme qu'il faut prendre dans le sens ou l'entend Charles Maurras', Judith Cladel, *Aristide Maillol* (Paris, 1937), p. 74.

49 Cited in Mark Antliff, *Avant-Garde Fascism: The Mobilization of Myth, Art, and Culture in France, 1909–1939* (Durham, NC, 2007), p. 235.

### 9 Eugenics and the Defence of the White Races

1 For an exhaustive account of Galton and the formation of eugenics see Karl Pearson, *The Life, Letters and Labours of Francis Galton*, 3 vols (Cambridge, 1914, 1924, 1930).

2 Howard Markel, *The Kelloggs: The Battling Brothers of Battle Creek* (New York, 2017), p. 461.

3 Alison Bashford and Philippa Levine, *The Oxford Handbook of the History of Eugenics* (Oxford, 2010), p. 319.

4 Francis Galton, *Memories of My Life* (London, 1908), p. 323.

5 Karl Pearson, *National Life from the Standpoint of Science* (London, 1901), pp. 43–4; Pearson was, in fact, from a Quaker family and claimed to be a socialist. He lectured on Karl Marx, but this did not prevent him from welcoming Hitler's racial policies. In 1934 he declared, 'Did I say "culminate"? No, that lies in the future, perhaps with Reichskanzler Hitler and his proposals to regenerate the German people. In Germany a vast experiment is in hand, and some of you may live to see its results. If it fails it will not be for want of enthusiasm, but rather because the Germans are only just starting the study of mathematical statistics in the modern sense!' *Speeches Delivered at a Dinner in University College, London, in Honour of Professor Karl Pearson, 23 April 1934* (privately printed, 1934).

6 Francis Galton, 'Composite Portraits, Made by Combining Those of Many Different Persons into a Single Resultant Figure', *Journal of the Anthropological Institute of Great Britain and Ireland*, VIII (1879), pp. 132–44.

7 Pearson, *The Life, Letters and Labours of Francis Galton*, vol. II, p. 301.

8 Francis Galton, 'Composite Portraits', p. 134.

9 D. Novak, 'A Model Jew: "Literary Photographs" and the Jewish Body in Daniel Deronda', *Representations*, LXXXV/1 (2004), p. 69.

10 Pearson, *The Life, Letters and Labours of Francis Galton*, vol. II, p. 324.

11 Francis Galton, 'The Measurement of Visual Resemblance' (1906), UCL Special Collections, Galton Archive GALTON/2/8/5/1, available at https://wellcomecollection.org, accessed 1 December 2022; Galton, 'Classification of Portraits', *Nature*, 76 (1907), p. 617.

12 Ida McLearn, G. M. Morant and Karl Pearson, 'The Importance of the Type Silhouette for Racial Characterisation in Anthropology', *Biometrika*, xx(b) (1928), pp. 389–400.

13 J. K. Lavater, *Essays on Physiognomy for the Promotion of the Knowledge and the Love of Mankind*, 5 vols (London, 1789–98), vol. II, pp. 176–238.

14 UCL Special Collections, Galton Archive GALTON/117-188/120-138/138/6/1, available at https:/wellcomecollection.org, accessed 1 December 2022.

15 I am greatly indebted in this section to Debbie Challis, *The Archaeology of Race* (London, 2013).

16 There appear to be only two surviving copies in the United Kingdom, and none in the Petrie Museum, UCL or the British Library. Ibid., p. 85.

17 W.M.F. Petrie, *Report of the Committee, consisting of Mr. Francis Galton, General Pitt-Rivers, Professor Flower, Professor A., Mcalister, Mr F.W. Rudler, Mr. R. Stuart Poole and Mr Bloxam (secretary), appointed for the purposes of procuring, with the help of Mr. Flinders Petrie, Racial Photographs from the Ancient Egyptian Pictures and Sculptures* (London, 1887). The Heidelberg University copy of the book is available online at https://digi.ub.uni-heidelberg.de, accessed 1 December 2022.

18 Nineteen of the original plaster casts were left to the British Museum by Galton.

19 W.M.F. Petrie, *Janus* (London, 1907), pp. 13–14.

20 M. Drower, *Flinders Petrie: A Life in Archaeology* (London, 1985), p. 428.

21 W.M.F. Petrie, *The Making of Egypt* (London, 1939), p. 67.

22 W.M.F. Petrie, 'Migrations (The Huxley Lecture for 1906)', *Journal of the Anthropological Institute of Great Britain and Ireland*, 36 (1906), pp. 189–232.

23 W.M.F. Petrie. 'Letter to Palestine Post', 19 January 1939, Cuttings Book, Petrie Museum Archives.

24 Drower, *Flinders Petrie*, p. 302; Petrie, *The Making of Egypt*, p. 4.

25 Of these heads, 57 still survive in a drawer labelled 'Racial Heads' in the Petrie Museum.

26 Challis, *The Archaeology of Race*, pp. 129–31.

27 Ibid., pp. 130–31.

28 W.M.F. Petrie, 'The Races of Early Egypt', *Journal of the Anthropological Institute of Great Britain and Ireland*, XXXI (January–June 1901), pp. 248–55.

29 A. H. Sayce, *The Races of the Old Testament* (London, 1891), p. 10.

30 Ibid., pp. 17–18.

31 Ibid., p. 77.

32 Ibid., p. 173.

33 Ibid., p. 75.

34 Ibid., p. 5.

35 Ibid., p. 83.

36 Ibid., pp. 88–9. For Virchow see Chapter Eleven.

37 Ibid., p. 83.

38 Ibid., p. 88.

39 Ibid., pp. 89–90.

40 Bruce L. Bennett, 'Sargent, Dudley Allen', *American National Biography* (New York, 1999), available at www.anb.org.

41 Clarence S. Yoakum and Robert M. Yerkes, *Army Mental Tests* (New York, 1920).

42 Christina Cogdell, *Eugenic Design: Streamlining America in the 1930s* (Philadelphia, PA, 2004), p. 130.

43 Arthur A. Stewart, 'Someday We'll Look Like This', *Popular Science Monthly* (July 1929), p. 47; cited in Christina Cogdell, 'Future Perfect? The Elusive "Ideal Type"', in *Art, Sex and Eugenics*, ed. Fae Brauer and Anthea Callen (London, 2008), p. 252.

44 Ibid., p. 253.

## 10 The Ape, the Coon and the Savage: From Racial Science to Racist Imagery

1 Tzvetan Todorov, *On Human Diversity: Nationalism, Racism, and Exoticism in French Thought* (Cambridge, MA, 1993), pp. 90–94.

2 Douglas A. Lorimer, 'Race, Science and Culture: Historical Continuities and Discontinuities, 1850–1914', in *The Victorians and Race*, ed. Shearer West (Aldershot, 1996), pp. 24–5.

3 Jenna B. Gibbs, *Performing the Temple of Liberty: Slavery, Theater, and Popular Culture* (Baltimore, MD, 2014), pp. 134–9, 145.

4 M. D. Harris, *Colored Pictures: Race and Visual Representation* (Chapel Hill, NC, 2003); Bryan F. Le Beau, 'African Americans in Currier and Ives's America: The Darktown Series', *Journal of American and Comparative Cultures*, XXIII/1 (Spring 2000), pp. 71–83.

5 See website of the Jim Crow Museum of Racist Memorabilia, Ferris State University, Big Rapids, Michigan, www.ferris.edu, accessed 3 December 2022.

6 J. Stanley Lemons, 'Black Stereotypes as Reflected in Popular Culture, 1880–1920', *American Quarterly*, XXIX/1 (Spring 1977), pp. 102–11.

7 Sadiah Qureshi, *Peoples on Parade: Exhibitions, Empire, and Anthropology in Nineteenth-Century Britain* (Chicago, IL, 2011), pp. 107f.

8 An attempt to reproduce an image from the book in *The Image of the Black in Western Art* (Cambridge, MA, 2012), vol. V, was firmly turned down.

9 J. Lenburg, *The Encyclopedia of Animated Cartoons* (New York, 1999), pp. 54–6.

10 B. D. Behnken and G. D. Smithers, *Racism in American Popular Media: From Aunt Jemima to the Frito Bandito* (Santa Barbara, CA, 2015), p. 106.

11 Charles Carroll, *The Negro a Beast* (St Louis, MO, 1900).

12 M. Stokes, *D. W. Griffith's The Birth of a Nation: A History of 'The Most Controversial Motion Picture of All Time'* (New York, 2007).

13 Matthew Aron Ginther, 'The Cult of Quality: White Eugenics and Black Responses in the United States, 1900–1934', *University of Saskatchewan Undergraduate Research Journal*, 1/2 (2015), pp. 52–3.

## 11 Responses to Racial Science and Eugenics

1 Franz Boas also studied with Virchow before settling in the United States.

2 Kwame Anthony Appiah, *Lines of Descent: W.E.B. Du Bois and the Emergence of Identity* (Cambridge, MA, 2014), pp. 25f.

3 Ibid., pp. 46–50.

4 See Julian Rothenstein, ed., *Black Lives 1900: W.E.B. Du Bois at the Paris Exhibition*, intro. by Jacqueline Francis and Stephen G. Hall (London, 2019).

5 Shawn Michelle Smith, 'The Art of Scientific Propaganda', in *Art, Sex and Eugenics*, ed. Fae Brauer and Anthea Callen (London, 2008), p. 65.

6 This concept was invented seven years before by Henry Lyman Morehouse and popularized by Du Bois. See Henry Louis Gates Jr, *Stony the Road: Reconstruction, White Supremacy, and the Rise of Jim Crow* (New York, 2019), p. 191.

7 Ibid., pp. 197–9.

8 Booker T. Washington et al., *The Negro Problem: A Series of Articles by Representative American Negroes of Today* (New York, 1903).

9 Dana Carluccio, 'The Evolutionary Invention of Race: W.E.B. Du Bois's "Conservation" of Race and George Schuyler's *Black No More*', *Twentieth Century Literature*, LV/4 (2009), pp. 510–46.

10 W. E. Burghardt Du Bois, *The Philadelphia Negro: A Social Study* (Philadelphia, PA, 1899), p. 311.

11 Renée Ater, *Remaking Race and History: The Sculpture of Meta Warrick Fuller* (Berkeley, CA, 2011), p. 103.

12 Henry Louis Gates Jr and Kwame Anthony Appiah, eds, *Africana: The Encyclopedia of the African and African-American Experience* (Oxford, 2005), vol. I, p. III.

13 Laurel Kendall, Barbara Mathe and Thomas Ross Miller, *Drawing Shadows to Stone: The Photography of the Jesup North Pacific Expedition, 1897–1902* (New York, 1997).

14 Andrew Zimmerman, 'Anti-Semitism as Skill: Rudolf Virchow's *Schulstatistik* and the Racial Composition of Germany', *Central European History*, XXXII/4 (2008), pp. 409–29.

15 Franz Boas, 'Eugenics', *Scientific Monthly*, III/5 (November 1916), pp. 471–8.

16 Mark Anderson, 'Ruth Benedict, Boasian Anthropology, and the Problem of the Colour Line', *History and Anthropology*, XXV/3 (27 May 2014), pp. 395–414.

17 Ruth Benedict and Gene Weltfish, *The Races of Mankind*, Public Affairs Pamphlet (New York, 1943).

18 For a selection of his satires see Robert Storr, *Ad Reinhardt: How to Look* (New York, 2013).

19 David Bindman and Henry Louis Gates Jr, ed., *The Image of the Black in Western Art* (Cambridge, MA, 2014), vol. V, part I, p. 260, fig. 220.

20 Berthold Laufer, 'Preface', in Henry Field, *The Races of Mankind: An Introduction to Chauncey Keep Memorial Hall* (Chicago, IL, 1933), p. 6.

21 Arthur Keith, *Ethnos; or, The Problem of Race considered from a New Point of View* (London, 1931), pp. 10–11.

22 Arthur Keith, 'The Evolution of the Human Races', *Journal of the Royal Anthropological Institute of Great Britain and Ireland*, LVIII (1928), p. 316.

23 Arthur Keith, *An Autobiography* (London, 1950), pp. 552–3.

24 Arthur Keith, 'Introduction', in Field, *The Races of Mankind*, p. 8: 'the eye, at a single glance, picks out the racial features more certainly than could a band of trained anthropologists, who depend on measurements to distinguish Negro, Indian, or Chinaman from European.'

25 Malvina Hoffman, *Heads and Tales* (New York, 1936), p. 12.

26 Ibid., p. 156.

27 Field, *The Races of Mankind*, p. 21.

28 Arthur Keith, 'Introduction', ibid., p. 9.
29 Éric Michaud, *The Cult of Art in Nazi Germany*, trans. Janet Lloyd (Stanford, CA, 2004), pp. 157–8.
30 Now in the Arno Breker Museum, Nörvenich.
31 Bernhard Fulda and Aya Soika, 'Introduction', in *Emil Nolde: The Artist during the Third Reich* (Munich, 2019), pp. 26–9.
32 Fulda, 'Nolde's Anti-Semitism', ibid., pp. 97–114.
33 Ibid., pp. 80–82.
34 Bernd Behrendt, 'August Julius Langbehn, der "Rembrandtdeutsche"', in *Handbuch zur 'Völkischen Bewegung', 1871–1918*, ed. Uwe Puschner, Walter Schmitz and Justus H. Ulbricht (Munich, 1996), pp. 94–113.
35 Fulda, 'Nolde's Autobiography', p. 82.
36 Corinth and Pechstein were not in fact Jewish.
37 Fulda, 'Nolde's Autobiography', pp. 88–9.
38 Some Nazi theorists even claimed that the ancient Greeks were themselves a Nordic people.
39 For Schultze-Naumburg's ideas see Johann Chapoutot, *Greeks, Romans, Germans* (Los Angeles, CA, 2016), p. 187f.
40 D. Bindman, *Warm Flesh, Cold Marble* (New Haven, CT, 2014), pp. 139–46.
41 Ibid., p. 126.

Postscript

1 Jeremy Tanner, Introduction to D. Bindman and Henry Louis Gates Jr, ed., *The Image of the Black in Western Art* (Cambridge, MA, 2010), vol. I, p. 20.
2 This was suggested to me by Brigid von Preussen.

# SELECT BIBLIOGRAPHY

Appiah, Kwame Anthony, *Lines of Descent: W.E.B. Du Bois and the Emergence of Identity* (Cambridge, MA, 2014)

Athanassoglou-Kallmyer, Nina, *Cézanne and Provence* (Chicago, IL, 2003)

Barbash, Ilisa, Molly Rogers and Deborah Willis, eds, *To Make Their Own Way in the World: The Enduring Legacy of the Zealy Daguerreotypes* (Cambridge, MA, 2020)

Bindman, David, *Ape to Apollo* (London, 2002)

——, and Henry Louis Gates Jr, eds, *The Image of the Black in Western Art* (Cambridge, MA, 2012–)

Brauer, Fae, and Anthea Callen, eds, *Art, Sex and Eugenics* (London, 2008)

Callen, Anthea, *The Spectacular Body: Science, Method and Meaning in the Work of Degas* (New Haven, CT, 1995)

——, *Looking at Men: Anatomy, Masculinity and the Modern Male Body* (New Haven, CT, 2018)

Carson, John, *The Measure of Merit: Talents, Intelligence, and Inequality in the French and American Republics, 1750–1940* (Princeton, NJ, 2006)

Challis, Debbie, *The Archaeology of Race: The Eugenic Ideas of Francis Galton and Flinders Petrie* (London, 2013)

Cowling, Mary, *The Artist as Anthropologist: The Representation of Character in Victorian Art* (Cambridge, 1989)

Donald, Diana, and Jane Munro, eds, *Endless Forms: Charles Darwin, Natural Science, and the Visual Arts*, exh. cat., Fitzwilliam Museum, Cambridge (New Haven, CT, 2009)

Feigenbaum, Gail, and Jean Sutherland Boggs, eds, *Degas and New Orleans: A French Impressionist in America*, exh. cat., New Orleans Museum of Art (New Orleans, LA, 1999)

Fryer, Peter, *Staying Power: The History of Black People in Britain* (London, 1984)

Fulda, Bernhard, *Emil Nolde: The Artist during the Third Reich*, exh. cat., Nationalgalerie (Berlin, 2019)

Gould, Stephen J., *The Mismeasure of Man* (New York, 1981)

Lafont, Anne, *L'Art et la Race. L'Africain (tout) contre l'œil des Lumières* (Paris, 2019)

*Le Modèle noir: de Géricault à Matisse*, exh. cat., Musée d'Orsay (Paris, 2019)

MacDougall, Hugh A., *Racial Myth in English History* (Montreal, 1982)

Meijer, Miriam Claude, *Race and Aesthetics in the Anthropology of Petrus Camper* (Amsterdam, 1999)

Michaud, Éric, *The Barbarian Invasions: A Genealogy of the History of Art* (Cambridge, MA, 2019)

Nochlin, Linda, *The Politics of Vision: Essays on Nineteenth-Century Art and Society* (London, 1991)

Painter, Nell Irvin, *The History of White People* (New York, 2010)

Qureshi, Sadiah, *Peoples on Parade: Exhibitions, Empire, and Anthropology in Nineteenth-Century Britain* (Chicago, IL, 2011)

Richards, Evelleen, *Darwin and the Making of Sexual Selection* (Chicago, IL, 2017)

Stauffer, John, Zoe Trodd and Celeste-Marie Bernier, *Picturing Frederick Douglass* (New York, 2015)

Stepan, Nancy, *The Idea of Race in Science: Great Britain, 1800–1960* (London, 1982)

Stoichita, Victor I., *Darker Shades: The Racial Other in Early Modern Art* (London, 2019)

Todorov, Tzvetan, *On Human Diversity: Nationalism, Racism, and Exoticism in French Thought* (Cambridge, MA, 1993)

# ACKNOWLEDGEMENTS

This book was largely enabled by something that has otherwise caused untold misery and sadness worldwide: the COVID-19 pandemic. By brutally terminating a number of active projects and forcing me to be alone with my laptop, it meant I could pick up this task again and work on it with relatively little distraction for over a year. With access to the Internet and JSTOR online, to books from the London Library, book chapters made available by the Harvard University Library and the expertise of colleagues, I was able to cover most of the sources I needed. What it has lacked – and that is also due to the pandemic – are more chances to work in archives and talk things over informally with colleagues in Britain, Europe and the United States.

Henry Louis (Skip) Gates Jr has been a constant inspiration through his works, friendship and leadership of the marvellous Hutchins Center for Africa and African American Research at Harvard University. I am highly privileged to have been a fellow there for many years, editing with him the series *The Image of the Black in Western Art*, but I have also had the further privilege of spending time with other fellows and staff who have been endlessly stimulating, whatever their specialisms.

I am particularly grateful to the following who read drafts and made cogent suggestions for improvement: Steven Lukes, Henry Louis Gates Jr, Faya Causey, Esther Chadwick, Brigid von Preussen, Rita Freed, Satish Padiyar and Ting Chang. Particular debts are owed to David Alexander, Robin Bernstein, Geoffrey Bindman, Suzanne Blier, Alan and Susan Budd, Sheldon Cheek, Adrienne Childs, Christa Clarke, Thomas Cummings, Karen Dalton, Natasha Eaton, Caroline Elam, Mechthild Fend, David Freedberg, Alejandro de la Fuente, Tamar Garb, Bonnie Greer, Tom Gretton, Serge Guilbault, the late Andrew Harrison, Katie Heleniak, Andrew Hemingway, Peter Hulme, Tim Hyman, the late Ian Jenkins, Ludmilla Jordanova, Deborah Kahn, Paul Kaplan, Antien Knaap, Robert Knox (not to be confused with his namesake), Joseph and Meg Koerner, Elmer Kolfin, Anne Lafont, Krishna Lewis, Laure de Margerie, Eckart Marchand, Jan Marsh, Rovianne Matovu, Olivier Meslay, Caroline Mustill, Pap Ndiaye, Steven Nelson, Frédéric Ogée, John Picton, the late Angela Rosenthal, Kim Sloan, Richard Taws, Cornel West, the late Helen Weston, the late Louis Wilson, Abby Wolf, Alison Wright and Alison E. Wright.

Finally, deepest thanks to Frances Carey and my children, who have persuaded me that the subject is important to those outside as well as inside the academic world.

# PHOTO ACKNOWLEDGEMENTS

The author and publishers wish to express their thanks to the below sources of illustrative material and/or permission to reproduce it. Some locations of artworks are also given below, in the interest of brevity:

Anacostia Community Museum, Smithsonian Institution, Washington, DC: 74; © ARS, NY and DACS, London 2022, photo from Ruth Benedict and Gene Weltfish, *The Races of Mankind* (New York, 1943): 107; Beaux-Arts de Paris: 16; Bibliothèque nationale de France, Paris: 21, 22; Birmingham Museum and Art Gallery: 66; from Pieter Camper, *Verhandeling . . . over het natuurlijk verschil der wezenstrekken in menschen van onderscheiden landaart en ouderdom* (Utrecht, 1791), photos Universiteitsbibliotheek Utrecht: 4, 5; Chris Lawrence Travel/ Shutterstock.com: 2; collection of the author: 78; from George Combe, *A System of Phrenology* (Edinburgh, 1830), photos Harvey Cushing/John Hay Whitney Medical Library, Yale University, New Haven, CT: 10, 11; © Colchester and Ipswich Museums Service/Bridgeman Images: 1; Detroit Institute of Arts, MI: 77, 92; © Estate of Malvina Hoffman, photo © The Field Museum/John Weinstein (image no. A115234d_002A, cat. no. 337117): 70; © Estate of Meta Vaux Warwick Fuller, photo Art and Artifacts Division, Schomburg Center for Research in Black Culture, The New York Public Library: 108; Galerie David d'Angers, photo Hickey and Robertson, Houston/The Menil Foundation: 14; Galerie Neue Meister, Staatliche Kunstsammlungen Dresden: 31; Ivica Gulija/ iStock.com: 54; Hamburger Kunsthalle: 28, 29, 30, 33, 60; Harvard Art Museums/ Fogg Museum, Cambridge, MA (bequest of Grenville L. Winthrop, 1943.209), photo © President and Fellows of Harvard College: 49; The J. Paul Getty Museum, Los Angeles: 61; Keble College, University of Oxford, reproduced by kind permission of the Warden, Fellows and Scholars of Keble College, Oxford/Bridgeman Images: 84; Kelvingrove Art Gallery and Museum, Glasgow: 86; Klassik Stiftung Weimar: 34; Albert Knapp/Alamy Stock Photo: 94; from Robert Knox, *The Races of Men: A Fragment* (London, 1850): 59; Kunsthalle Bremen, photo akg-images: 32; Landesmuseum Oldenburg, photo bpk/Hermann Buresch: 25; from Johann Kaspar Lavater, *Physiognomische Fragmente, zur Beförderung der Menschenkenntniß und Menschenliebe*, vol. I (Leipzig and Winterthur, 1775), photo ETH-Bibliothek Zurich: 3; Library of Congress, Prints and Photographs Division, Washington, DC: 102, 103, 105, 106; after Ida McLearn, G. M. Morant and Karl Pearson, 'On the Importance of the

Type Silhouette for Racial Characterisation in Anthropology', *Biometrika*, xxb/3/4 (December 1928): 96; Medical Historical Library, Harvey Cushing/John Hay Whitney Medical Library, Yale University, New Haven, CT: 9; Stelios Michael/ Alamy Stock Photo: 51; Musée d'Art Roger Quilliot, Clermont-Ferrand (on deposit at Château de Versailles): 64; Musée des Beaux-Arts, Lyon: 91; Musée des Beaux-Arts, Pau: 88; Musée Fabre, Montpellier: 17; Musée du Louvre, Paris: 18; Musée du Nouveau Monde de La Rochelle (MNM.2001.I.I), photo © Max Roy/Musées d'Art et d'Histoire de La Rochelle: 63; Musée d'Orsay, Paris: 19 (photo Janmad, CC BY 3.0), 87, 90, 93; Musée du quai Branly – Jacques Chirac, Paris: 20; Musée de Picardie, Amiens (M.P.375), photo Hugo Maertens/Musée de Picardie: 62; National Gallery of Art, Washington, DC: 15, 35, 65; The New York Public Library: 82, 101; © Nolde Stiftung Seebüll: 67 (private collection), 68 (Harvard Art Museums/Busch-Reisinger Museum, Cambridge, MA (G. David Thompson Fund, BR54.117), photo © President and Fellows of Harvard College), 69 (photo bpk/Nationalgalerie, Staatliche Museen zu Berlin/Jörg P. Anders); from J. C. Nott and G. R. Gliddon, *Types of Mankind*, 8th edn (Philadelphia, PA, and London, 1857), photos U.S. National Library of Medicine, Bethesda, MD: 53, 55, 56, 57, 58, 75; Österreichische Nationalbibliotek (LAV VIII 68/ 19664), photo © ÖNB, Vienna: 6; © Parliamentary Art Collection (WOA 3153): 46; Peabody Museum of Archaeology and Ethnology, Harvard University, Cambridge, MA, photos © President and Fellows of Harvard College: 71 (35-5-10/53037), 72 (35-5-10/53041), 99 (gift of Dr Dudley A. Sargent, 1920; 20-3-10/59929.0 and 20-3-10/59930.0); after Karl Pearson, *The Life, Letters and Labours of Francis Galton*, vol. II (Cambridge, 1924): 95; Petrie Museum of Egyptian Archaeology, UCL, photo Dr Osama S. M. Amin (CC BY-SA 4.0): 98; from James Cowles Prichard, *The Natural History of Man*, 3rd edn (London, 1848): 73; private collection: 76, 85; Royal Holloway, University of London: 26; Royal Shakespeare Theatre, Stratford-upon-Avon: 12; from A. H. Sayce, *The Races of the Old Testament* (London, 1891): 97; Science Museum, London, photo Wellcome Collection (CC BY 4.0): 8; courtesy of Swann Auction Galleries: 89; Tate Britain, London: 37; Tiroler Landesmuseum, Innsbruck, photo Album/Alamy Stock Photo: 27; © The Trustees of the British Museum, London: 23, 52; United States Holocaust Memorial Museum, Washington, DC: 79; Universitätsbibliothek Heidelberg: 104; University of Dundee Fine Art Collections/ Bridgeman Images: 83; from Richard Verstegan, *A Restitution of Decayed Intelligence in Antiquities, Concerning the most noble, and renowned English Nation* (London, 1634), photos George Peabody Library, Johns Hopkins University, Baltimore, MD: 39, 40, 41, 42, 43, 44, 45; © Victoria and Albert Museum, London: 38; from Julien-Joseph Virey, *Histoire naturelle du genre humain*, vol. II (Paris, 1800), photo Bibliothèque nationale de France, Paris: 7; The Walters Art Museum, Baltimore, MD: 13; Warren Anatomical Museum collection in the Center for the History of Medicine, Francis A. Countway Library of Medicine, Harvard University, Boston, MA (WAM 20519 and 20520), photo Samantha van Gerbig: 100; from Eden Warwick (George Jabet), *Nasology; or, Hints towards a Classification of Noses* (London, 1848), photo Wellcome Library, London: 81; Watts Gallery Trust, Guildford: 48 (COMWG.91), 50 (COMWG.139); from Samuel R. Wells, *New Physiognomy; or, Signs of Character, as Manifested through Temperament and External Forms, and Especially in 'the Human Face Divine'* (New York, 1867), photo Library of Congress, Washington, DC: 24; Yale Center for British Art, New Haven, CT: 36; Yale University Art Gallery, New Haven, CT: 80; York Museums Trust (York Art Gallery): 47.

# INDEX

Illustration numbers are indicated by *italics*